FASHION
ILLUSTRATION
& DESIGN

—

Manuela
Brambatti

FASHION
ILLUSTRATION
& DESIGN

Methods & Techniques
for Achieving Professional
Results

A tutorial by
**Gianni
Versace's**
star illustrator

 HOAKI

 HOAKI

Hoaki Books, S.L.
C/ Ausiàs March, 128
08013 Barcelona, Spain
T. 0034 935 952 283
F. 0034 932 654 883
info@hoaki.com
www.hoaki.com

hoaki_books

Fashion Illustration & Design
Methods & Techniques for Achieving Professional Results

Reprint: 2021 (two times), 2019, 2018

Copyright © 2017 Hoaki Books S.L.
ISBN: 978-84-16851-06-5
Imprint: Promopress
Copyright © 2017 Ikon Editrice srl
Original title: *Fashion Design Professionale*

Author: Manuela Brambatti
English translation by Lisa Kramer Taruschio
Cover design by spread: David Lorente / Noelia Felip

D.L.: B 23780-2018
Printed in Turkey

Introduction to the Author

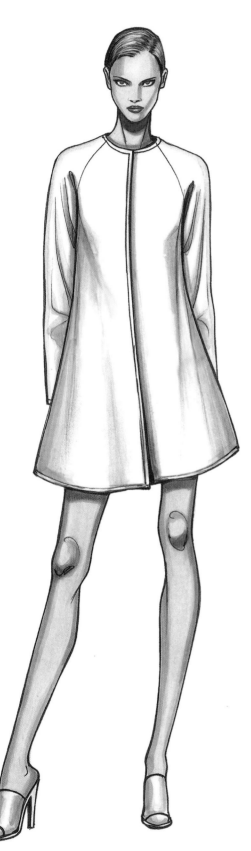

This book was born of an idea of Fabio Menconi, who tells us that when, in Ancona, he received Gianni Versace's designs for Genny, and he was fascinated and was inspired to design in a wholly different way.

One day he called me and asked, "Have you ever thought of doing a How-To book?" I said that honestly, I never had--the idea had never dawned on me. He showed me some videos and persuaded me that it would be useful for people like him to have materials of that kind available.

During the last few years, I heard many similar opinions expressed, both by co-workers and by simple fashion design enthusiasts, some wondering how to achieve a certain effect, others simply fascinated by what certain designs told them.

We already have diverse, and useful, books on fashion design available. Perhaps what makes this project interesting is the uniqueness of one kind of fashion design, which is not necessarily better than others and recognizable because it is not "classic and stereotyped", but falls somewhere halfway between sketch and illustration.

This is simply the fruit of taste and personal tendencies linked to an innate talent and mature experience in the sector, which has added to the "good hand" a much broader vision of taste and creativity.

Once these designs appeared and were seen in publications linked to Gianni Versace, they became well known and appreciated and associated with the beauty of his artistry.

Some people are convinced that I was born an illustrator, and this may be true in that I love design more than Fashion in and of itself. But my professional experience has been in design offices as "designer", that is, as the creative contributor behind the collections. The silhouettes that represent the garment and which are on view in the first part of this volume were my own designs, our daily fare.

I also like the idea of showing the world fashion sketches done in a professional key where designers have left school for the working world with its organizational demands, practicalities and often steady rhythm.

Several techniques develop when following the logic of the practical. I have always used magazines and books of photographs for inspiration. I discovered several effects through experimentation...

I like to think of this book as an open work bench for whoever finds it useful. It was never conceived as a teaching tool, but simply for the pleasure of sharing. I dedicate the finished product, along with all my gratitude, to Fabio, whose idea it was: also his were the inspiration and the enthusiastic prod that made this project alive and tangible.

Preface

It was Gianni Versace who made me fall in love with his fashion: with his ideas, so ahead of their time, with his reactions that could blend a myriad of inspirations into one whole of absolute harmony, with his stylistic language which could be as haughty and regal as it could be rock and aggressive. But the one who brought me into his universe and immersed me completely in his fantasy world—and thus I came to know him even more profoundly— was the Artist whose work I appreciated first and then, many years later, came to appreciate his extraordinary personality.

In the early 1990s I produced a fashion program entitled "Angoli", which presented the most important runway fashion shows of the time: Gianfranco Ferré, Valentino, Montana. I paid special attention—given my admiration for the designer—to the films that I received from the Versace press office which used to send me (besides the usual press releases) catalogues of the collections as well. For me, barely past adolescence, fashion was a huge dream in which I could hide; it was like receiving true religious relics. Browsing those volumes introduced me to the world of Gianni Versace and, given that this was an omnivorous designer who gorged himself indiscriminately on art, music, theater, dance and high and low speech with equal passion, it meant learning something new, broadening horizons, knowing new forms of beauty and feeling them first-hand.

The Versace, Versus and Istante catalogues featured images by Richard Avedon. Bruce Weber, Patrick Demarchelier, Doug Ordway, Steven Meisel, Mario Testino before alternating with photographs of garments and multiple accessories signed by Manuela Brambatti and Bruno Gianesi who were the more prominent members of the Versace design studio. Those drawings were in every way equal to the pieces signed by Avedon in terms of evocative power and artistic fascination. They were moving, they caught you in their spell, they were enchanting. The inspiration for the collection was the glittering crowd that populated Ocean Drive in Miami, and there were lush palms and a golden sheen to the girls' skin. On the other hand, the young ladies who twenty years ago showed off the elegance of sailors' stripes that Versace reworked into a display of optical fireworks were more slender and cerebral. Their expressions were stolid and their bodies as solid as statues—these were the women who chose the luxurious version of the sadomasochist clothing from that famous collection which, even today, is copied by so many (and so poorly).

In any case, the girls set up on the runway by the talent and mastery of Manuela were always proud, and their character did not go unnoticed. Thanks to the power of illustration, which knows no limits and can nail the wildest visions, Versace could count on even the most sensational interpretations from his wildly famous top models.

I don't know how many hours I spent admiring Manuela's work as published in those catalogues. Each time I was torn between awe for the sheer beauty and admiration for the solid, wise technique. Each time I was drawn into a fantastic universe, a planet of gorgeous and tender or cruel creatures, all fascinating beyond imagination, who expressed their power through Versace's clothes.

When I wrote my first book on Gianni Versace—a collection of interviews with individuals who had known or worked with him—I did all I could to get in touch with Manuela, but in vain. Her absence in that book was, for me, a source of regret. The regret was fully vindicated two years later when I authored a biography of the designer. The book was enriched not only by an interview with Bruno Gianesi, but also by the memories of Manuela Brambatti and by ten plates by her which reviewed Versace's fashion as she interpreted it. The draped pink garment from the Atelier Versace presented before Versace's murder, the 1994 sari done in a punk key, the Morte Torchon from Béjart's ballet—so vivid, so moving were these as to seem three-dimensional. No one but Manuela could bring attitude, movement and personality to life on paper.

To know Manuela and to love her is something unique. When I met her for the first time I instinctively wanted to hug her, as though she had always been my friend. Her smile, her voice, her gestures contain all the sincerity, purity, honesty and authenticity that only true artists possess. And her art is the proof: no tricks, no winks, no pandering, just a unique and rare combination of talent and technique. And sensitivity, which is so acute in this woman, so greatly perceptible.

This book comes a perfect time, for two reasons.

The first is that in this age of tutorials it's really necessary for a person with the experience and expertise of Manuela Brambatti to teach those who wish to be fashion designers the secrets for obtaining amazing results: a designer may conceive of the cleverest garment the world has ever seen, but if it is drawn poorly or carelessly it will not gain approval, will not be chosen, and will win no one over. These pages, therefore, make up a real treasure chest of advice, if not of secrets, to be taken to heart with the knowledge that an Artist of limitless talent is sharing her knowledge with the read-

er. The second reason why this volume constitutes something priceless rests in the habit, which is increasingly more widespread in the world of fashion, of freezing at the essence of the project and dedicating increasingly less time and precision to the accuracy of the sketch. It's true, tastes have changed; in sketches today tendencies possibly derived from the world of comics and Japanese manga seem to prevail. But aside from these aesthetic considerations, what I do see when I visit or when I view the work of some designer friend is how little time is dedicated to this creative phase.

When I fell in love with fashion, a designer's sketches could convey, as well as the garments themselves, his or her concept of grace and beauty; they were a distinct feature: Valentino's needle-thin women, the abstract brush strokes of Gianfranco Ferré, Lagerfeld's ironic croquis. And then came Manuela Brambatti's women for Versace.

They say you can get used to anything, including the extraordinary. Not true.

So many years later, Manuela's sketches still fill me with identical wonder. I see many of them on the Internet, I see them anew in old catalogues, I find them again in my book and, when I am lucky enough to receive them as gifts, I can show off their beauty on the walls of my house. Each time I feel blown away: those women can still hypnotize me, conquer me. It is the same as when I was a boy, when I would look at those illustrations and fantasize about that "Manu" person, so fanciful, so engaging, so exciting, who took me by the hand and led me into the creativity of Gianni Versace.

Tony Di Corcia

Contents

THE TUTORIAL

DESIGNING THE BASE

Classic Bases

All my bases start from photographic images which I find interesting and useful to show a garment.
At this point, I translate them into nude 'bases'.
If I have previously drawn poses available which are similar to the new one (the same angle of the body, etc.), I use these as bases, putting them under a sheet of white paper so that I can easily trace the proportions. So I change only the details: an arm or a leg placed in a different position, etc. For this step, sheets of light paper are useful—for example, Schizza and Strappa pads.
If I have no base which is close to the pose I am looking for, I create a brand new one. Each pose is useful according to the garment I want to design and work on. I do not follow precise measurements. Although I retain a slender silhouette with long legs, the proportions are closer to the 'human' profile. I like viewing the clothed figure as though it were 'real', almost like a photograph that previews the effect of the garment. This also depends on your hand: mine is potentially more a painter's hand than a sketcher's.

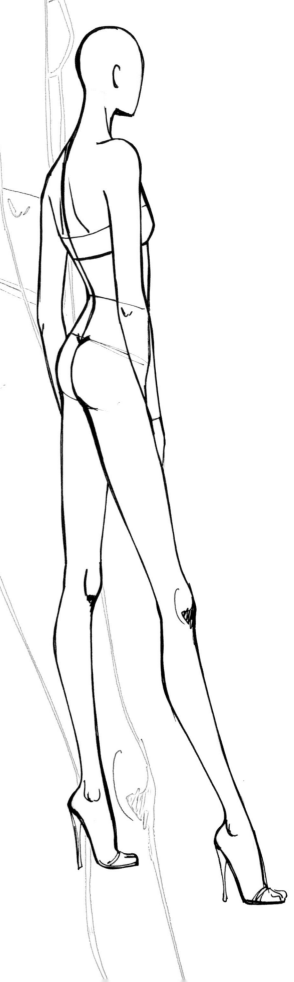

Tools

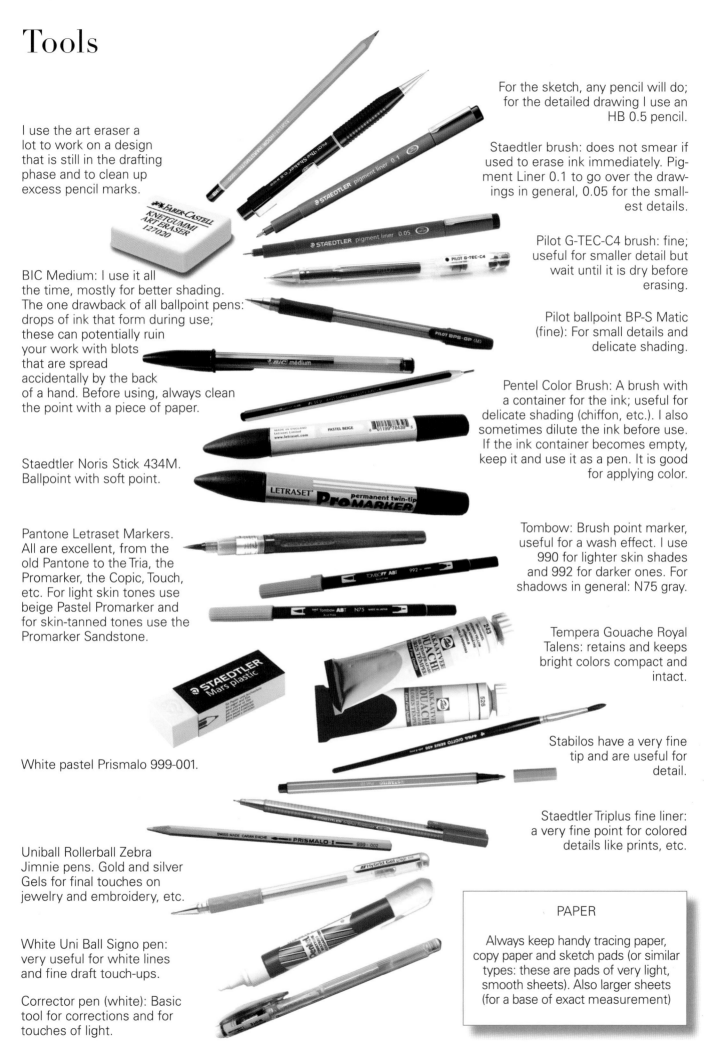

I use the art eraser a lot to work on a design that is still in the drafting phase and to clean up excess pencil marks.

For the sketch, any pencil will do; for the detailed drawing I use an HB 0.5 pencil.

Staedtler brush: does not smear if used to erase ink immediately. Pigment Liner 0.1 to go over the drawings in general, 0.05 for the smallest details.

BIC Medium: I use it all the time, mostly for better shading. The one drawback of all ballpoint pens: drops of ink that form during use; these can potentially ruin your work with blots that are spread accidentally by the back of a hand. Before using, always clean the point with a piece of paper.

Pilot G-TEC-C4 brush: fine; useful for smaller detail but wait until it is dry before erasing.

Pilot ballpoint BP-S Matic (fine): For small details and delicate shading.

Staedtler Noris Stick 434M. Ballpoint with soft point.

Pentel Color Brush: A brush with a container for the ink; useful for delicate shading (chiffon, etc.). I also sometimes dilute the ink before use. If the ink container becomes empty, keep it and use it as a pen. It is good for applying color.

Pantone Letraset Markers. All are excellent, from the old Pantone to the Tria, the Promarker, the Copic, Touch, etc. For light skin tones use beige Pastel Promarker and for skin-tanned tones use the Promarker Sandstone.

Tombow: Brush point marker, useful for a wash effect. I use 990 for lighter skin shades and 992 for darker ones. For shadows in general: N75 gray.

Tempera Gouache Royal Talens: retains and keeps bright colors compact and intact.

White pastel Prismalo 999-001.

Stabilos have a very fine tip and are useful for detail.

Staedtler Triplus fine liner: a very fine point for colored details like prints, etc.

Uniball Rollerball Zebra Jimnie pens. Gold and silver Gels for final touches on jewelry and embroidery, etc.

White Uni Ball Signo pen: very useful for white lines and fine draft touch-ups.

Corrector pen (white): Basic tool for corrections and for touches of light.

PAPER

Always keep handy tracing paper, copy paper and sketch pads (or similar types: these are pads of very light, smooth sheets). Also larger sheets (for a base of exact measurement)

Frontal Pose

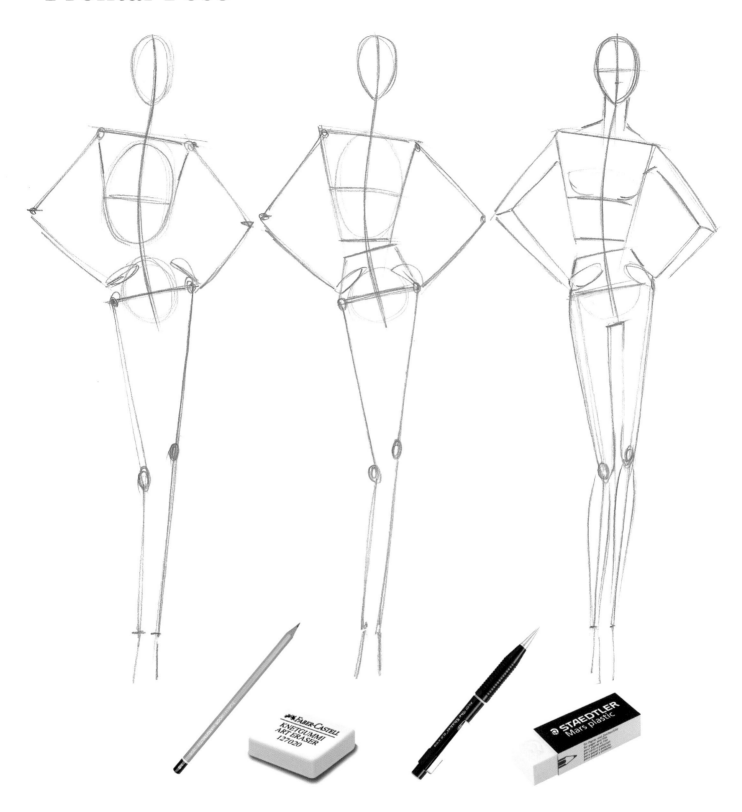

Start from the oval head, then split it vertically in half with a line drawn from top to bottom to show the inclination of the body (the backbone).

Use straight lines to show the various inclinations: shoulders, waist, hips.

If desired, the volume of the thorax can be shown by an oval at shoulder level. A circle with a horizontal line through it can be drawn to show the hip area; from that line, extend the lines for the legs. The first leg line stops at the knee (which I show with a small circle) and the other leg line is at the inside of the leg. This demonstrates the direction of movement.

For the arms: two straight lines trace the position. The elbow measurement corresponds to the height of the waist. Squared lines suggest the larger lines of the body's volume.

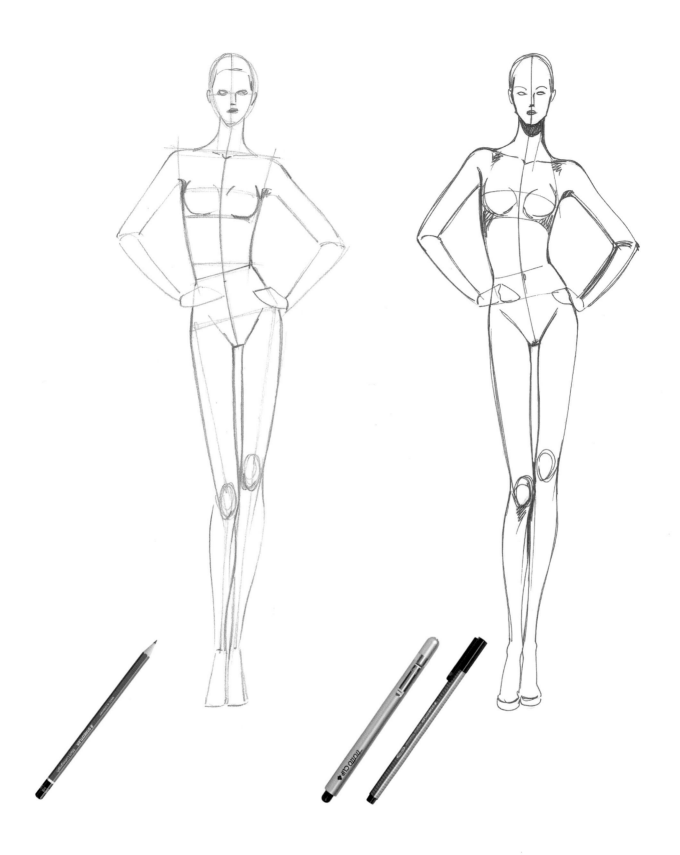

Fill out the drawing of the human body adding details like hands, etc.
NB: If you are working with a Type B pencil, pat the lines gently with a white eraser to clean up the excess lines and tracings. Once you achieve the pose you want, brush over the drawing with brush (not a very fine point, however; use a Tratto pen which is excellent for a good view of the base to be copied later). The Tratto is also useful for all the garments: more legible and direct.

Frontal pose, ¾ view

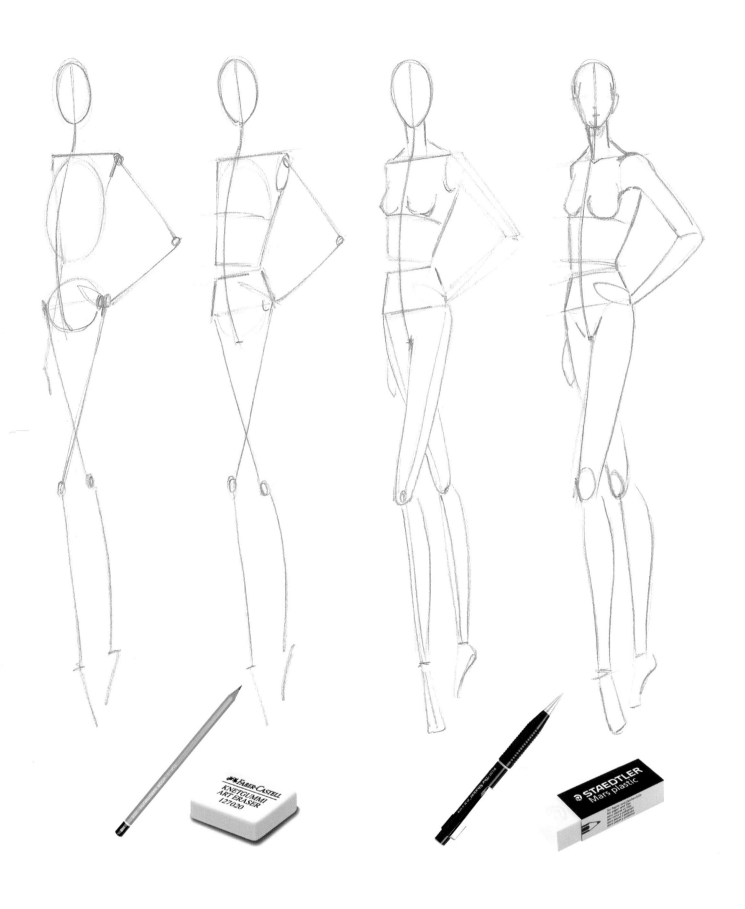

Personally, I use this semi-profile pose a lot: it shows off nearly all garments well and provides views of both the front and side at once.

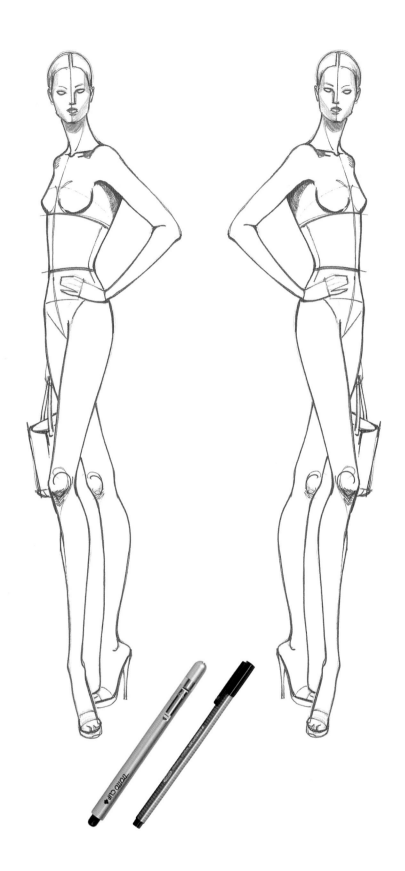

Mirrored bases are useful. They are equal sizes and are also an excellent alternative so as not to have to repeat them and in cases where there are asymmetrical details which are visible only on one side I can redraw these directly on the back of the sheet.

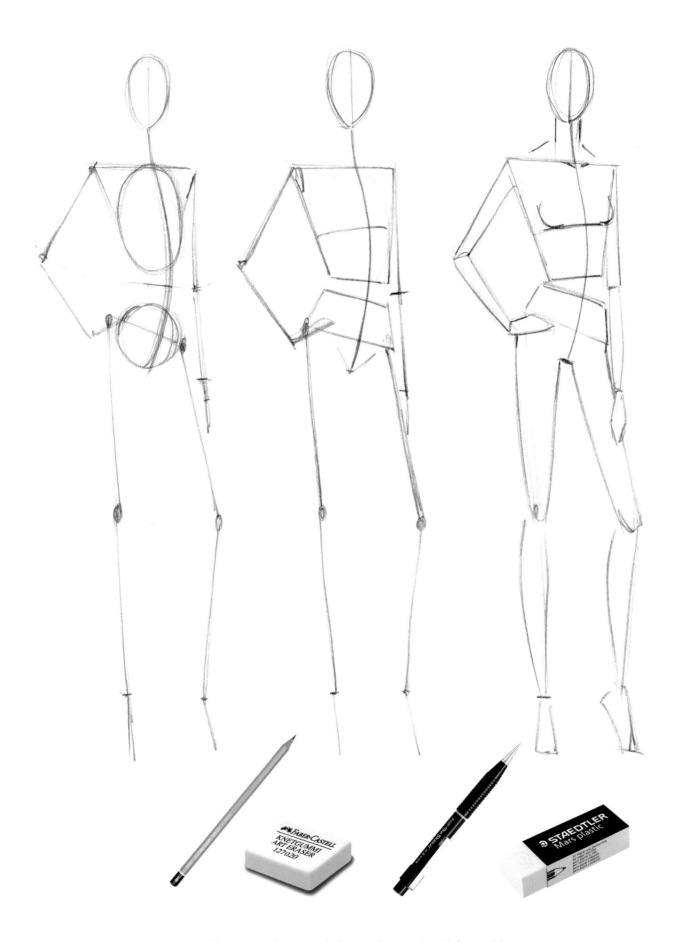

This pose is a good alternative to the ¾ frontal base.

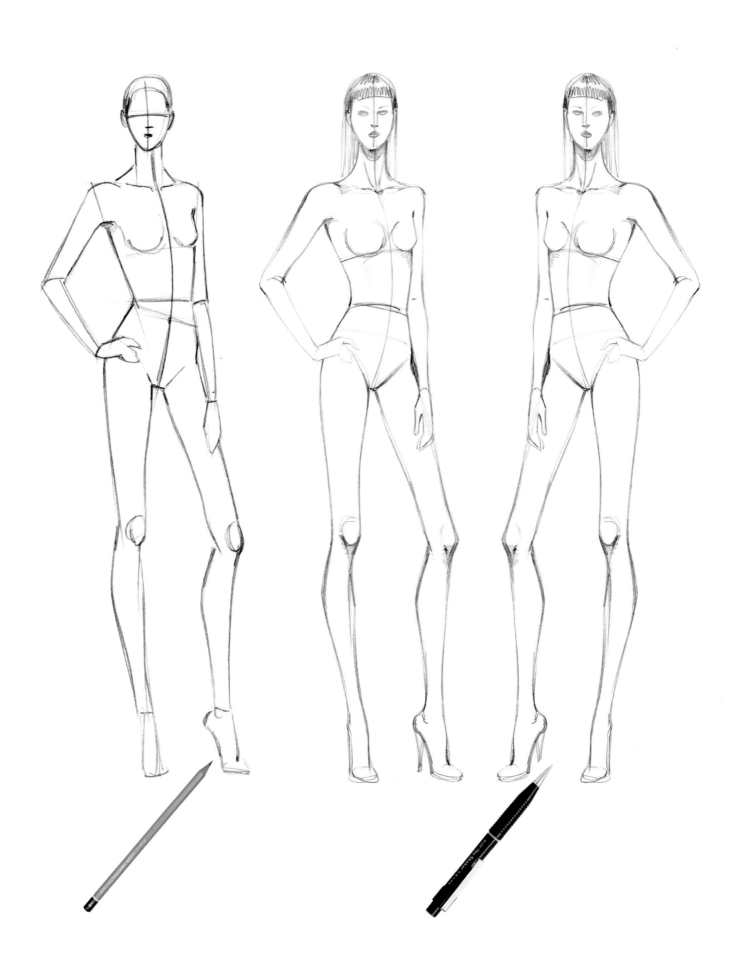

Profile Pose

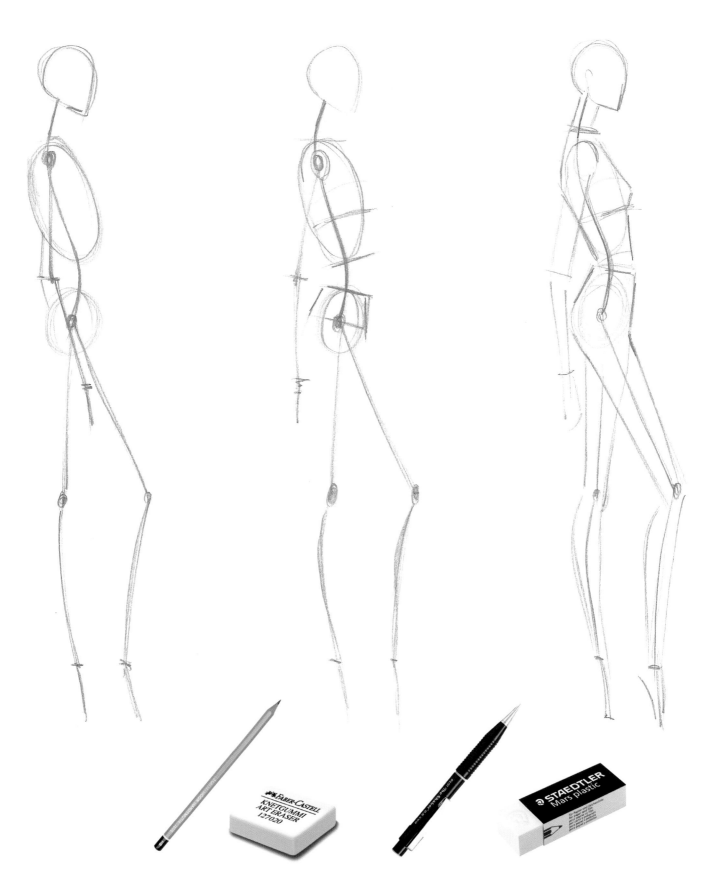

The construction concept is similar to the others. The inclination of the backbone determines the movement of the figure.

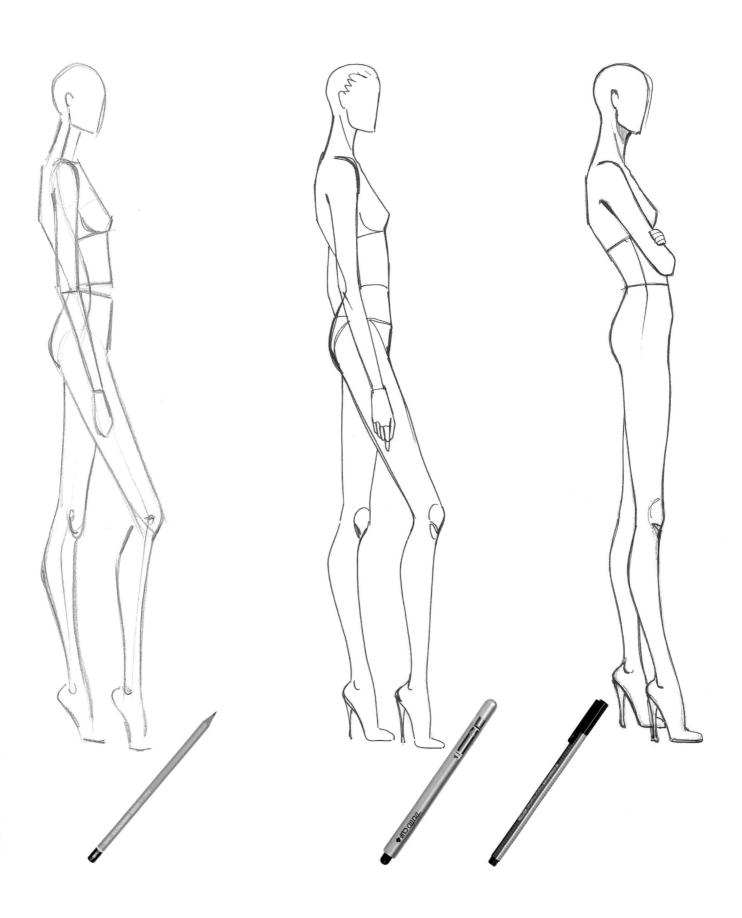

Useful for side detail, which might be embroidery,
a kick pleat, or a flared inset that we want to show,
etc.

Rear View

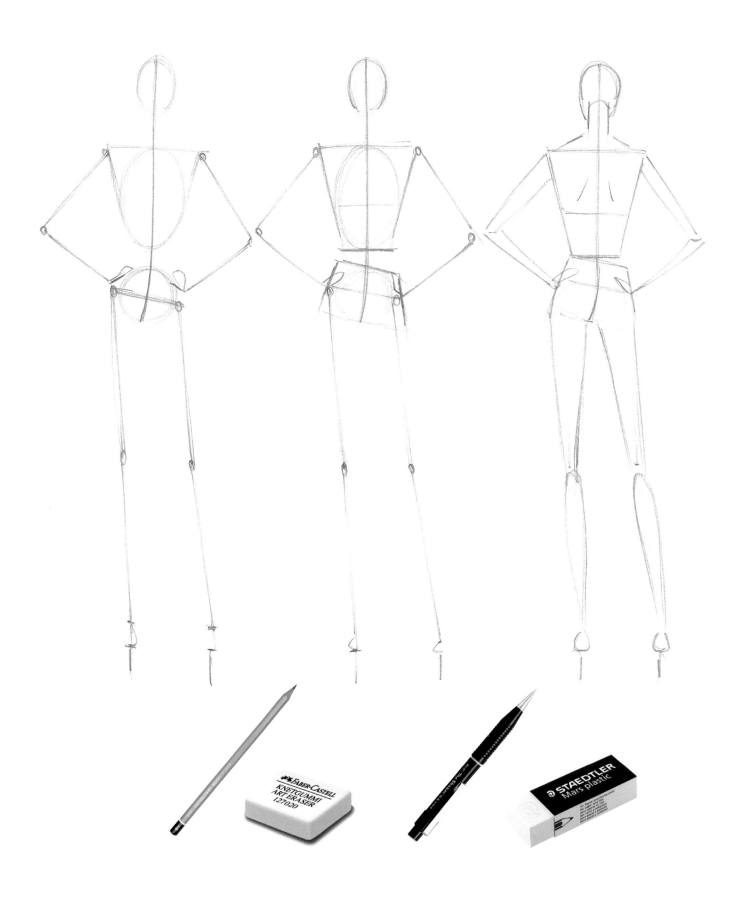

Construction for the rear view is very similar to the front view.

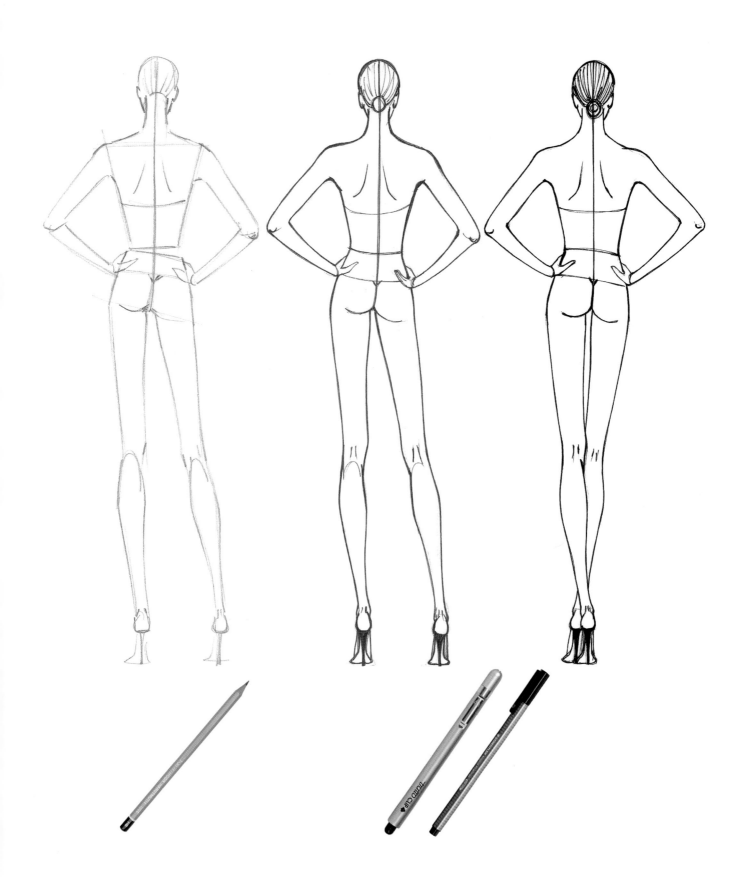

If the garment's design calls for a simple front but
important detail in the back, it's best to show this in
a suitable pose.

¾ Rear Pose

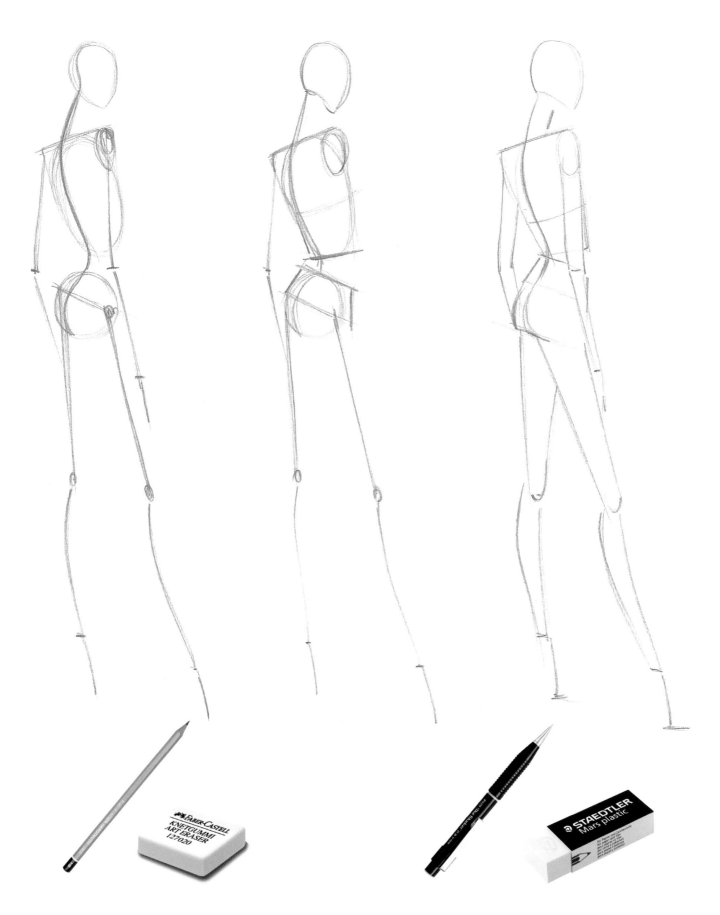

This pose serves the same purpose as the ¾ front pose in that it shows off both the side and the back.

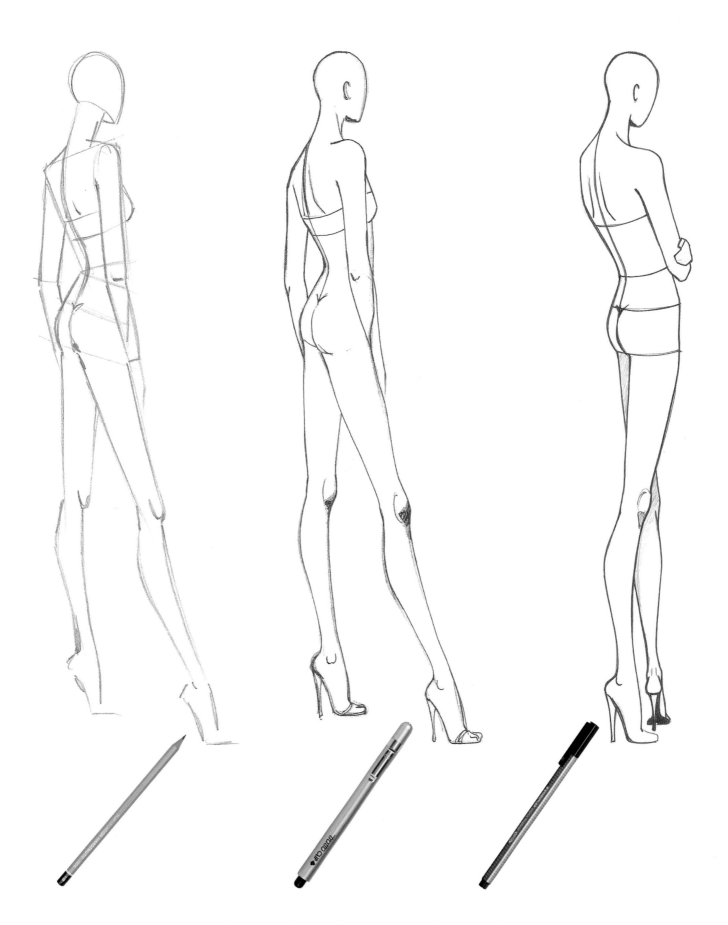

Useful and effective if we want to show a back or
side opening or kick pleat, cross straps, etc.

More Complicated Poses

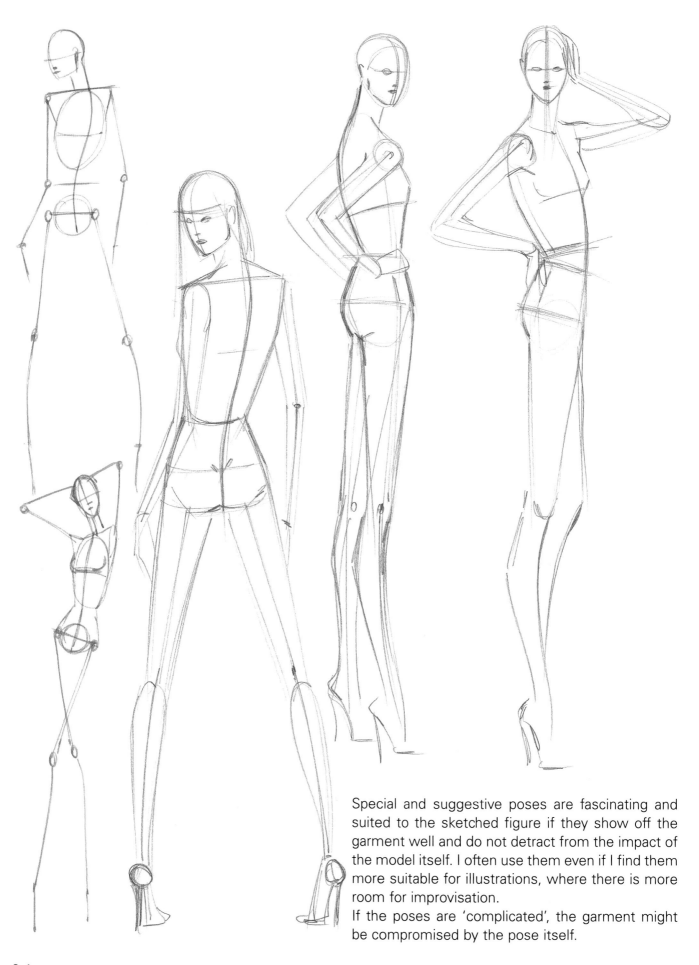

Special and suggestive poses are fascinating and suited to the sketched figure if they show off the garment well and do not detract from the impact of the model itself. I often use them even if I find them more suitable for illustrations, where there is more room for improvisation.

If the poses are 'complicated', the garment might be compromised by the pose itself.

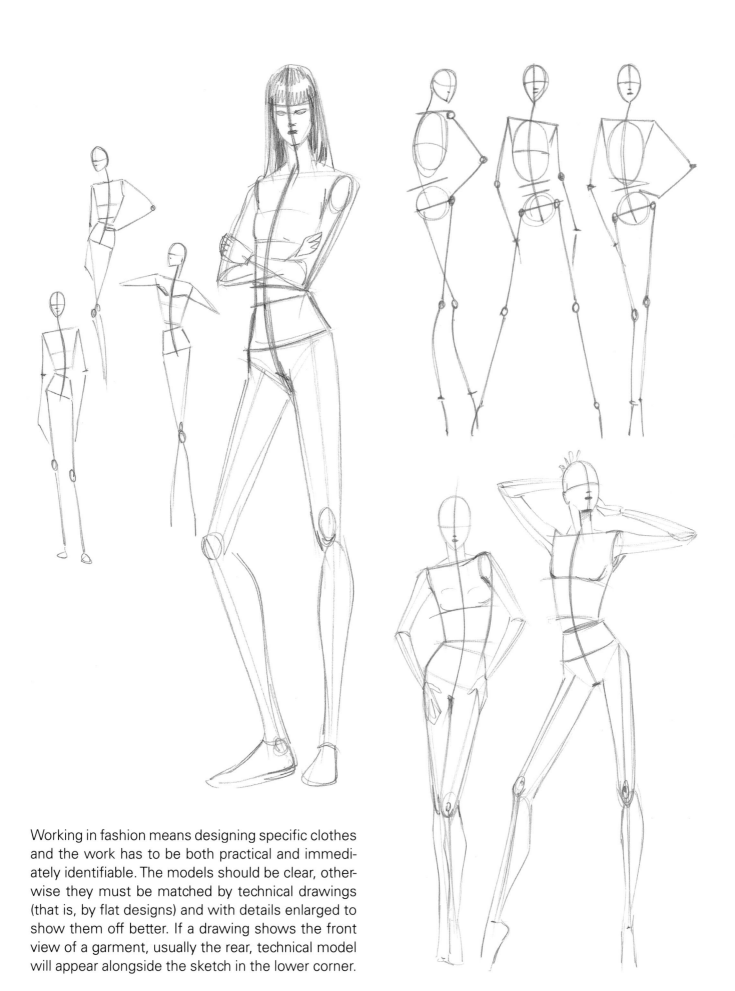

Working in fashion means designing specific clothes and the work has to be both practical and immediately identifiable. The models should be clear, otherwise they must be matched by technical drawings (that is, by flat designs) and with details enlarged to show them off better. If a drawing shows the front view of a garment, usually the rear, technical model will appear alongside the sketch in the lower corner.

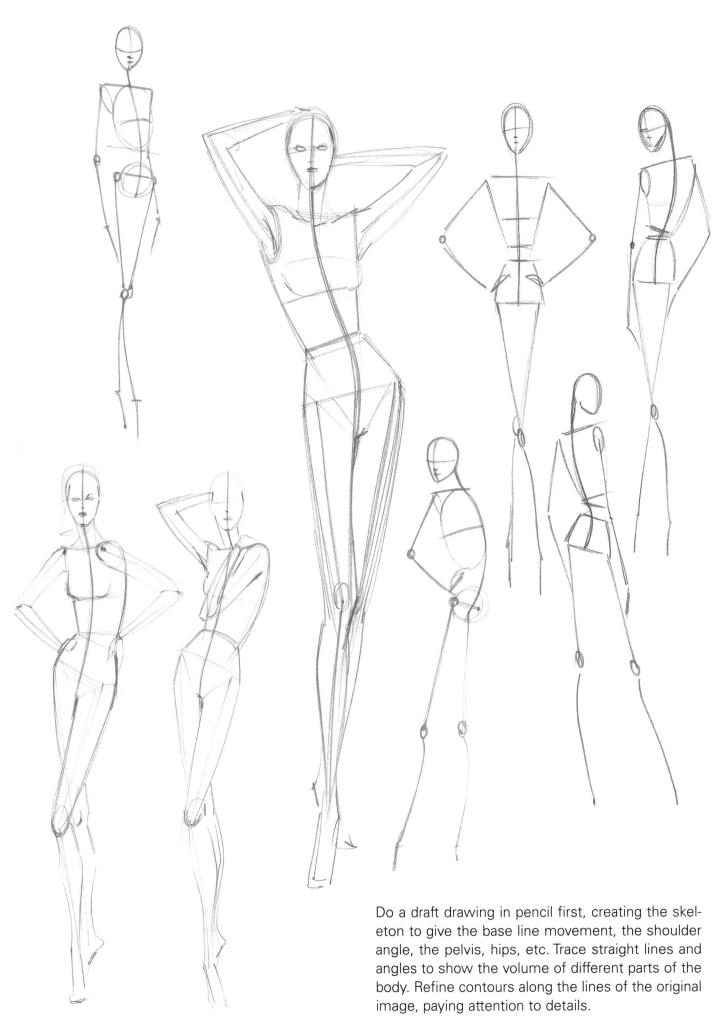

Do a draft drawing in pencil first, creating the skeleton to give the base line movement, the shoulder angle, the pelvis, hips, etc. Trace straight lines and angles to show the volume of different parts of the body. Refine contours along the lines of the original image, paying attention to details.

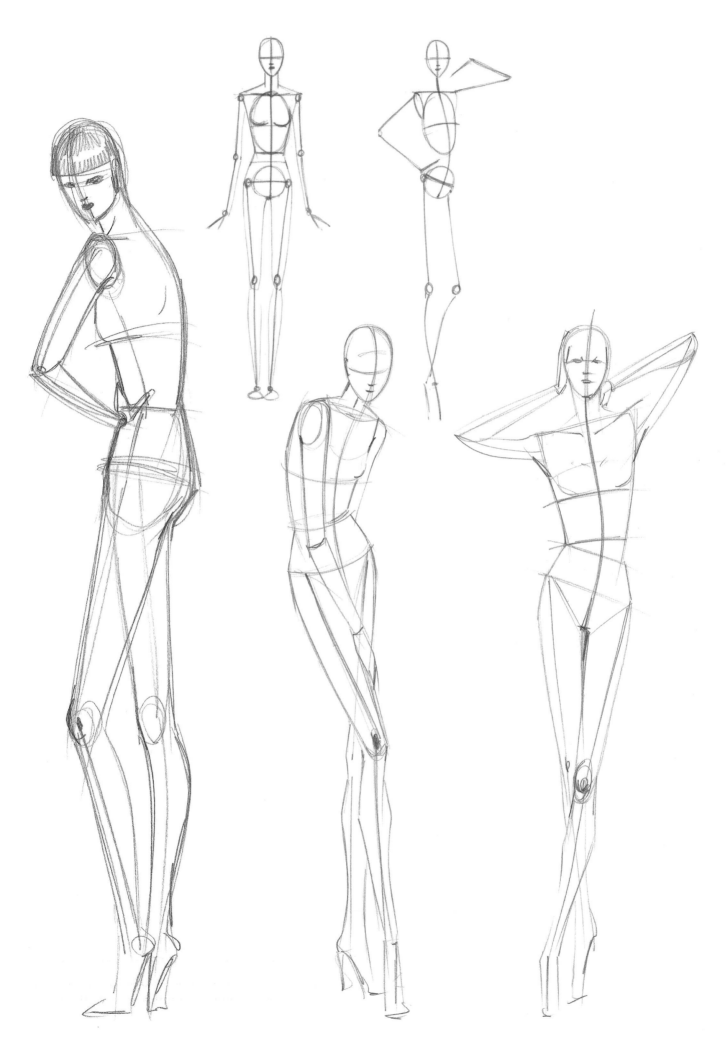

CREATING THE FACE

Western Face

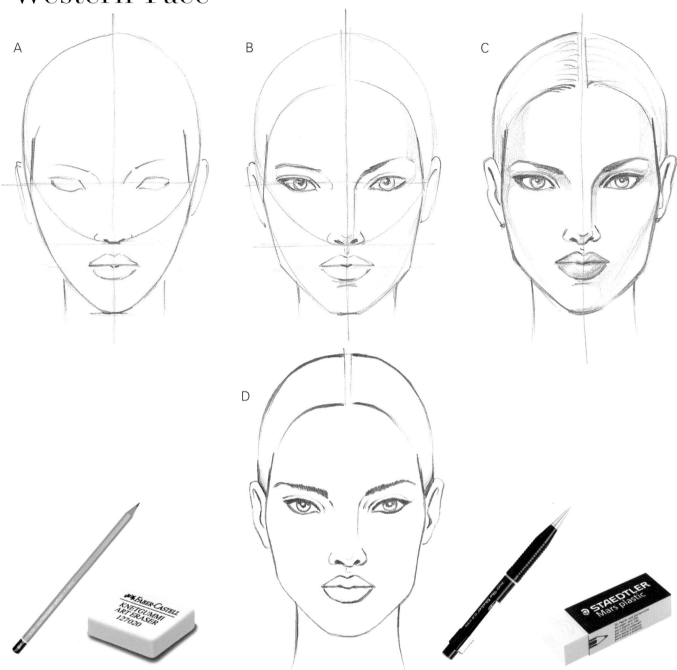

First, I choose a face I like to use as a model. A) In this case, draw a circle: at the top, mark the top of the head and below it mark the position of the nose. Proceed by drawing an oval that you divide in half vertically and horizontally toward the halfway point to mark eye height. Halfway between the nose and the chin is the height of the mouth. Determine the measurement by starting from the line of the eyes and proceeding in a downward triangle until the lines meet at the center of the chin. Draw the temples with two lines and add approximate marks for the eyes, nose and mouth. B – Moving down from the eyes, trace the contours of the face stopping at the top line of the mouth (the jaw). From there, trace two straight lines toward the base of the oval (the chin). Delineate more exactly the eyes, nose and mouth. C – Define and polish up details following the image that was your original inspiration. D – Delicately swab the drawing with a white eraser to clean and remove excess pencil traces, keeping only the clean contours and tracing over these with an HB 0.5 mechanical pencil.

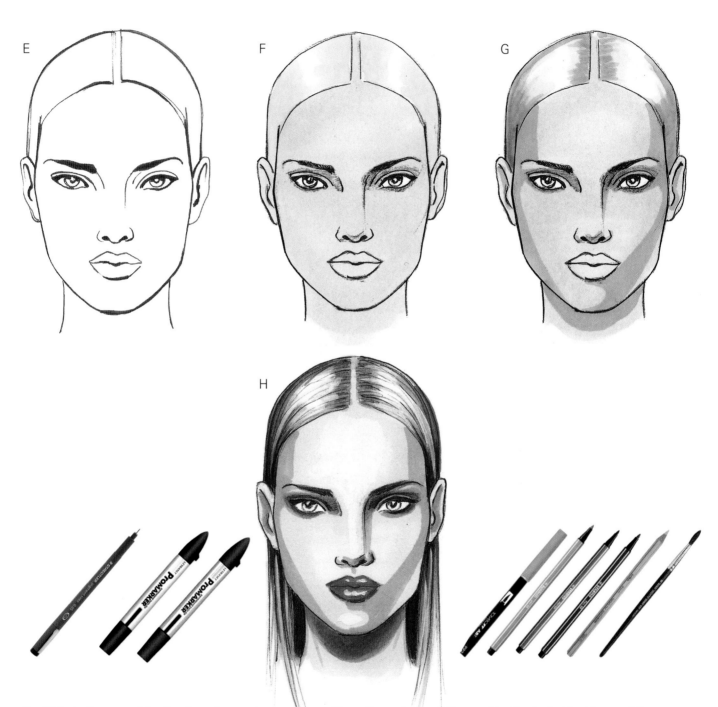

E – This is the graphically clear face, cleaned up with a soft brush. F – Spread skin color with a Pantone brush leaving the area around the eyes and mouth white. Barely color the hairline toward the center of the head and from the outside line inward, leaving a white line to be used as light. (Tombow 990 or 992 or Stabilo Swan 68/39 marker). G – Once the Pantone is dry, go over it to shadow the temples, cheekbones and chin.

Shadow the hair with a darker color, working from the edges of the head toward the center and from the edges of the part in the hair. H – Use red Pantone or a red Stabilo for the lips, which should be darkened slightly toward the sides and on the contour of the lower lip. Also darken the part under the chin, working toward the neck (Sandstone Promarker or an even darker shade). Lightly go over the cheekbone line with a pastel; shade the eyelid areas and the base of the nose. Use white pastel (or white tempera) for a touch of light on the hair and lips.

Slightly Downward Gaze

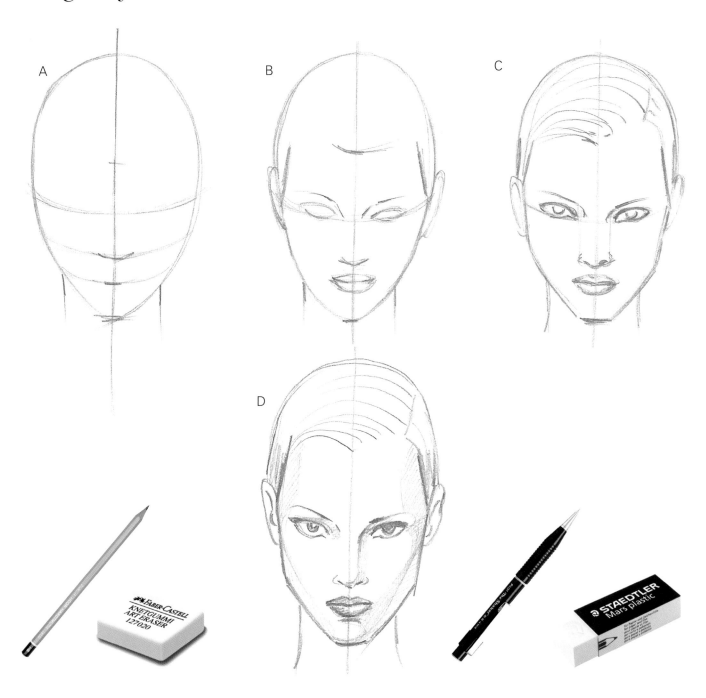

A – Trace an oval and split it in half vertically. Draw a horizontal line curving toward the bottom just below the halfway point on the oval, reaching the height of the eyes. Divide the lower part of the oval into 3 equal parts and a line making the same curve to define placement of the nose and mouth. B – Mark the temples with two inclined lines that start from the line of the eyes and move toward the inside of the upper oval. C – From the eye line itself, move downward outlining the contour of the face and stop at the top of the mouth line (the jaw). If the head is slightly lowered, the jaw line will be a little higher. From here, trace two straight lines toward the base of the oval (the chin). Sketch the eyes,

nose and mouth. D – Go over the details carefully. E – Go over the face with a very fine-tip black marker (like the Staedtler pigment liner 0.1) to make it clean and graphic. For these steps I often use a ballpoint pen (like the Pilot B.P.S Matic Fine) because it gives a lighter, thinner line than a marker. F – AP-PLYING THE FIRST COLOR First, apply it to the base areas (skin, hair). Facial surface: I use a beige Promarker Pastel for light skin and the Sandstone Promarker for more tanned skin tones. Apply the color leaving the areas around the eyes and mouth white. (If there seem to be lines when you apply the Pantone, go over it quickly to get a more homogeneous color).

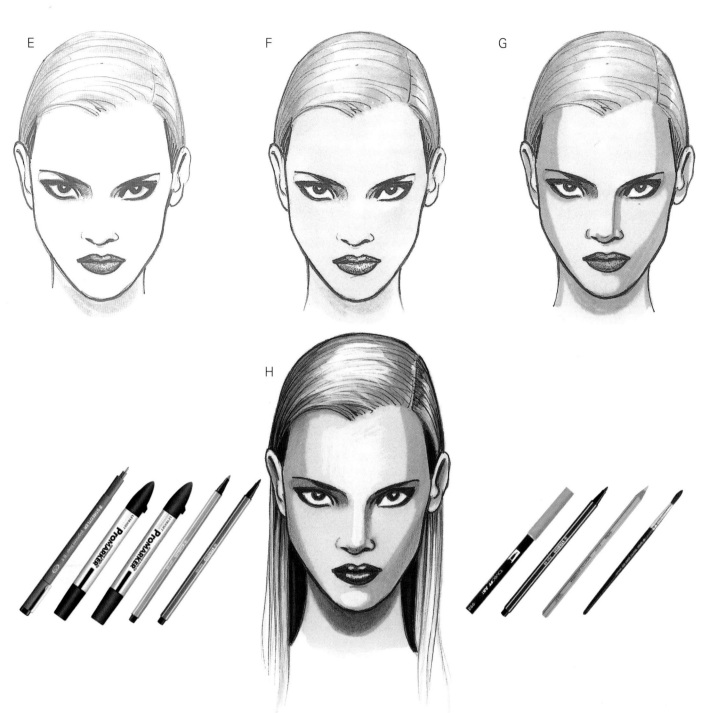

Hair: For blonde external surface and hairline hair color use the Stabilo Swan 68/39. G – SHADOWING Now start refining the details of light and shadow. Wait until the Pantone color is completely dry and go over it to shadow the temples, cheekbones and chin. You can also use a slightly darker tone; sometimes tone-on-tone provides lightness, especially if you apply it immediately and the underlying base is not thoroughly dry. Alternatively, you can also use a Tombow 990, or 992 (a somewhat darker tone): these are markers with marker point and are very useful for the more blended lines of a Pantone. Sometimes I use them for the hair as well, in the

same color. For shadowing in hair: to darken use a Stabilo, to blend from the outer part of the head towards the inner parts and at the part in the hair. H – REFINING DETAILS Pantone or red Stabilo for the lips; darken slightly toward the outside lines and the contours of the lower lip. Darken the part below the chin, toward the neck. Lightly retrace the cheekbone line with a touch of Tombow or pastel to give more depth. Shadow the eyelid areas and the base of the nose. For a touch of light use white pastel (or tempera) at the center of the hair, on the most visible locks of hair, and on the lips.

The Asian Face

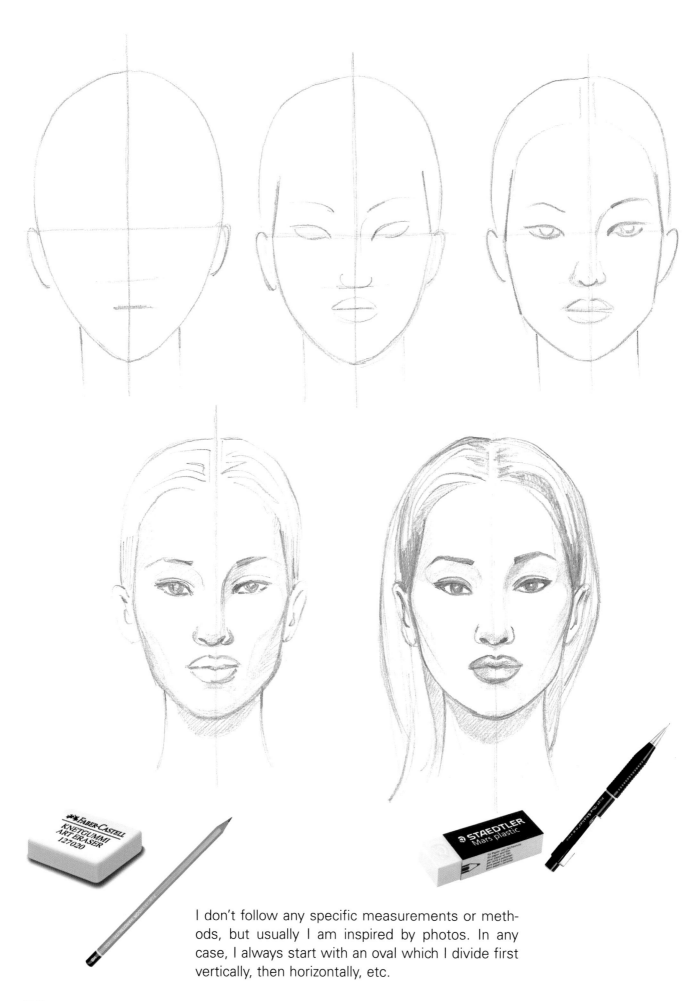

I don't follow any specific measurements or methods, but usually I am inspired by photos. In any case, I always start with an oval which I divide first vertically, then horizontally, etc.

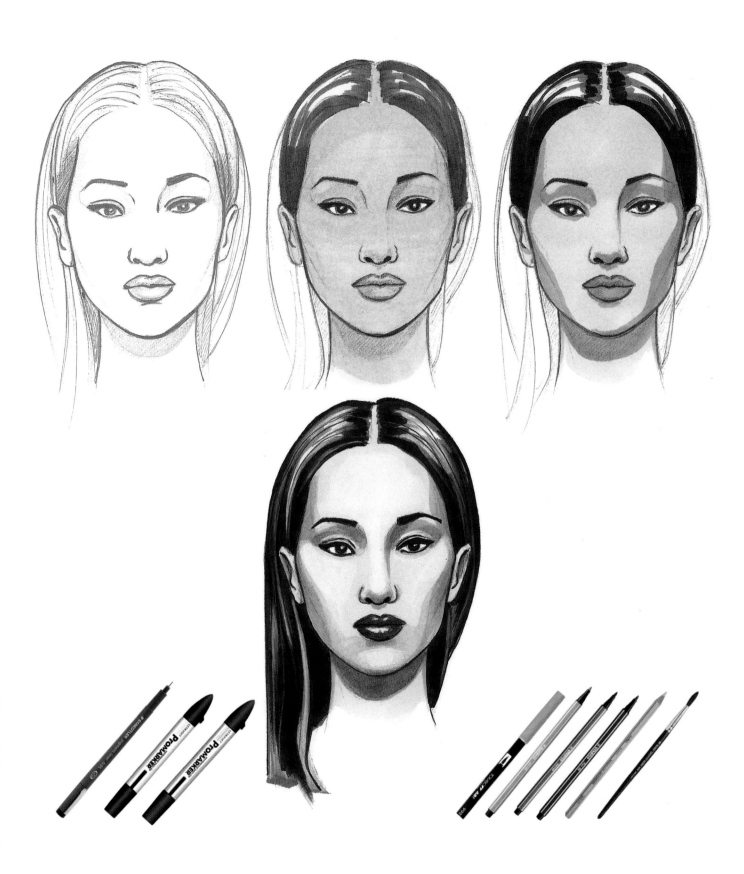

The procedure for all faces is the same: use a fine marker to draw the graphic of the face. Then apply the base color for the skin and hair. Shadow the broadest areas. Finally, go over and refine the minute details. For coloring use the same material that you use for Western faces except for the hair color. For hair, use a black Pantone; for shadow a Tombow. Use white tempera for shiny reflections which, when used with Tombow black ink, take on a blue-ish hue.

The African Face

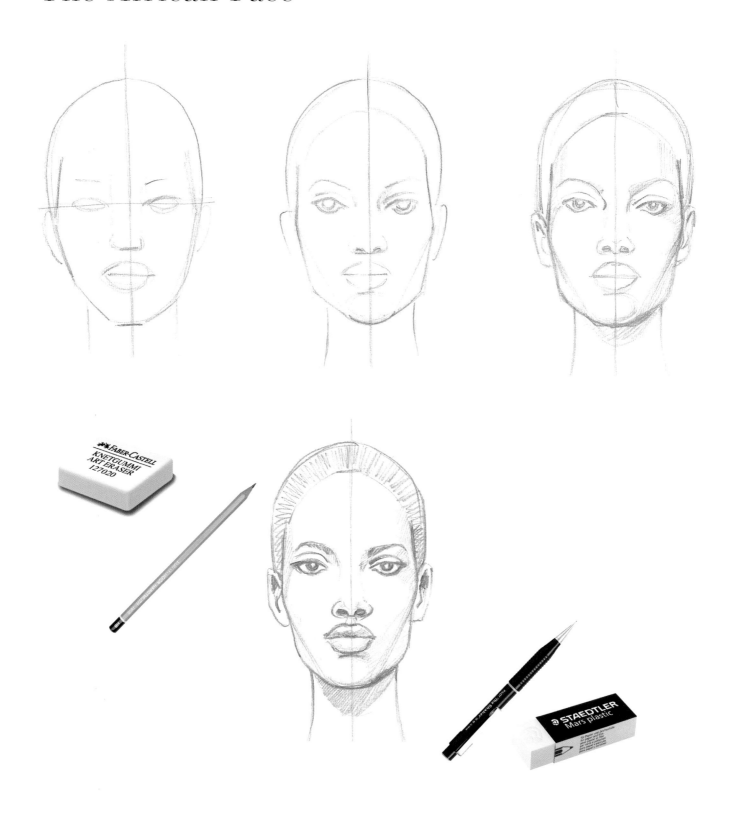

For skin color use a brown Cinnamon Promarker and go over it a second time for shadowing on the temples, cheekbones and chin. For heightened shadowing, use a dark brown pastel (Bruynzeel Design 540) and a Tombow 992. For the lips, a Pantone Tria Red 032T, lightened with a touch of tempera white. Stabilo black for the hair. White pastel (Prismalo 999001) and Royal Talens white tempera on the vertical nose line, forehead and chin.

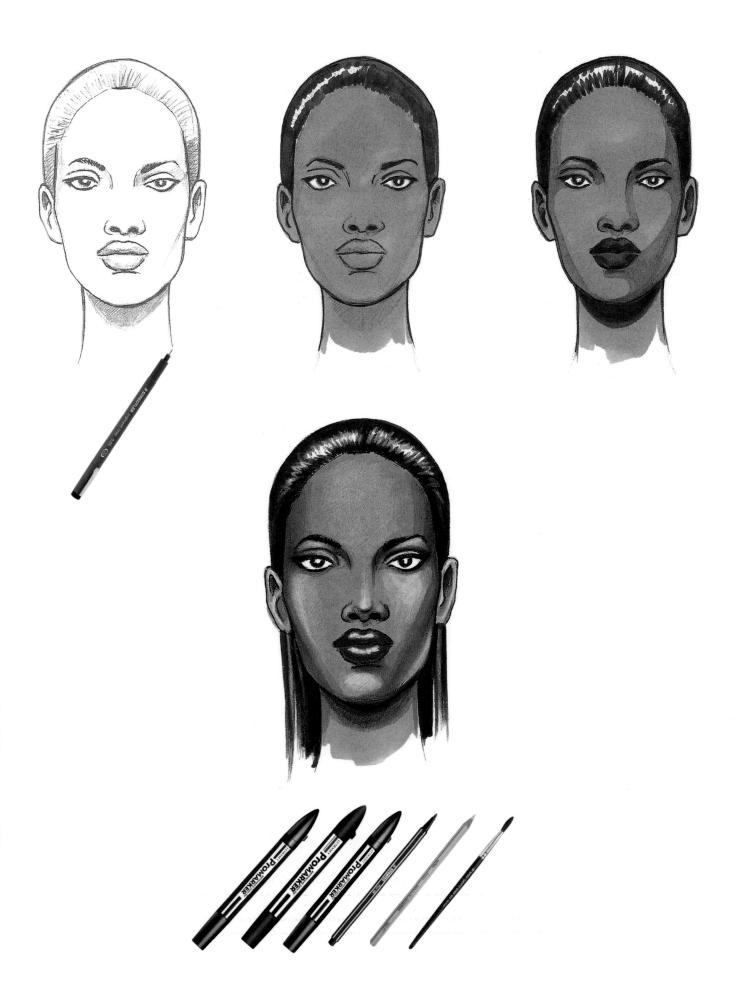

Face in 3/4 Profile

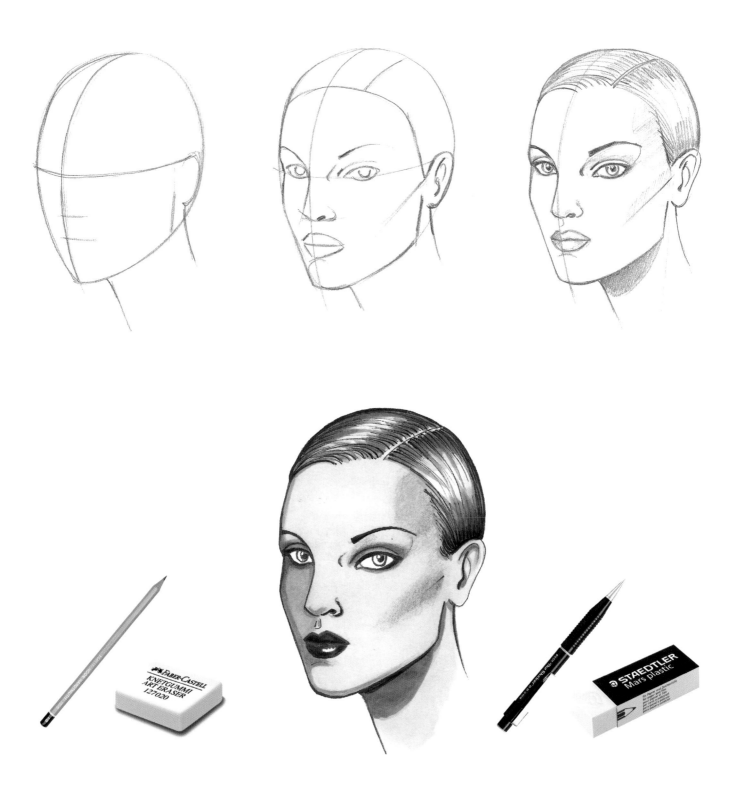

Draft the oval in pencil. With a curved line, move the pencil downward dividing the oval in two, one part more narrow than the other. The parts for the eyes, nose and mouth are equal; the lines will not be straight but rather slightly curved, following the curves of the oval.

Face in Profile

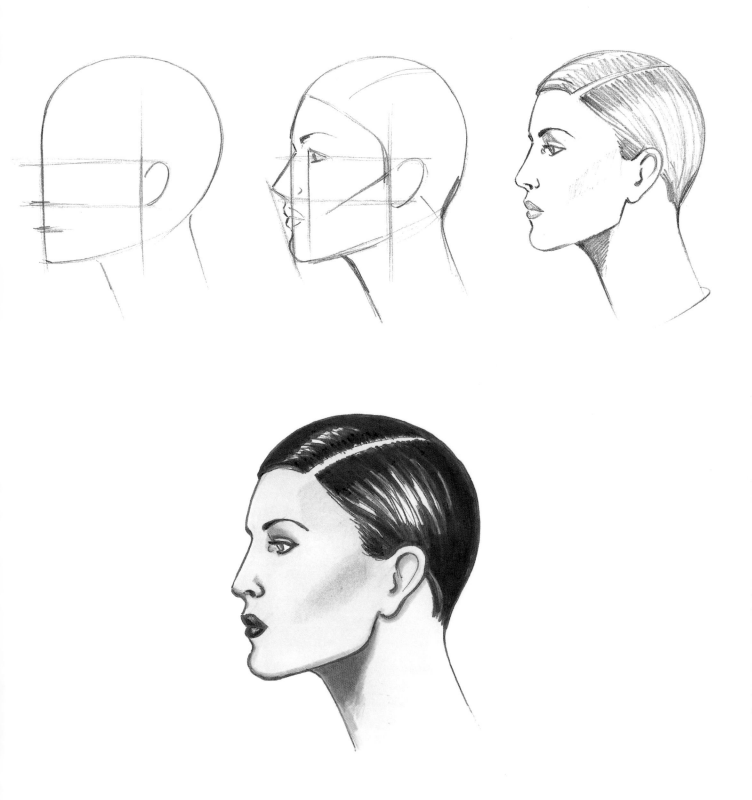

Draw a sort of half-heart shape in pencil. Start from the bottom and work the pencil upward vertically to trace the curves of the roundness of the head and join these at the chin. This becomes the outline of the head. Divide it with horizontal and vertical lines, maintaining the same proportions as the full front view of the face.

DRAWING MODELS

Free-Hand Drawings

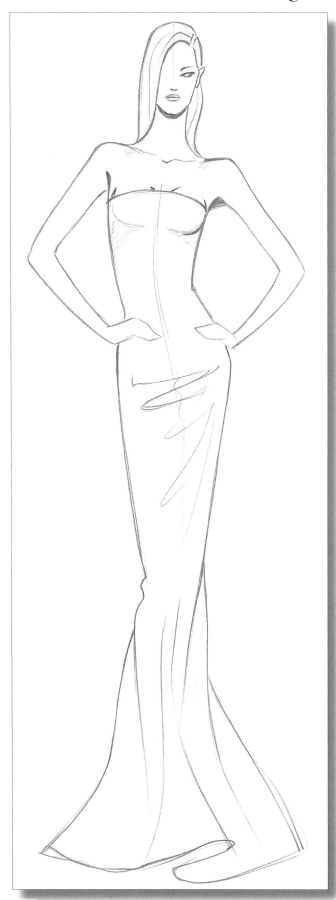

Free-hand drawings are always new from scratch, with faces only hinted at and hairdos chosen last minute. A blank white sheet of paper can be placed over a pre-sketched figure to be used as the base for the pose and proportions. Personally, I never use one because my style is not "quick sketch" but I do use the "series sketch" system.

The Series Sketch

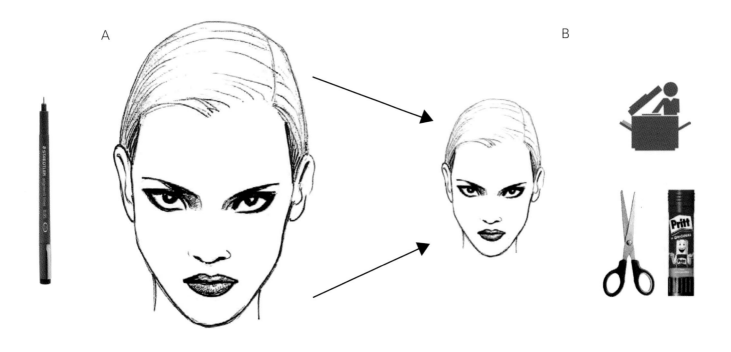

A

B

I use the method which is usually used in design studios; it is useful especially if you have to make many drawings with many variations. (For example, the same garment with different hemline lengths, or in different colors, etc.) It helps speed up the work. A – Prepare a face you like (usually it should be a large size drawing at first, for example 8/10 cm high). With these measurements, the details look better once reduced and the lines of the pen look cleaner and finer than if drawn directly on a small face.

Once the face is drawn, go over it with a fine-tip marker to get the graphic image (without shadow). Leave the hairline on the forehead well defined and the roundness and height of the head as well, but do not draw the hair because in later

photocopies you can choose which hair style to use without having to erase anything. B – Using the photocopy machine, reduce the size of the head to what is suitable to the proportions of the base of the sketch (about 3 cm high). Cut out the photocopy of the head you have shrunk (which becomes a sort of postage stamp) and glue it onto a blank white sheet of paper, high and centered, at the proper height for use as a base.

N.B. *Keep all the different faces you have chosen glued each to its own sheet of paper and the papers in a file handy and ready for use. Each time you need one, photocopy it—working on a copy of the copy. Of course you will have faces seen front-on, in profile, in 3/4 view, etc. In a second folder keep the different heads, all photocopied and ready for use.*

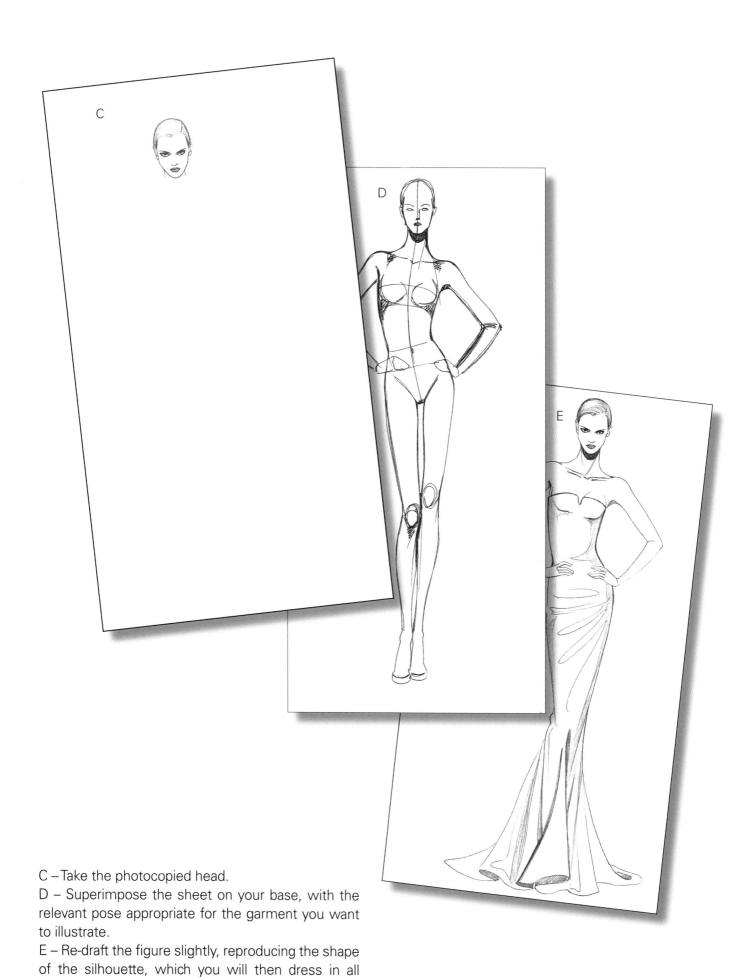

C – Take the photocopied head.

D – Superimpose the sheet on your base, with the relevant pose appropriate for the garment you want to illustrate.

E – Re-draft the figure slightly, reproducing the shape of the silhouette, which you will then dress in all detail.

ALL DESIGN STEPS

From Construction to Finished Base.

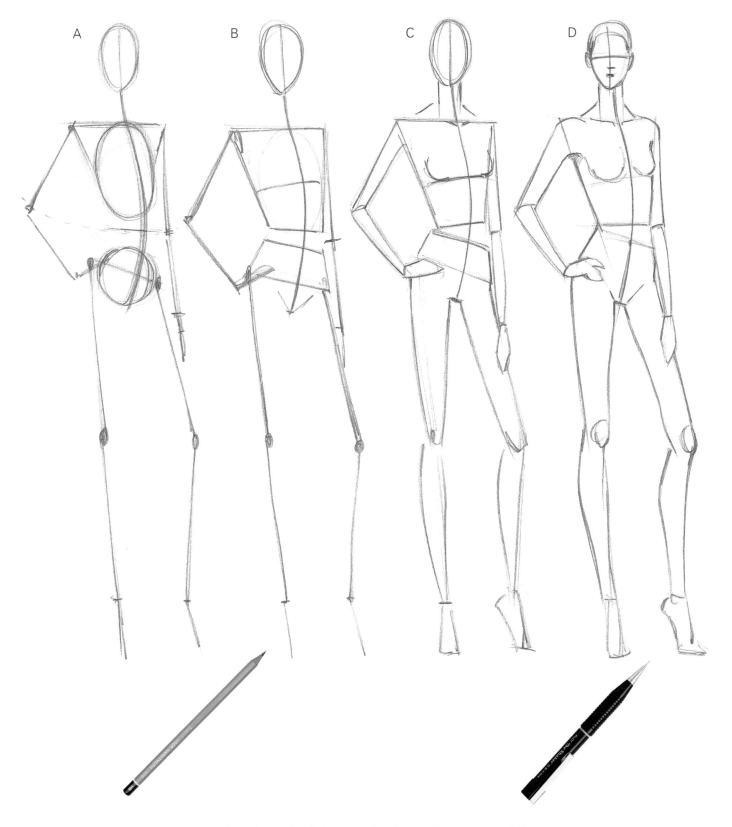

A - B - C - D. Building a relax base (front pose, 3/4 semi-profile).

From Base to Finished Garment

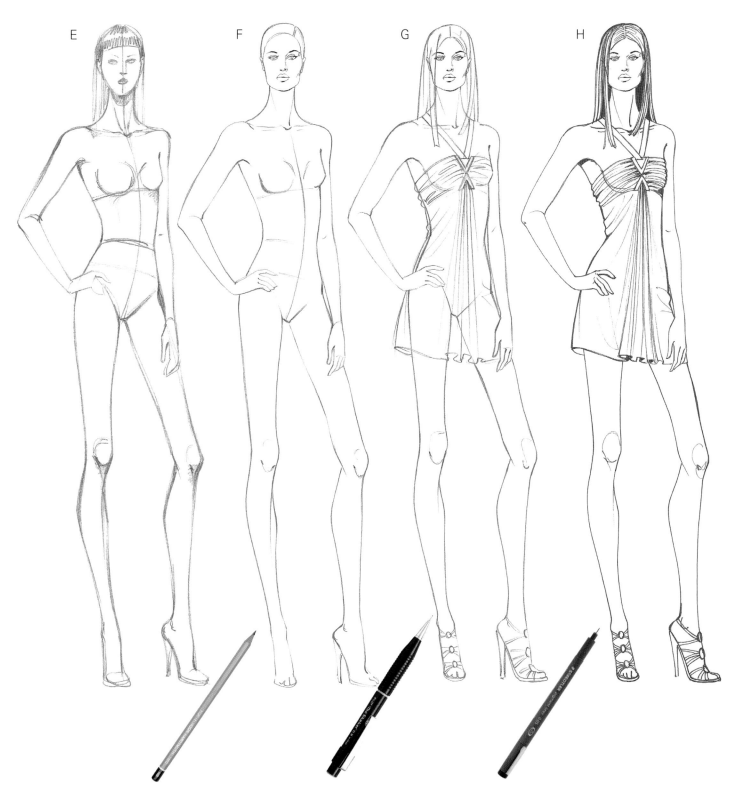

E – Start by doing a pencil drawing of the base (to be retraced with a marker when the drawing is finished).

F – Take one of the photocopied heads and superimpose it on the posed base figure, tracing the shape of the body with a light pencil.

G – Now accentuate the shape of the garment and the hat. Use pencil to define the details of the garment.

H – Go over the entire figure with a fine-tip marker.

I – Apply the flesh color base, the hair color, and the garment color.

J – Go over the skin shadowing with a fine point Sandstone Promarker or a Tombow 990 for lighter tones (like the contours of the legs and arms) and a 992 for the darker areas (knees, underarms). Shadowing is needed under the breasts, the chin, and under the hemline of the garment. For the garment shadowing:

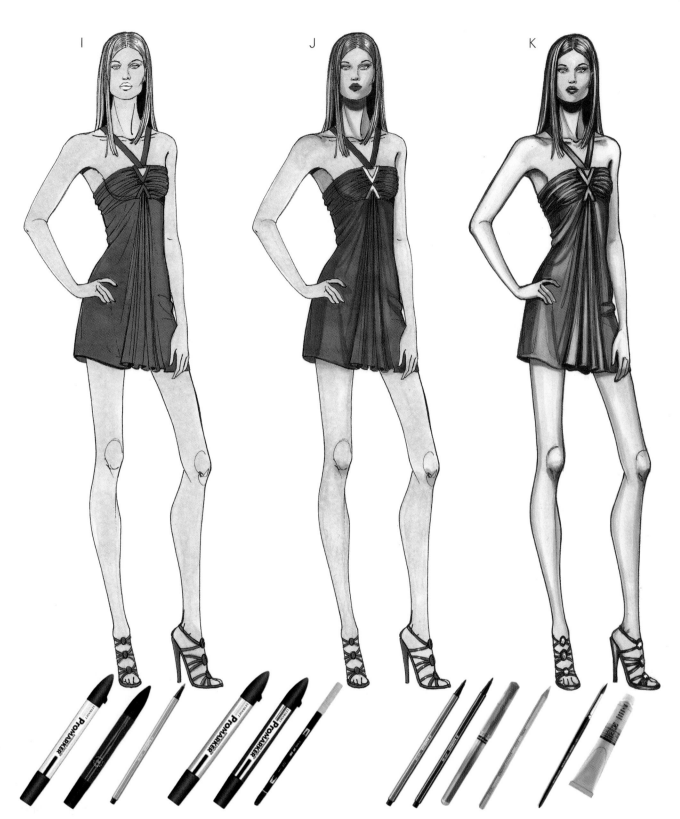

Re-apply the same Pantone color (or one that is slightly darker) to the body form, below the breasts and inside the pleats to suggest depth. K – Using a Stabilo marker with a relatively fine point, retouch a bit more to achieve greater contrast. For example, under a lapel in the shadow area under the hem of the jacket, under the skirt, or between pleats. Again using a Stabilo, darken by smudging the hairline and the outside of the head, the lip line and areas where shadows should be more defined. Use a white pastel for luminosity on the more visible parts and for borders (pockets, lapels, hemlines, etc.). If the pastel mark is weak, reinforce it with a touch of tempera white. Use a white corrector or a pen with white ink for reflections of light on the gold of the sandals.

THE TUBE DRESS

(clingy line)

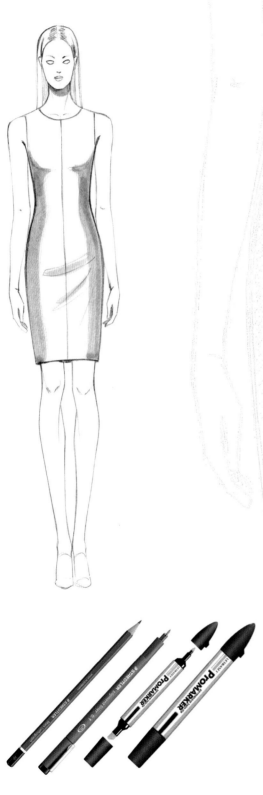

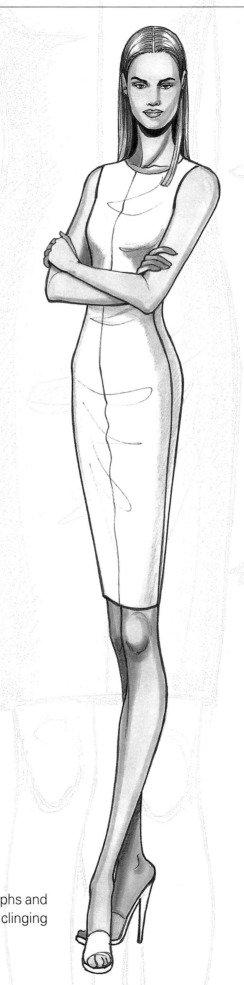

For different volumes, I often look at photographs and try to reproduce the effect I need. For a more clinging line, use a simple base with legs closed.

The Sack (straight line)

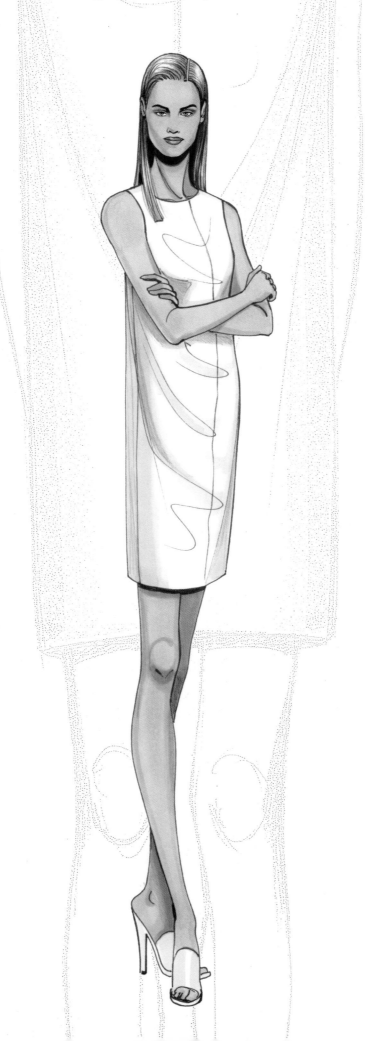
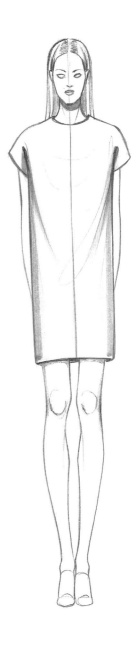

Empire Flared

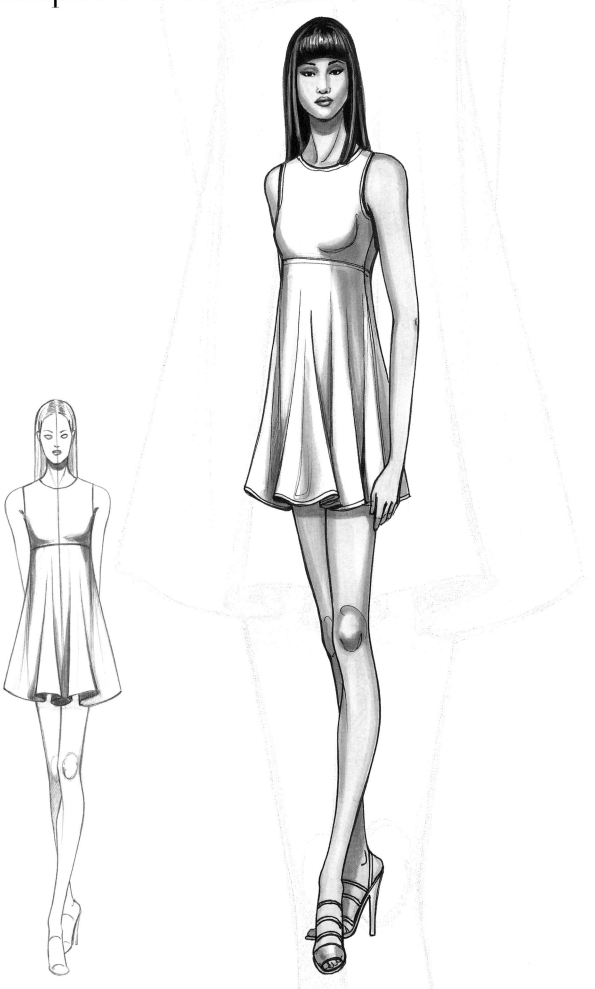

The Godet

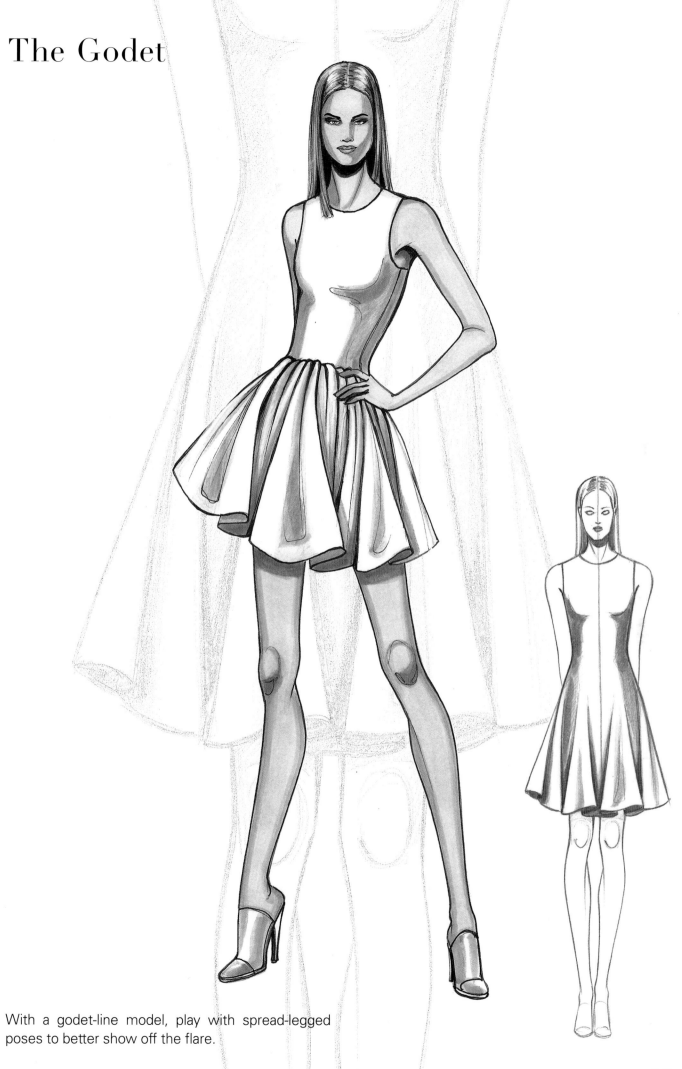

With a godet-line model, play with spread-legged poses to better show off the flare.

Balloon

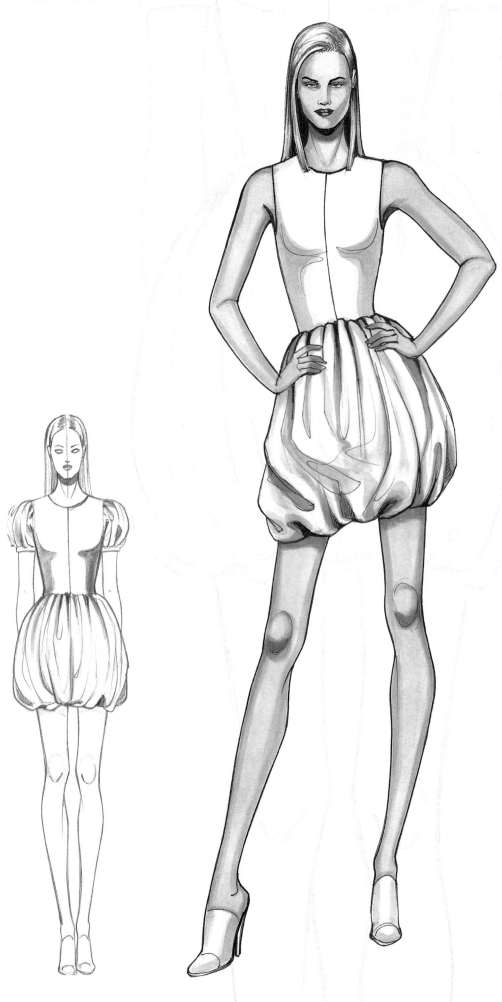

The Blouson (gathered, tucked in)

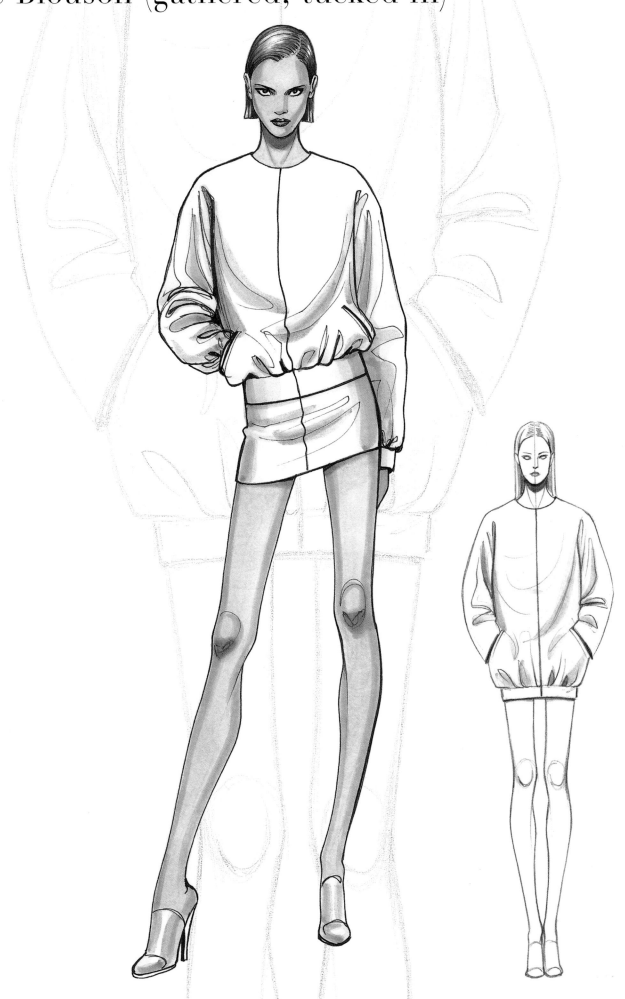

Kimono Sleeves

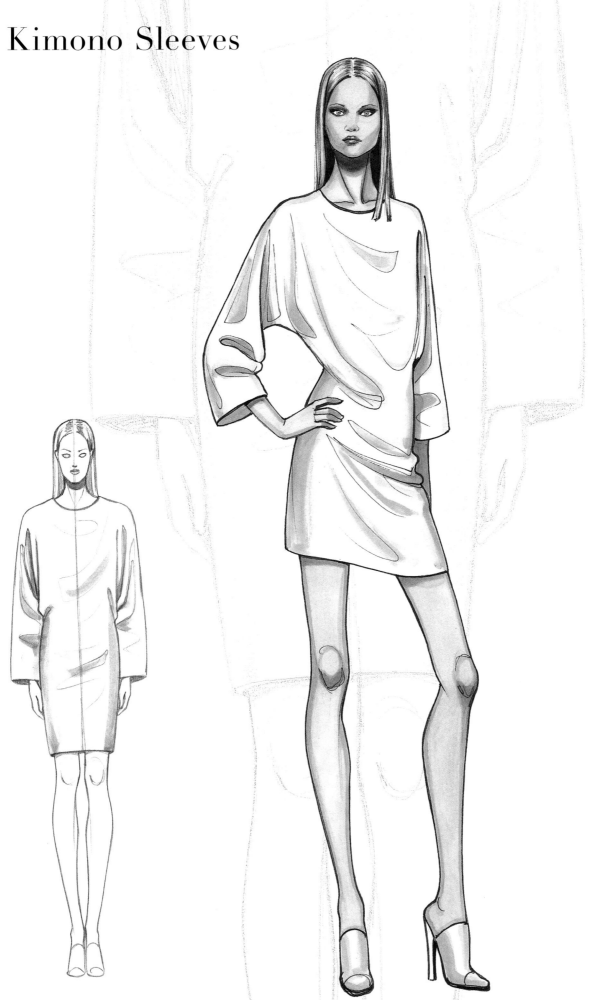

For kimono sleeves, akimbo arms are useful to show
the detail on the sleeve line.

Oversize

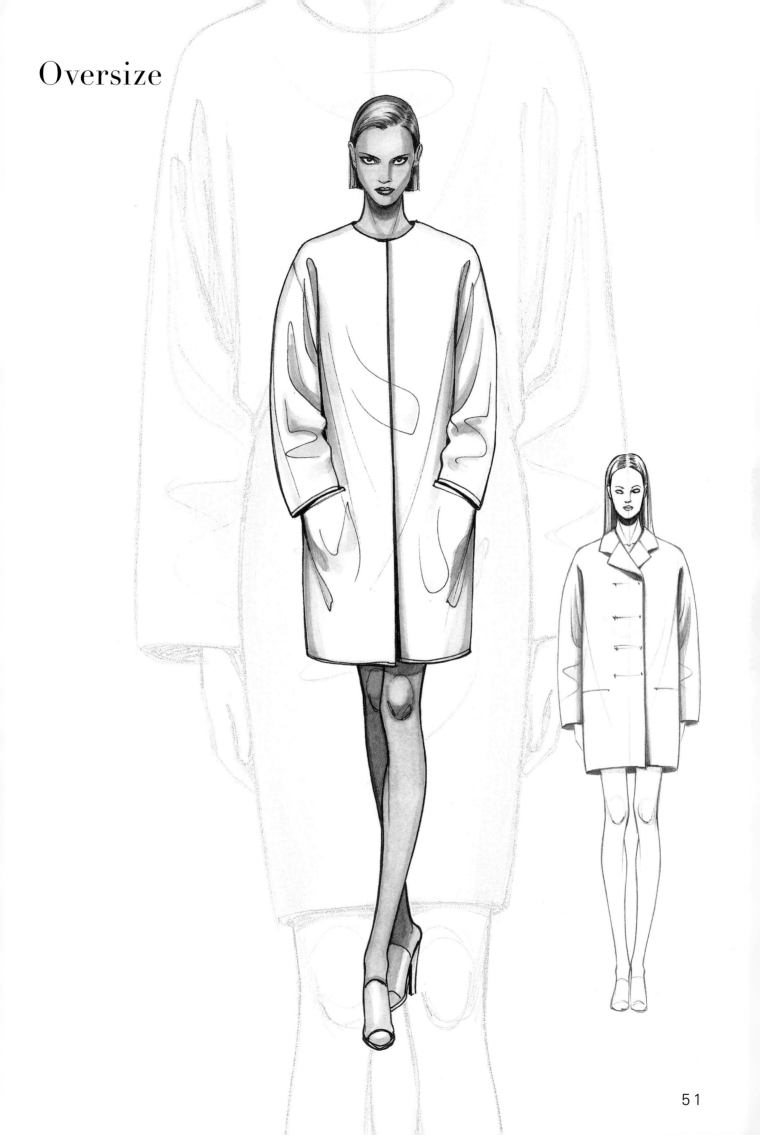

Trapeze

Reverse Trapeze

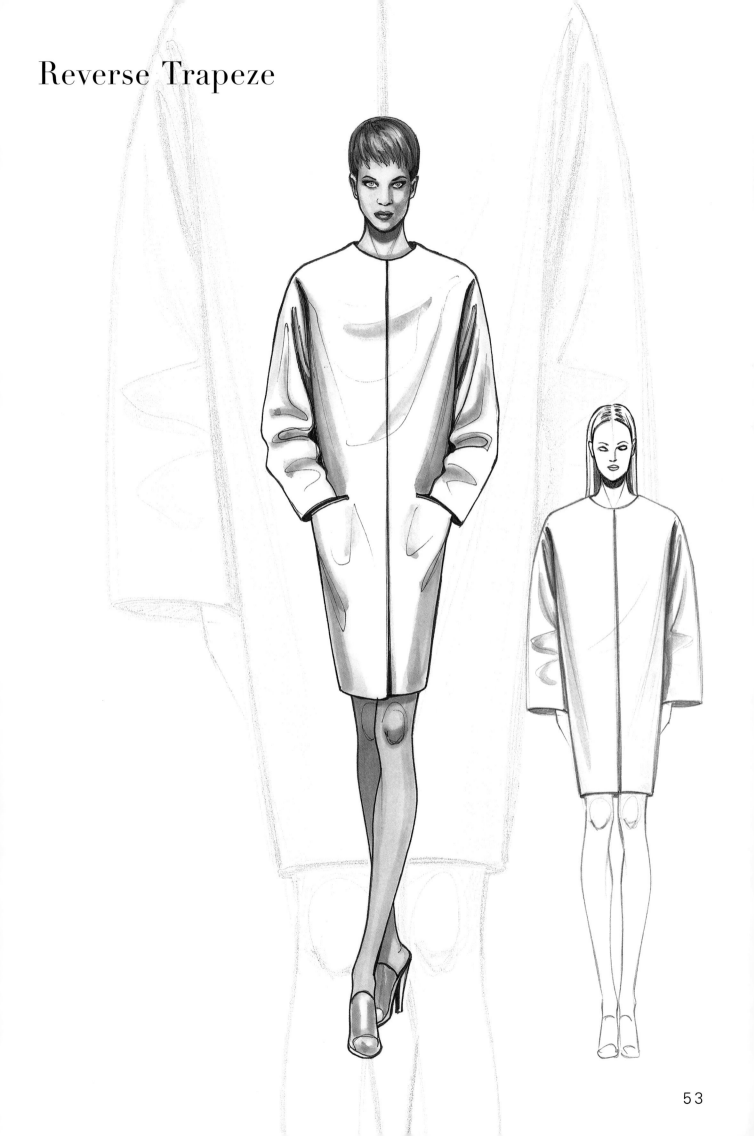

Egg-shaped

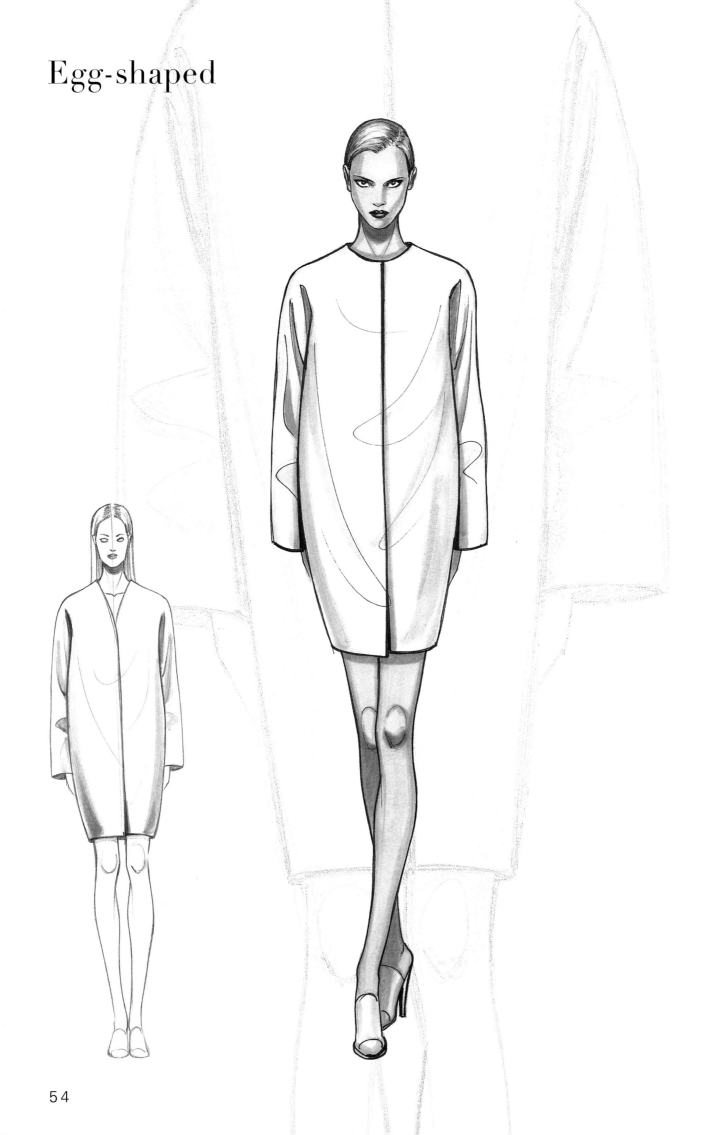

The Mermaid

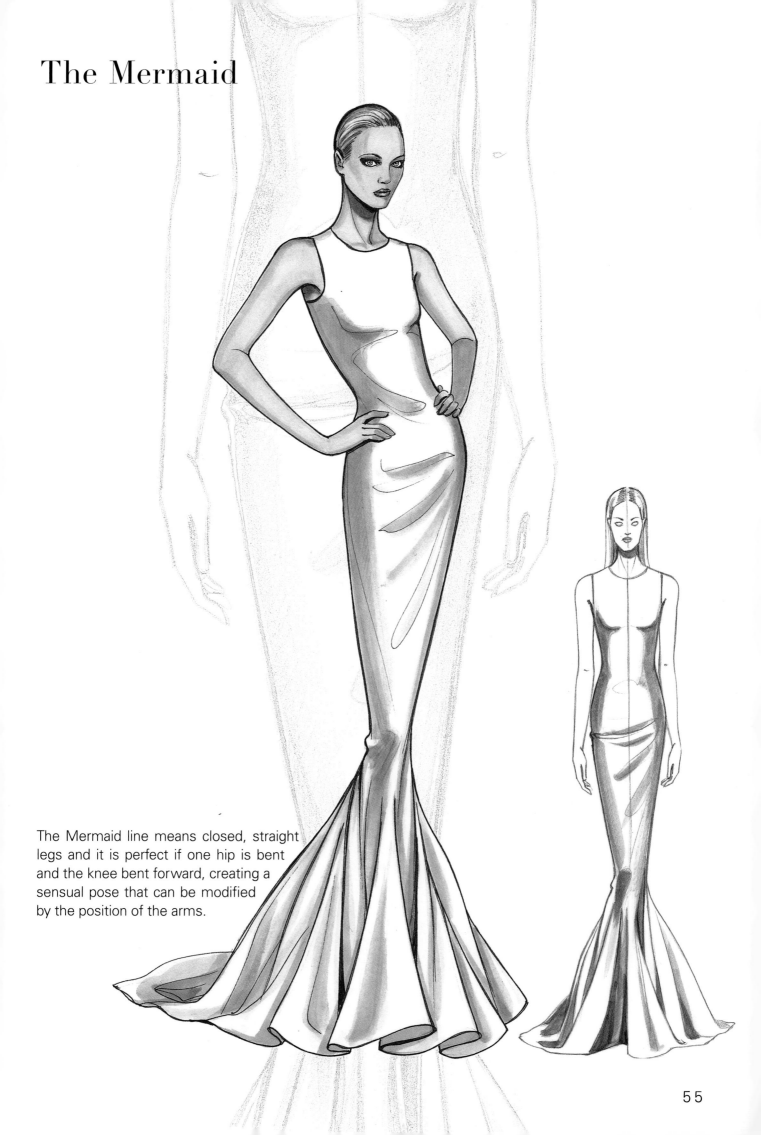

The Mermaid line means closed, straight legs and it is perfect if one hip is bent and the knee bent forward, creating a sensual pose that can be modified by the position of the arms.

Full Skirt Evening Gown

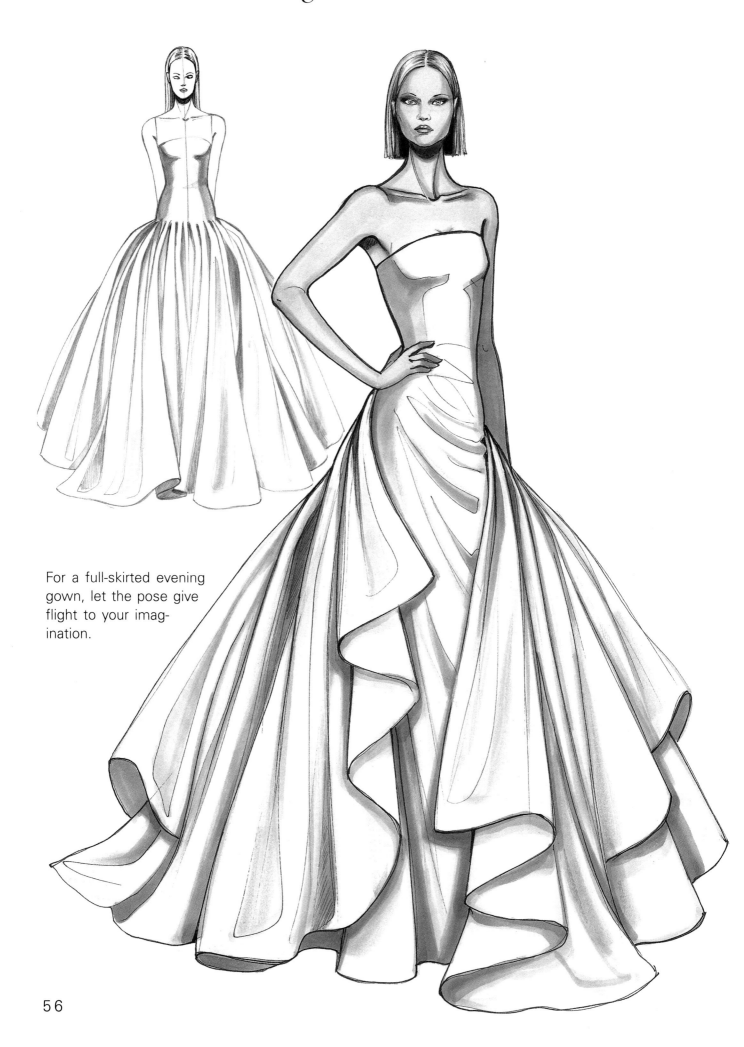

For a full-skirted evening gown, let the pose give flight to your imagination.

COLOR

Light and Shadow

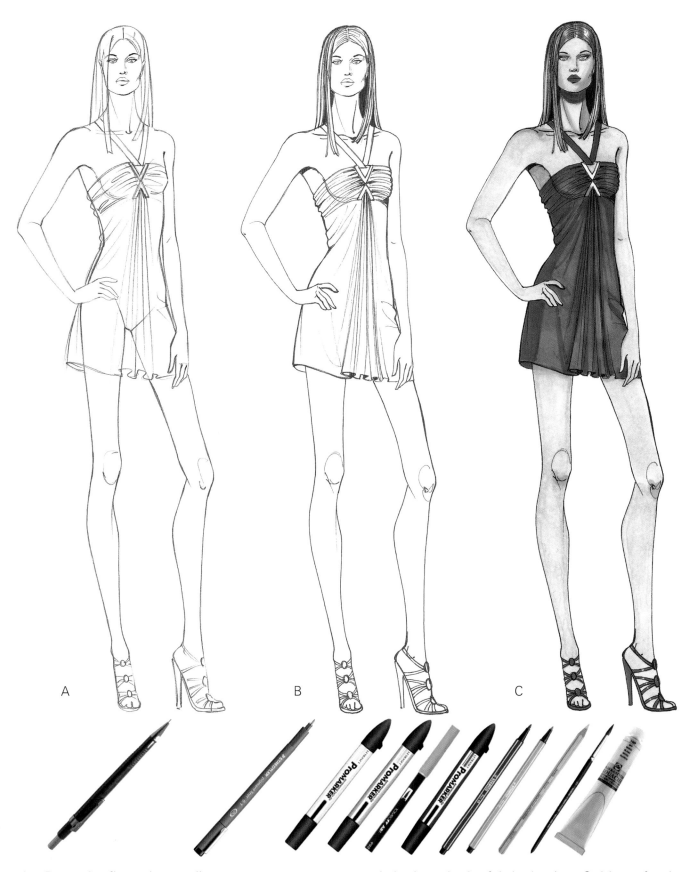

A – Draw the figure in pencil.

B – Go over it with a Staedtler Pigment Liner 0.1 marker.

C – Use Pantone Promarker Pastel beige for skin base color, and Tombow 990 and 992 for shadowing. Use Promarker red for the garment and Stabilo Swan 68/39 for hair. Use Stabilo red for the sandals and for the smaller details like shoulders, lips and shadows in the fabric draping. Gold pen for the metal details. White pastel or tempera for the light areas.

N.B. *On the preceding pages, I used the equivalent of the model as background, drawn flat, as I explained in the page dedicated to more complicated poses. Usually drafts for studies of garments use these as well because they are both convenient and fast. For the silhouettes only those chosen will be drawn.*

Light and Shadow in the Fabric

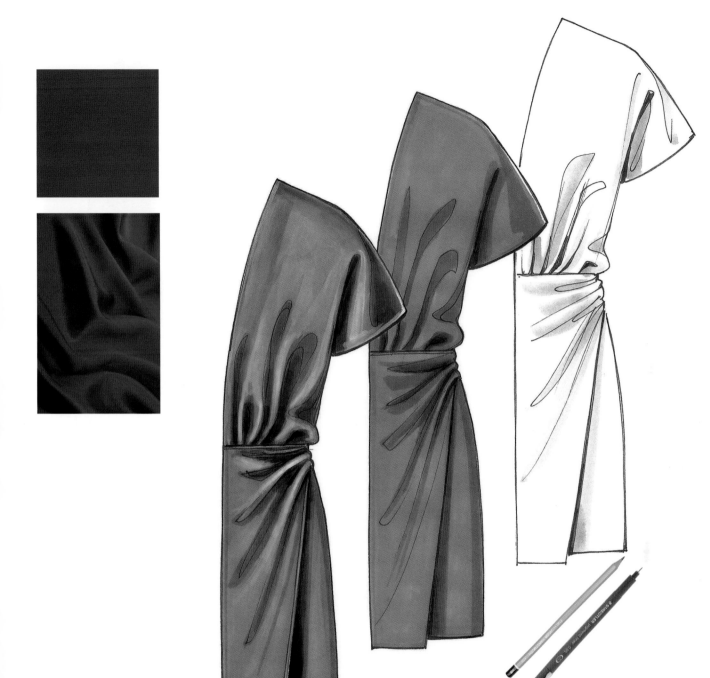

Trace the base of the garment and apply color evenly with a Pantone marker, in this case a Poppy Red Promarker. Once completely dry, go over the drawing again in red along the darkest outside outline and between the folds of the draping. A Stabilo marker is excellent for this because it leaves a very clear mark (in this case use a Stabilo 68-50). A touch of a darker Pantone gray like Cool Grey 3 is good on the more shadowed areas. Blot with a white pastel (Prismalo 999-001) for luminosity, especially on the more prominent parts and borders.

Black

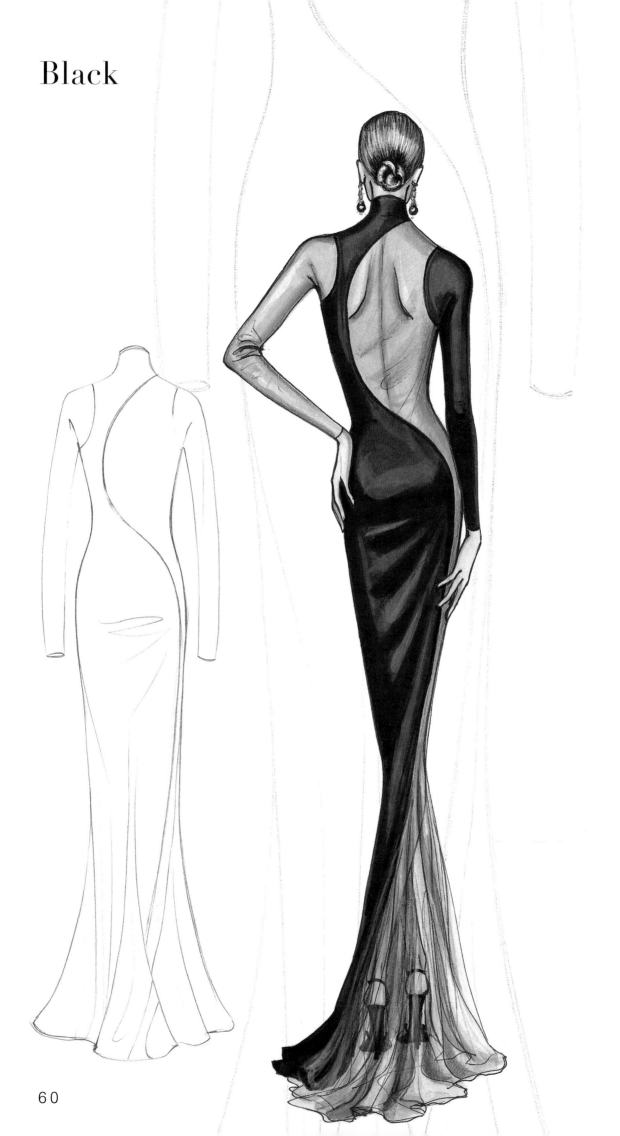

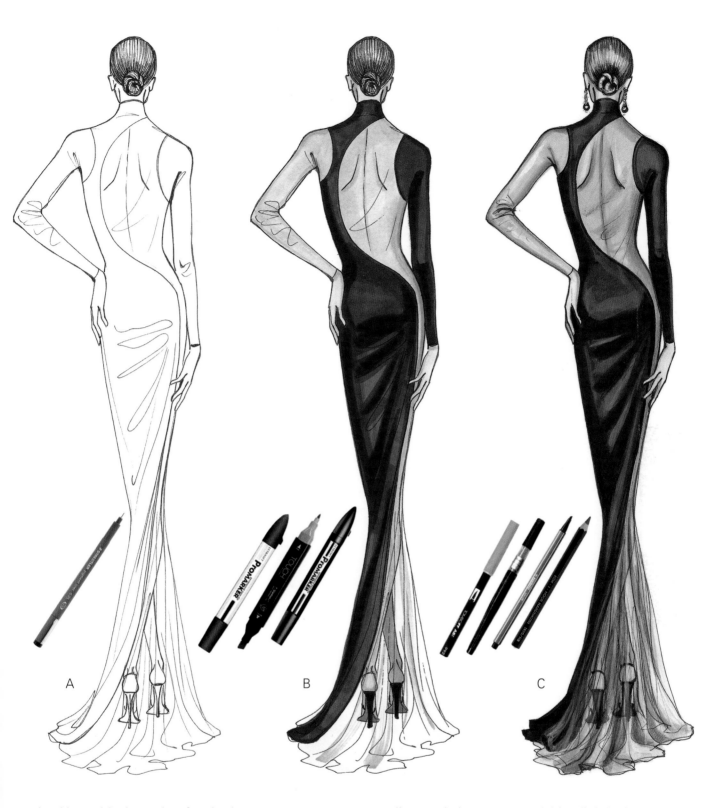

A – Use a black marker for the base.

B – Apply Pantone to the skin areas and Pantone on the garment.

NB – Instead of black, use a very dark Pantone gray (Touch ShinHanart CG9). The effect is the same and the shadowing in black will be more visible and contrasting. Next, shadow the skin, the outside areas and deeper areas of the garment with black Pantone.

C – The transparent effect of the black against the skin is achieved by applying a thin veil of black pastel. Use just a little in the shadow areas, the body outline and the arms, and blot lightly in other areas because the skin should be seen through it. For a shadow of transparency in the train, use light gray Pantone and a touch of diluted Color Brush. Always try this first on a separate piece of paper to be sure that the color is not too dark. I have one of these brushes with a nearly empty cartridge, but I keep it dipped in tempera and use it for applying color; it is also perfect with the black tempera point for light shadowing. If you can't find markers like these, use a gray Tombow or a gray Pantone.

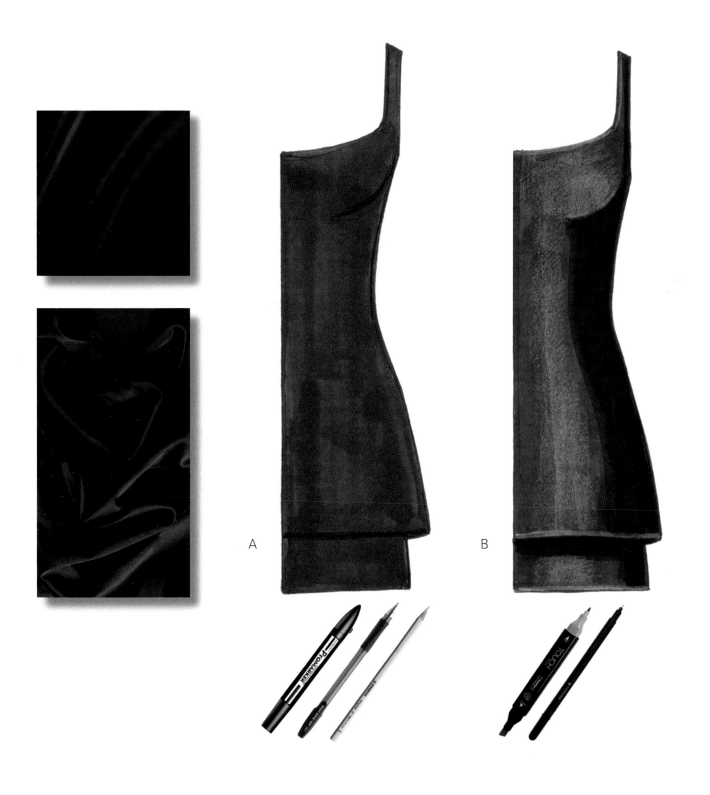

A – Apply Touch ShinHanart CG9 to the base (a very dark Pantone gray also works).
B – Use Pantone black to trace the shape of the hips, the line under the breasts and under the fla-

re, again providing further highlighting with a black ballpoint. With a dry white Pastel, highlight the light on the breast and the lateral front, marking the hemlines.

White

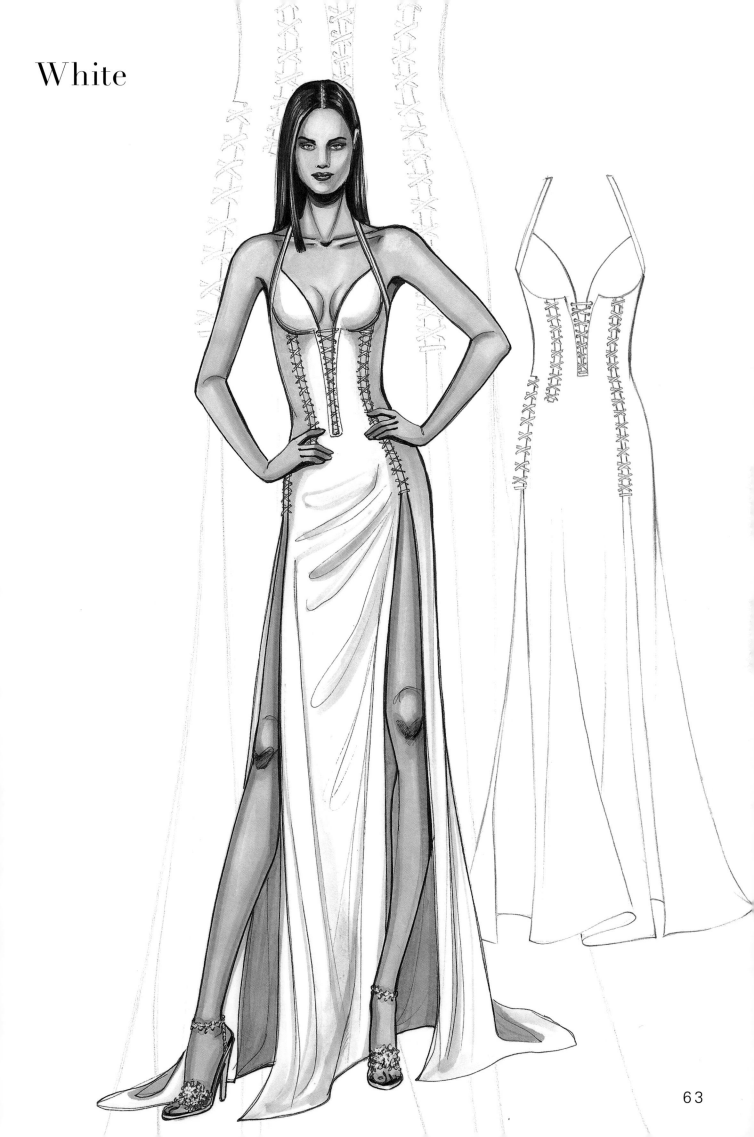

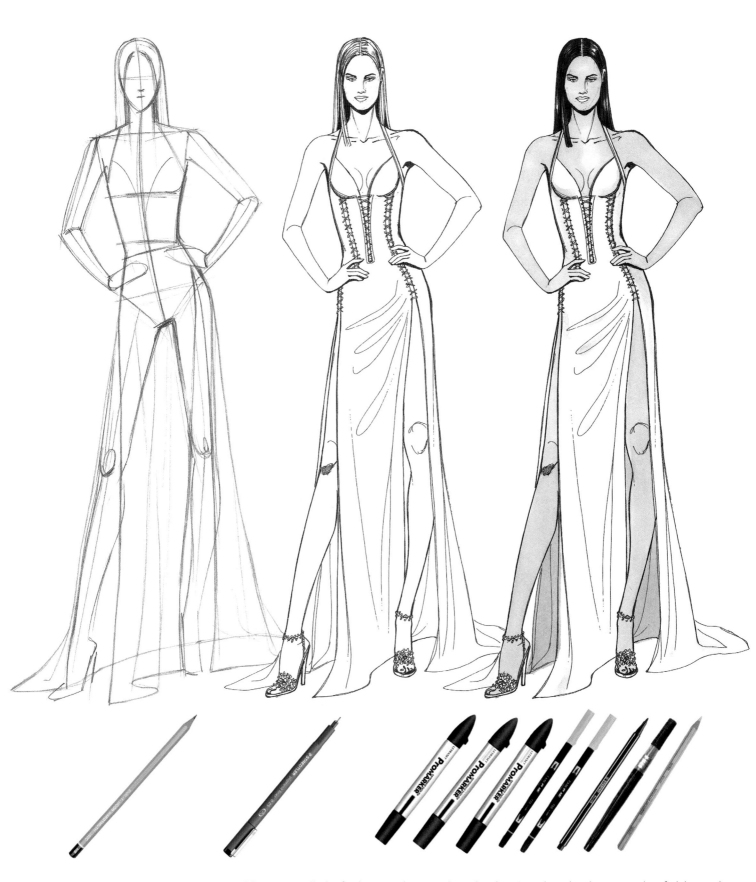

Here we have a base outlined in a pencil draft that shows the volume of the garment we are about to draw. Once the model we are going to use has been defined in pencil, go over it again with a fine marker. Then apply color using a Pantone marker. Apply a first layer on the skin. For the garment use Pantone Cool Grey 2 or 3 for the outline of the shape, the shadow under the breast, the folds and the inner parts of the garment. Tombow gray N75 is really useful here to show the fluidity of the skirt (or a very diluted gray Pentel Color Brush). Use a black Stabilo for the hair, leaving the white part in the hair in the lighted area, which should later be highlighted with white pastel.

White in Fabrics

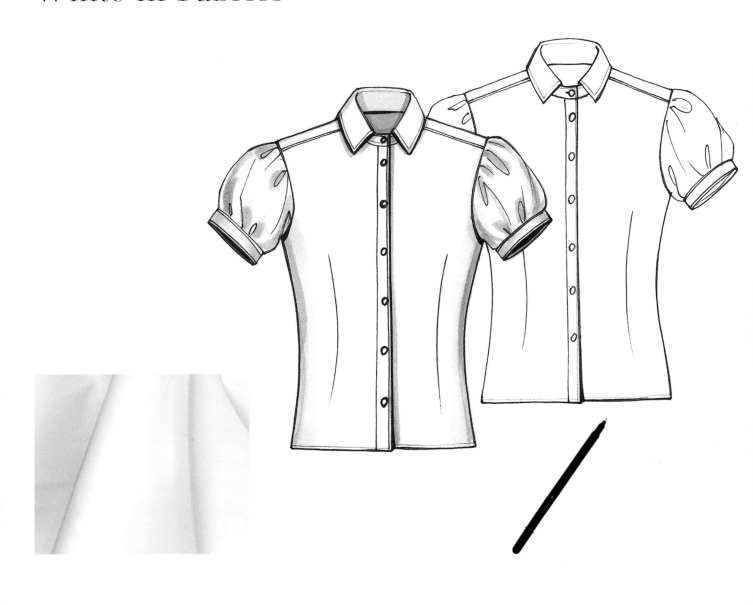

Use a light gray Pantone for the inside parts of the gathered areas and the base outline. When the color is thoroughly dry, apply a second coat of Pantone in the areas that should look deeper and therefore darker.

N.B. *Here too, we see an example of the technical model of a shirt.*

Quilted (Tufted)

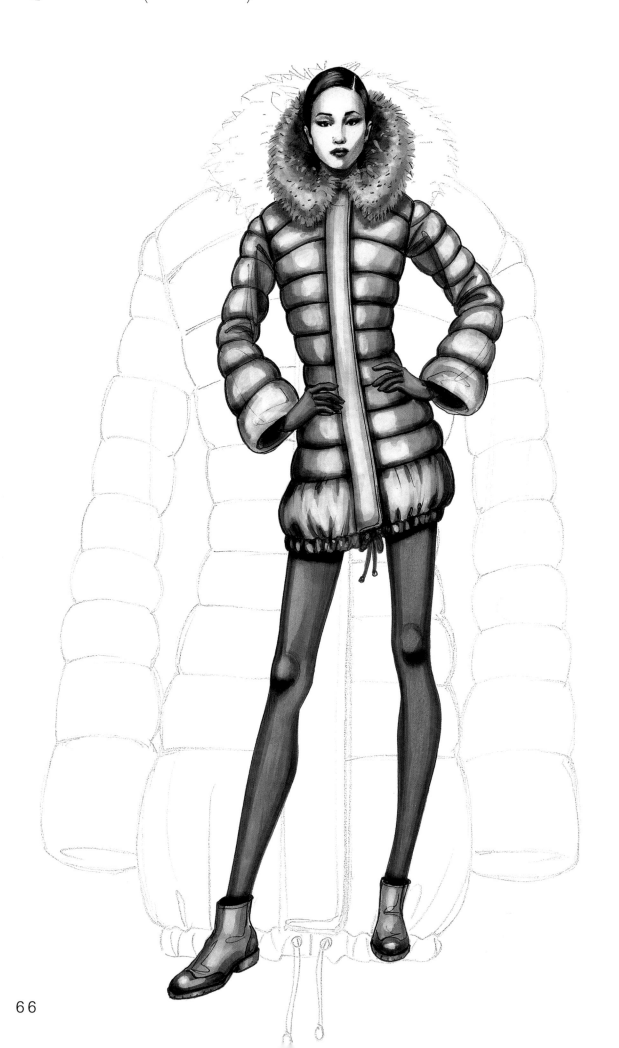

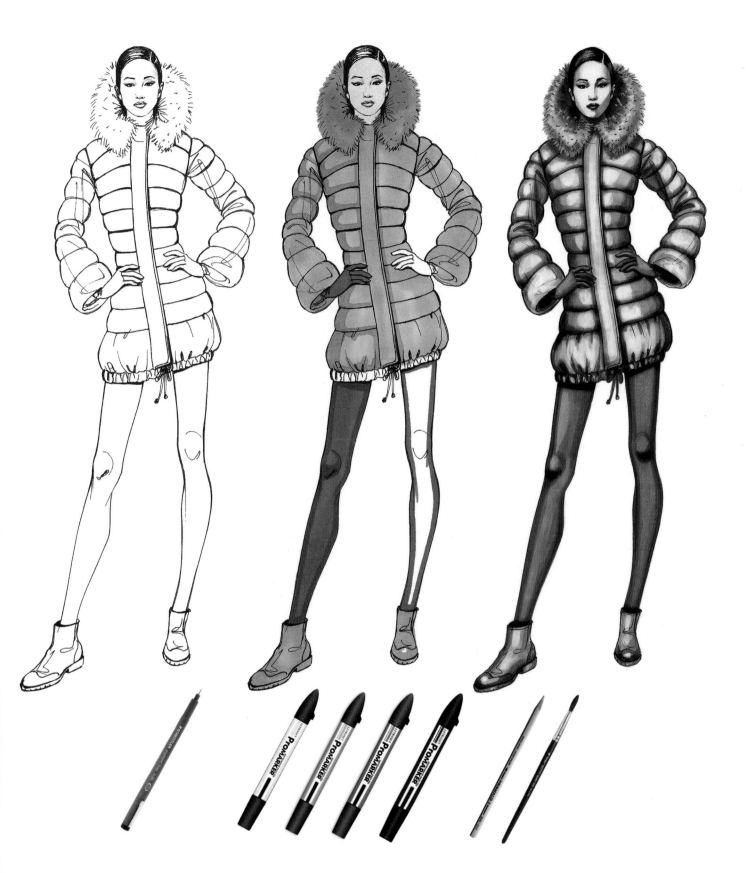

For the color of the down jacket, I applied a base with Marsh Green Promarker. Color the legs (Petrol Blue) and the fur collar and shoes with Pantones. For the rounded, quilted look, use the same green or one that is slightly darker but with the same grade to create shadows; then use a white pastel or tempera on the parts that are most in relief.

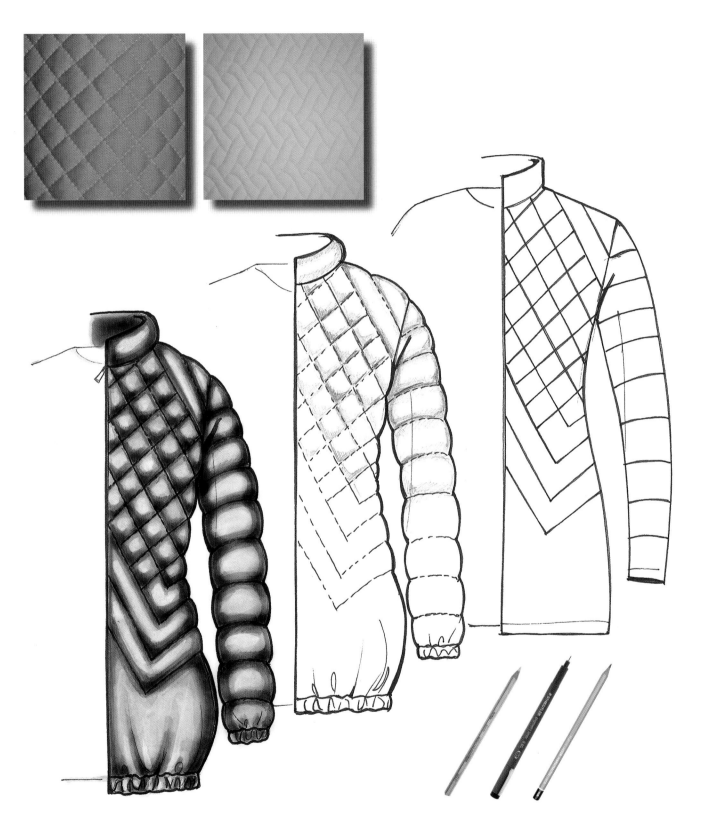

Make a flat, pencil drawing of the base of the garment and with straight lines trace the direction that the tufting stitches follow. Join the parts between one seam and another with rounded lines. Go over the drawing with a marker, tracing the seams and removing the pencil traces.

Apply the color and gently blot over the base of the seams with a Pantone. The shadow should flow in the same direction, in this case both on the outside (the garment's outline) and downward. On the higher tufts use white pastel (dabbed) slightly more heavily applied at the centers.

Knits

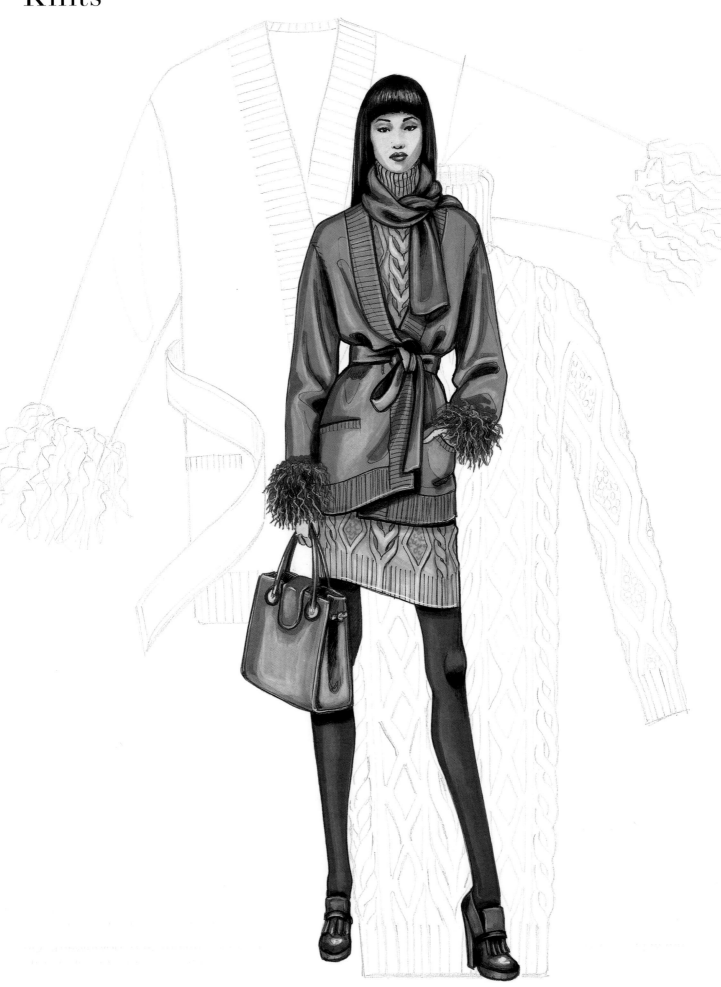

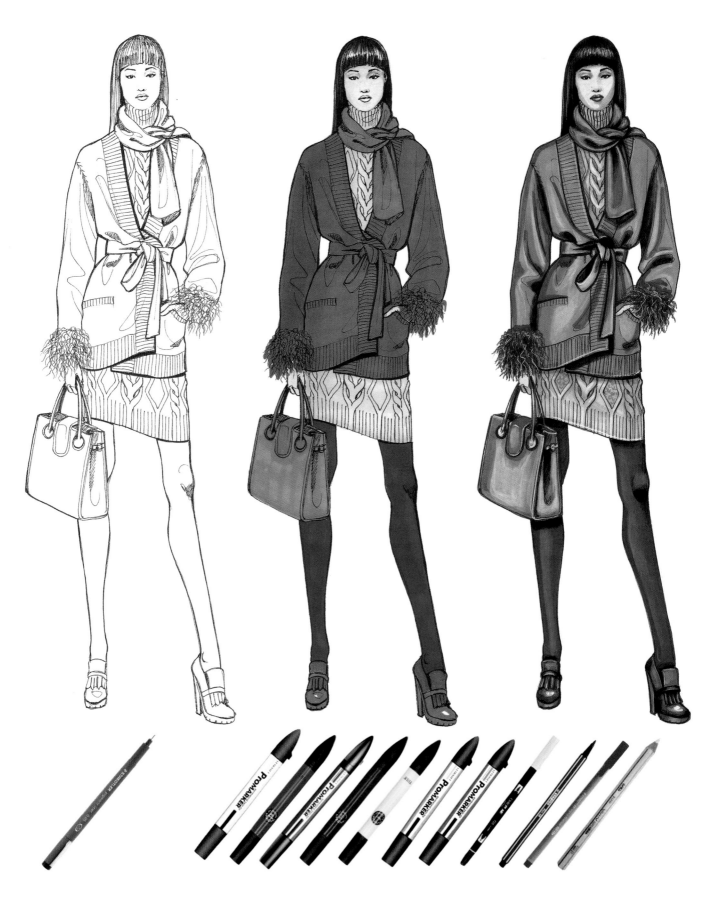

After tracing over the base design with a marker, apply the colors of the garment with Pantone Tria or Promarker. Use black Stabilo for the hair, leaving the curve of the bangs white to create shine. With the Pantone marker used earlier, trace over the shadowy areas on the single bits using markers of darker shades for the deeper spots (the folds of the scarf, the cardigan folds, the stockings under the skirt hem, etc.).

I used white pastel to provide shine in the most obvious areas, on the pleats, on the most obvious detail on the knit, on the knees, the tips of the shoes, and so on.

Knitted Fabric

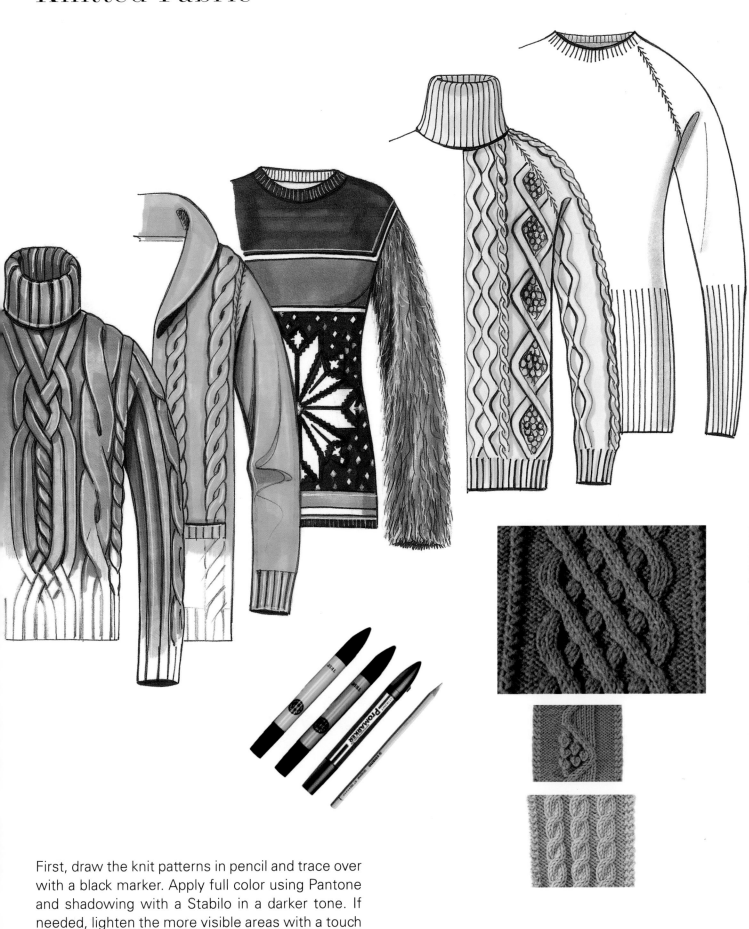

First, draw the knit patterns in pencil and trace over with a black marker. Apply full color using Pantone and shadowing with a Stabilo in a darker tone. If needed, lighten the more visible areas with a touch of white pastel. For ribbings (like cuffs) use Stabilo or a fine-tip marker to trace over the dividing line with a slightly darker color.

Jeans

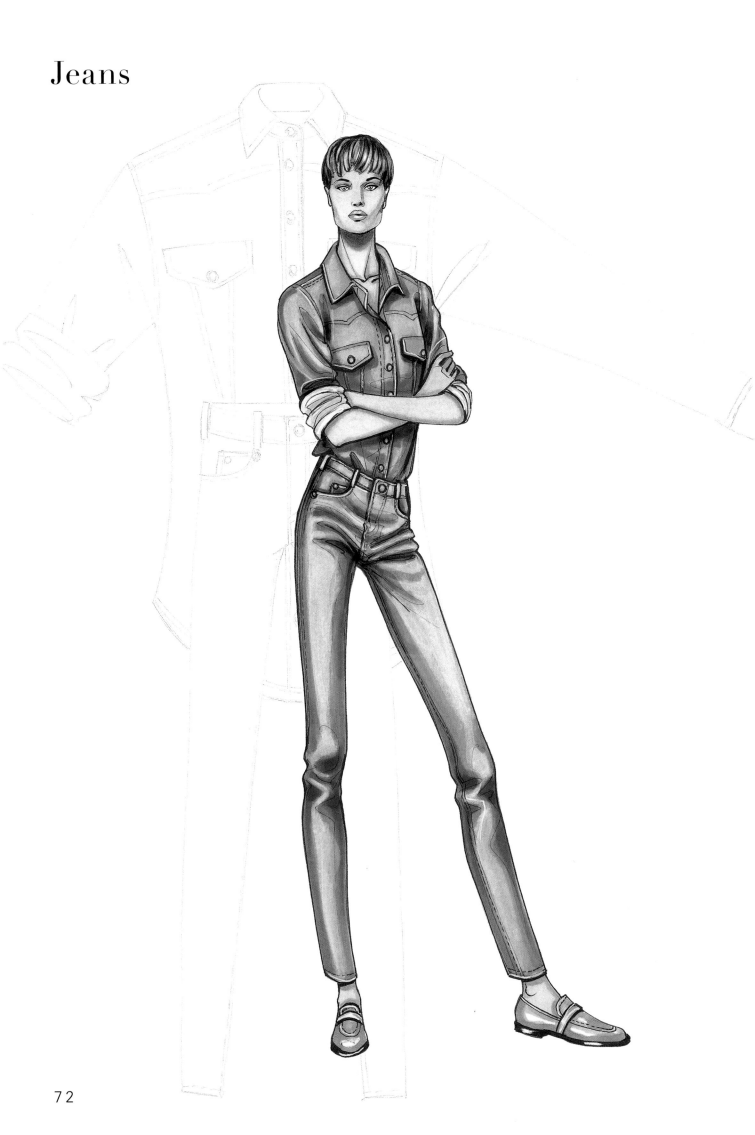

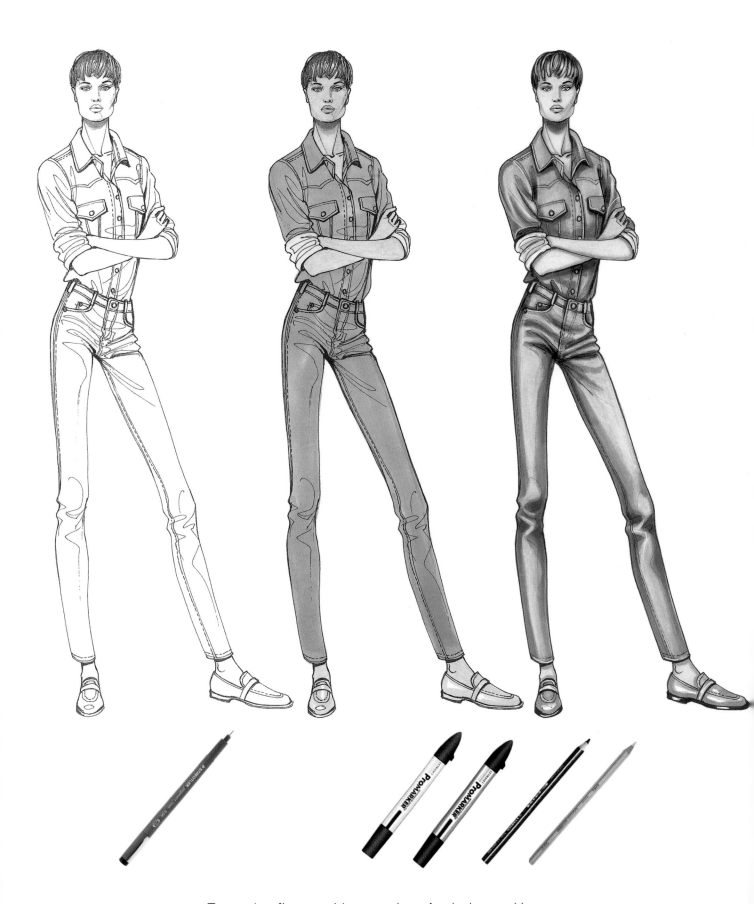

Trace the figure with a marker. Apply base skin color and jeans color with a Cobalt Blue Promarker. When thoroughly dry, trace over to provide shadow, using a blue pastel for the higher contrast points. Dab white pastel to lighten and provide faded areas to jeans.

Jeans Fabric

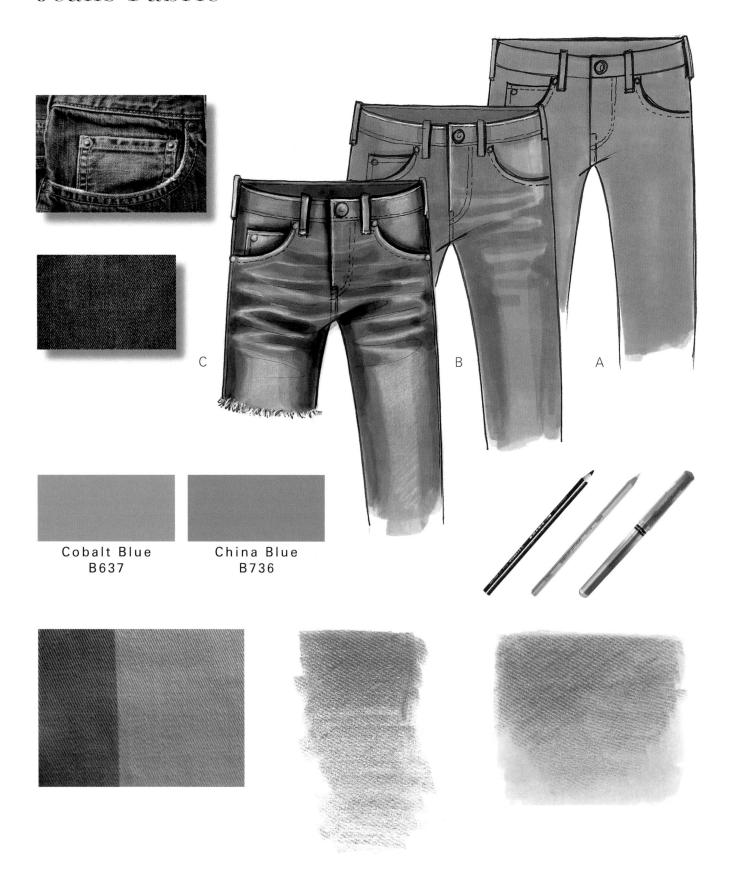

Cobalt Blue
B637

China Blue
B736

A - Apply color using Cobalt Blue Promarker.
B - Trace along the outside line. Accentuate the folds, darkening the insides, the borders and pockets, etc.
C - Use white pastel dabbed on the legs and thicker in the center. Keep using white pastel for a line on the edges of the pockets, the belt and the closure. Use a gold marker for buttons and rivets.
For an even more detailed jeans fabric effect, use frottage. (TABLES)

Prince of Wales

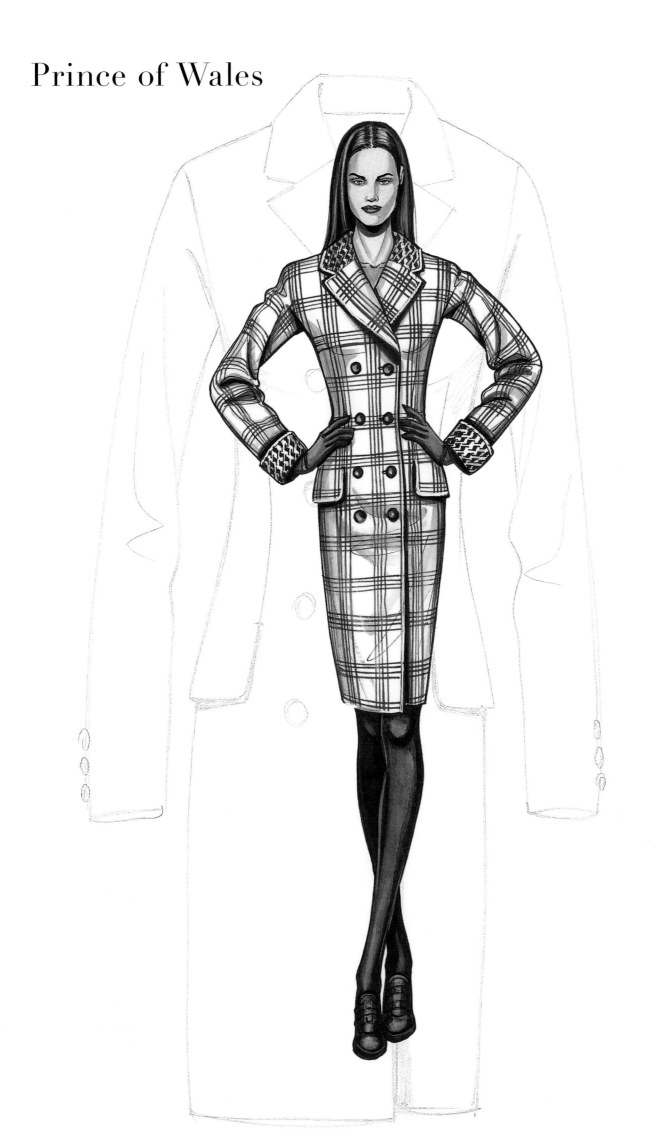

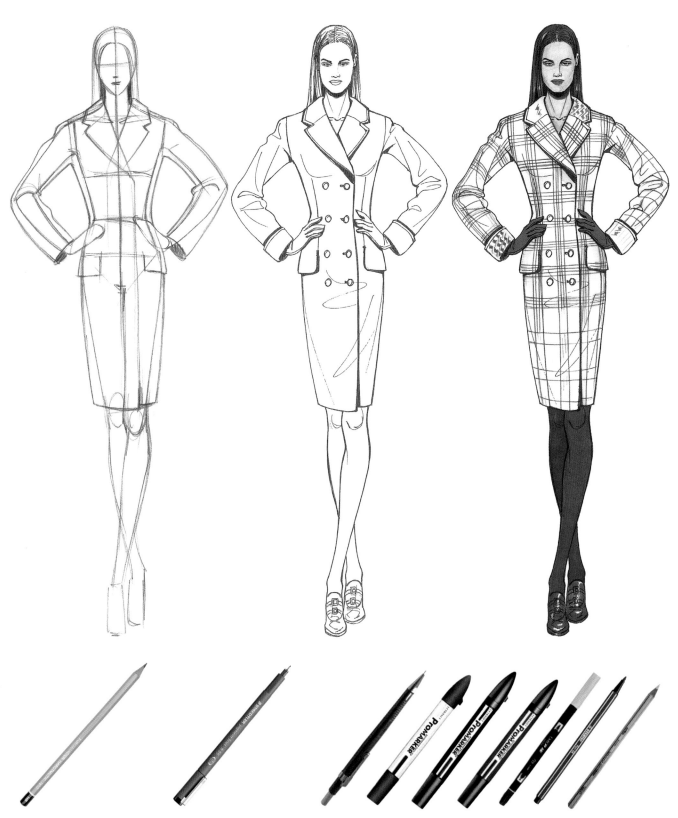

The outline of the figure, in pencil, shows the volume of the coat. It is fitted, leaving just the minimum thickness afforded by the fabric. Trace with a marker, including all details. After coloring the skin, color the stockings. Use a dark gray Pantone for the front of the legs, and black for the back, because the back of the legs is more in shadow. Use a fuchsia Pantone for the gloves and a red Stabilo for the hair. The coat should be white; use a medium gray Pantone to trace the external lines of the body, under the breasts, and the folds of the sleeve. Next, work on the contrasts, emphasizing with a black marker the shadow under the revers, the coat's closure, the area under the pocket flaps; use a white pastel for shine to the hair, the gloves, the contour of the knees and the central part of the leg in the foreground.

Prince of Wales and Houndstooth

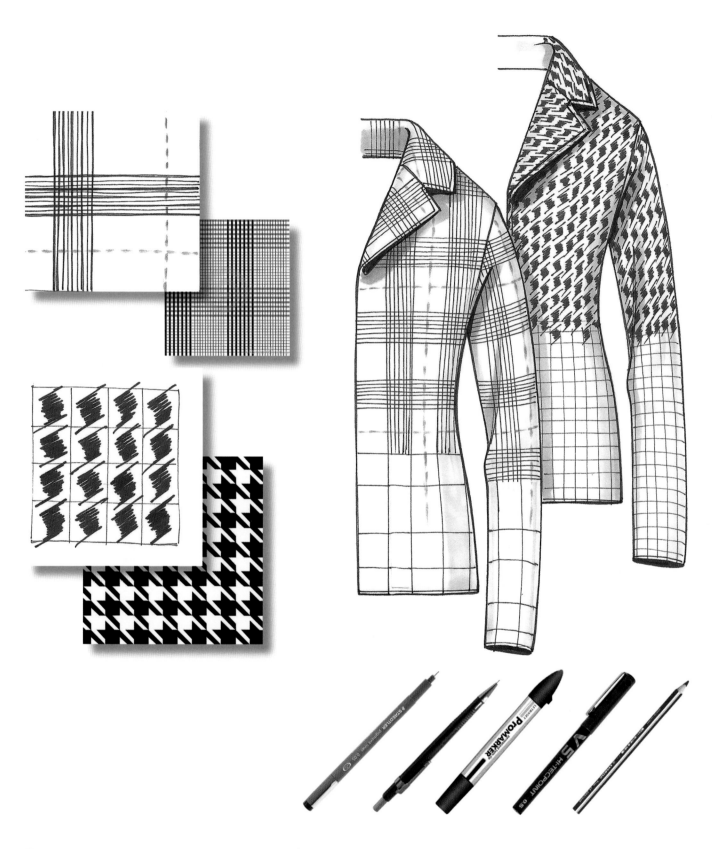

For the Prince of Wales pattern, in pencil trace 4 or 5 vertical lines close together leaving equal white space between them and then start again with another bunch of vertical lines. Do likewise with horizontal lines, creating squares.

Halfway into the blank spaces, trace lines of dashes going in both directions (in this case using a red

pastel or a fine-tip marker). To create the houndstooth effect, divide areas of the garment into equal squares. In each square, start at top right and work downward diagonally creating a zig-zag pattern that ends in the bottom left corner.

Houndstooth, Overall Print, Processed Fabrics

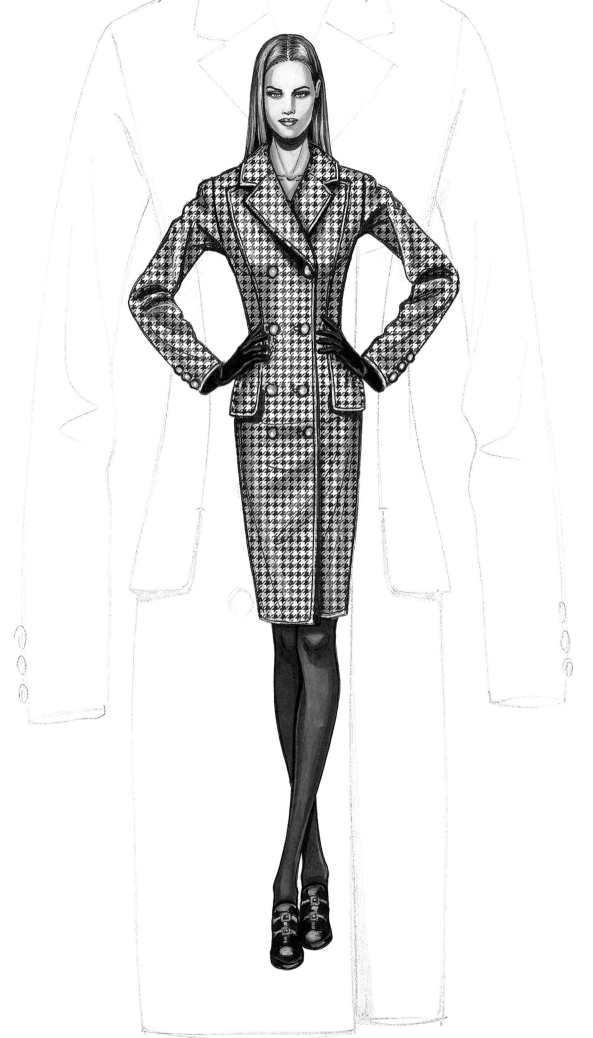

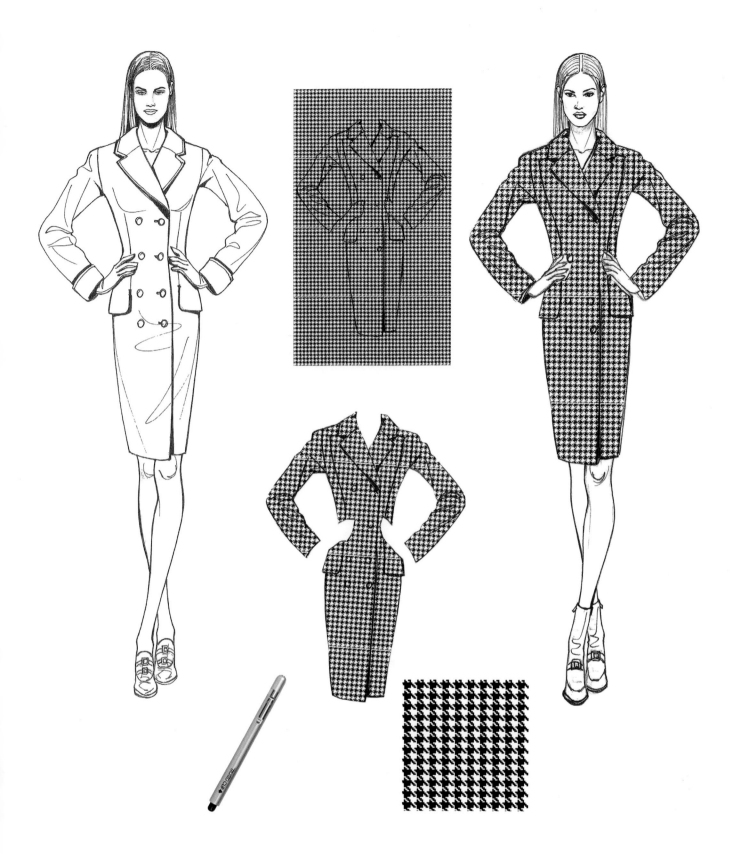

It is difficult to create a perfect houndstooth pattern by hand, so to speed the work up and achieve a perfect outcome (this goes for most checkered patterns or very small repeat patterns), take a sample of the fabric and photocopy it. Then, using a light table, trace the shape of the coat with a marker, leaving out the hands and other areas that you don't need. Cut it out and paste it on the base you have prepared earlier. Proceed to color the hair, face, etc.

Shadowing can be done directly on the photocopy because the formula used in the manufacture of Pantone Trias and Promarkers prevents ink from spreading the way it used to with older Pantones. If you have older Pantones that still work, delicately but quickly make multiple dots on the area to be shadowed, keeping the dots inside the edges so that the ink does not spread or expand too far beyond the design outline.

Pinstripe and Twill

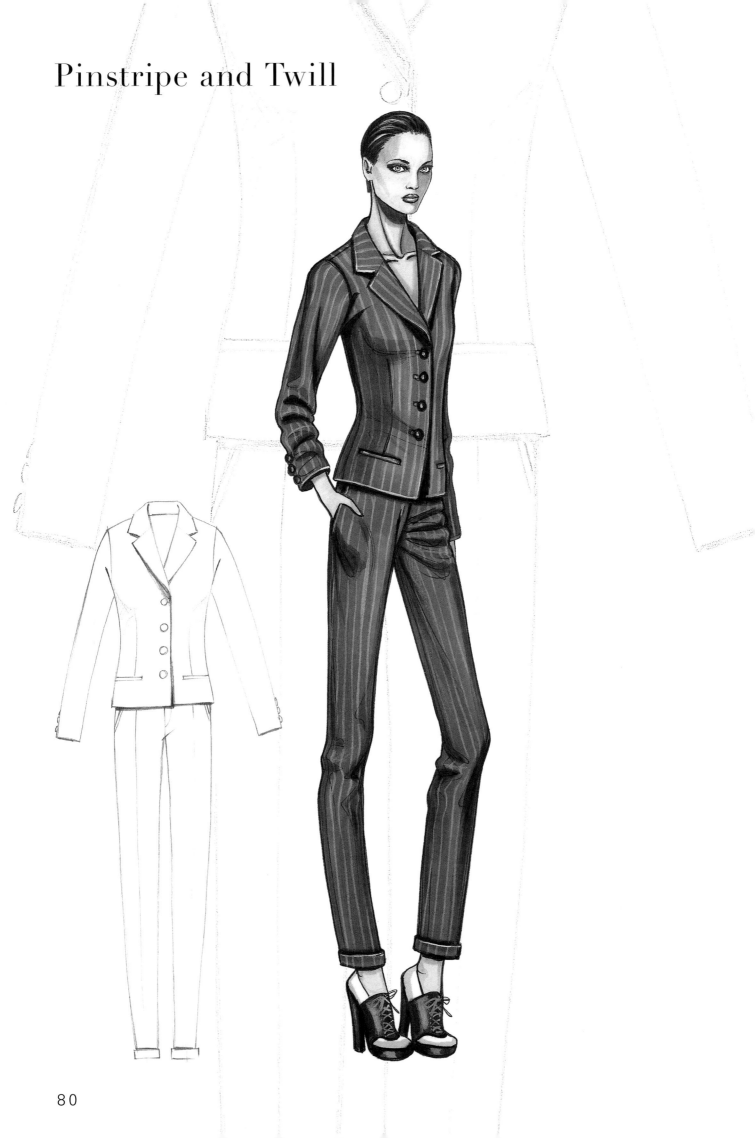

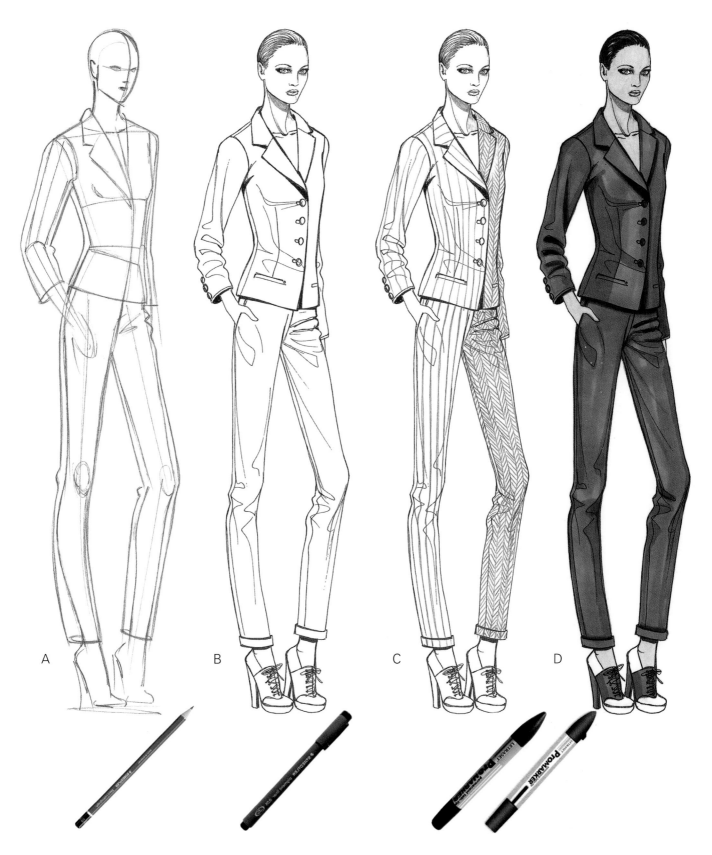

A – Trace in pencil the shape of the body and the suit.

B – Go over the tracing with a marker.

C – I have traced the fabric pattern with a pencil (pinstripe and twill) to show it better graphically, but it should be drawn on a base that is already colored.

D – Apply flesh colors. I used a Slate Promarker for the suit and a black Stabilo for the hair.

Once the base color is dry, do the shadowings. With a well-sharpened white pastel, I drew the vertical pinstripes taking special care with folds and curved body lines. With a white pastel go over the more pale points along the revers, cuffs, jacket and pocket edges.

Twill fabric, Pinstripe and Tweed

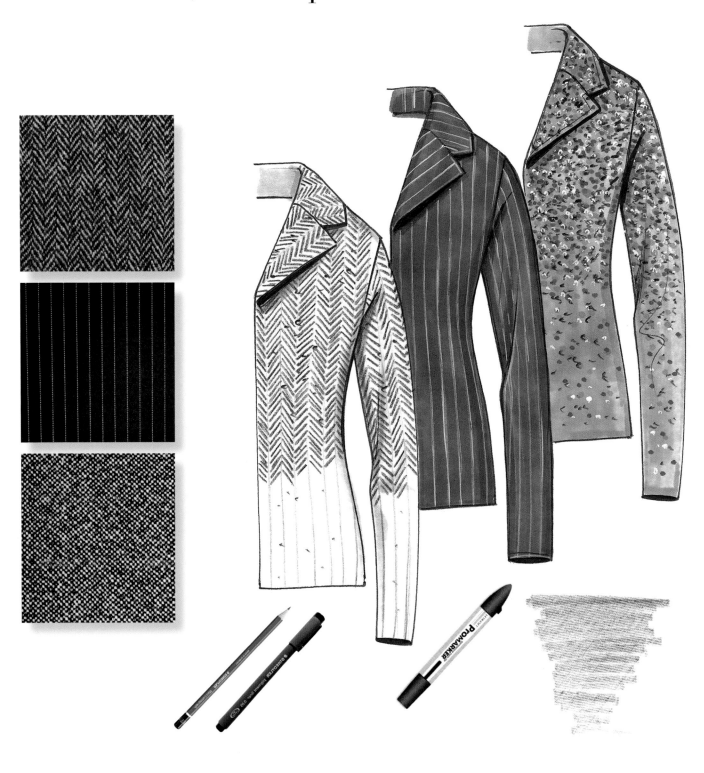

Chevron/Twill: Use a pencil to draw regular vertical lines as a guide. With black pastel trace diagonal lines, first in one direction, then in the other. Dot the base here and there with the point of the same pastel. Pinstripe: Spread the base color with a Pantone; when thoroughly dry, trace vertical lines in equal distances with a white pastel or a white pen like the Signo-Uniball. Tweed: Apply a base gray with a Pantone, dot this with a medium-point gray marker darker than the surface, then dot the surface again with a soft white pastel.

N.B. *For a Tweed or grisaille effect, frottage can be used: place the sheet on a rough surface with the rough side up (a cloth with a thick relief like a book cover, etc.) where the pattern is most like the effect you are aiming to achieve, and rub that part of the pattern with a pencil or pastel.*

Scotch Plaid

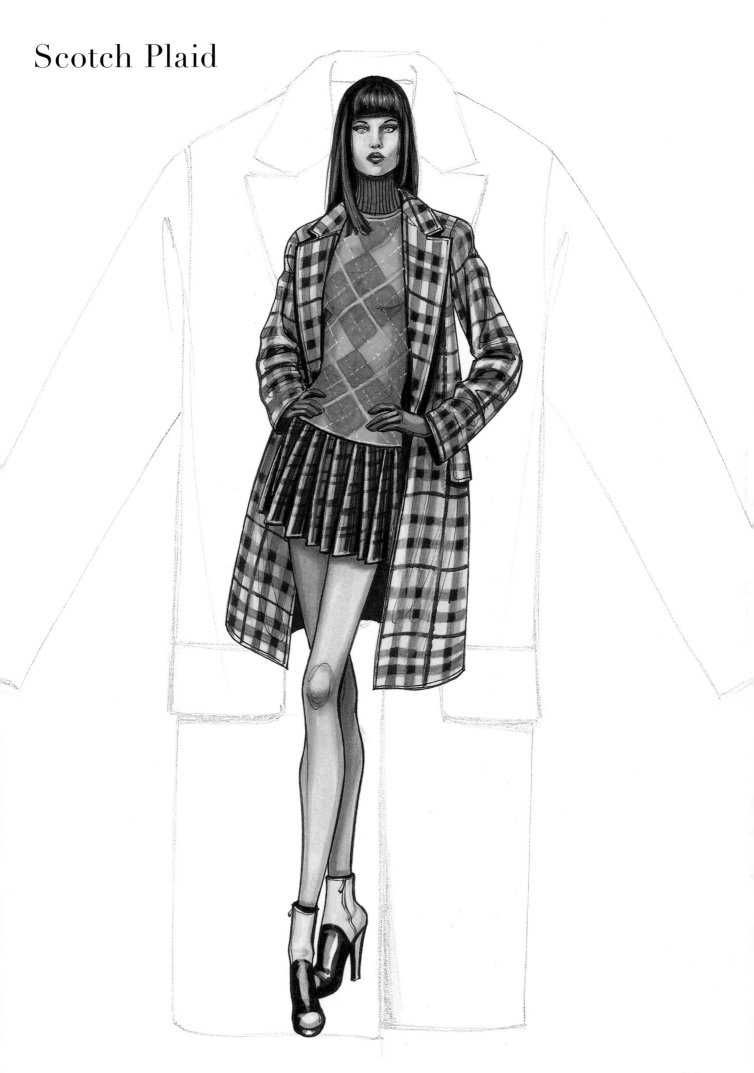

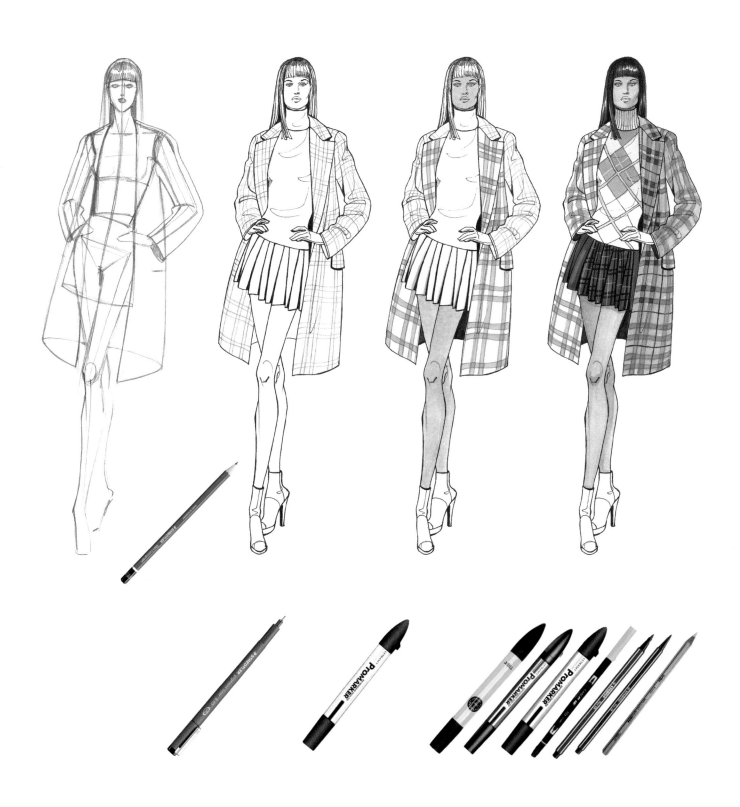

Draft the nude base, emphasizing the volume of the coat and skirt. Once the pencil model is done, go over it with a marker. In this case show the plaid design in pencil on a white background to underline the direction of the pattern on the fabric. Actually, the base color should be applied first (in this case a Yellow Promarker), and once it is completely dry, the guidelines lines for the plaid can be drawn in pencil. Bear in mind the direction that the pattern is taking based on the movement of the jacket or body so that it looks natural and not stiff. Shadow the coat first, then the tartan using a gray Pantone and a fine-tip red marker although a red pastel will also do.

Tartan and Scotch Plaid

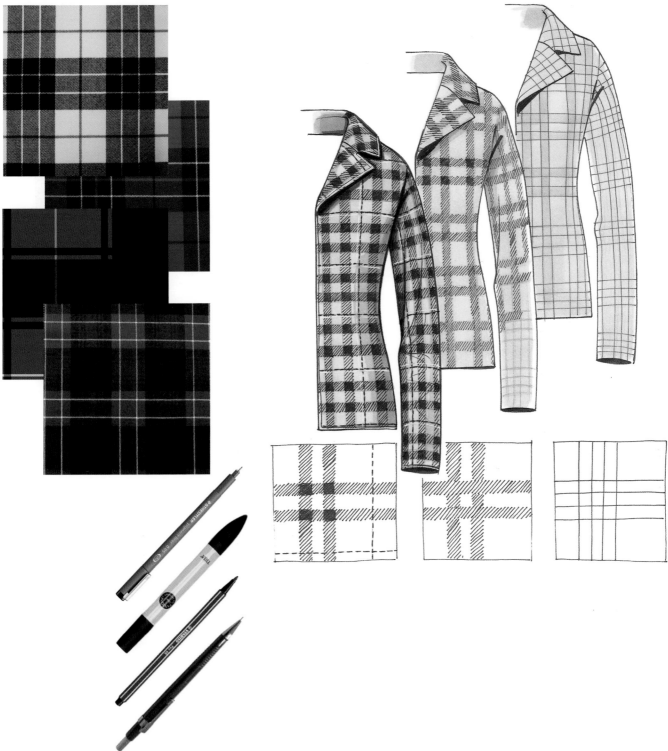

Apply the base color with a Pantone. Once dry, trace the guidelines with a pencil horizontally and vertically to achieve a symmetric grid. Fill in and join the two parallel lines with diagonal lines using a fine-tip marker. To further emphasize the squares, color the lines with a clear gray pantone. Once the color is applied with pencil, it becomes permanent and cannot be erased, so be sure that this is your final drawing. If the base color of the fabric is white, do the grid lines with a light pencil and then the color. Go over the Tartan squares with a darker or a black marker.

Tartan and Scotch Plaid

A

B

A – Use a red Pantone as base color. First, use a pencil to draw two equal lines in both directions and trace over these with a dark gray or black Pantone. Trace a fine line in pen with white ink.

B – Alternatively, trace a line of equal size to the two dark lines to cross at exactly the center of their square and fill it with diagonal lines using the same white pen. Where the small squares intersect, use full white.

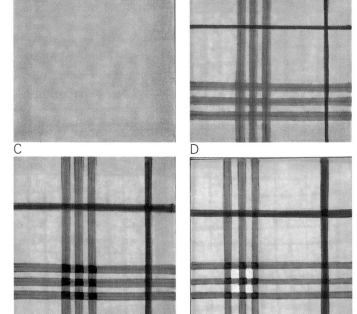

C

D

E

F

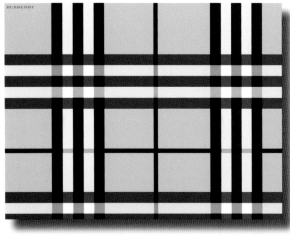

C - Use Promarker Sandstone (or a Pantone camel color) for the base.

D – For the 3-line horizontal and vertical grid use Pantone Cool Grey 3, and a red marker for the finer colored line.

E – Use black Stabilo for the cross squares on the Scotch plaid.

F – With white ink highlight the inner squares.

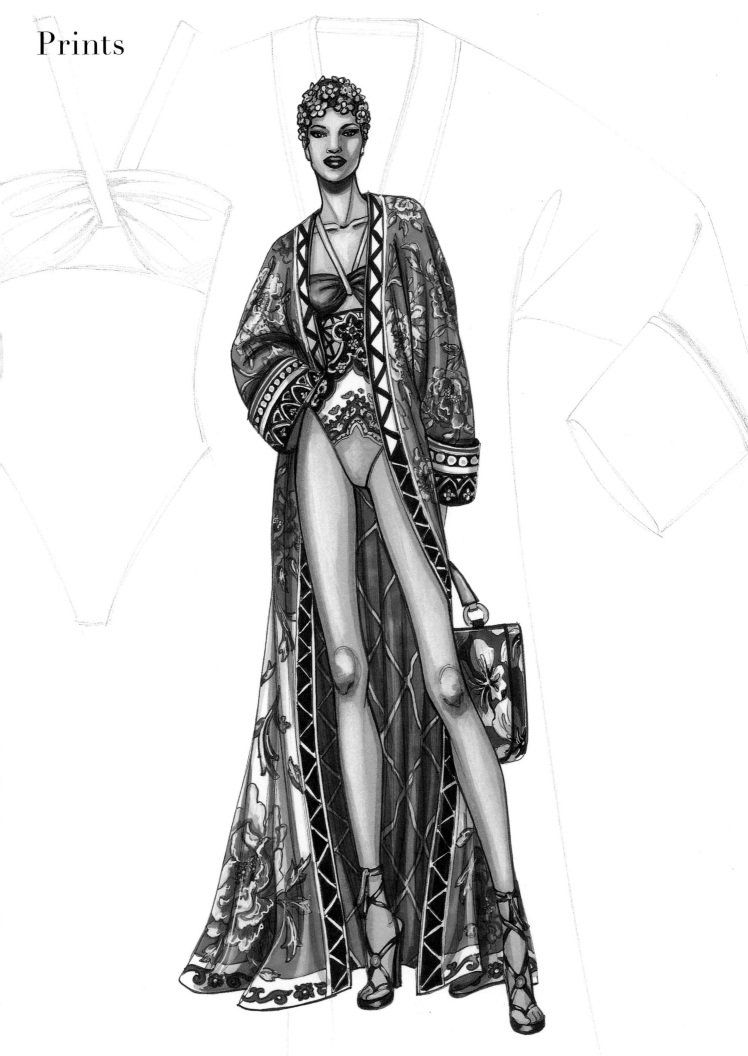

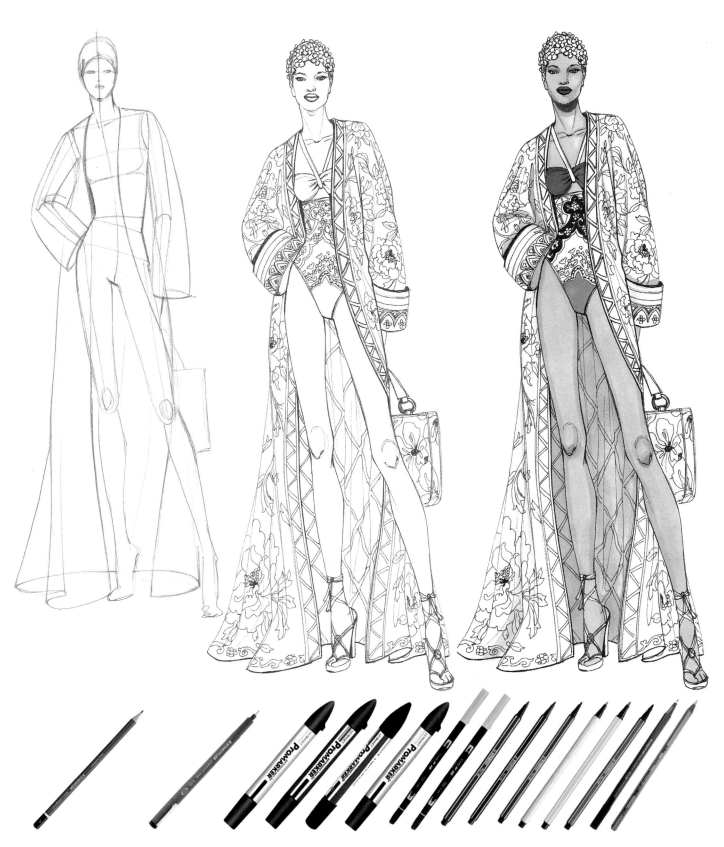

Here we see the base with the garment's volume drafted and later the print done in marker. Recreate the print design in pencil, tracing over later with fine-tip black marker. The print should follow the movement of the garment so that it does not appear flat or stiff. Use Pantone for the skin and the extended colored areas. Shadow the skin and garment with Pantone. First, do the light and shadow detail on the face and body, then later do the print. For the print, follow the sample, coloring the larger areas and leaving the smallest details for last, coloring these with brushes with tips of different thicknesses.

Printed Fabric

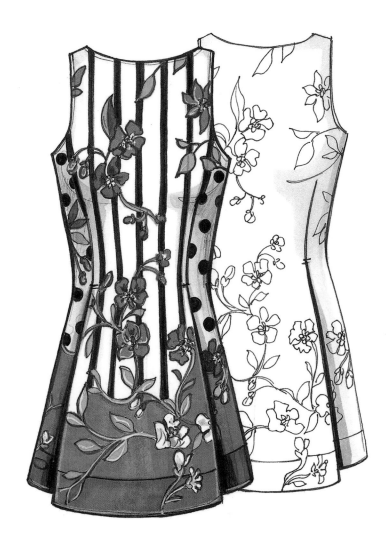

Violet
V245

Magenta
M865

Choose the print and draw it lightly in pencil, first in a quick draft and then in detail.
Go over the design with a fine black marker and fill in the larger colored zones.
Use very fine tip markers for the smallest details (like Stabile and Staedtler triplus fineliner). If the print is graphic and flat, use only brushes; if it is, for example, floral with blended areas, also used colored pastels and tempera.

Brocade

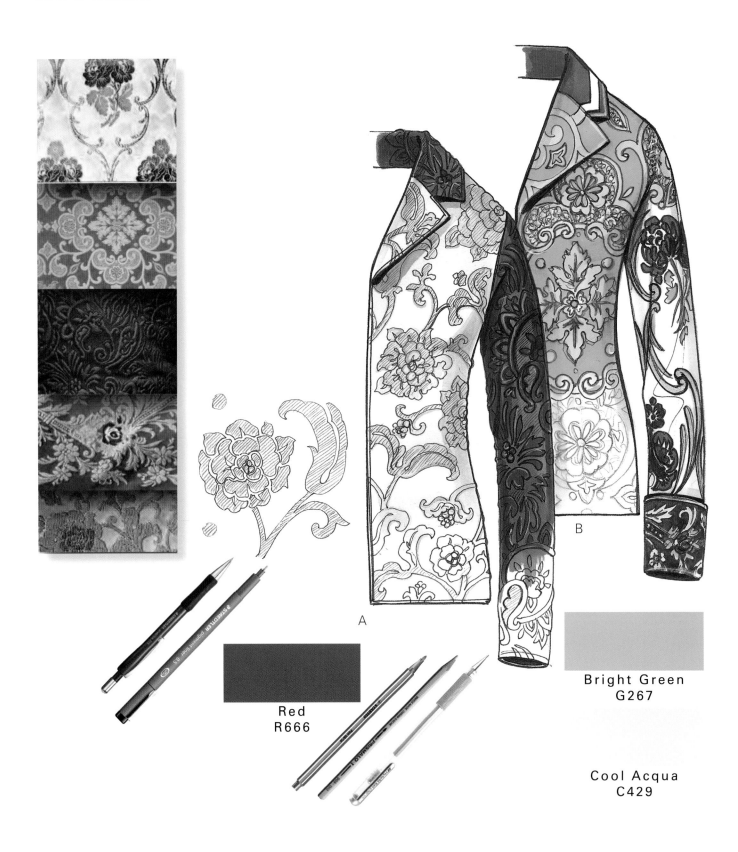

Red
R666

Bright Green
G267

Cool Acqua
C429

A

B

Brocade A – In pencil, trace the outline of the design in the brocade. Go over it lightly with a very fine tip marker like the Staedtler Pigment Liner 0.05, filling in the inner parts of the pattern with light diagonal dashes. For the sleeves, since the pattern is raised apply the pantone red and highlight the shape of the design with a darker Stabilo red. Use white pastel to trace the rounded contours so that they remain visible.

Brocade B – Use pencil to trace the pattern and then go over the pencil with a marker. Use tow different Pantone greens to fill in the colored areas, also using a gold roller point for the sleeve detail.

Fur and spotted fur

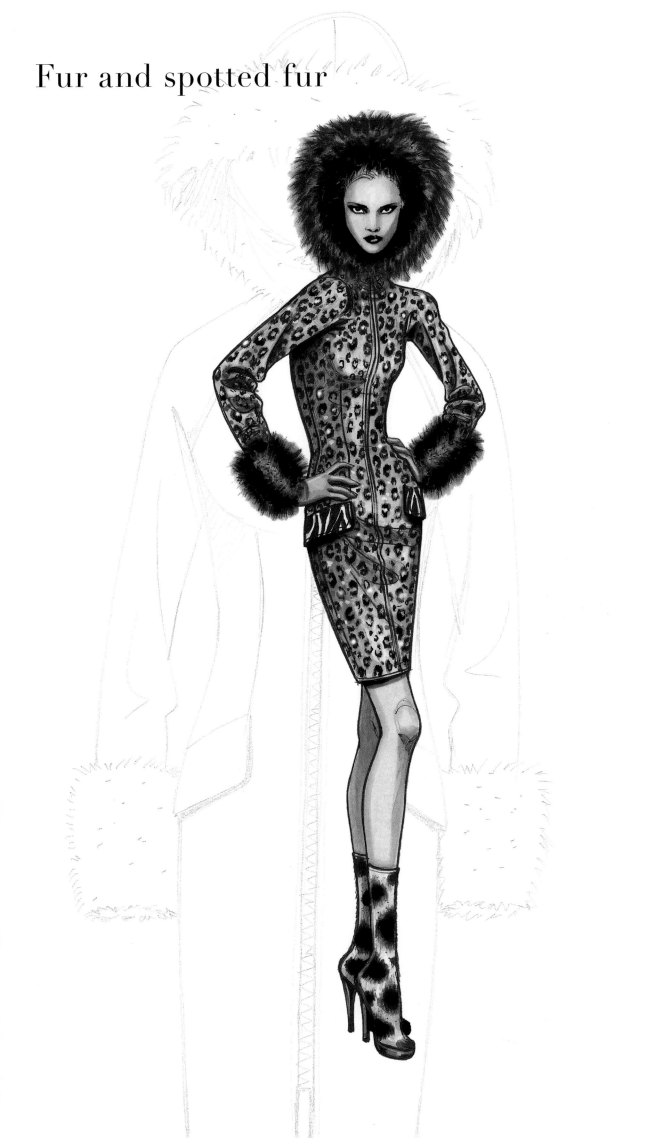

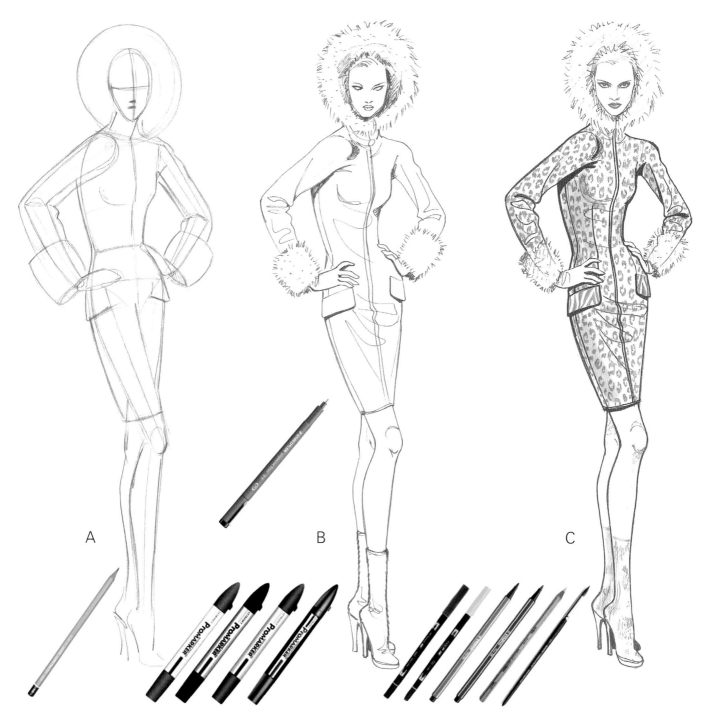

A – Here we see the shape of the body, drafted in pencil, showing the volume of the body.

B- A more detailed drawing, this also in pencil, of the figure and the coat.

C – Trace over the drawing with a marker, using pencil to show the leopard spots (here I used a pencil for the leopard spot on a white background to show the spotted effect, but it should be drawn on a colored base). For the coat, apply the base color with a Sandstone Promarker. Then use to the same color to outline the contours of the garment (hips and the folds that form at the elbows, etc.). Shadow the underarms with a Stabilo 6892 to provide more contrast. Use a warmer yellow (Promarker Mustard) on some of the background areas to make the drawing of the fur less flat. Accentuate the spots, then trace over with a medium point marker, either black or dark brown. Use a white pastel to blend the breast and folds in the sleeves and at the hips. For the in side areas of the fur use black pantone, and for the external borders of the fur you can use a black pastel to create small marks that blend. Here, I used a somewhat faded black Tombow. White or pastel tempera will brighten some point in the center of the spots. For the horsehide boots, create the outline of the spots in pencil, color it black and blend the outline with a pastel black or a marker, working in the same direction for the hides. The black should reach downward, while from the top the white blend should cover somewhat the black spot. For light on the hides I used a white tempera applied with light, uneven brush strokes. The best effect is produced using a flat, almost dry brush.

To refinish the external border of the hides, use either a black, almost empty Pantone (which if only it is used will create a lined effect) or even better a black Tombow, also nearly empty. Press the point starting from inside the fur and leaving a smudged mark toward the outside. If it is new and therefore filled with ink, use the very tip with light brush touches.

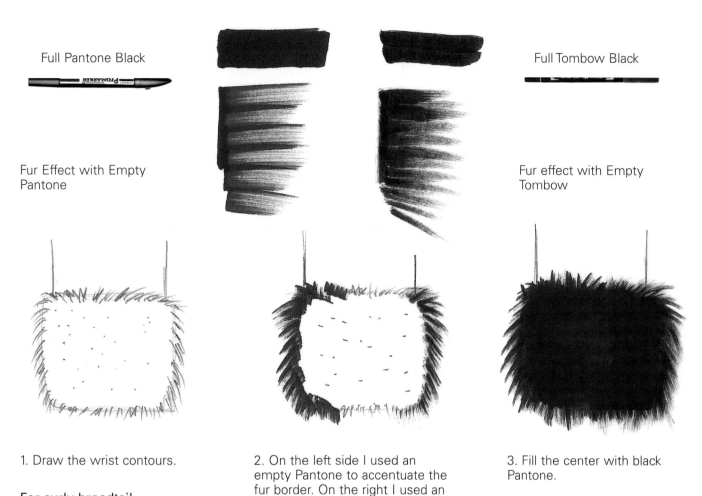

Full Pantone Black

Fur Effect with Empty Pantone

Full Tombow Black

Fur effect with Empty Tombow

1. Draw the wrist contours.

2. On the left side I used an empty Pantone to accentuate the fur border. On the right I used an empty black tombow.

3. Fill the center with black Pantone.

For curly broadtail

1. Draw the wrist outline wavy.

2. Color the wrist with black Pantone and fill the wavy curlicues with a fully loaded ballpoint pen.

3. Go over the white pastel in the center (you will still see the curlicues).

4. Finished sleeve: shadow the sides and below (inside the cuff) to provide depth. Apply a few more pastel dots.

93

Spots and fur

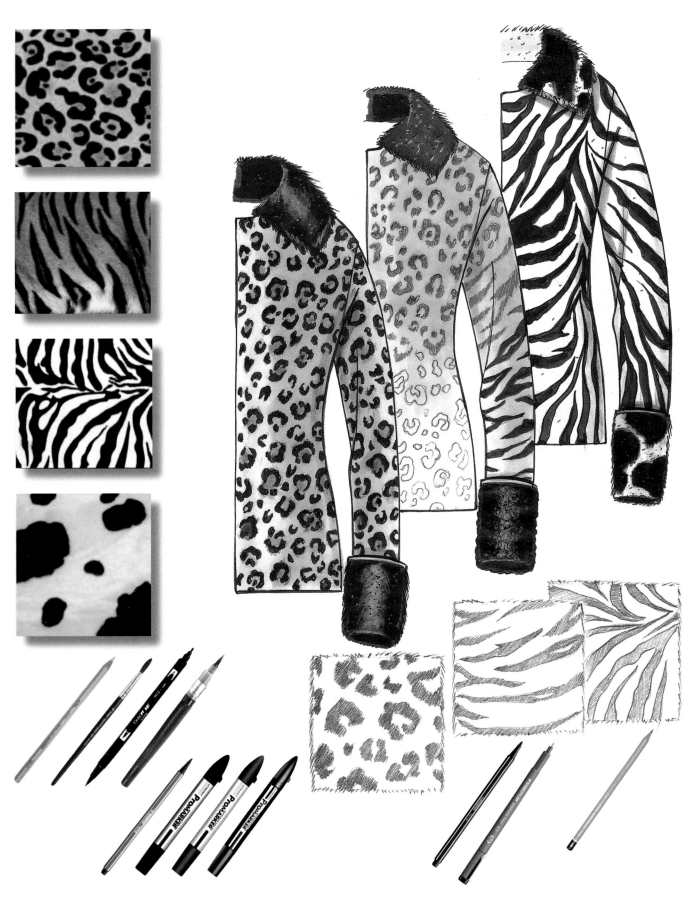

The fur effect is achieved by dotting the inner area of the fur using a fine tip marker, and the shape by using small, blotted marks working outward diagonally. (For details on the coloring for leopard and horsehide spots, see the preceding page.)

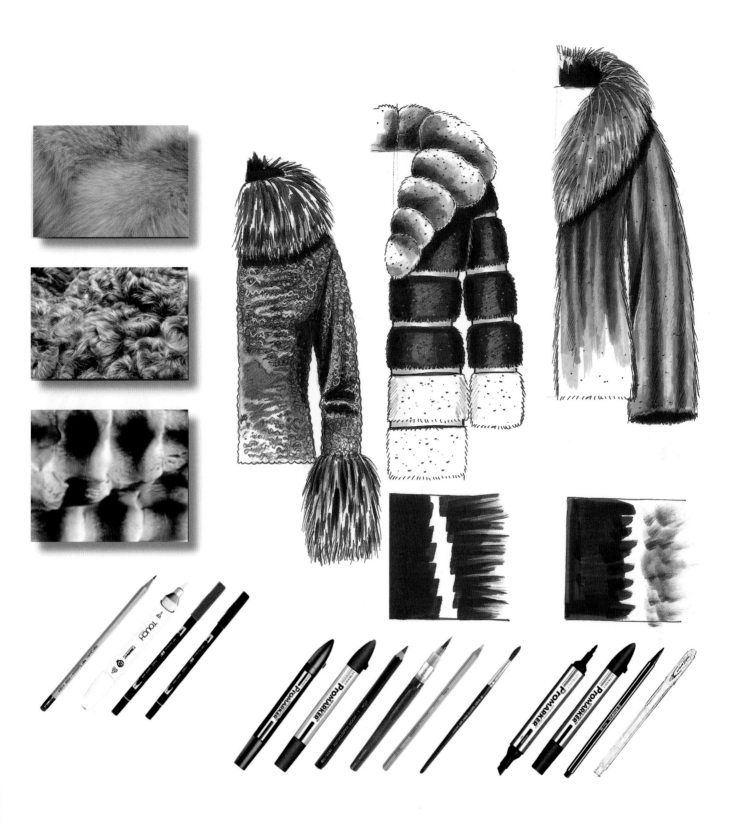

For broadtail, use pencil to accentuate the shadow areas, filling these with Touch CG3 brush marker (brush point). For very curly broadtail, after applying the Pantone color fill in the curlicues with a ballpoint. Apply color with Pantone and lighten using a light, white pastel. If you use a full ballpoint like the BIC, the trace of the curl will stay visible. For the fox collar and cuffs: use quick, irregular touches with a Tombow n.35, white tempera not very diluted, or white pastel. For chinchilla use Ice Grey 2, with blots of black pastel. NB: If you blot using black pastel and later go over it carefully and slowly using a clear Pantone, you will obtain a more even blend. Lapin: Use anthracite gray as a base (Touch WG9); for shadow use a black Pantone and a white pastel; lighten and dot sparsely. Mink: Use a Promarker Cinnamon base with vertical touches of Promarker Shale applied and blended downward. To strengthen the blending and darken the more central parts of the spot use a still moist, very fine tip Pantone to blot downward. To illuminate the fox fur collar, use a white Uniball ballpoint and provide shadow under the collar with a Stabilo 68/45.

Draping

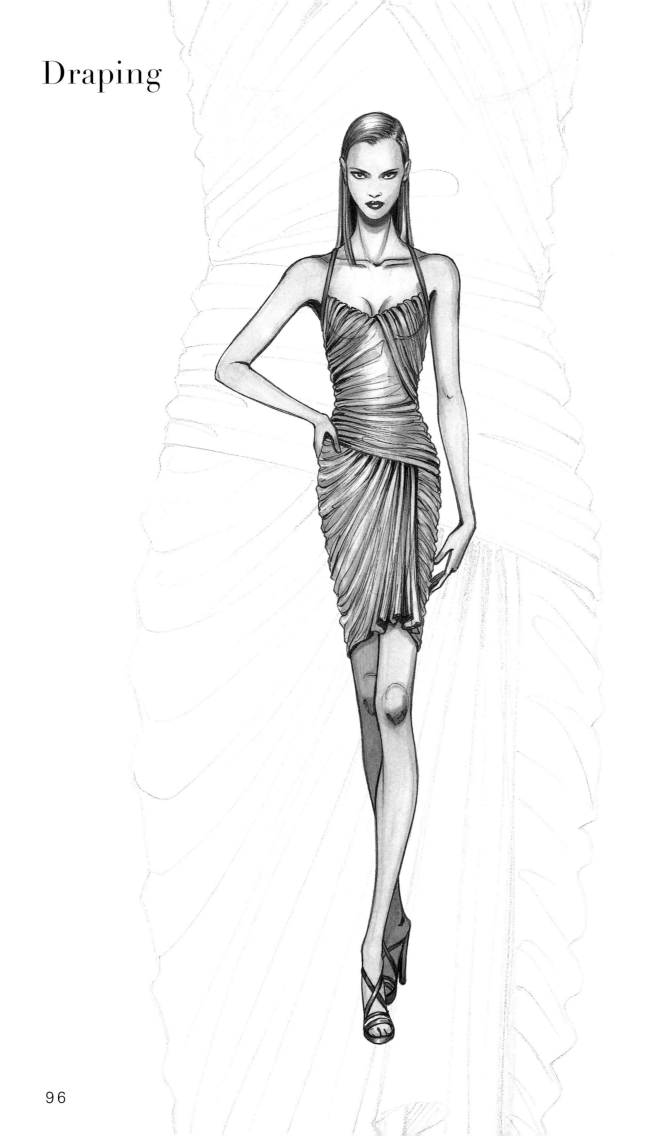

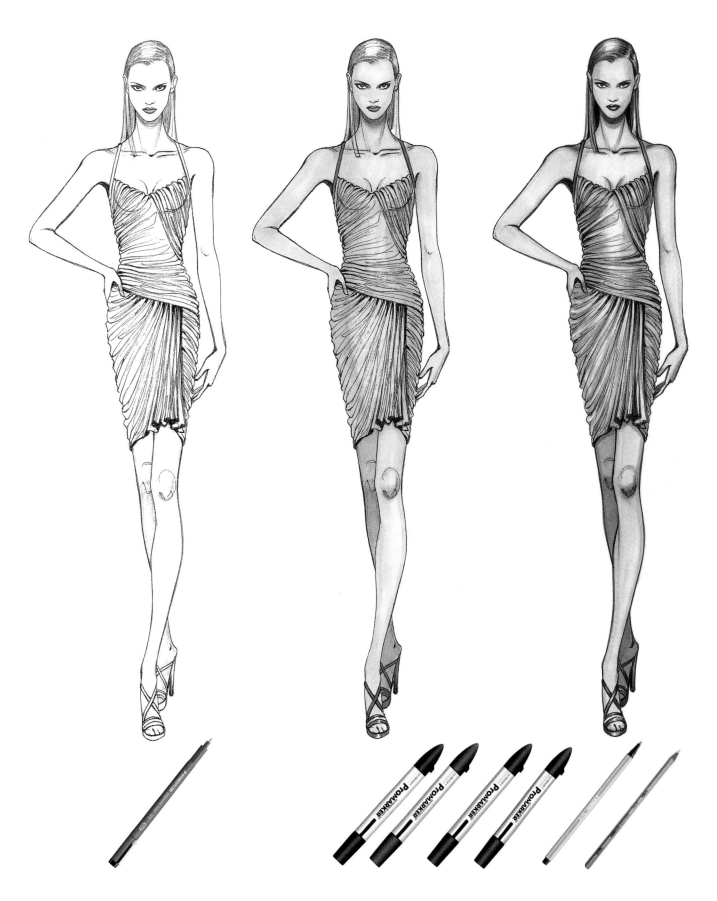

Go over the base you have already drawn in pencil with a black fine tip marker. Apply color base for the skin and Promarker Gold for the garment. Shadow the skin and with Sandstone; color the leg that remains in the shade. Retouch facial details with an extra-fine tip marker (Stabilo for the hair, beige Promarker Pastel for the face, allowing time for the first application to dry completely, otherwise it will tend to be absorbed and will create a weak contrast), for the shine on the hair use white pastel or tempera. Shadow the garment and use a yellow Stabilo 68-37 (and a medium gray) to darken the inner part of the pleats created by the draping. Use Violet Promarker for the shoulders and sandals.

97

Draping

Canary
Y367

Gold
O555

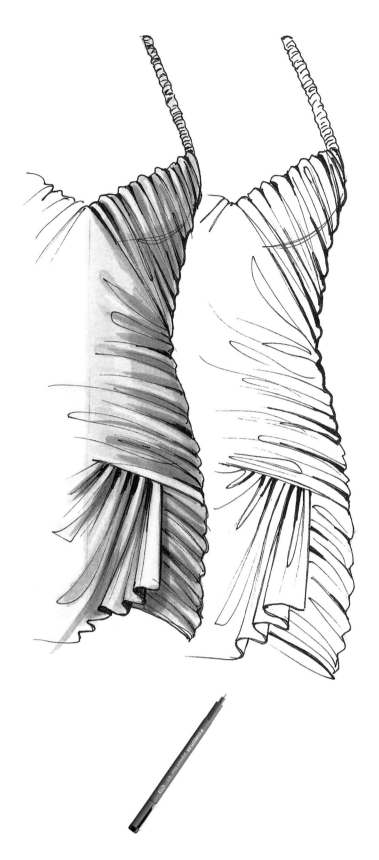

Shadow the garment on the outer lines of the body and under the breasts with the same, or a slightly darker, yellow. Darken the areas where the pleats open out from the draped fabric and which are therefore deepest. Accentuate the shadowing toward the outside parts of the garment where the pleats are to provide volume. Use white pastel to lighten areas where the pleat is more rounded and raised.

Tulle, Plissé and Net

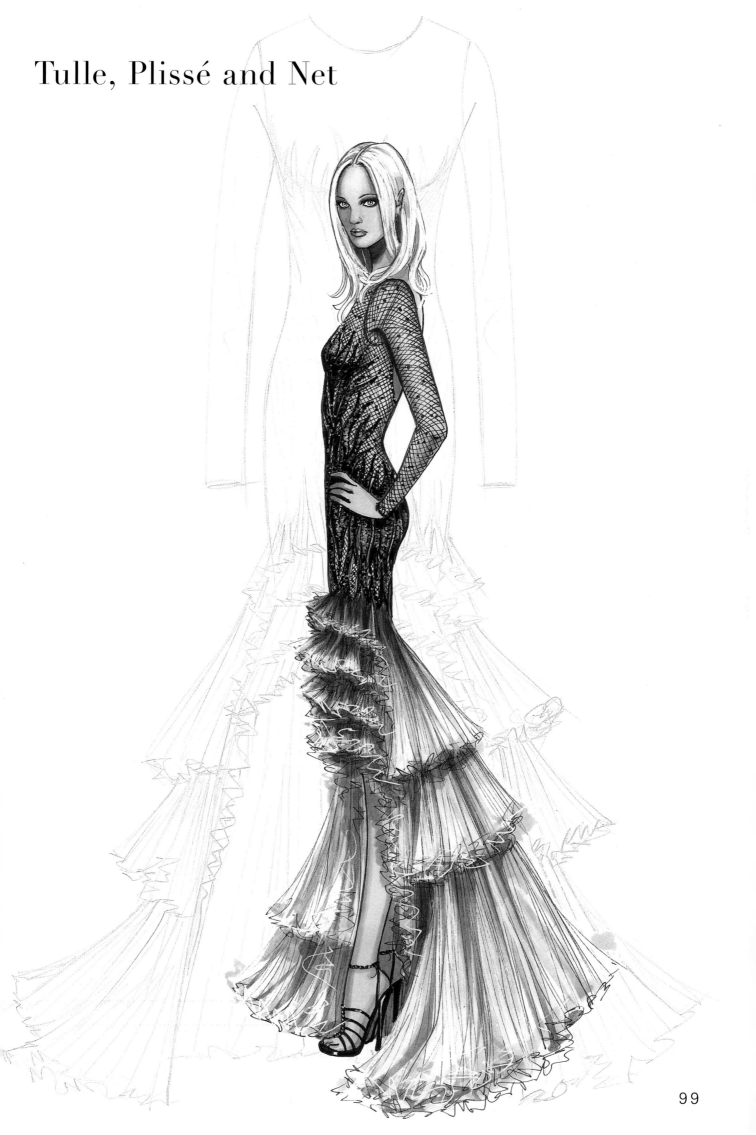

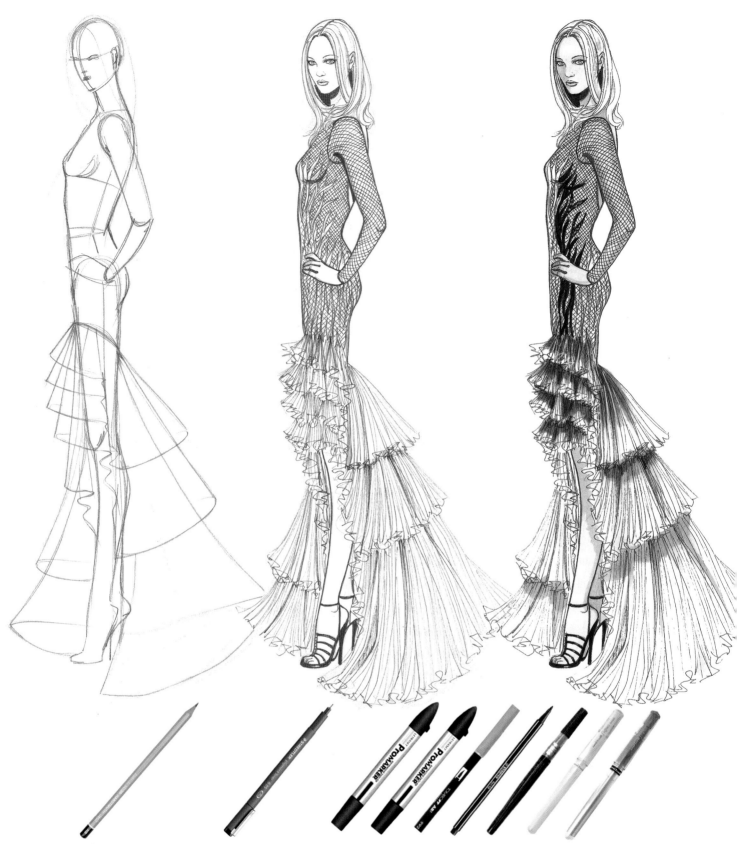

Draw the outline of the figure, then draft the fuller areas with pencil. In this case the skirt will have irregular flounces of pleated tulle, therefore rather full. Once you have gone over the figure with a marker, draw the embroidery in pencil then go over it with a marker starting at the outline and working the details carefully. Go over the net immediately with a marker because it should be quite visible and striking.

Fill in the embroidery with a black Stabilo and dot it using a silver and white ink pen, making thicker dots on the raised areas, less thick on the other parts. This will help illuminate the embroidery. For the plissé use straight lines close together and slightly curved to create a full, rich look that follows the movement of the skirt. Using a medium gray Pantone, shadow under the flounces and wherever there are deep movements in the skirt.

Tulle and Pois d'Esprit

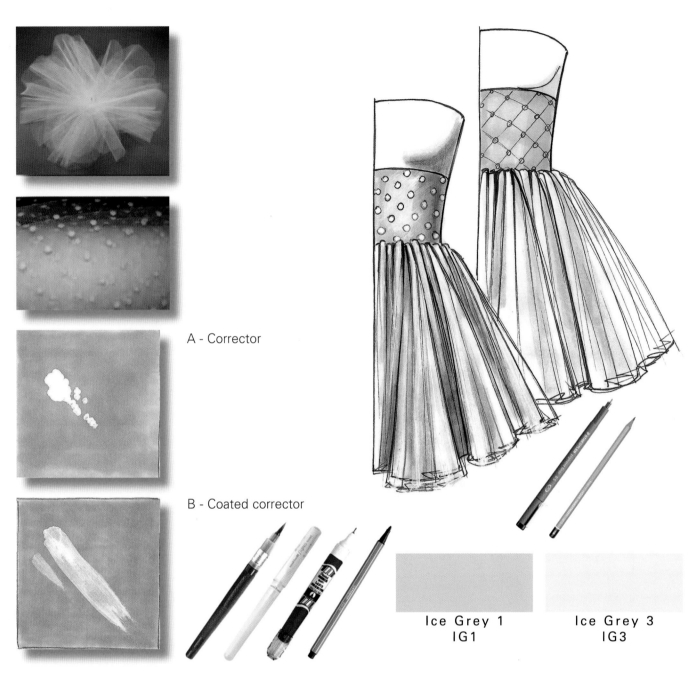

A - Corrector

B - Coated corrector

Ice Grey 1
IG1

Ice Grey 3
IG3

For the tulle, do the plissé vertically, weaving through and following the movement of the pleats. For the hem use an irregular zig-zag. For shadowing on a white background use different shades of Pantone gray: Ice Grey or Cool Grey, starting from n. 1 for the fuller areas (the full skirt, the bride's veil, etc.) and then go to a darker shade like n. 3 for the areas more in shadow. For more and for more pronounced contrasts, a dark gray Stabilo is good, or a black marker. For more light, touches of corrector done vertically and then smudged with the fingertip for a light, steamy effect (see images A and B). Go over the zig-zag hem with a white pen or pastel where it is most shadowed.

Pois d'esprit: on the already colored base of the skin, trace a grid of small squares creating regular rhombi, then use a marker to make a dot or a small circle at the meeting point. Erase the pencil to get empty dots. With a white pastel, blot the outer part of the skin and give the fabric a slight smudge. Fill the empty dots with a touch of corrector, or with a white ink pen if they are very small. If this is a proper bride's veil, use a light gray Pantone for shadow, leaving broad areas of white in the veil. Emphasize the movement of the folds with a clear gray Tombox or a well-diluted Pentel Color Brush and then with a white pen dot randomly everywhere.

Iridescent

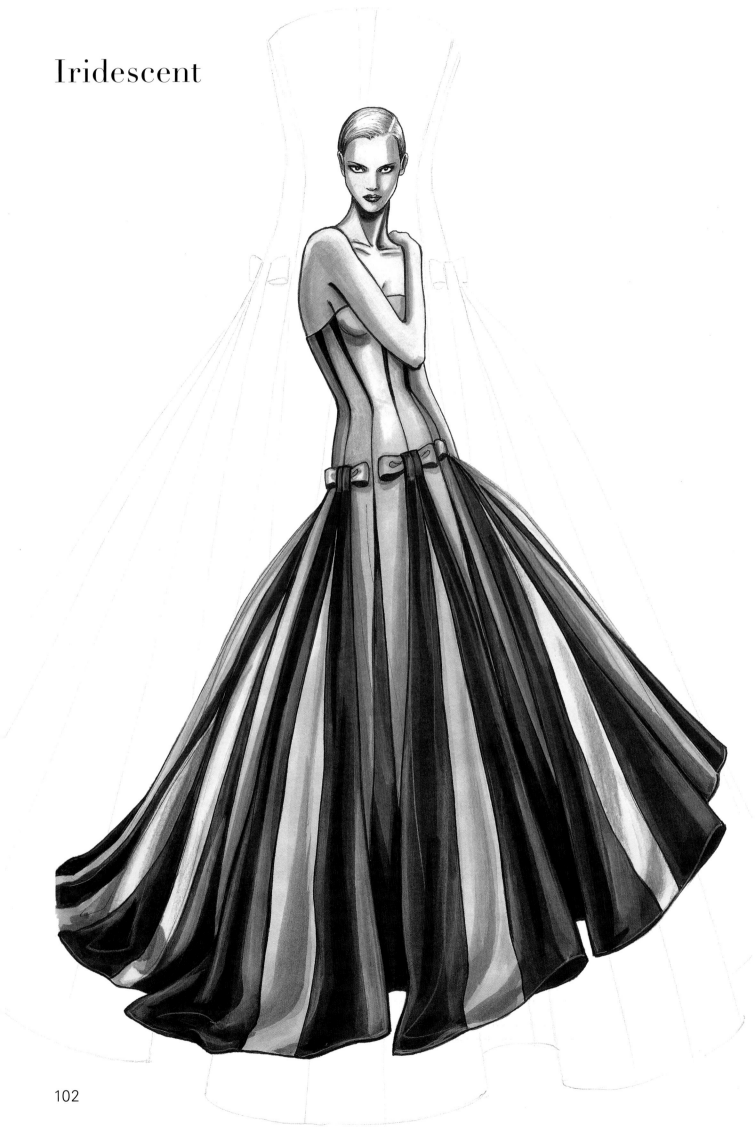

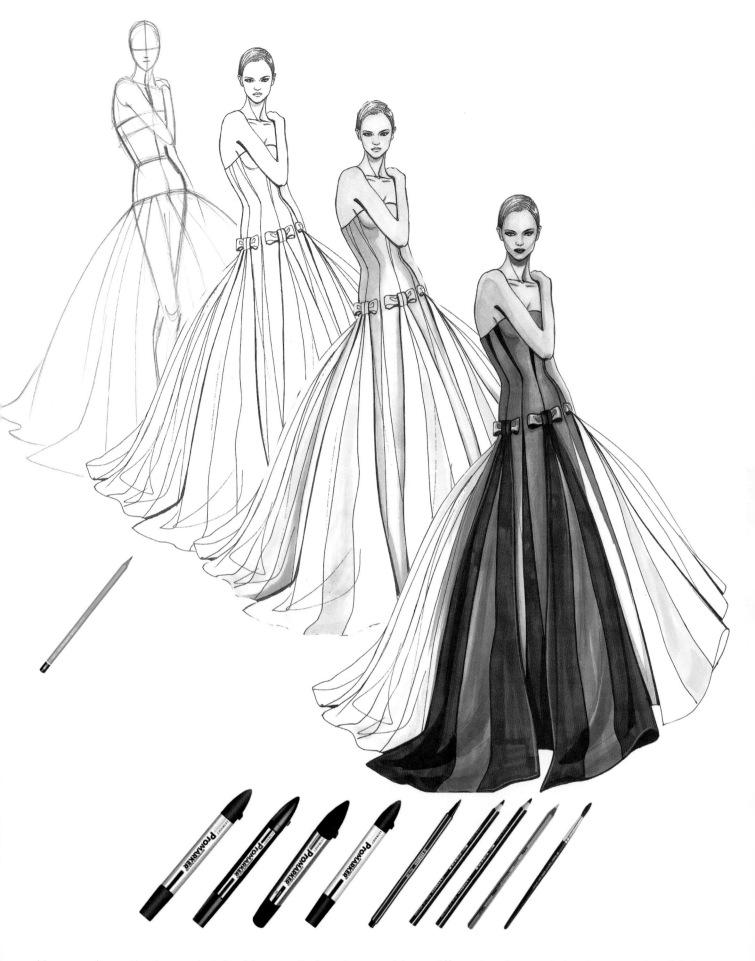

Here we have the base sketched in pencil showing the garment's volume. Then we see the drawing with the base skin color, and then the gown with Pantone shades of lilac, green and black. Once shading has been applied to the gown and to the lighter shiny areas with a white pastel, create the iridescence with a different color pastel wherever the fabric moves, showing folds and pleat movements. Where you have applied Pantone lilac, blend with a green pastel, and on the green Pantone areas blend with a lilac or violet pastel. The more dry the Pantone color is, the more the pastel color will stand out.

Iridescent Fabrics

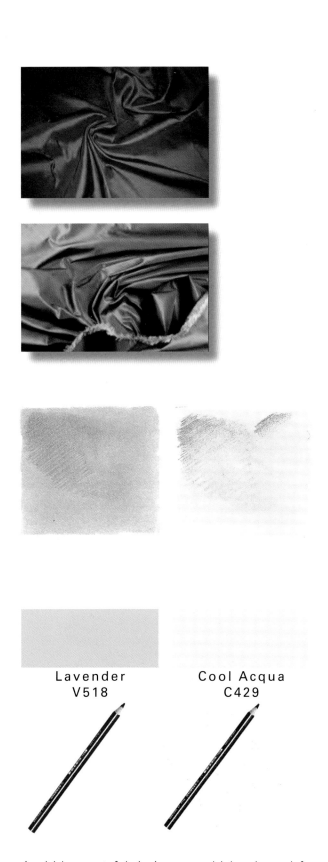

Lavender
V518

Cool Acqua
C429

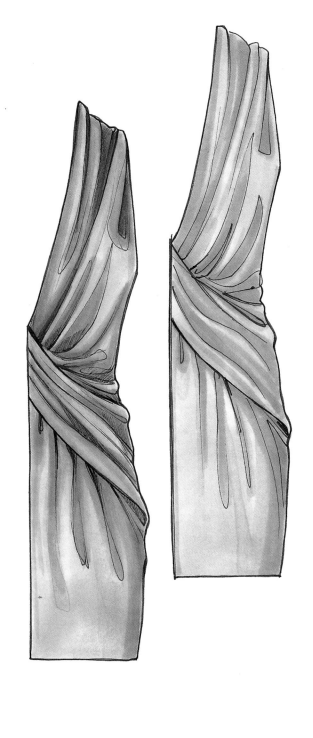

An iridescent fabric is one which, viewed from a different angle, changes color and becomes almost iridescent. The effect is produced by warp threads of a different color from weft threads. You can produce it with a colored pastel that you blend onto the base drawing onto which a different color Pantone has already been applied. In this case, apply a green pastel over the lilac Pantone base, starting thicker in the shadow zone and blending in the lighter areas and vice-versa. The iridescent effect will appear where the fabric creates movements.

Skins and Leather

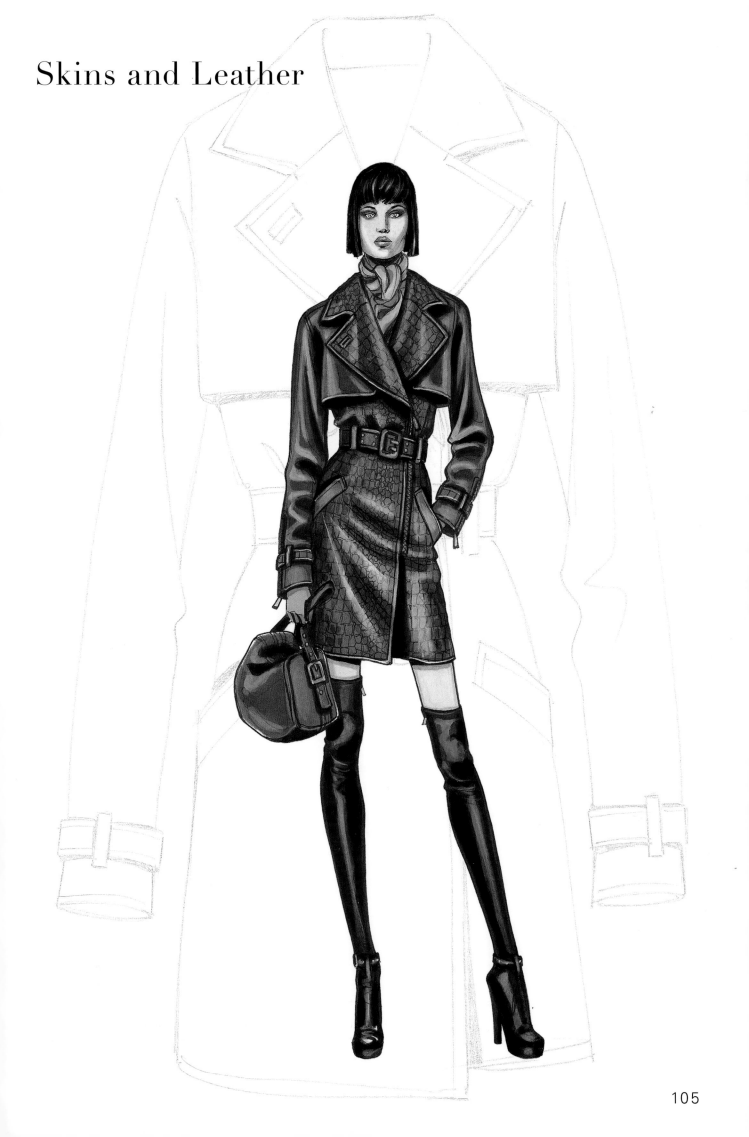

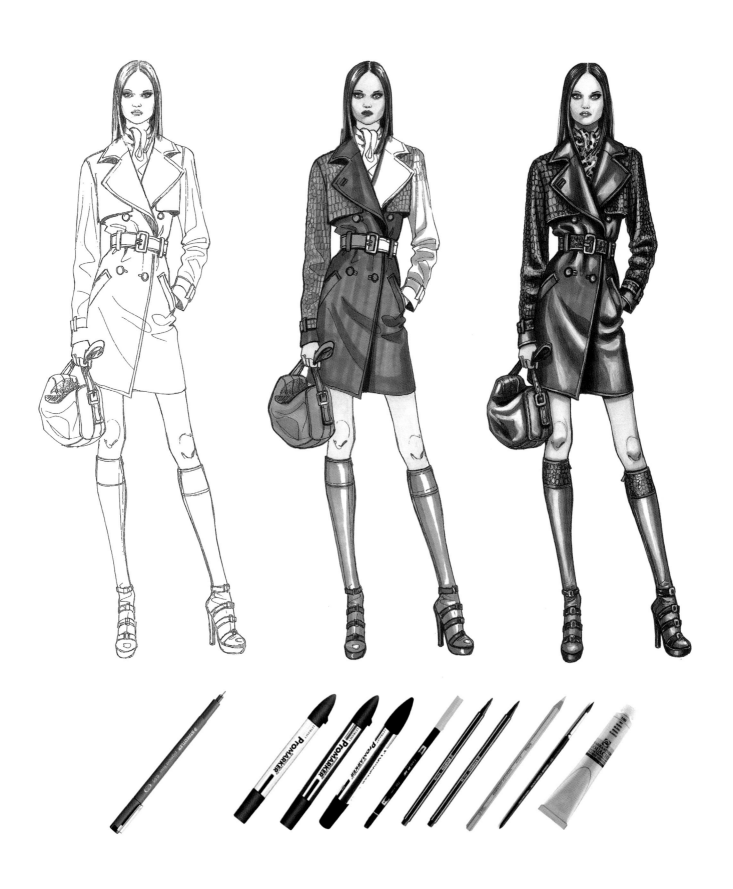

Skin: Beige Pastel Promarker, shadow using Tombow 990. Hat: black Stabilo. For the leather coat I used a Burnt Sienna Promarker; for the sleeves, cape, boots and handbag a Cocoa shade. Use the same color for the outside body shadows, and a Stabilo 68-45 for the parts that are most in shadow such as the coat's closing, the shadow of the cape, and the shadow under the revers. White pastel: Pastello bianco: somewhat thick at first, then blending toward the more shiny outside areas. White ink pen for the borders. For more light, use a white tempera.

Leather, Hides and Crocodile

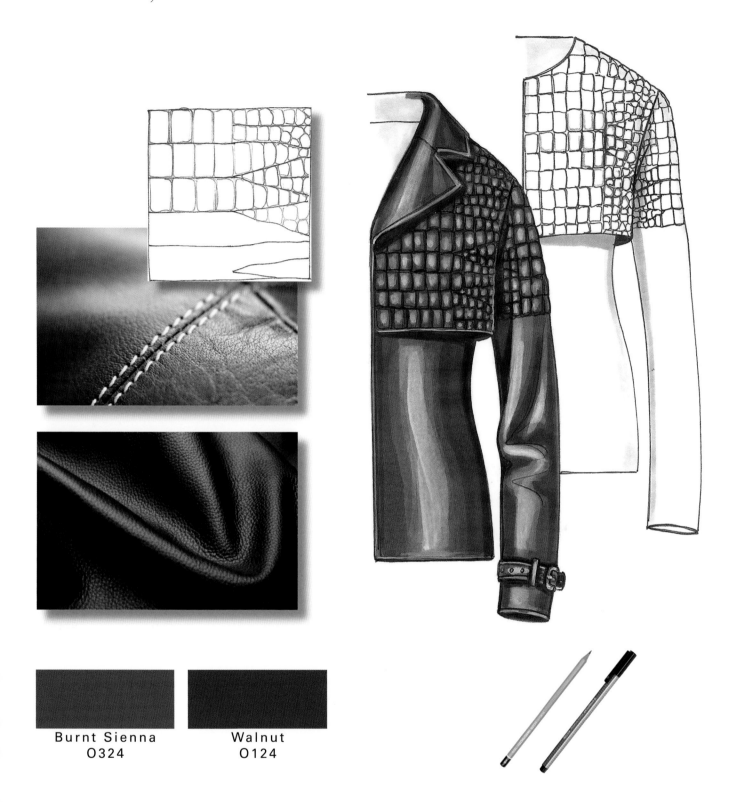

Burnt Sienna
0324

Walnut
0124

Apply the Pantone color. Then apply the same brown to the areas in shadow (torso, breast) and apply a somewhat darker color to the sleeve folds at the elbow height, under the revers and the mantellina. Use a soft white pastel to color the center of the torso, the folds, and the wrist and neck borders. Once the shiny area is done in pastel, go over it and accent even more heavily at the center of the lighter areas. If that is not enough, touch up with white tempera diluted for effect: if still more is needed, apply again, less diluted this time. For crocodile, draw a small grid with pencil, then trace over the single squares rounding the corners (the sizes of the squares are not equal so reduce them gradually and then enlarge them again little by little.

N.B. Here too, frottage is a good technique to use if you find a raised surface with the pattern.

Satin and Shiny Fabrics

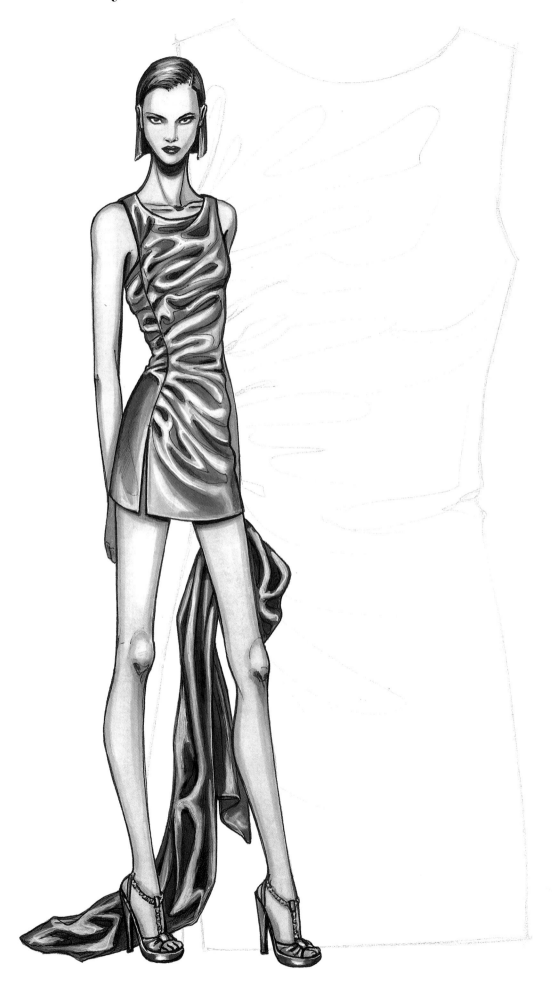

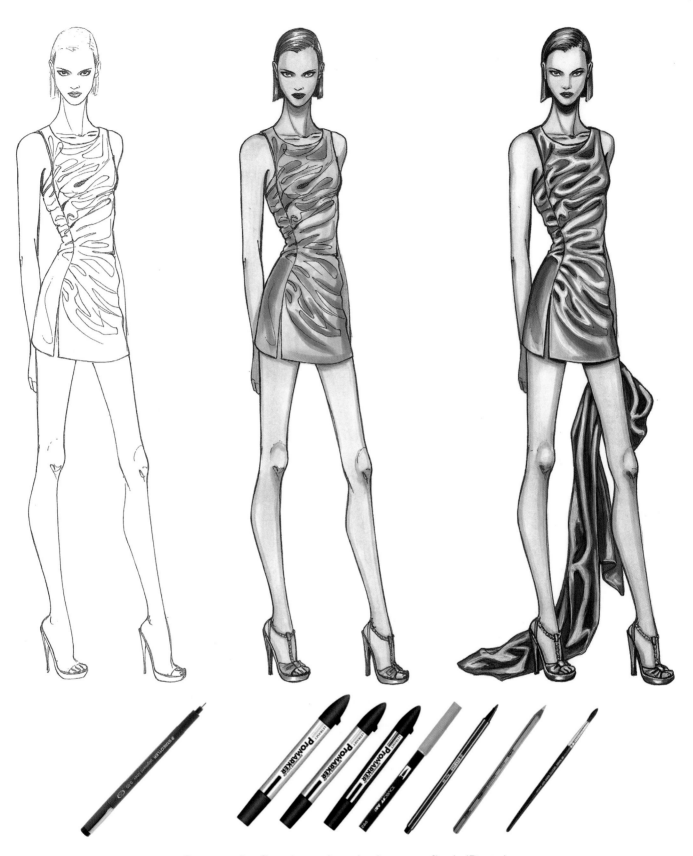

Go over the figure; apply color base on flesh (Pastel Beige or Satin). Use a Violet Promarker for the dress and Maroon for the shoes.

Use the same Pantone to shadow the inside of the pleats and lighten them with a soft white pastel or diluted white tempera and with heavier touches where there is more light.

Satin

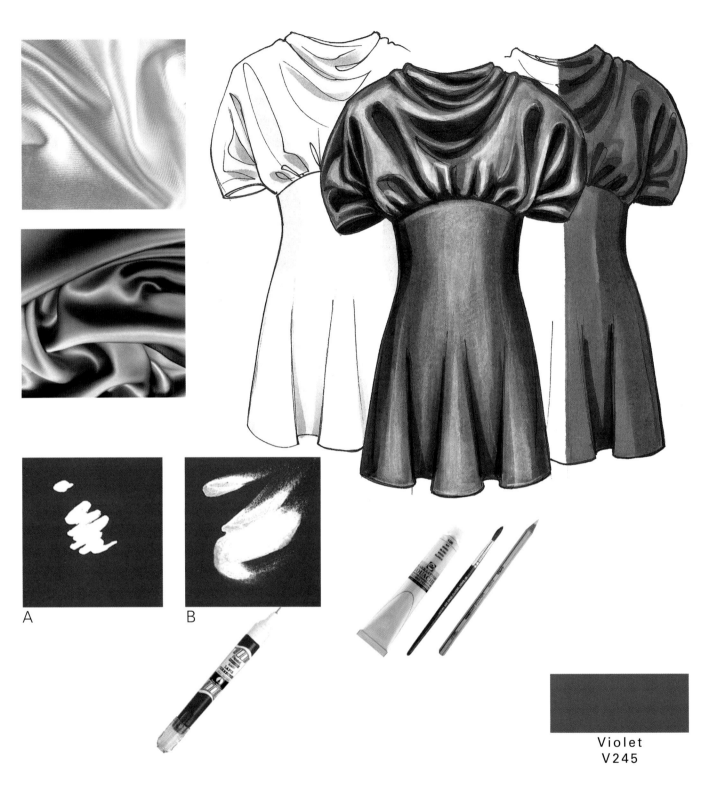

A

B

Violet
V245

For the dress, shadow the necessary areas with the same Pantone between the pleats and the outside of the body. Use a Pantone darker shade to create contract in the more shadowed parts (inside deep pleats). In the more visible areas, outline the areas of light first, blending with a white pastel, and then thicken the color considerably in the center area and the visible areas.

If more pastel is needed, add a touch of white tempera. To achieve an even shinier effect, apply a spot of corrector and spread it immediately with your fingertip in the direction of movement of the fabric (see A and B).

Coated silk, PVC

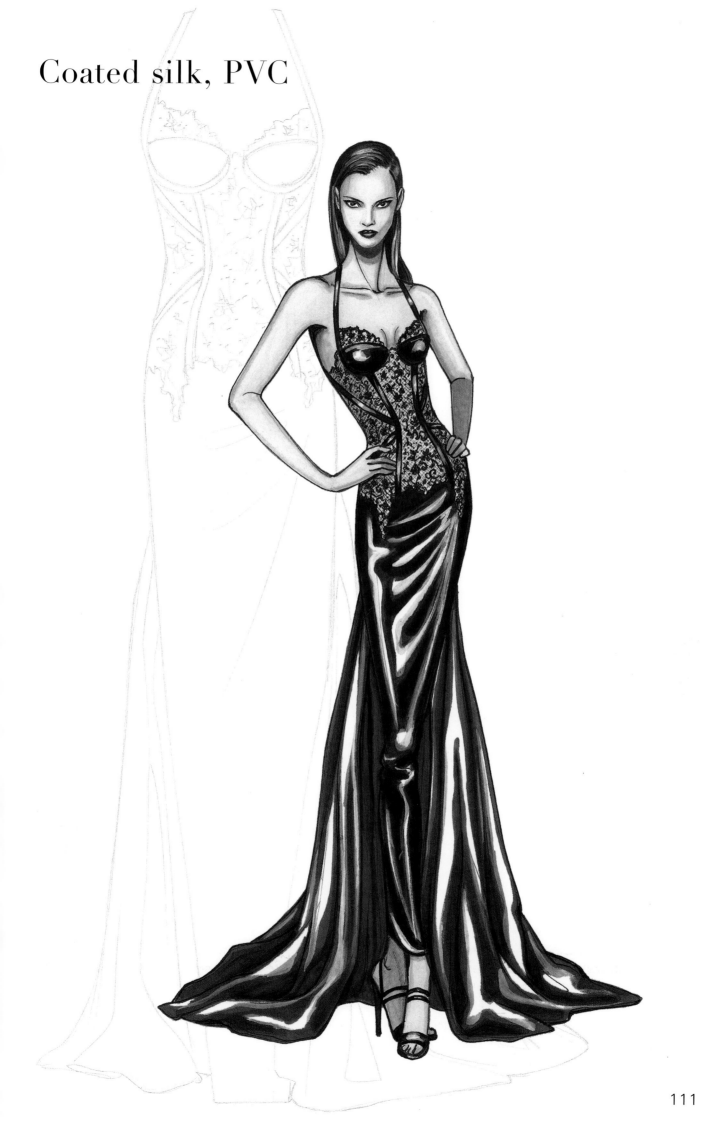

Lace

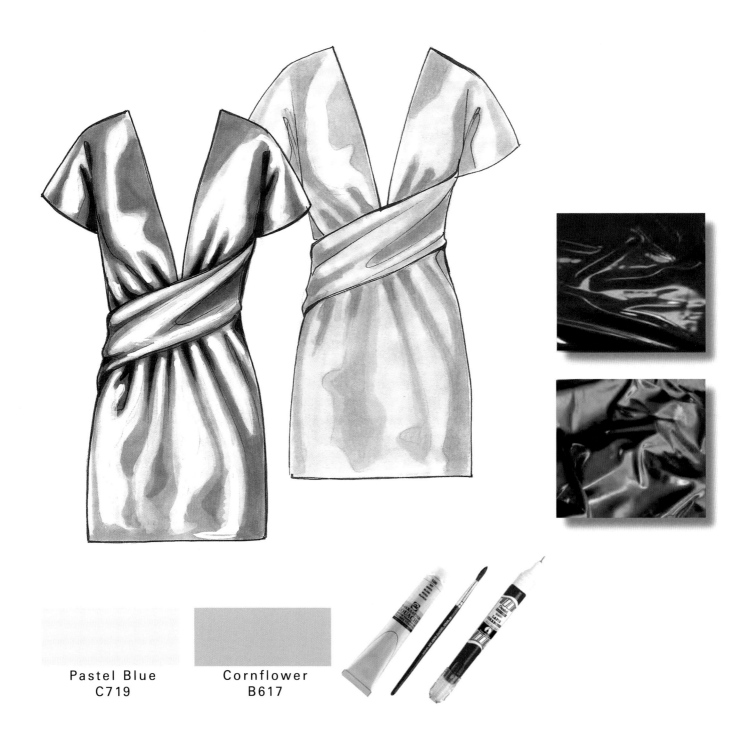

Pastel Blue
C719

Cornflower
B617

SHINY EFFECT: Apply color; go over the shadows on the outer parts and under the breasts, pleats, etc. With white pastel outline the areas that should be lighter and apply thick color (do not blend the lighter spots too much, they should stay compact). If you use tempera, first use a very diluted brush, and if this does the trick go over it with a stronger color.

Here too, you can create a more defined spot using corrector; blend with fingertip immediately working in the direction of the light.
Otherwise, you can outline the shiny areas with a pastel then go over the more concentrated light with tempera or corrector.

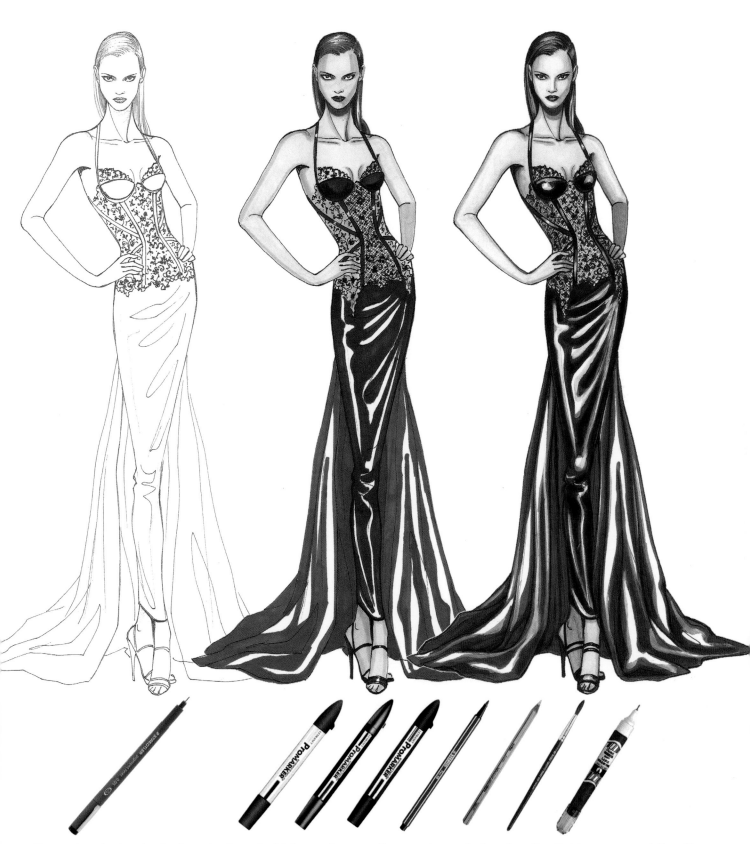

Trace the design including the lace (which you have quickly sketched in pencil) and go over the details with a fine-tip black marker. Wait until you have finished coloring the skin to do the 'grid' (if you are using a fine tip ballpoint pen); you are using a very fine tip brush (Staedtler liner 00.5), draw it immediately. Once you have applied the skin color to the base, apply black to the garment and color,

flat, to the train leaving the lighter areas white. Go over shadowing for the skin and garment using the same colors. Refine the details of the lace, filling in the floral design and the larger details in black. Do the light for the rubbery skirt with full tempera or with corrector pen which should be blended with fingertip immediately after application and in the same direction as the movement.

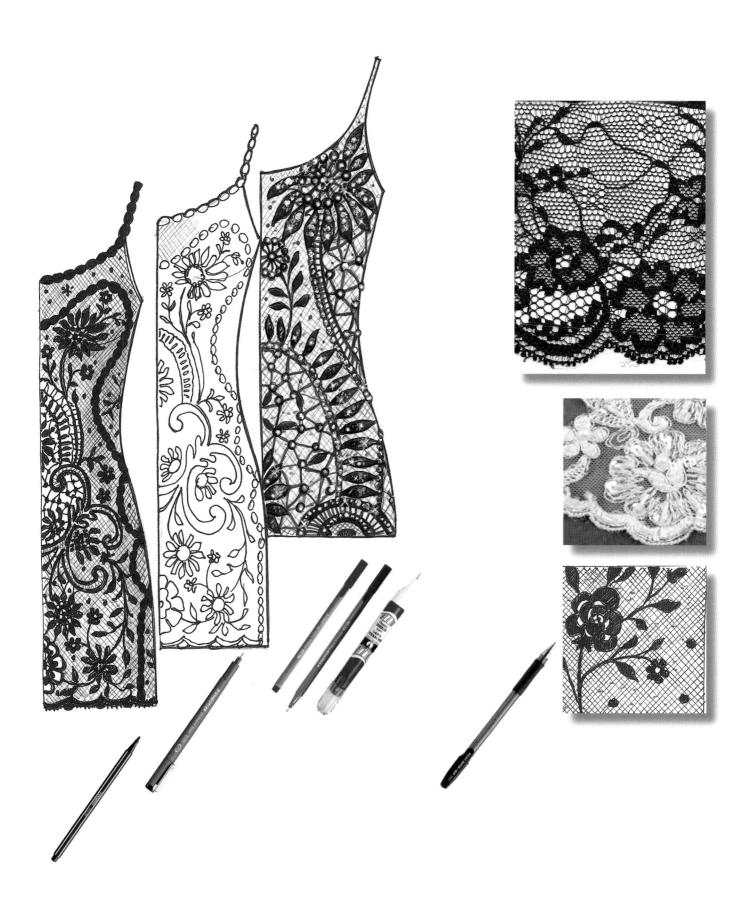

For the lace, draw the larger lines of the design motif over the drawing you have already traced with a marker. Then go over it again with a fine tip marker with utmost attention to the details and to filling in the darker areas (example: flower fantasy with full petal). If you are using a very fine marker, go over the underlying base pattern, otherwise add this at the end with a very fine tip ballpoint pen like the Pilot BP-S Matic Fine, randomly dotting the lace base.

114

Lurex and Lamé

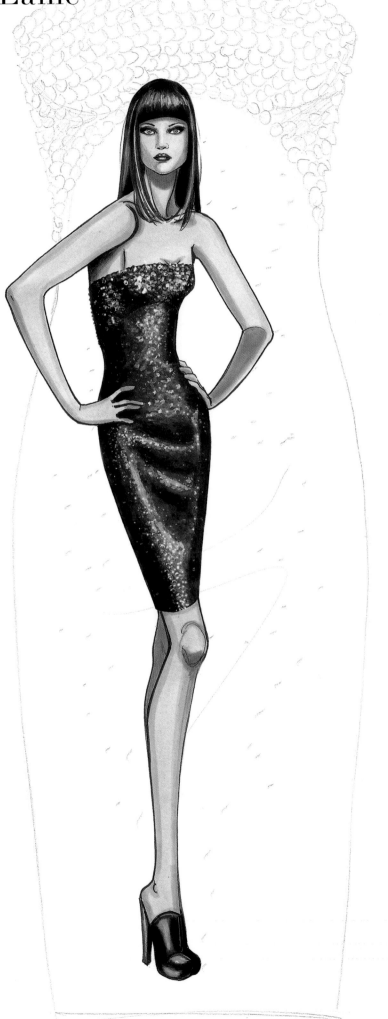

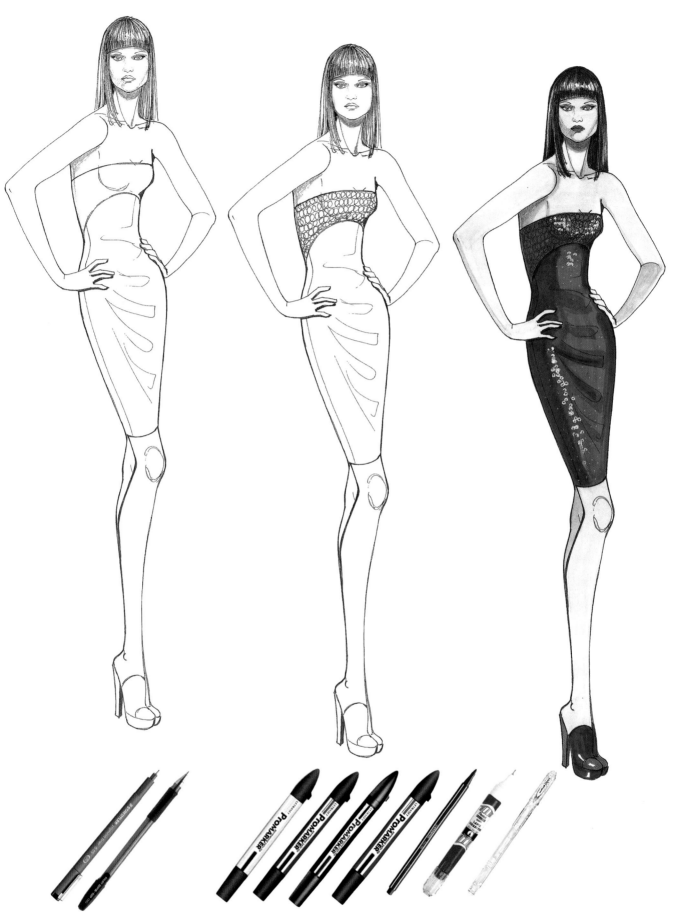

For the sequined bust of the dress, I used a ballpoint to do curlicues. I applied red and blue for the dress, shadowing the outlines and using a white corrector to make a lot of white dots along the central line of the leg and the contour of the breast. I applied other random dots on the rest of the garment. Then I distributed a few light dots on the rest of the dress using the point of a white pastel as well, or a pen with white ink with a finer point than the corrector.

Lurex and Sequins

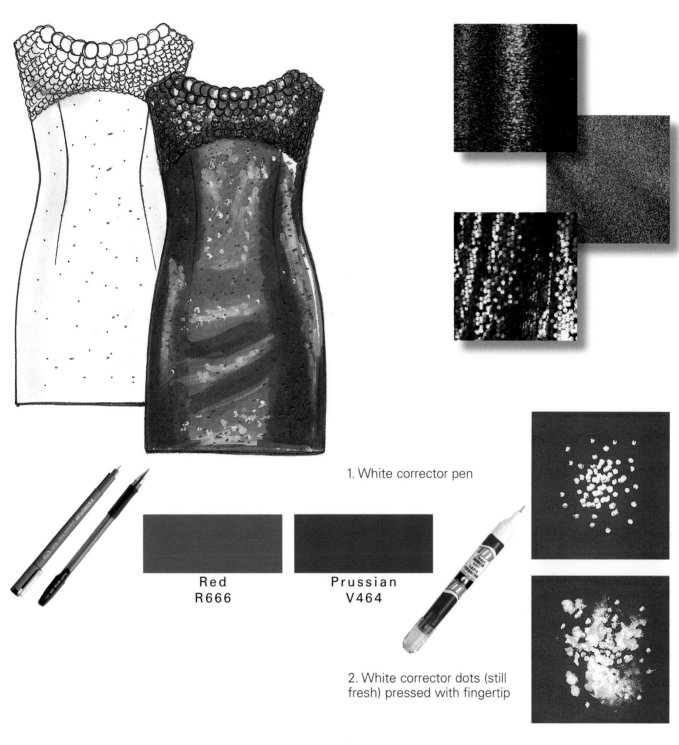

Red
R666

Prussian
V464

1. White corrector pen

2. White corrector dots (still fresh) pressed with fingertip

Sequins: Draw irregular circles with a ballpoint, little curlicues. Apply color, then apply shading and lighten randomly with white corrector dots. The dots should be thicker at the curve of the breast and the raised areas. For lighting effects on the sequins and the Lurex: I use a white corrector pen on the shinier areas, creating a mass of many fine dots (1) which I then immediately press lightly with

my fingertip (2) so that the ink which is still damp spreads and creates a blended effect. At the edges of this shiny spot I add scattered, small dots of light on the rest of the dress. In the shadowed areas the dots of light should be sparse and created using a finer point (a pen with white ink is perfect for this).

Gold

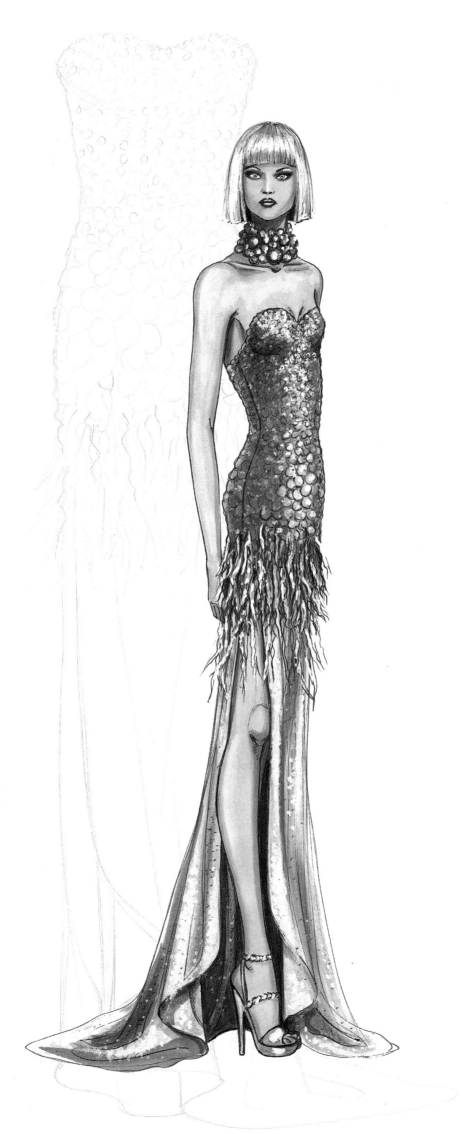

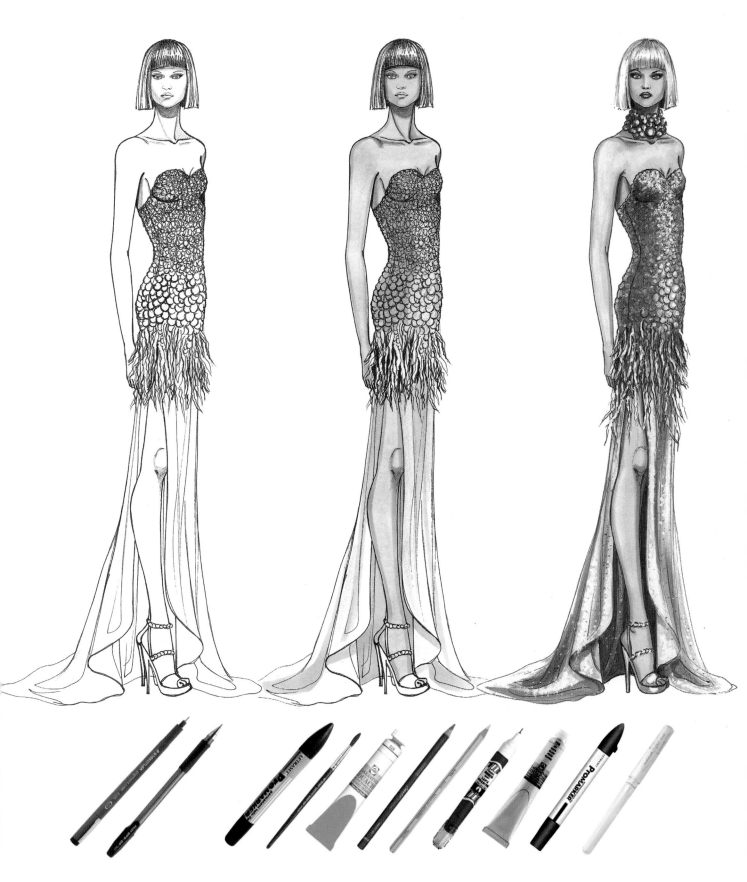

Color the skin. Apply the somewhat diluted gold tempera so that you can shadow it later, once it dries, with a hazelnut color pastel. If the tempera is thick, it will cover over the model and the details, making these difficult to see. You can go over some points with thicker tempera later, to give a richer tone. Furnish touches of light using a soft white pastel (or tempera) for the skirt and touches of corrector for the shinier parts of the bust (breast, etc.). Darken the feathered area in the lower torso of the dress which is more shadowed and to emphasize those in the foreground use a corrector on the wavy lines with small touches that fan out toward the outer part. I shadowed the outer part of the hair and the fullness of the bangs with grey Pantone and with a white tempera I applied the touches of light in the center.

Gold, Lamé

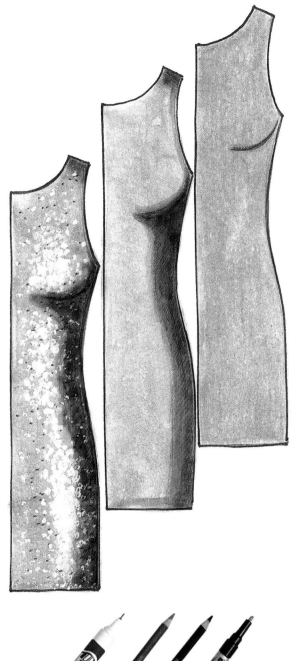

1. Corrector dots on a gold marker base.

2. The effect of still damp corrector pressed with the fingertip.

In this example, I have used a classic gold marker with a thick, rounded tip and I applied the color on the entire surface. When it was completely dry, I did the shadows under the bosom and on the hip using a dark hazelnut color pastel or a dark grey. With the tip of the corrector I dotted the raised areas of the bosom, pressing the still moist ink lightly and delicately with my fingertip. Add other corrector dots to defuse the effect, then scatter to lessen even more. The Pantone ink, applied directly onto the marker to create shadowing, does not take well, but if you use a pastel to provide shadow beforehand, you can apply it to create a stronger contrast.

Net, Feathers

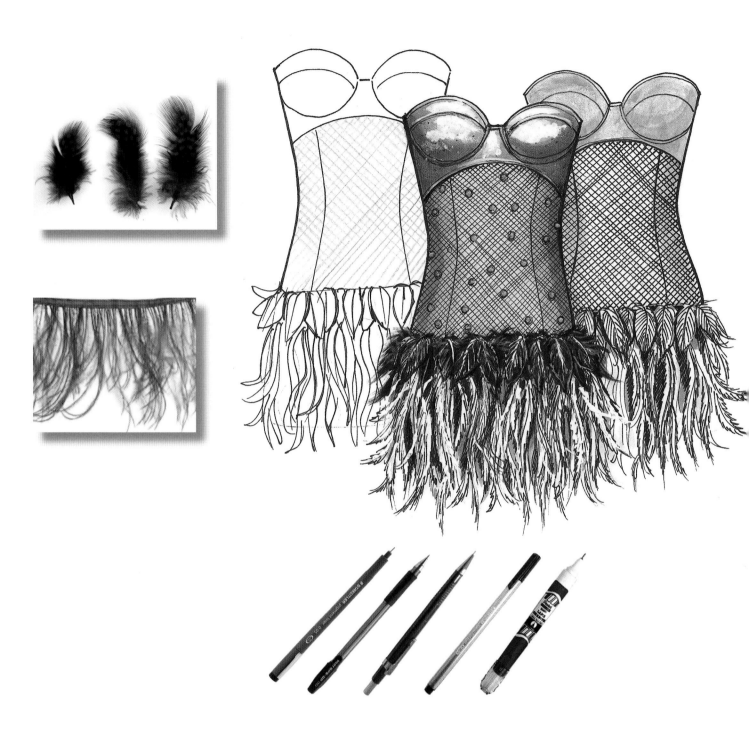

For the net, use a fine-tip ballpoint. Draw the grill only after you have colored and shadowed the skin because the ink from the ballpoint can change and spread when it comes in contact with the Pantone color and ruin the drawing.

If on the other hand you use a marker with a very fine point like the Staedtler Pigment Liner 0.05, you'll have no problems and will be able to draw before coloring. I prefer using a ballpoint because the lines are more clear and delicate than those produced by a marker. When you have finished coloring, create a light grid of diagonal lines to make very small rhombi. If the grid is thick, it's good to use a brush. The feathers: Draw the feathers; darken the inside areas and shadows in black marker. Use a grey marker to shadow for volume and depth. With tempera or corrector, trace wavy vertical lines as little fringes that blend somewhat.

Metal

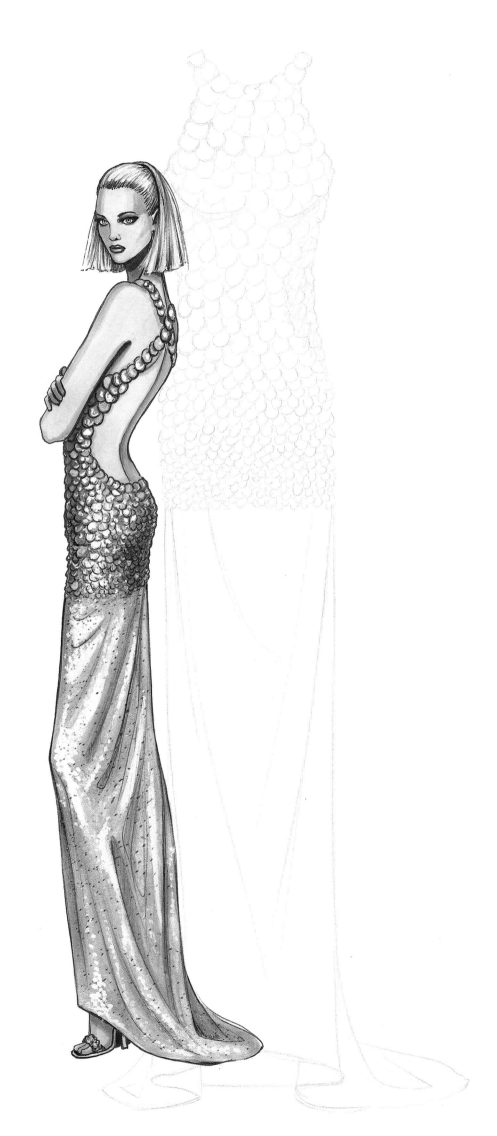

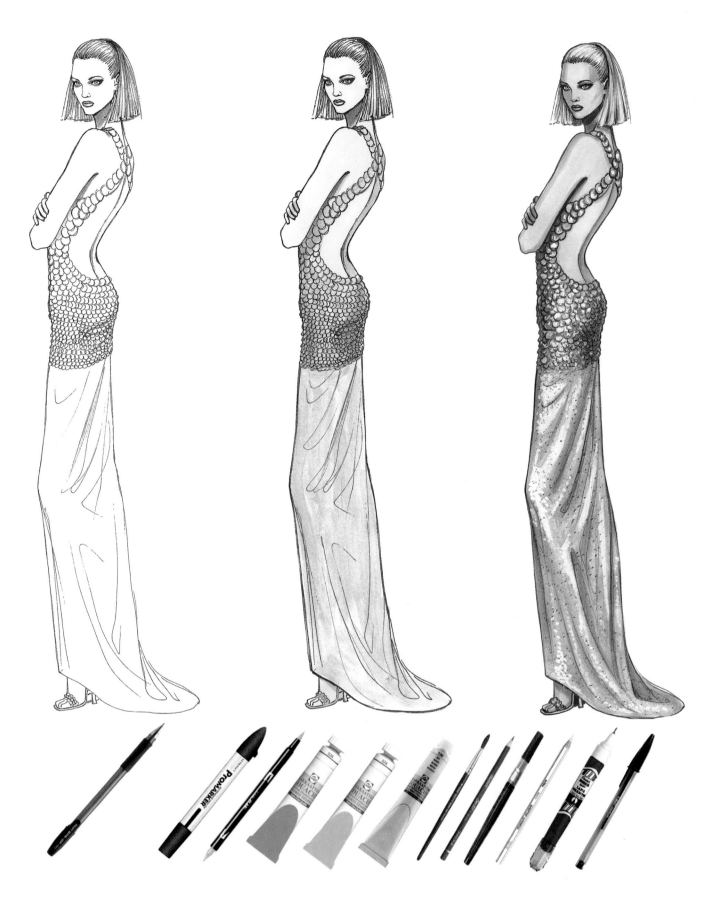

Go over the figure with a fine black marker. Apply Pantone flesh tones and at the bottom of the gown use a well diluted tempera gold and silver. Begin shadowing the gown when the tempera is fully dry, using a pastel. Define details with shadowing for the skin (Tombow 990 or 992). Use a clear grey Pantone to blend the hair and brighten it

with white tempera. Define the contrasts in the metal carefully, using a dark grey pastel for the shadows of the folds. Dot the bottom lightly with a ballpoint. Use white pastel to highlight the light areas, reinforced with touches of white tempera. In the shinier areas use touches of corrector thickly dotted and scattered on the rest of the gown.

Metal

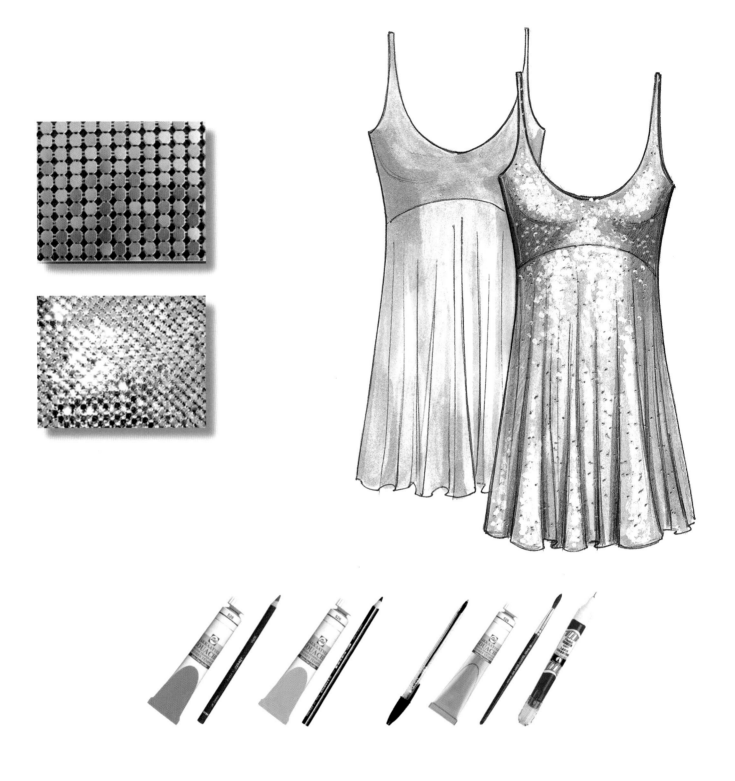

The concept is the same as that described for gold. Apply a well diluted gold tempera base (I use Royal Talens Light Gold 802) and silver (Royal Talens Silver 800). A marker can also be used, if you like. On the dry gold, use a dark hazel color pastel and secondly a Sandstone Pantone. Pastel or a dark grey marker can be used for the silver. Dot lightly using the tip of a ballpoint and a corrector for the lighter areas. Illuminate the movement of the fabric with a white soft point pastel. In the especially luminous areas, dot thickly with a corrector and press with fingertip before it dries.

Transparencies

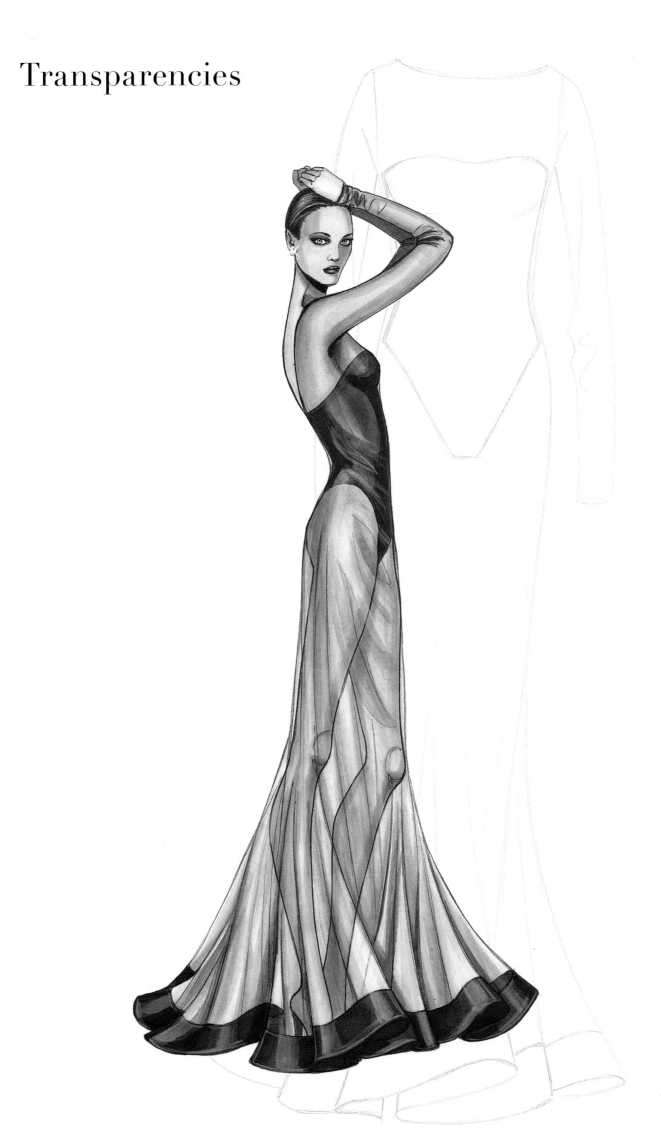

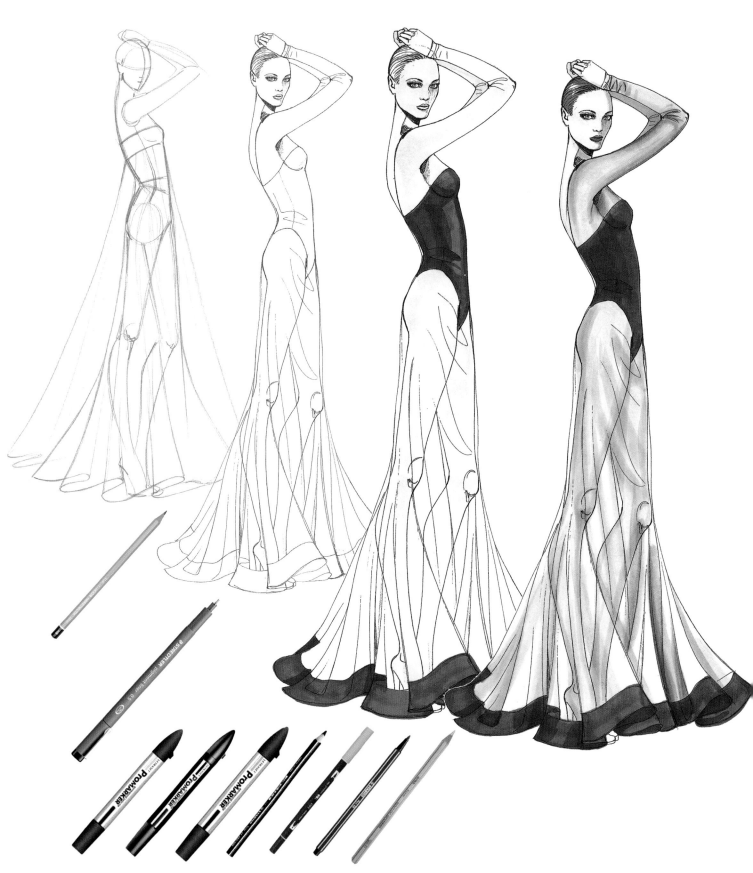

After tracing the entire figure including the transparent parts of the body, color the skin base and apply shadowing immediately. Use a Pantone black for the body and the border of the garment, and a clear grey Pantone in the chiffon areas. To shadow the chiffon, use a dark or black pastel, somewhat thicker on the edges of the arms or the body and blend it with a slightly lighter touch working toward the inside and along the pleats that form at the elbows. Lightly blend the folds of the skirt as well with a black pastel where the fabric is superimposed and creates layers. To give a more fluid and softer highlight to the shadowed parts, use a clear grey Tombow or a well diluted Pentel Color Brush.

126

Transparent Fabrics (Chiffon)

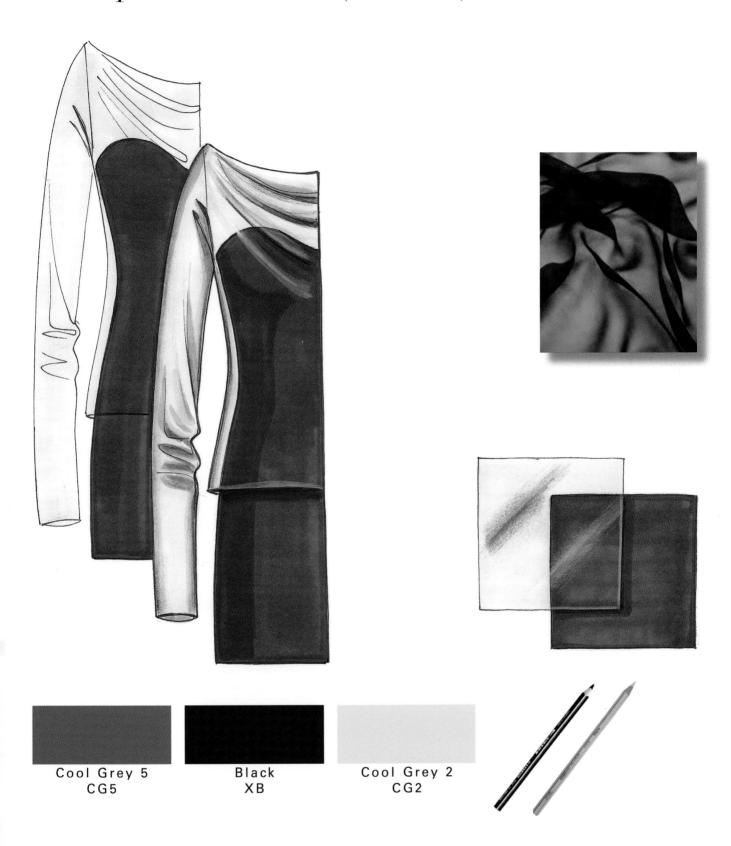

Cool Grey 5 CG5	Black XB	Cool Grey 2 CG2

To achieve a transparent effect on a black base, blend the raised areas with a dry white pastel for the movement of the fabric (wrinkles and pleats) superimposed on the black base. Go over the borders and contours of the details (the hemline, the raised lines of the folds, seams, etc.). If the transparency occurs on a nude area, a touch of black pastel along the body's contour will do, blended lightly inward. Dry white pastel will do for the points of light.

In the box, note that the pastel, more or less thickened, creates the transparency.

Rhinestone Embroidery

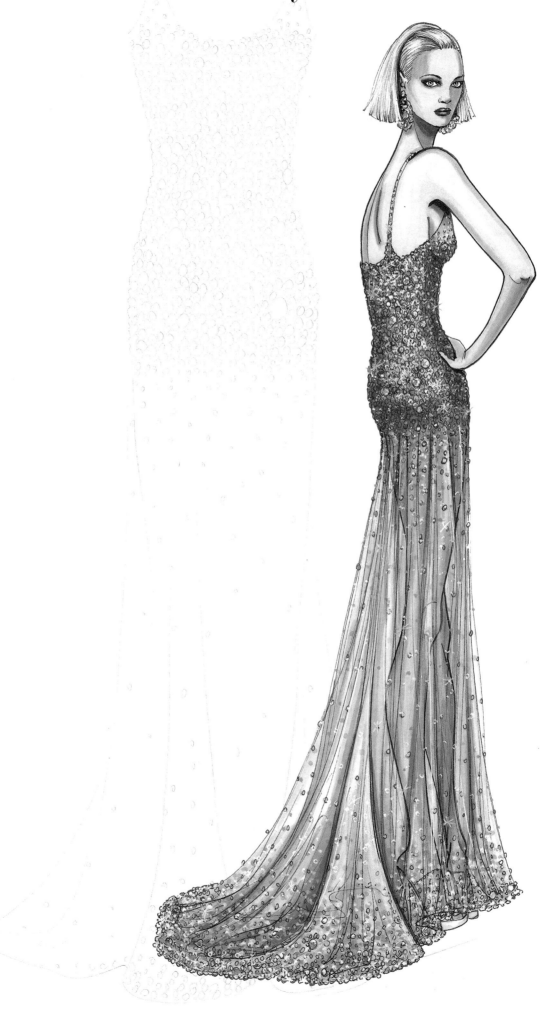

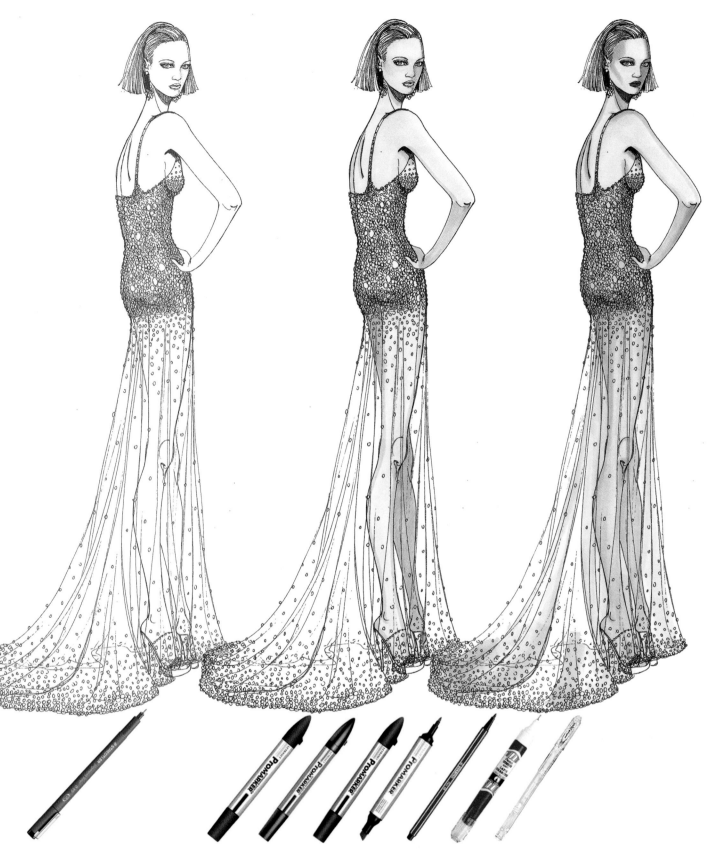

I chose an embroidery pattern with several larger stones scattered throughout, surrounded by lesser stones and the rest in small stones. With a very fine marker, trace scattered, irregular curlicues on the body of the gown. On the skirt itself trace scattered small circles. Fill the edge of this embroidery close to the body with small circles, blending upward as they diminish in size and number. Color the skin, including the legs which should remain covered by the (transparent) skirt but outlined in a pronounced shadow because they will be covered by the color of the garment and therefore must nonetheless be visible through the fabric. Apply the lavender color on the inside of the gown (including the legs), using the same Pantone for shadowing and using grey also for the shadow created between the pleats. Add luminosity on the garment in general with a white pastel and touches of rhinestone with a corrector.

Rhinestone Embroidery

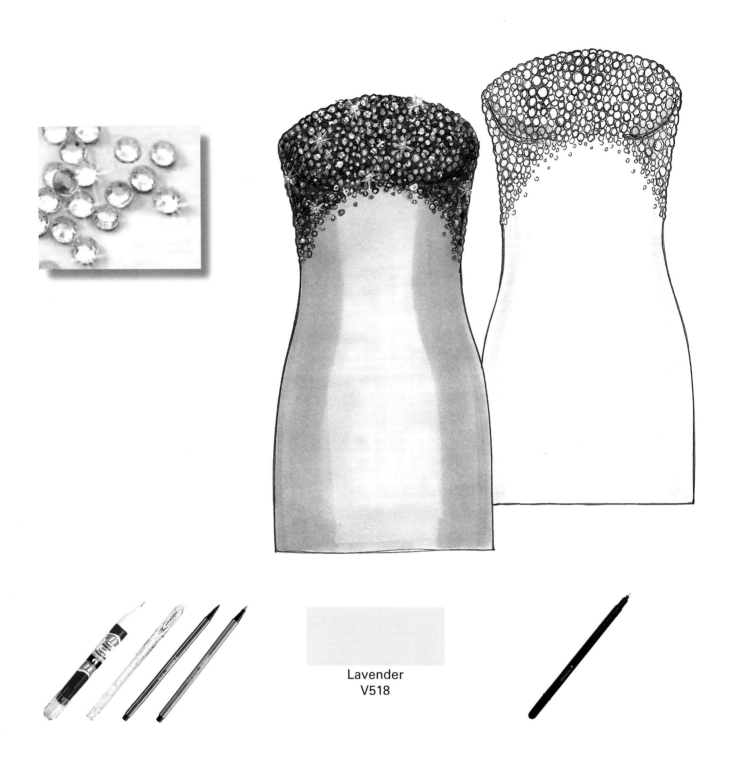

Lavender
V518

After applying the base color, concentrate on the depth of the embroidery using a fine point darker color Pantone to dot several stones and create contrast and depth. If you are using a lavender base color and want some scattered pink stones in the embroidery, create little white dots with a corrector and later color these with a pink marker. After you have shadowed and darkened some of the stones, make thick dots with corrector in the lighter areas and create a few scattered over the reset of the embroidery. You can also create small stars by using a white ink pen to make asterisks to create the effect of glitter here and there. If the white pen or the corrector suddenly runs out of ink, use the point of a small brush dipped in fairly thick white tempera.

Embroidery

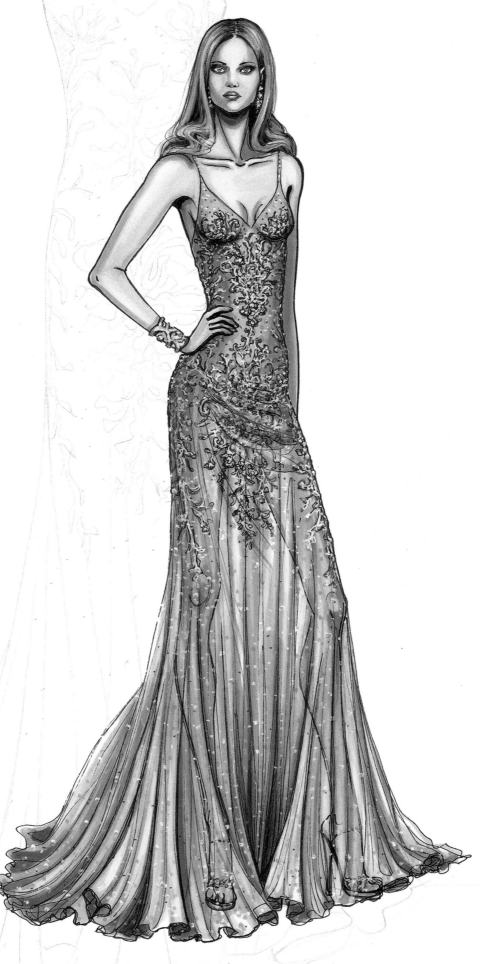

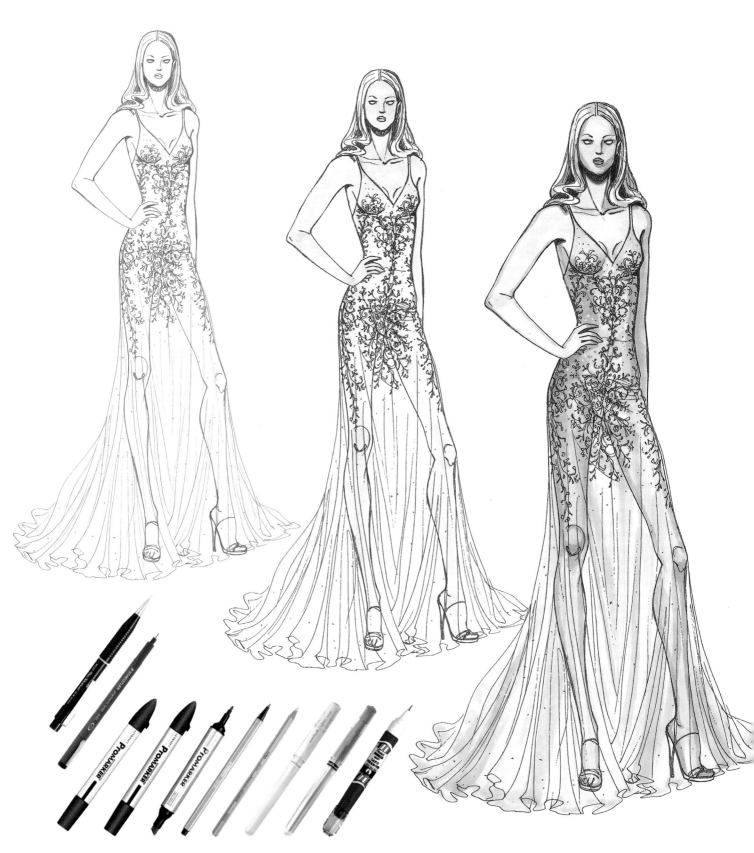

These drawings show lace embroidery with scattered light on a light, transparent background. First, make a pencil drawing of the embroidery; you can refine the details when you go over it with a marker. Color the skin, including the legs, and shadow them immediately. Wait until the Pantone base is thoroughly dry and apply pink Pantone to the gown, including the legs. Then shadow the gown in the same pink color, using a darker pink for the contrasting areas. Also use it to darken the interior parts of the embroidery with a Pantone Tria very fine tip; Stabilos work well also (it depends on the degrees of color available for these different products). Use corrector dots for the stronger light and a white pen for the smaller spots of light. Here and there apply dots with a silver pen. The same technique works for the embroidery on the sandals. Finish up by applying white pastel to add a touch of light for the movement of the skirt.

Embroidery

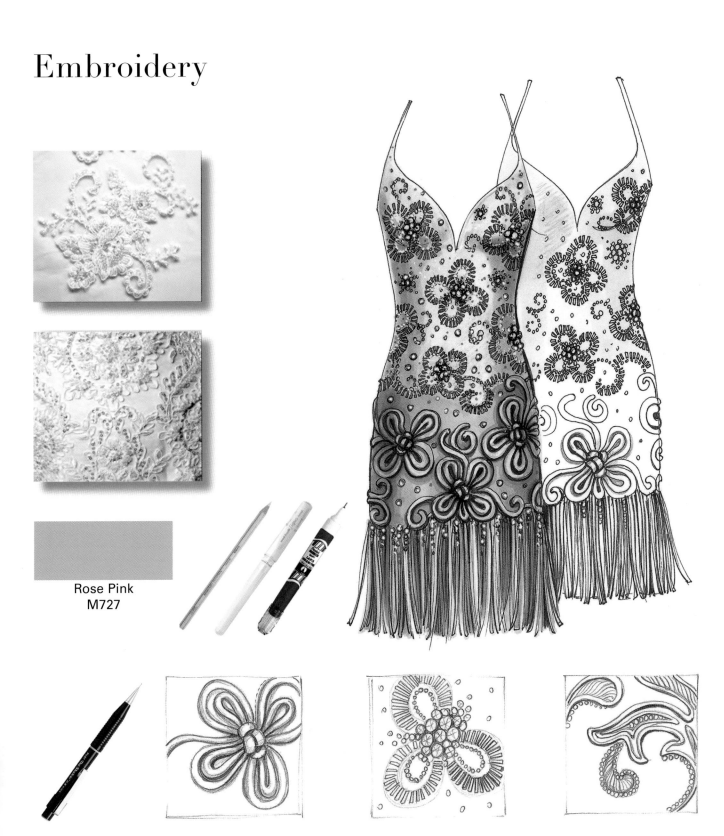

Rose Pink
M727

Color the upper areas of skin because the embroidered fabric is transparent, and accent the blended color using pastel. With a Pantone pink, color the skirt and the fringe, and with fine point markers color the embroidery. First shadow the darker areas of the stones with a dark marker (between one stone and another create a shadow area and fill it so that it heightens the effect of the stone), which you can ultimately lighten with a touch of corrector, white pen or tempera. A – Place the embroidery design in the center (meaning the embroidery with fewer stones) and surround it with a floral motif with glass-stemmed petals on a transparent background. B –In the second embroidery sample, made with fabric to recreate a flower with petals composed of sewn-on bean- shapes), tufting is the key. Apply color everywhere and shadow the contours to provide roundness and depth, and a touch of pastel for lighting along the outline which stays raised. For the fringe, use fine vertical lines more wavy in some spots than others to create a kind of movement that does not appear flat. Darken slightly the ones underneath and use a white pastel to trace several lines and brighten those above.

The Celebrities

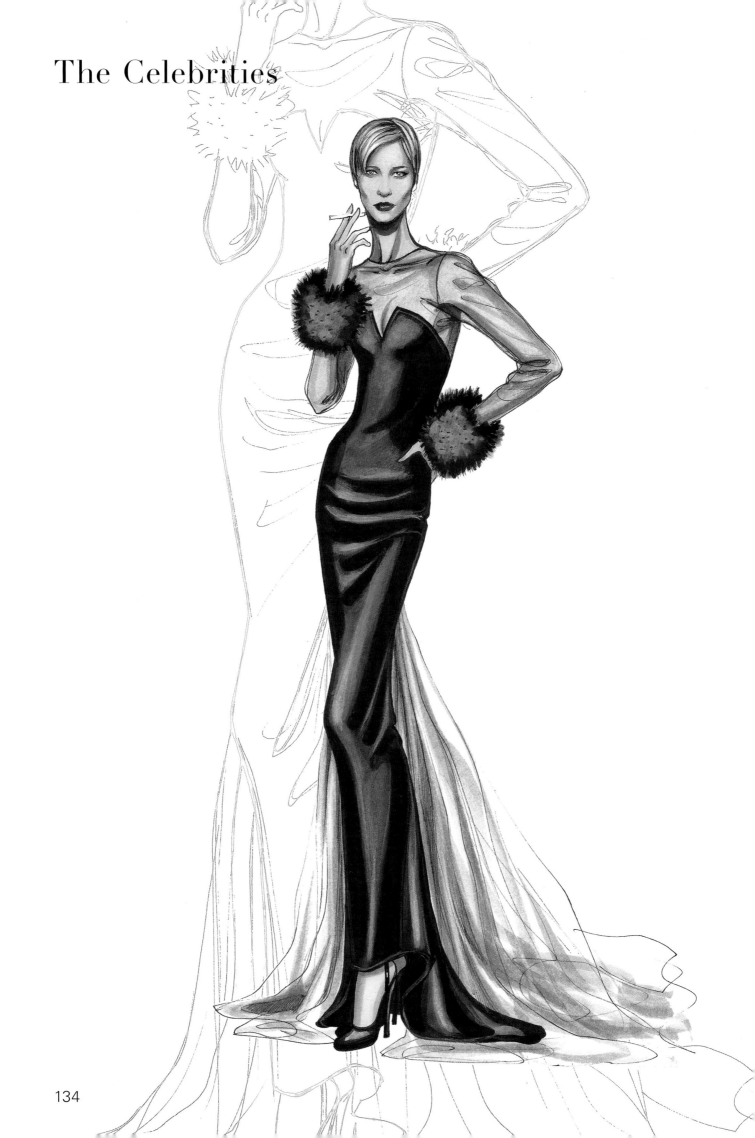

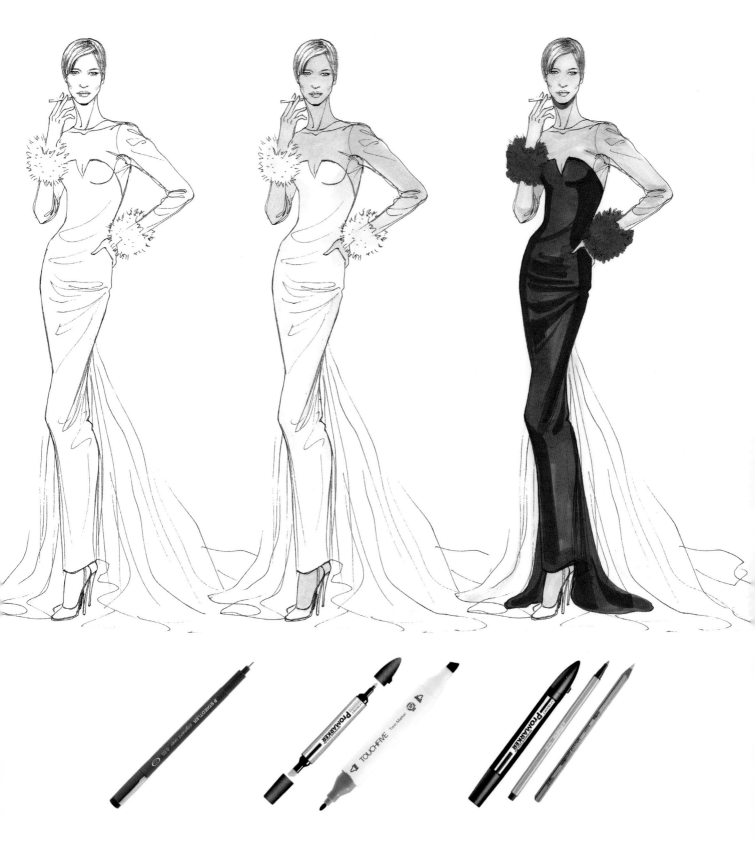

Usually one-of-a-kind gowns are made for a princess's wedding gown or a rock star or a Red Carpet gown for the Grammys or Oscar Night. It's fun to show the gown on the person for whom it has been designed: to excite both the designer and the recipient. I have chosen Cate Blanchett in this example. I looked for an image of her face that would be suitable (without any particular expression) and transformed it into b/w by photocopying, to obtain good graphic contrast. You can redesign faces free-hand using the photo to help with proportions and photocopying to reduce the image, following the same steps that I detailed in "Figurini in serie", or by directly photocopying the graphically refined photograph. But the effect of a "drawing" will be lost. This way we have the material ready for use whenever we need it and we can quickly reproduce it for different projects and variations with the subject we need to dress without losing precious time.

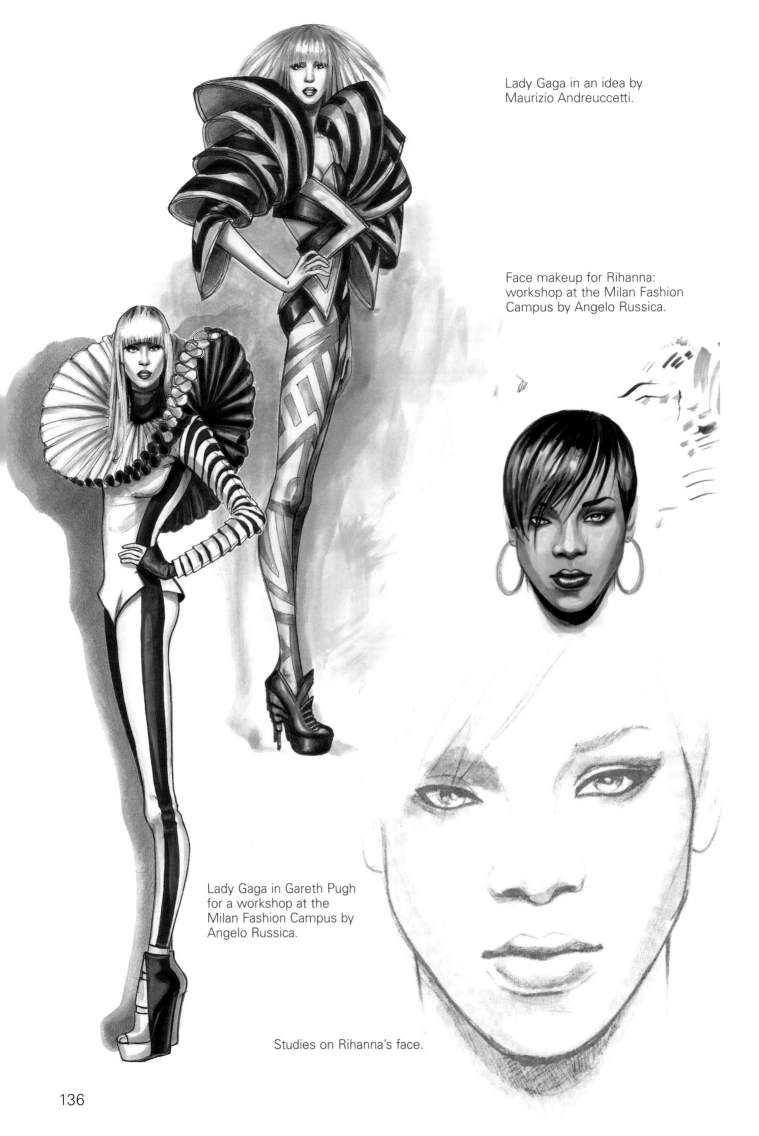

Lady Gaga in an idea by
Maurizio Andreuccetti.

Face makeup for Rihanna:
workshop at the Milan Fashion
Campus by Angelo Russica.

Lady Gaga in Gareth Pugh
for a workshop at the
Milan Fashion Campus by
Angelo Russica.

Studies on Rihanna's face.

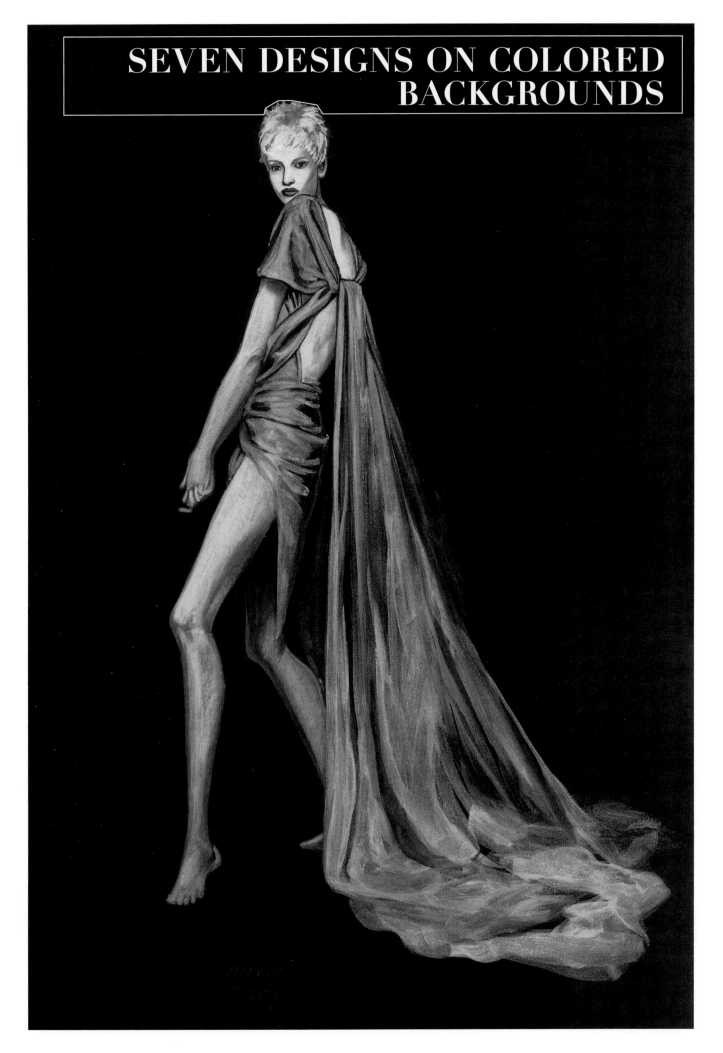

SEVEN DESIGNS ON COLORED BACKGROUNDS

Drawing on a Black Background

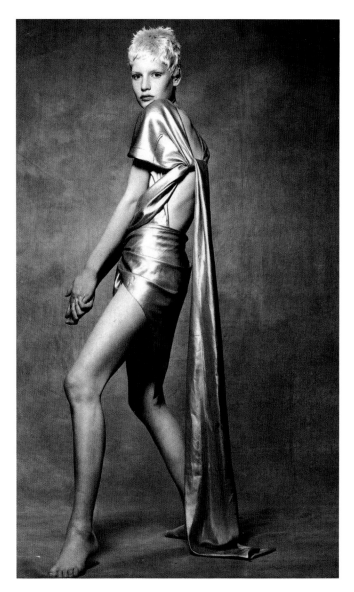 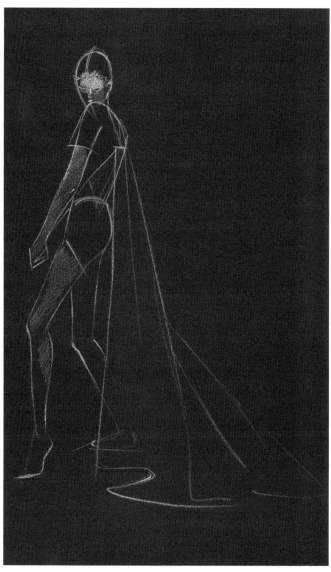

I took the subject for the pose from a good photo. In this case, I wanted to reproduce the gown as it was, for the pure pleasure of drawing it. Work free-hand in pencil on a sheet of black paper; trace the final contours of the figure with a dry white pastel. If you trace over with white pastel immediately instead of with pencil, it will be difficult to erase it or remove it successfully. But if you want to use a base you have already and which is ideal for reproducing the design on

a black background, trace again lightly on clear carbon paper (usually white or yellow) so that you have the proportions down quickly. Using a well-tempered white pastel, go over the figure removing very carefully and slowly the design left over on the carbon paper (just go over it with your fingertip and blend lightly). The white pastel becomes our pencil. To fill in the skin areas, go over the pastel first, lightly, and more thickly in spots that seem more visible and luminous.

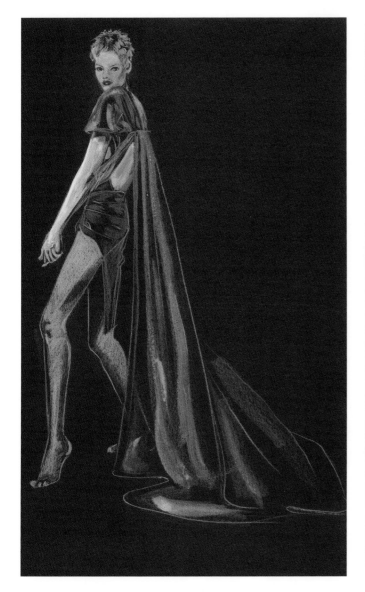 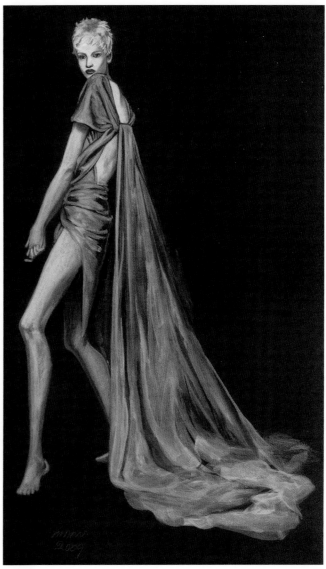

For the details: use white Tempera as you would pastel, that is, more diluted in the shadow areas and somewhat thicker in the lighter areas. Use a marker or ballpoint for better contour and detail. Go over shadow areas with a colored pencil or a skin-colored pen. Roughly and lightly outline the areas to be colored with a gold pastel to be gone over later with tempera. For other colors, the process is the same. Do not apply color flat and full on all surfaces, because it then becomes more difficult to apply light and shadow on the tempera if it is too thick. Try for a diluted touch and you can thicken it next time wherever you think necessary. Once the color has dried, use a fine-tip pen for finishing. If you use it lightly, it can be as light and easy to use as a pencil, while on thicker surfaces the shadowing is more effective.

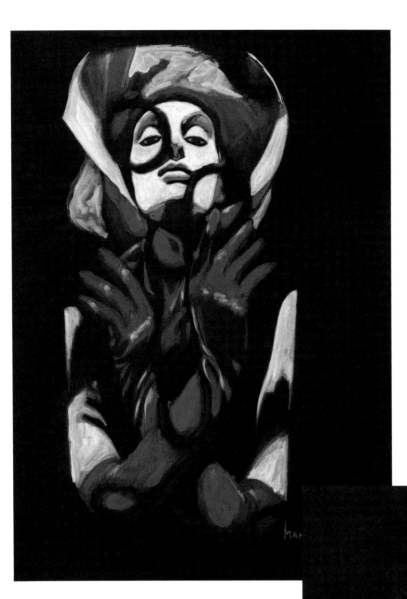

For the design on the facing page, I drew my inspiration from a photo that appeared in a past issue of Vogue. In the original black and white image, I especially liked Linda Evangelista's volumes, face and hairdo, all reproduced here free-hand on black cardboard. I changed only some smaller details and added colors using first a pastel base which I then enriched with a heavier tempera. The lighter areas of the jacket were created with rather diluted white tempera and applied to the still moist yellow base so as not to make the contrast too strong.

Tempera and pastel were used for the background spots.

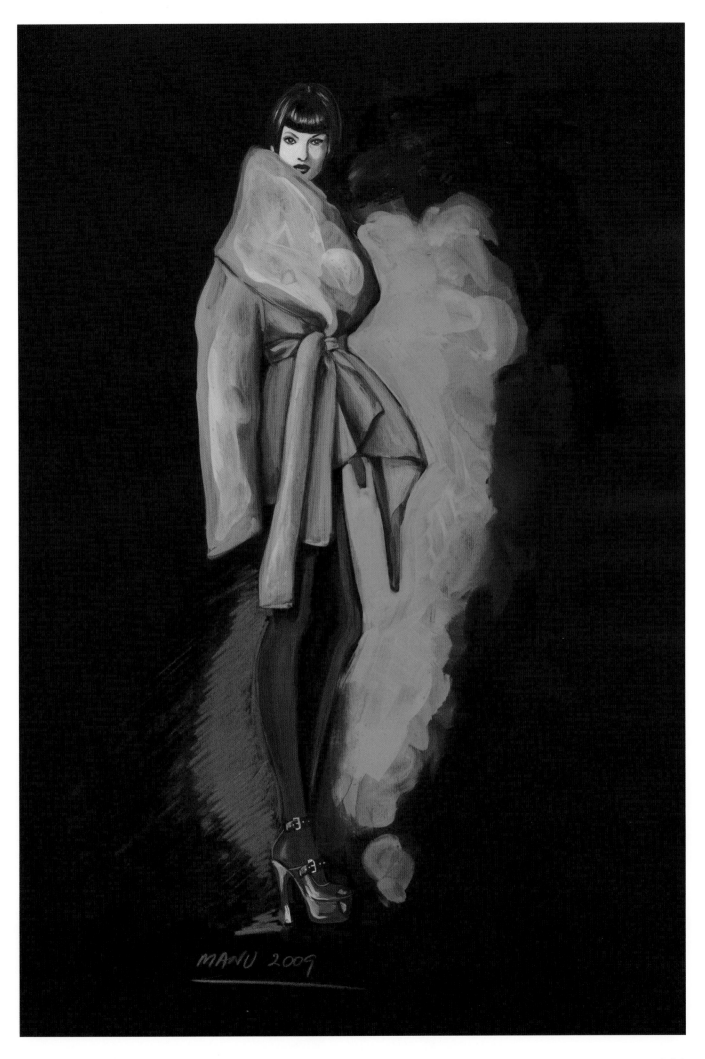

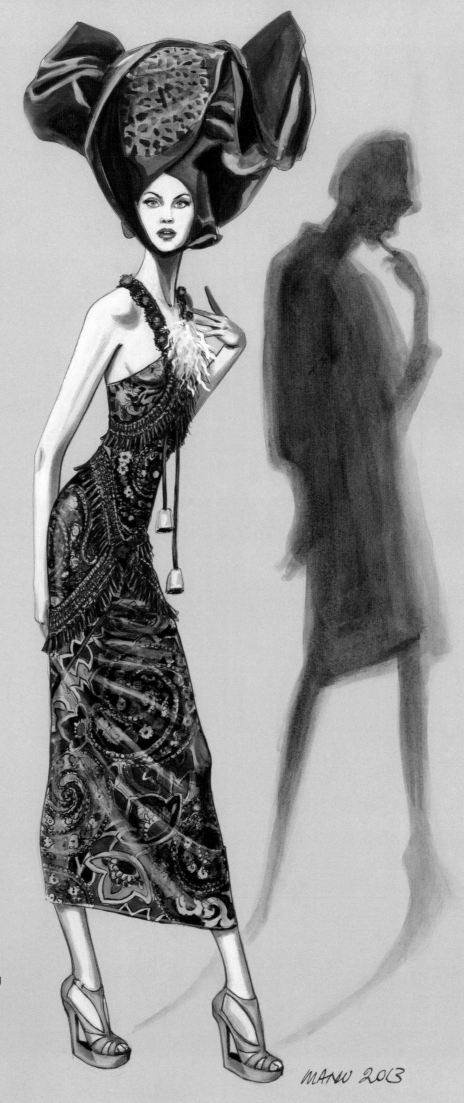

Jean Shrimpton wearing
Galliano, mixed media
on coloured pasteboard.
Pages 144 to 153 are
drawn using the same
technique.

MANU 2013

VIP'N'TAGE

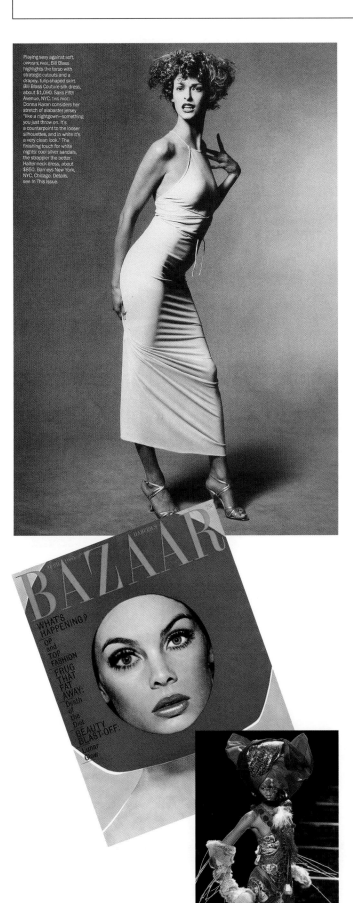

Playing sexy against soft, OPPOSITE PAGE, Bill Blass highlights the torso with strategic cutouts and a drapey, tulip-shaped skirt. Bill Blass Couture silk dress, about $1,090. Saks Fifth Avenue, NYC. THIS PAGE: Donna Karan considers her stretch of alabaster jersey "like a nightgown—something you just throw on. It's a counterpoint to the looser silhouettes, and in white it's a very clean look." The finishing touch for white nights: cool silver sandals, the strappier the better. Halter-neck dress, about $850. Barneys New York, NYC, Chicago. Details, see In This Issue.

For some time I had wanted to draw a series of plates using the faces of the great actresses of the past wearing clothes designed by modern designers. I can't remember how I wound up with mannequins instead, but the concept is the same because I used historic models. I wanted to see them in modern dress and creations of MacQueen, Galliano or Pugh offered the perfect stimulus for anyone who enjoys design. Inversely, the famous top models of the 80s wear the legendary clothes of High Fashion of the 40s, 50s, etc. I was looking for material for both the faces and the clothes, matching these on the basis of the poses I had available and wanted to use, fundamental elements that fed on my desire to design. Some faces were designed free-hand, for others I used the process I described on page 134 (Celebrities). For the design on colored cardboard see the issue of a black background; I used mostly white (pastel and tempera) for the skin coloring.

143

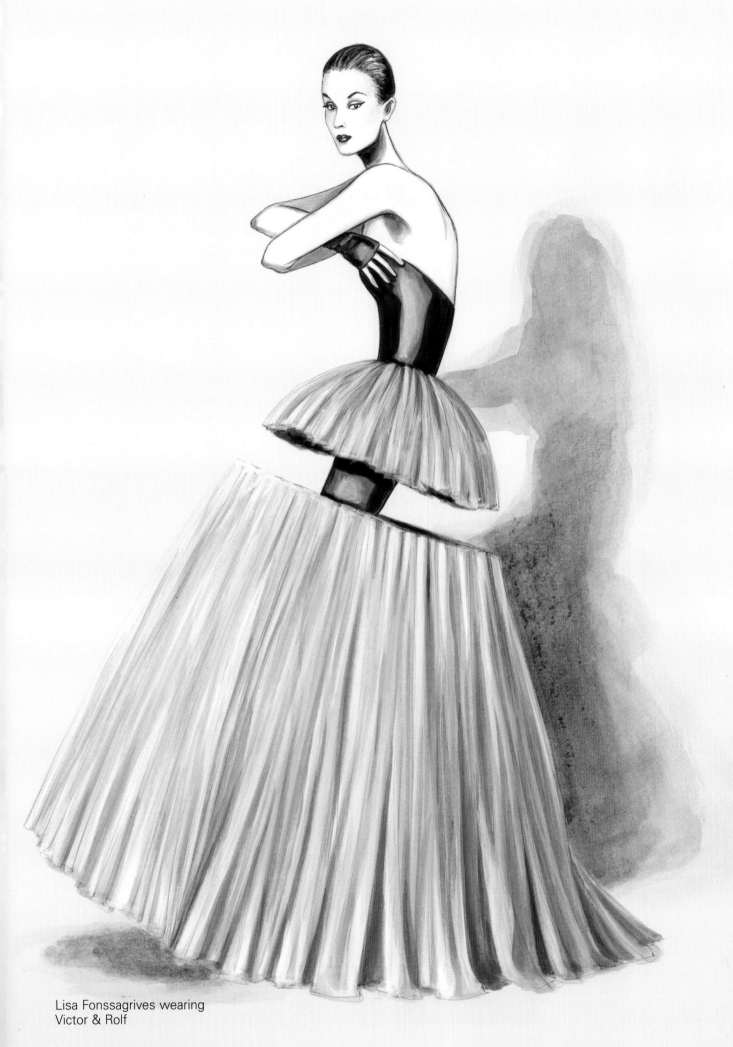

Lisa Fonssagrives wearing
Victor & Rolf

MANU 2013

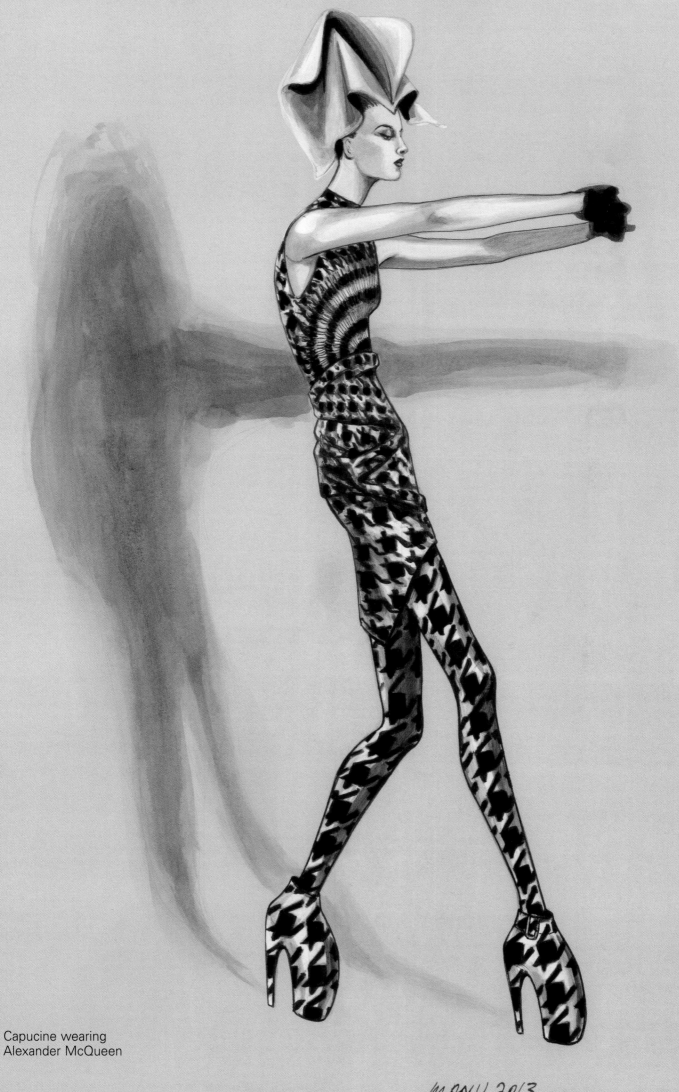

Capucine wearing
Alexander McQueen

MANU 2013

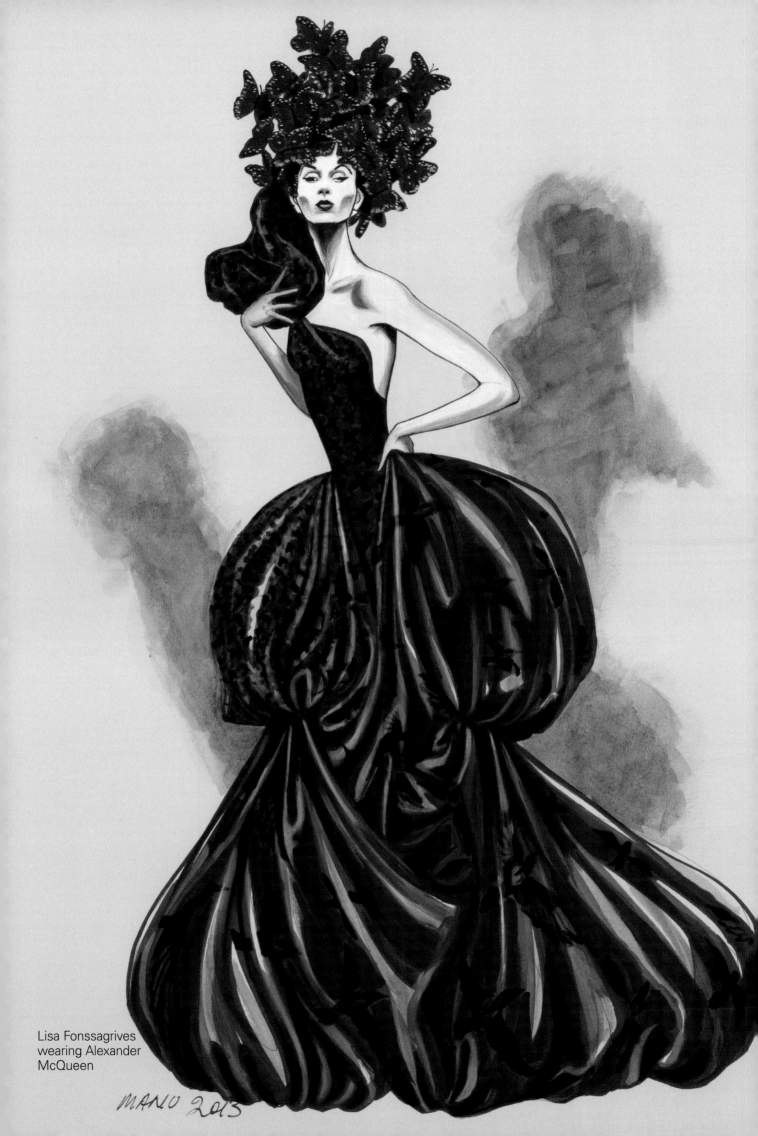

Lisa Fonssagrives
wearing Alexander
McQueen

MANU 2013

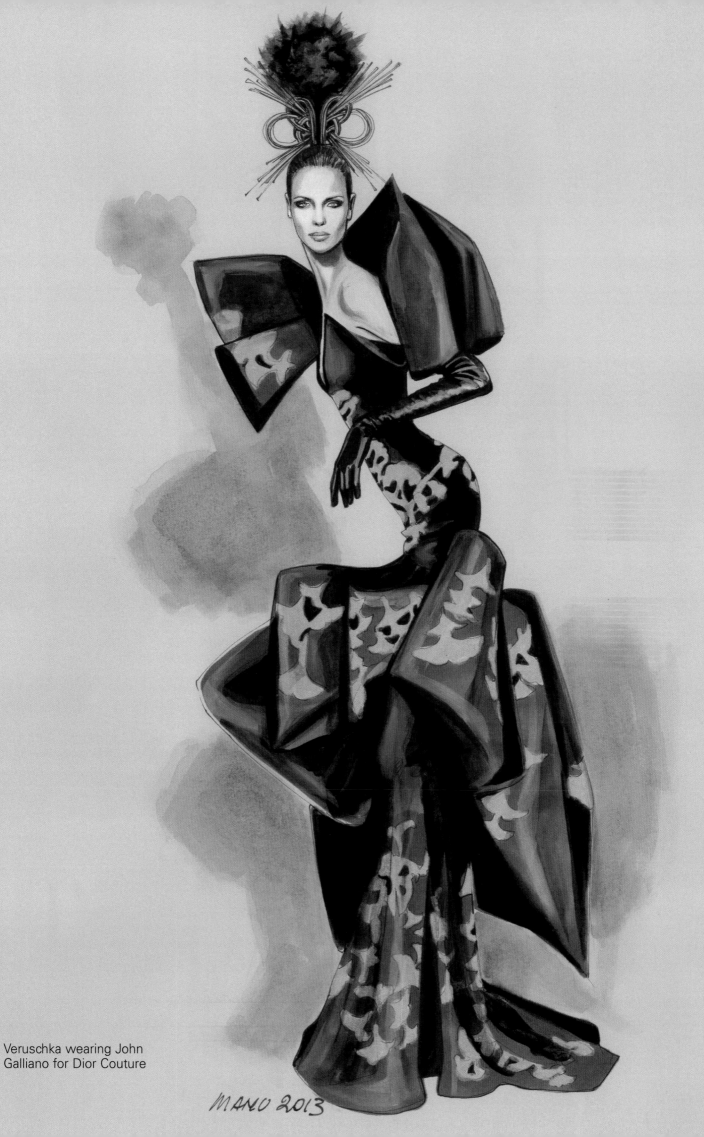

Veruschka wearing John
Galliano for Dior Couture

MANO 2013

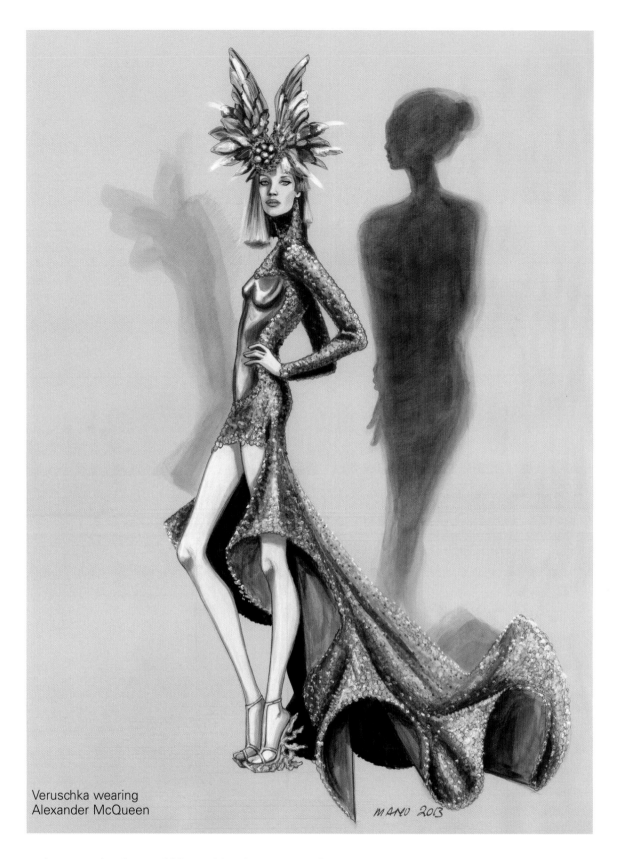

Veruschka wearing
Alexander McQueen

MANU 2013

Once you've got the face of Veruschka from one of her famous photos, reproduce it on a figurine base of colored cardboard combining two different gowns by designer Alexander McQueen. I like the body detail in the first and the long train in the second. Naturally every detail from the hairdo to the accessories is by the designer himself but re-assembled as you like. For the skin use a white pastel as base then go over with tempera in the more luminous parts and use a colored lead pencil for the shadowing. For the gown use a diluted gold tempera as base and once dry, apply shadow with a dark pastel and grey Tombow. Re-apply heavier gold tempera on the more external areas and do the body in a metal effect, illuminating it later with a white pastel and a touch of tempera. Finally, use a black marker to accentuate the embroidery and create glitter with a white pen. For the darker shadowed areas (curve of the shoulders, the arm extending backward in shadow) use slight ballpoint

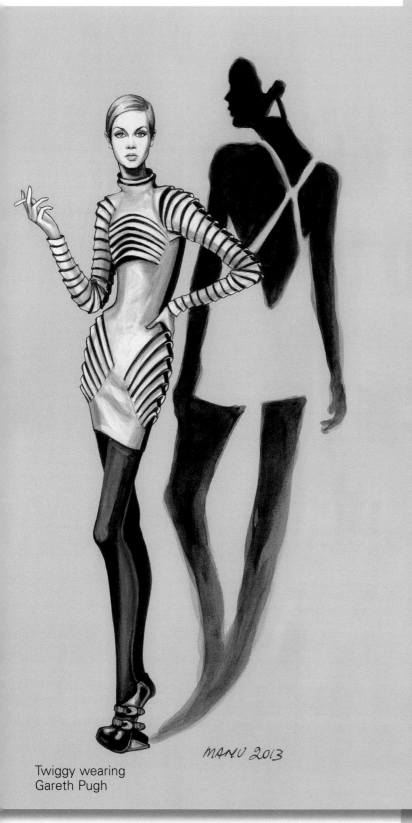

Twiggy wearing
Gareth Pugh

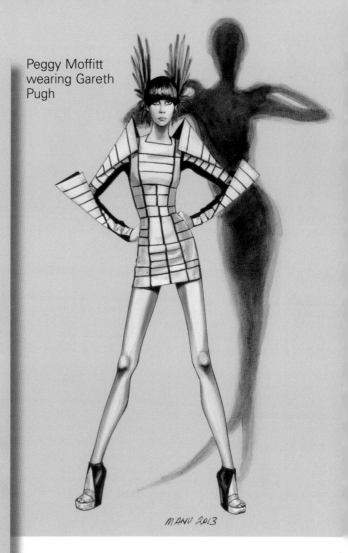

Peggy Moffitt
wearing Gareth
Pugh

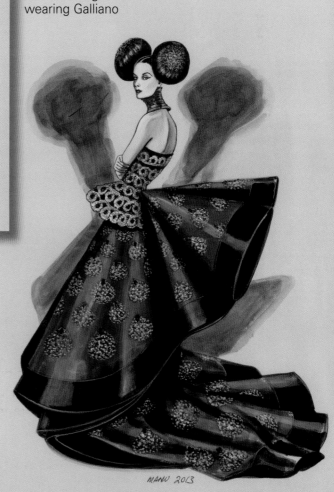

Lisa Fonssagrives
wearing Galliano

markings. The hairdo was first applied with a black marker, also used to fill in the shadow areas; a hint of color with a Pantone blend, touches of tempera. With a pencil, accentuate the outline of the shadow, filling it later with tempera. The shadow on the left is created with a much diluted black tempera and using a broad, round-tip pen. For the finer details of the footwear use a pen with silver ink.

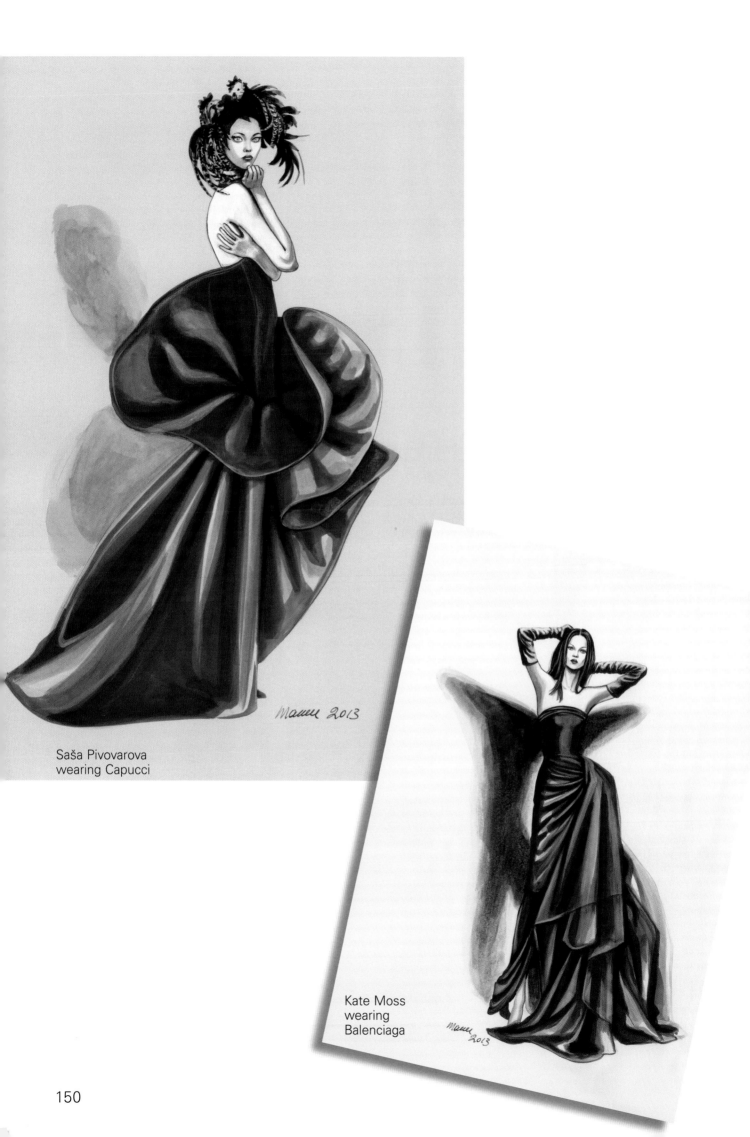

Saša Pivovarova
wearing Capucci

Kate Moss
wearing
Balenciaga

150

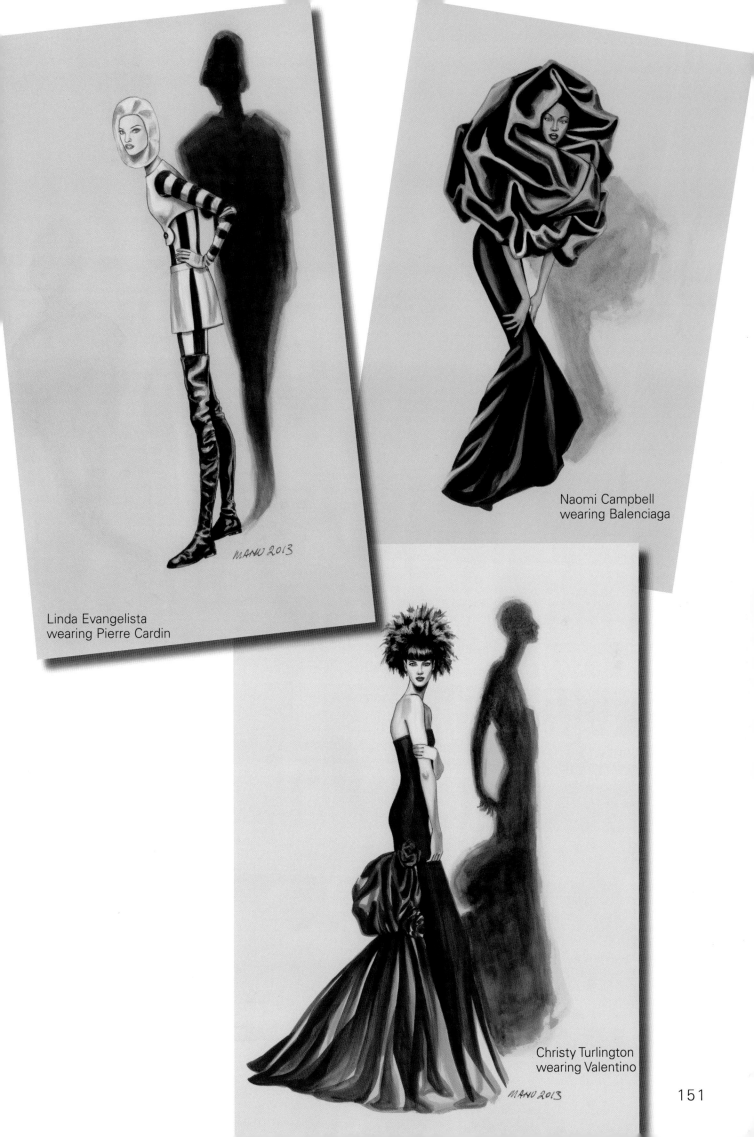

Linda Evangelista
wearing Pierre Cardin

MANU 2013

Naomi Campbell
wearing Balenciaga

Christy Turlington
wearing Valentino

MANU 2013

151

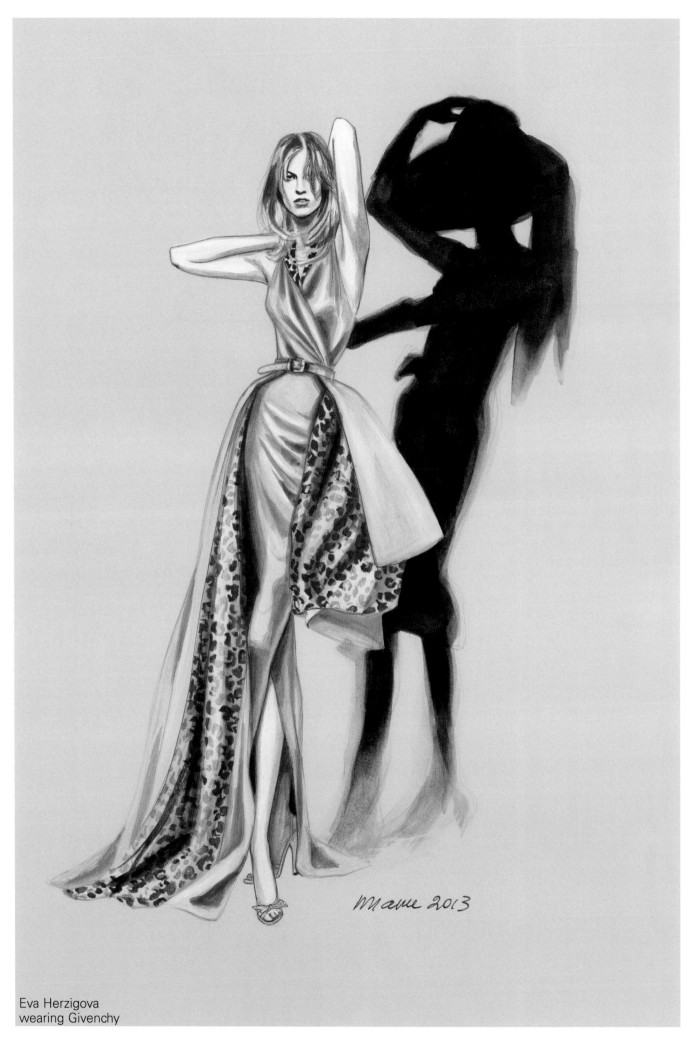

Eva Herzigova
wearing Givenchy

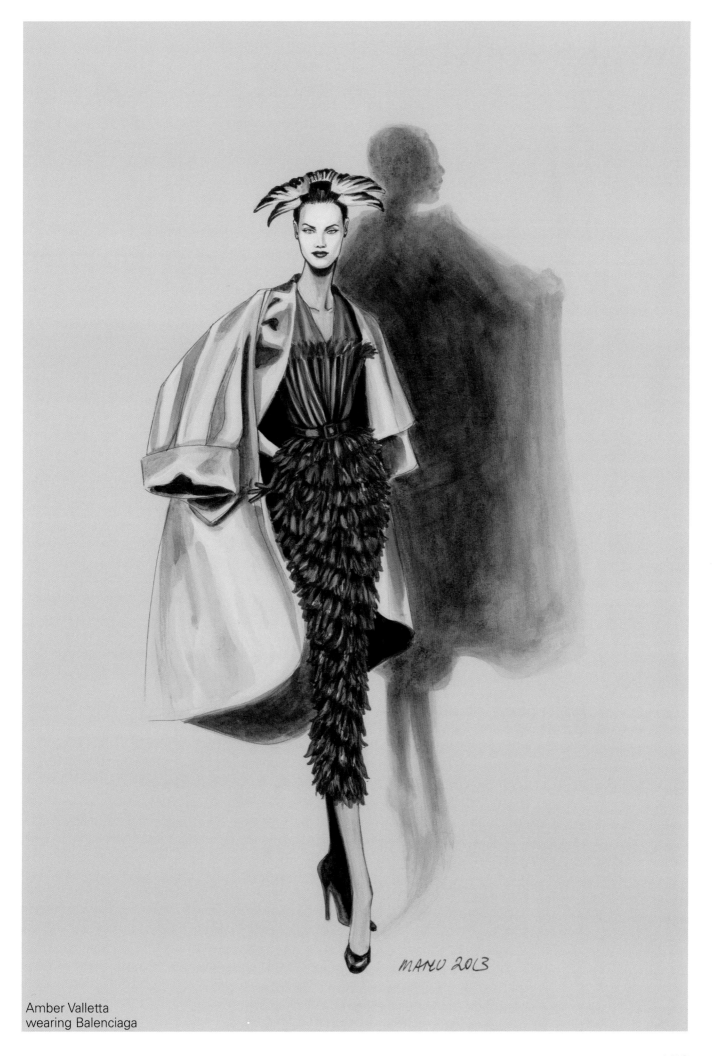

Amber Valletta
wearing Balenciaga

ACCESSORIES

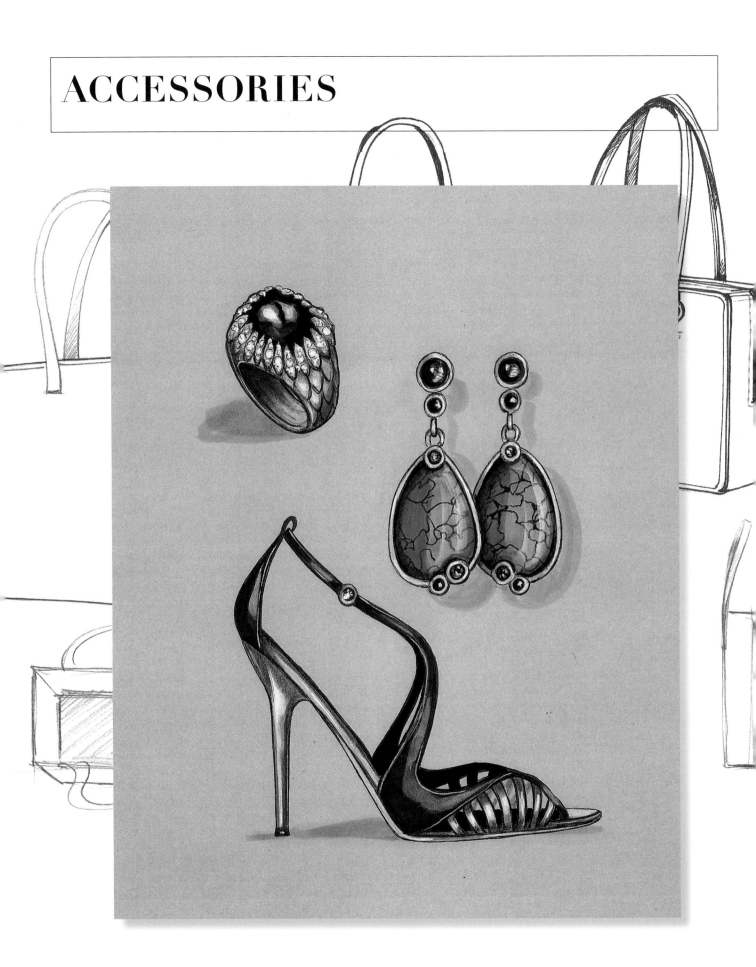

Initially, for these plates I reproduced accessories from different sources (books and magazines), adding new ones or designing them as I liked. They are for the most part 'illustrations' to keep my hand in training.

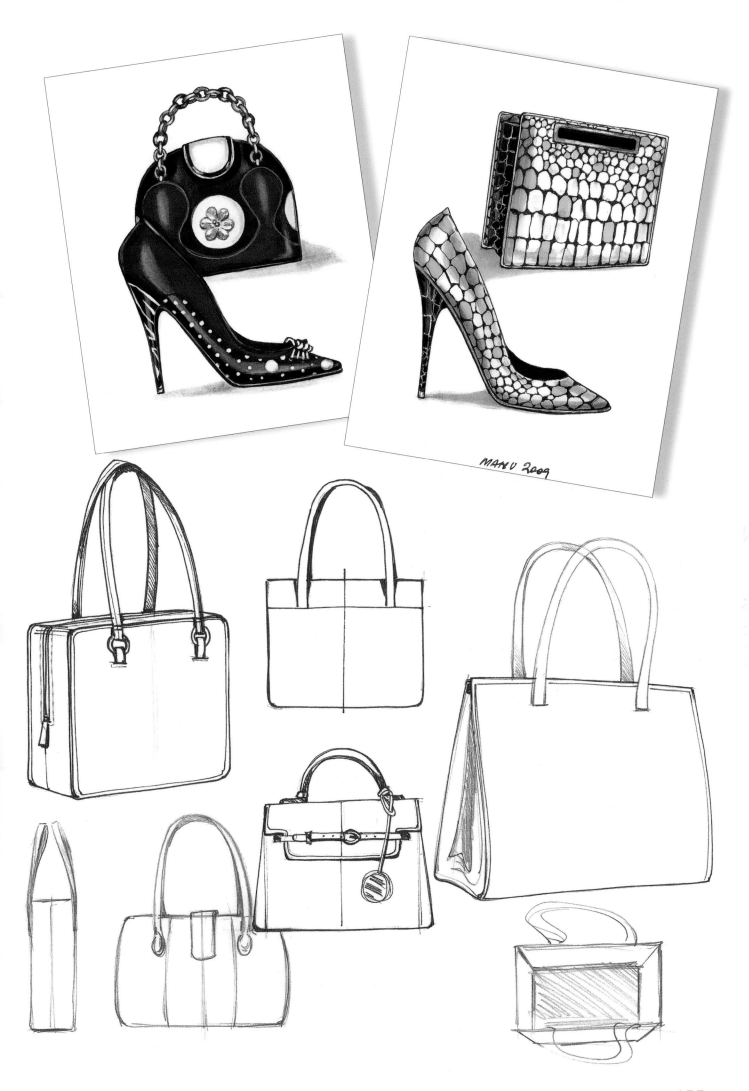

MANU 2009

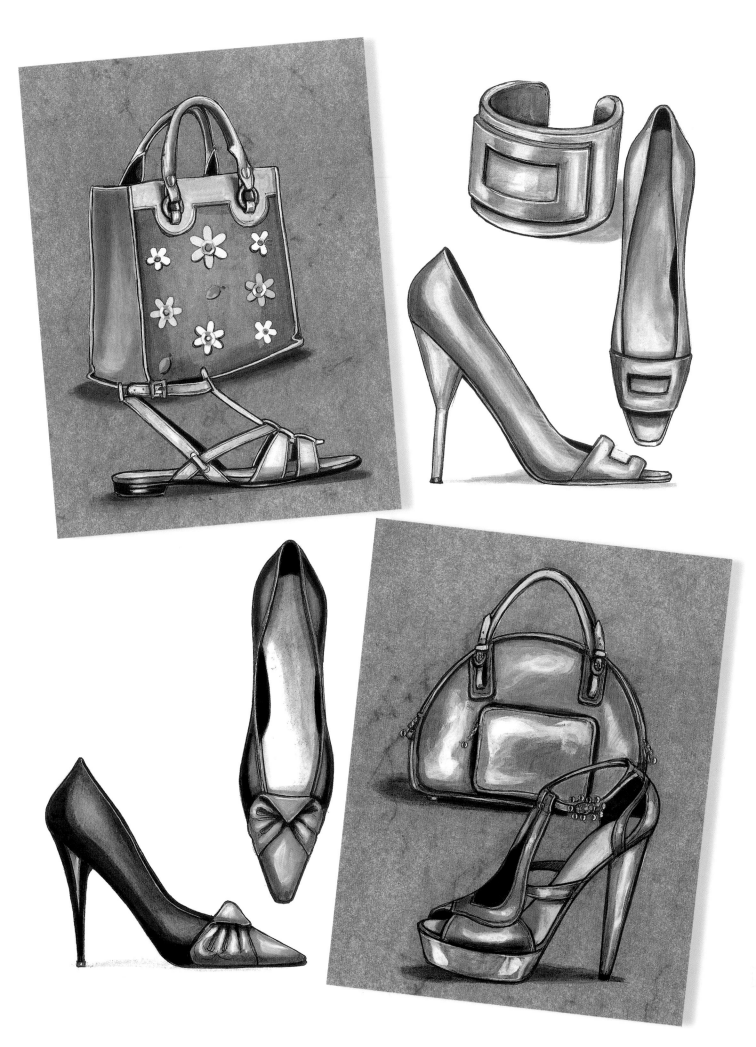

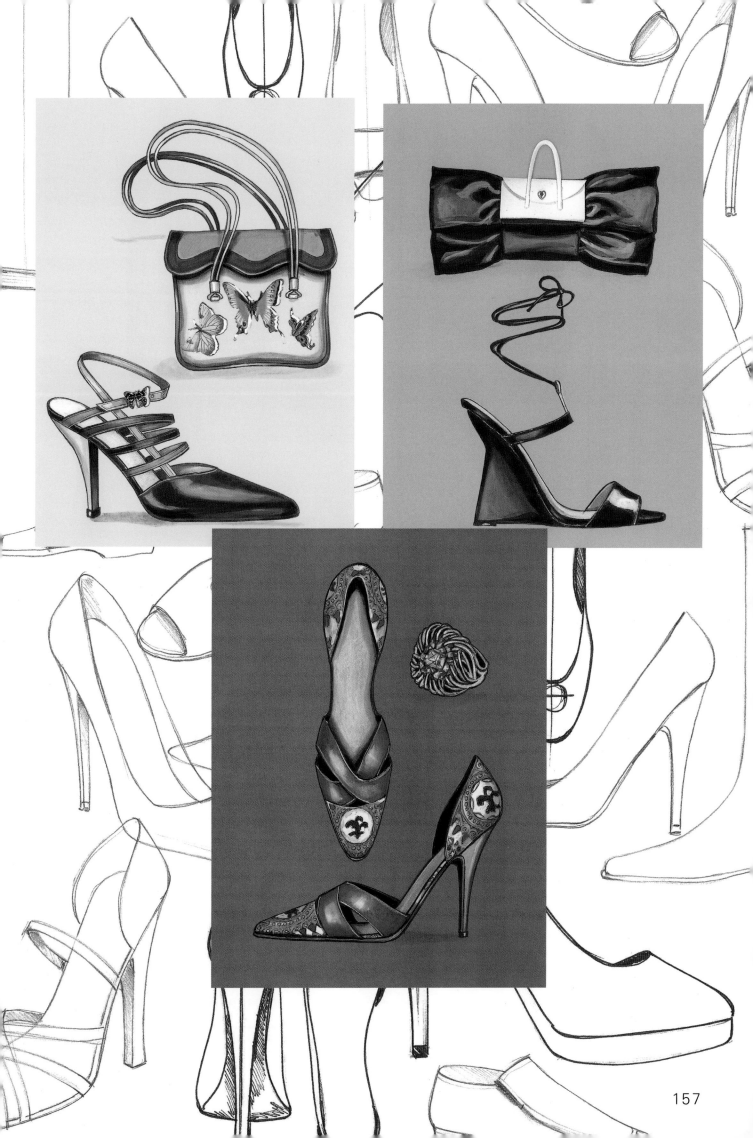

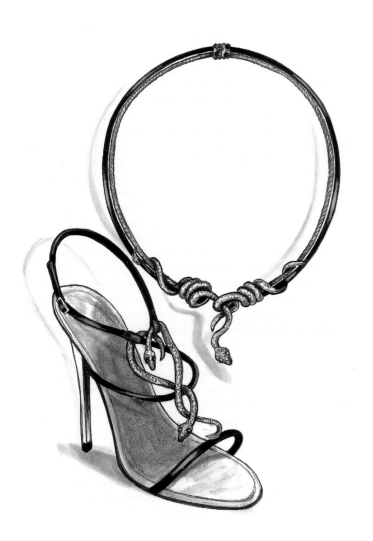

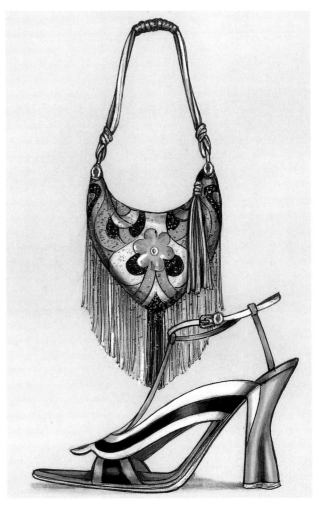

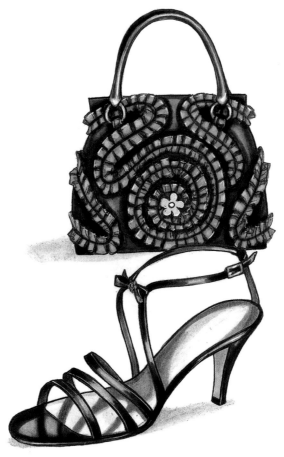

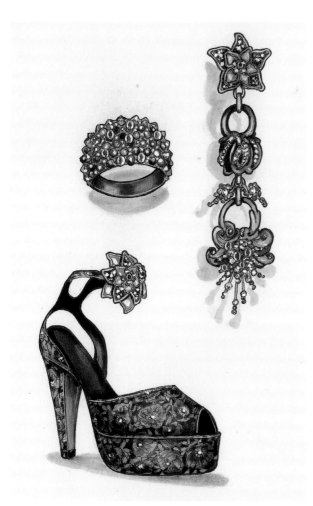

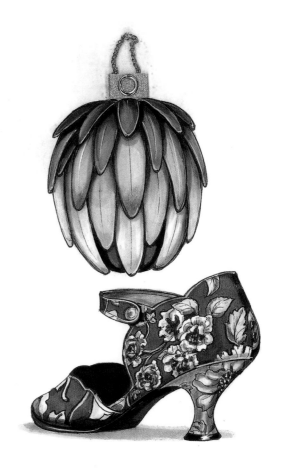

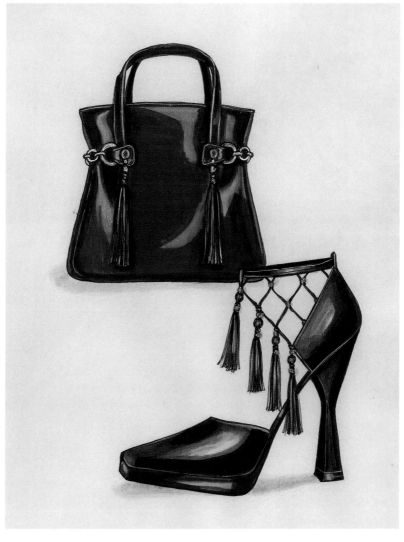

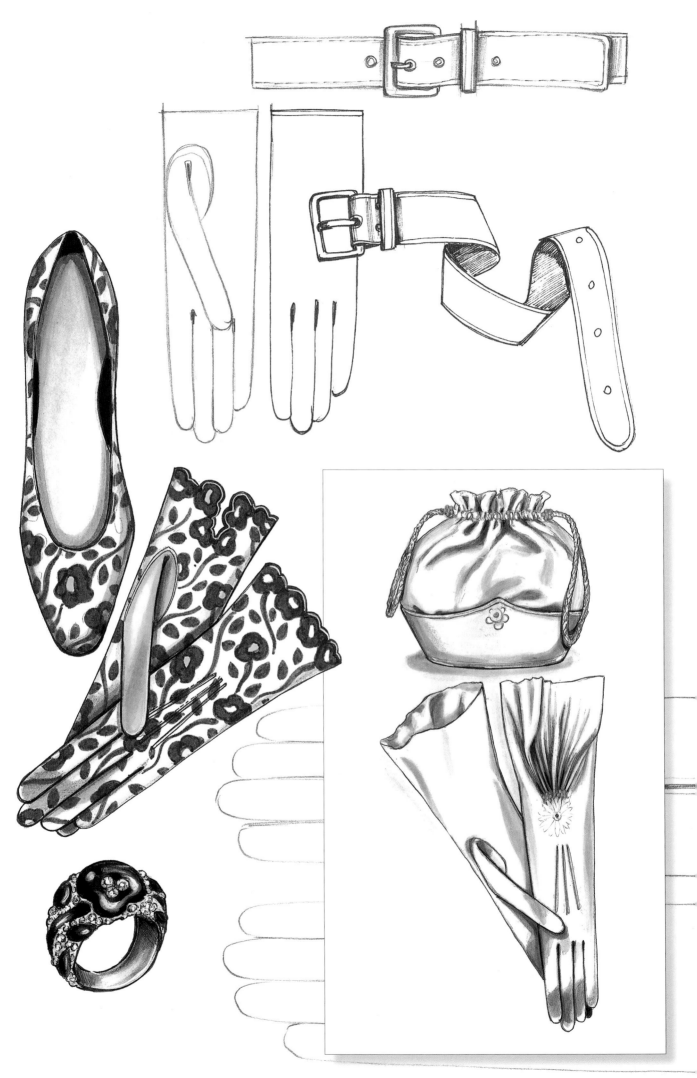

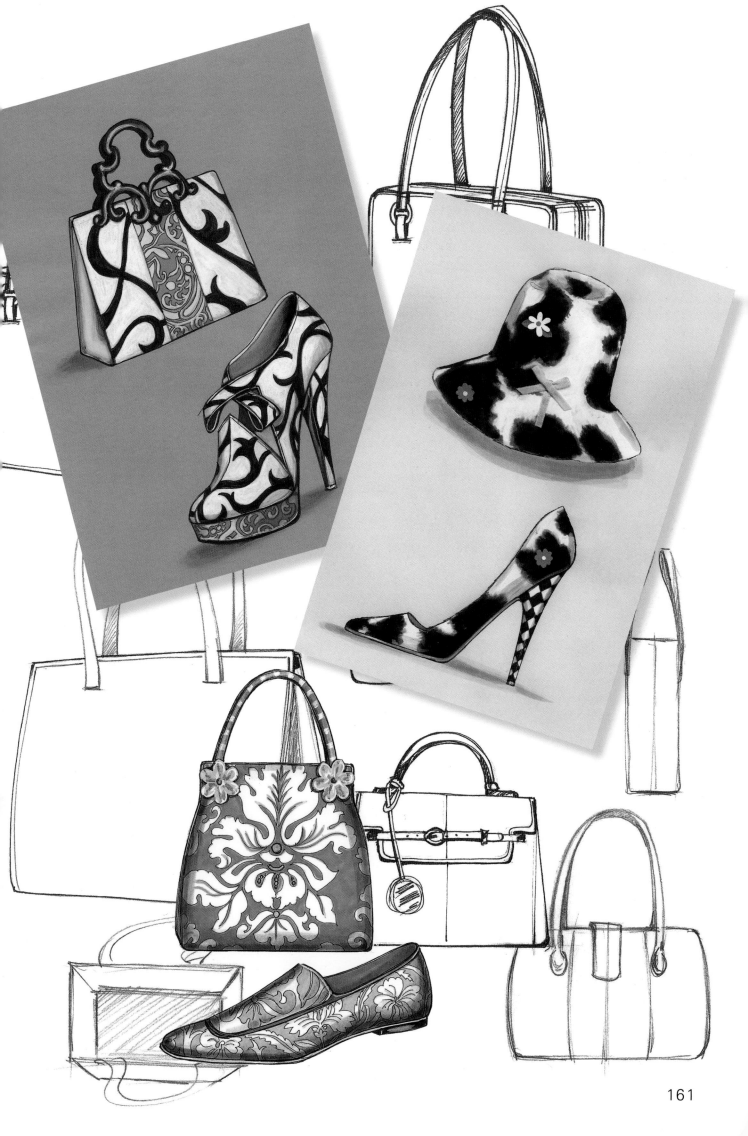

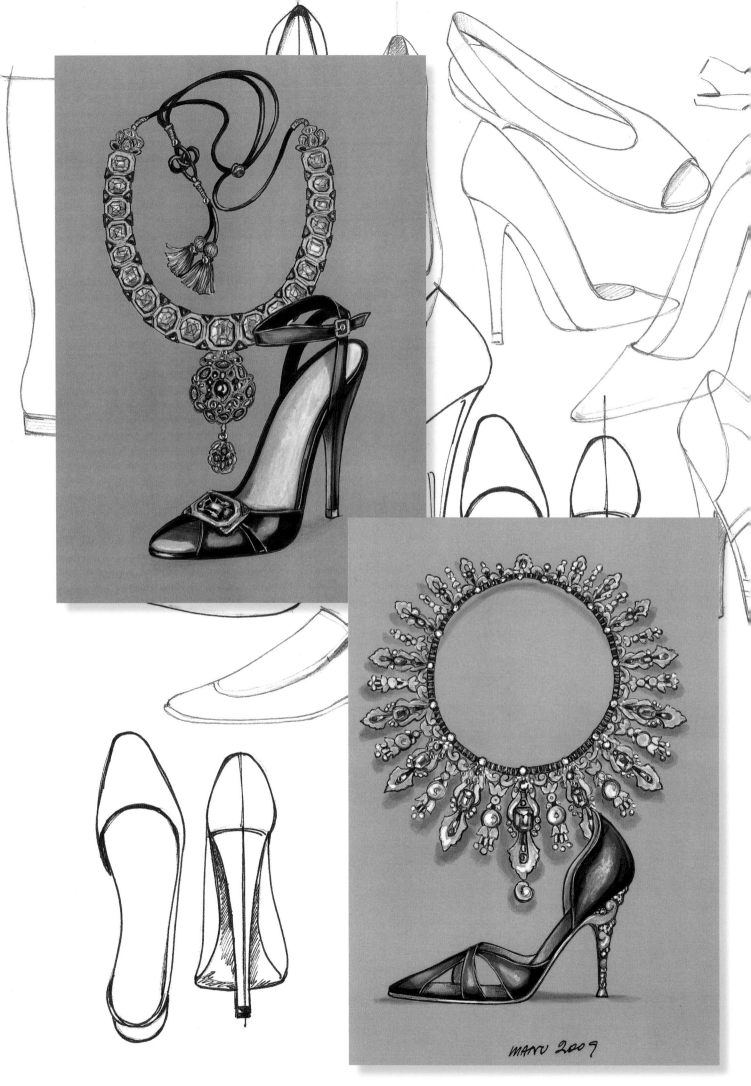

MARU 2009

162

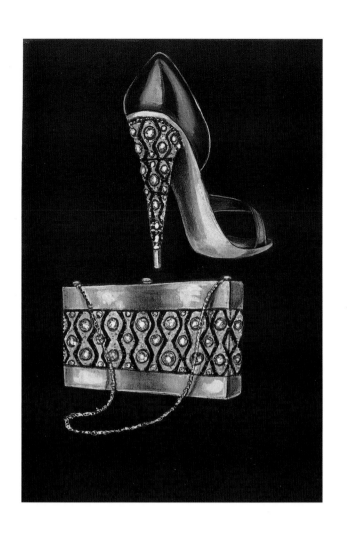

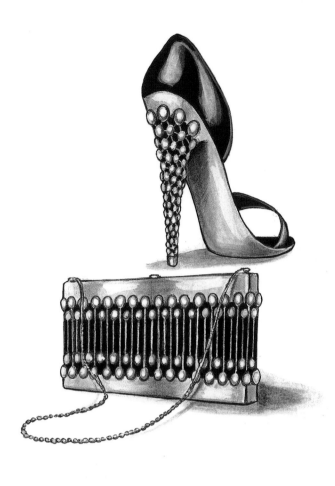

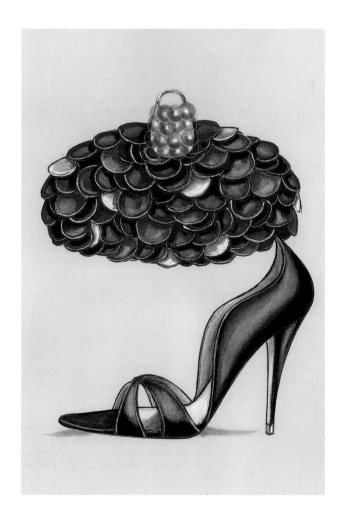

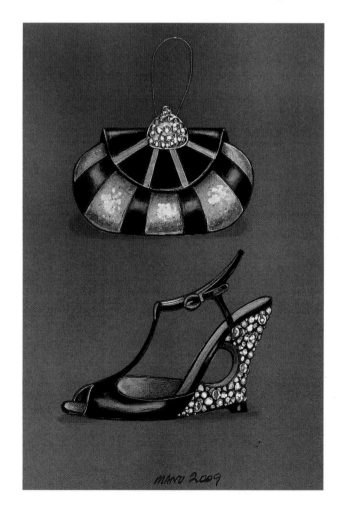

JEWELRY

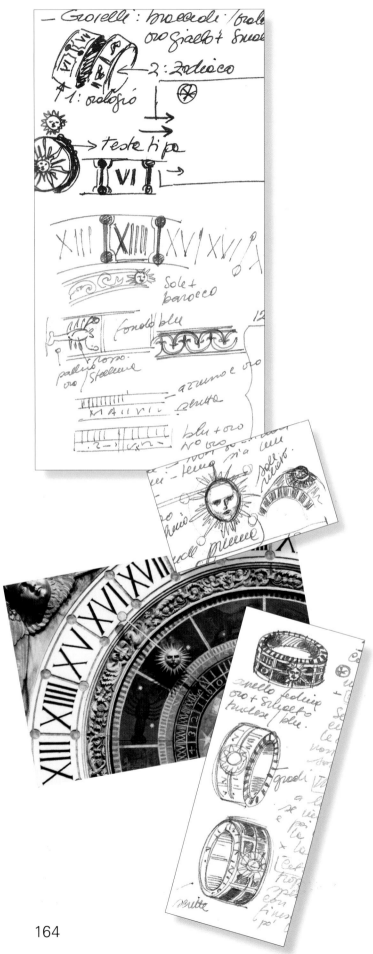

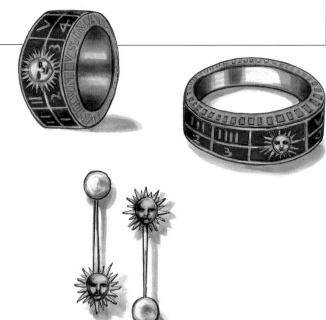

As with the other themes and subjects that grab our attention and stimulate and inspire us, an idea may follow to either transform or simply reproduce the thing. I saw this image of the Astronomical Clock of Lyon and I was fascinated and had fun taking elements from the face of the clock and reassembling them into a jewelry set. The idea of jewelry is similar to the idea of fashion, of an accessory: the development and evolution have as one idea a basic concept, a form, an effect to transform. The easiness of the process, however, comes from years and years of training and practice in the working world where I learned to broaden my mind on the development of a concept, and force myself to constantly discover new alternatives to try. This was both useful and fundamental because imagination and creativity are important but developing a method is equally important, if not more so. I used Pantone and Stabilo markers, black fine-tip markers, gold and white tempera, correctors and black ballpoint on regular cardboard.

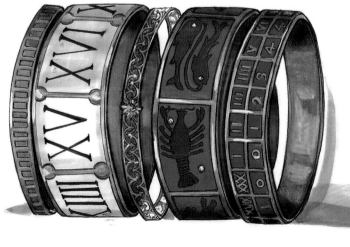

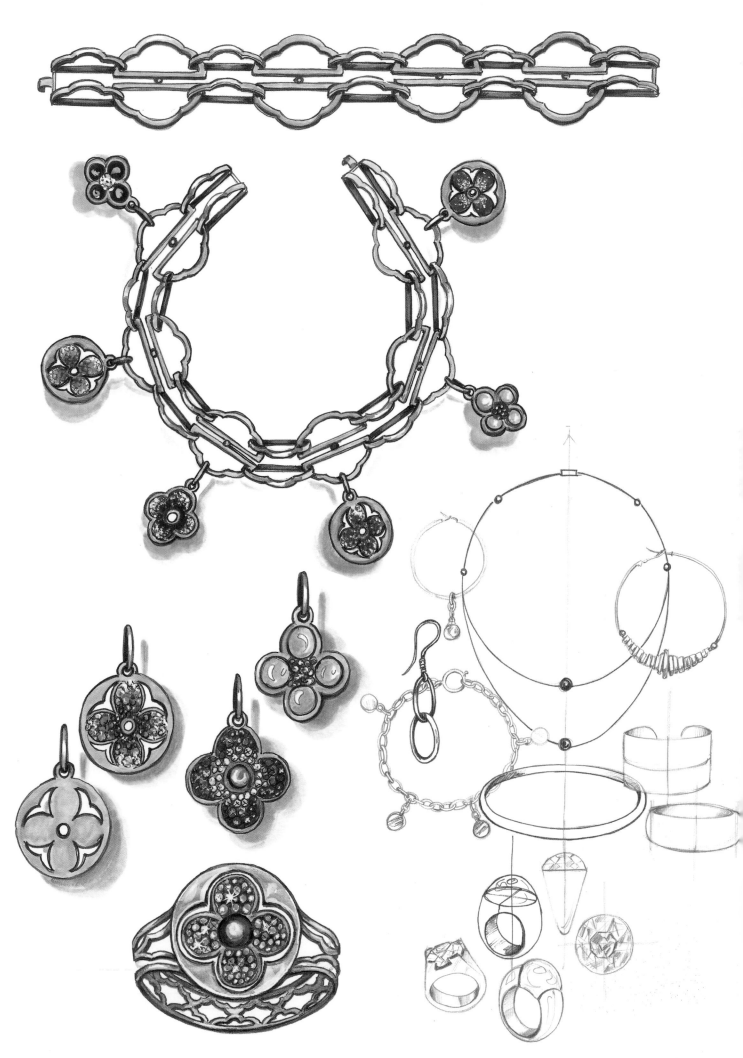

Circular grain shapes are fascinating forms for designers to play with, especially for jewelry. After sketching, use a sheet of colored cardboard to bring out the golds and silvers, following a base you have prepared earlier where you can divide the sheet in half vertically and place the shapes for the rings seen in different perspectives; then do the bracelet and the necklace to show the complete set on the same theme. Trace the outlines in pencil, accentuating the details, and then retrace the drawing with a black fine-tip marker. The procedure is identical to the one used for the figurine: first the base details then the small and more complicated ones. Apply a light tempera color base and once the shadow is dry, reinforce it with gold and silver pastels and a more compact tempera (that is, less diluted). Retouch the details with a ballpoint and brush, and a corrector for light in the stones.

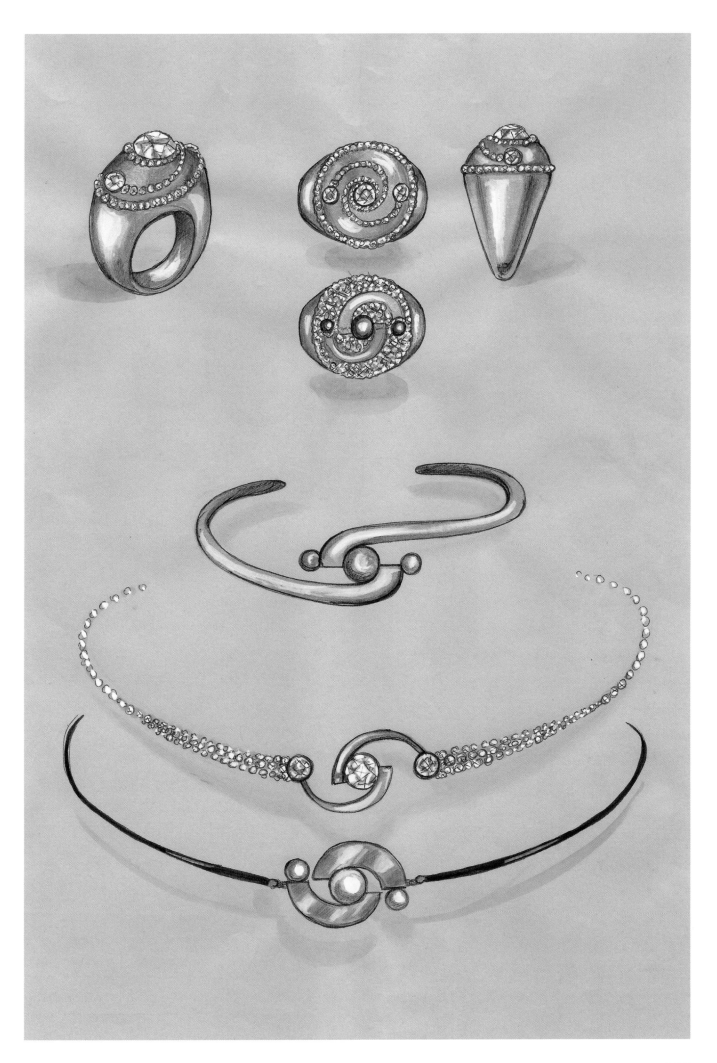

IDEAS FOR A COLLECTION

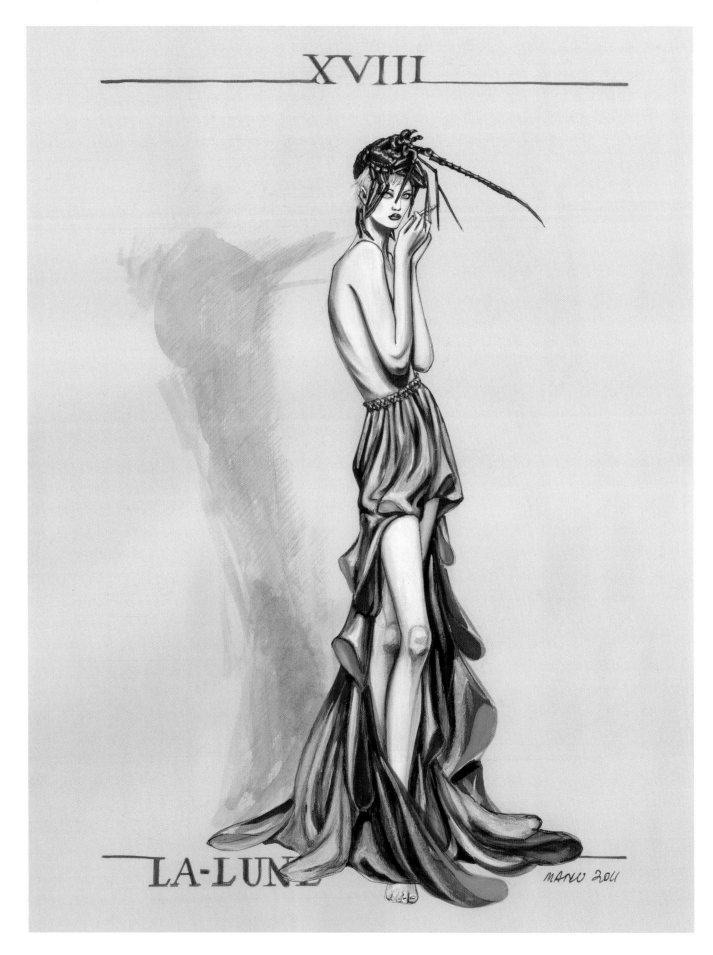

XVIII

LA-LUNE

MANU 2011

168

The Tarot

Having previously illustrated a personal version of the zodiac and because I love these kinds of themes, the Tarot are for me a trusted source of illustration ideas for the single cards when I have the colors and elements available. So I have studied their symbolism and the classic representation of the 22 Arcanas, taking notes and then developing a series of sketches, using the information for fashion and lifestyle. Based on the garment I want to design, I look for a photo with the right pose for the idea. Other times, the solution to the idea comes from an image that I want to build on, and I then adapt the garment to it. I used a pad of sketch paper and several faces and bases drawn as figurines. I magnified these to an A3 format and photocopied them directly onto sketching paper as samples. Naturally, I first drew the figure in pencil, re-doing the base then working on the garment. I used a light table for this stage, but if one isn't available you can superimpose two sheets of paper on window glass and draw over them. Once you have traced over these with a black marker, fill in the skin areas with a veil of white pastel thicker in the brighter areas and thinner in the areas of shadow. Go over these with white tempera for a more compact effect. Use a colored pencil for a shadow effect on pale skin and trace over with a Tombow or a skin color Pantone for the more shadowed areas, applying this directly on top of the colored pencil (it sets the color and evens it out). Apply Pantone color on the garment and then do the shadowing. For details use colored tempera and pastels. The final touches should be made using a fine or medium point ballpoint which should also be used for shadowing, from the lightest to the darkest.

169

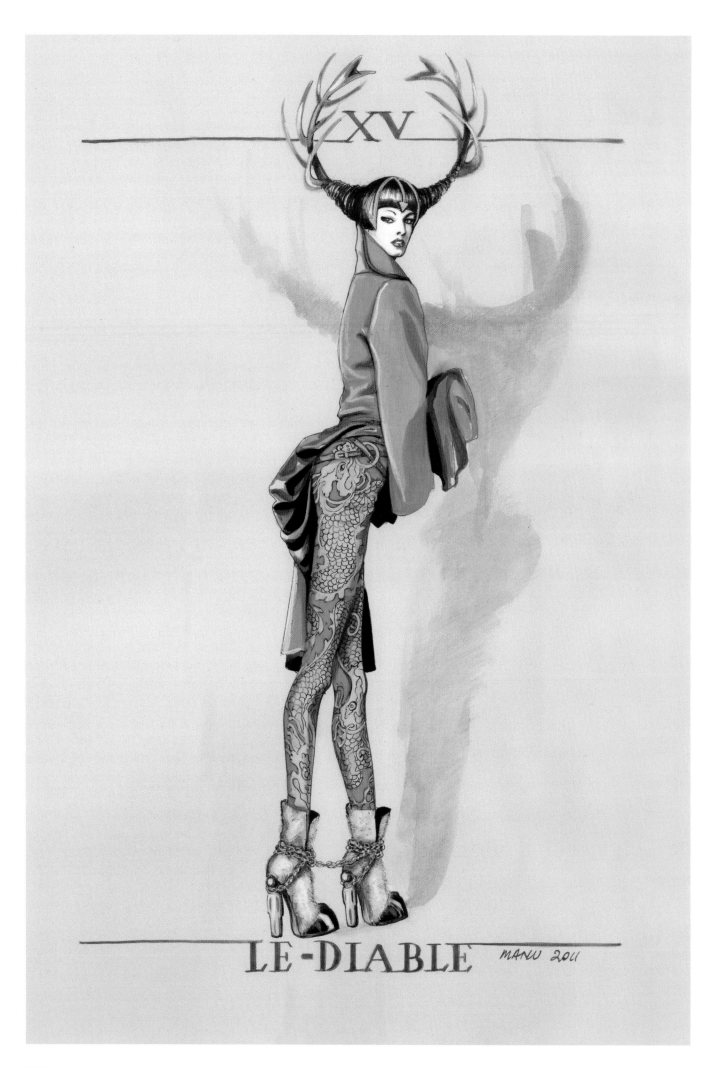

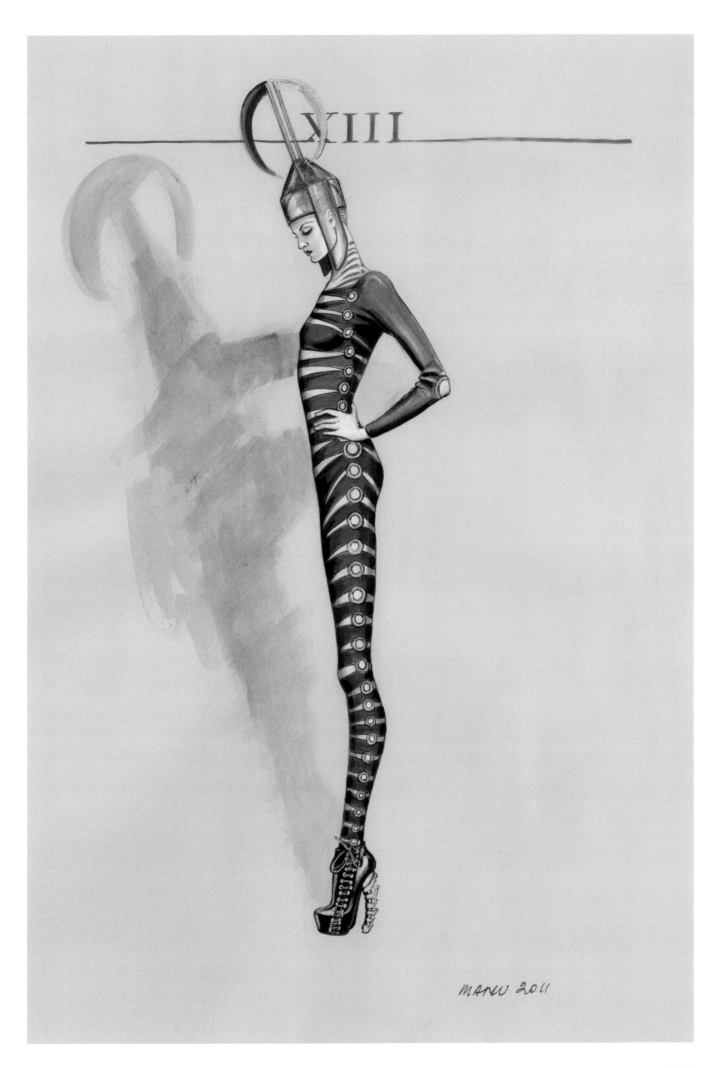

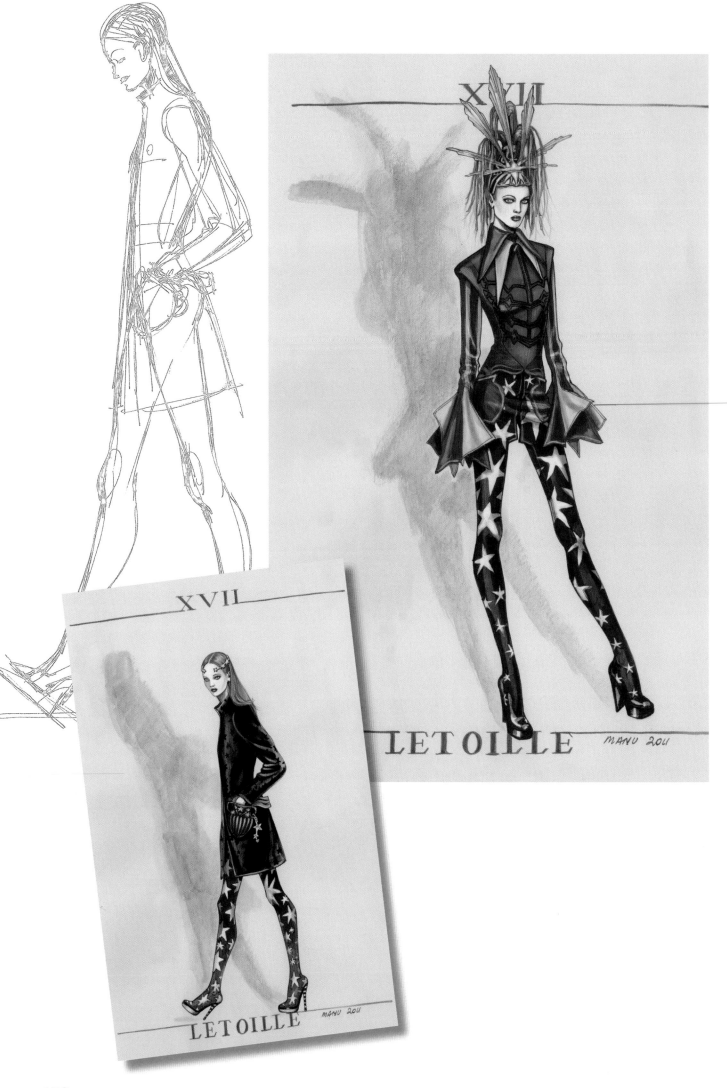

172

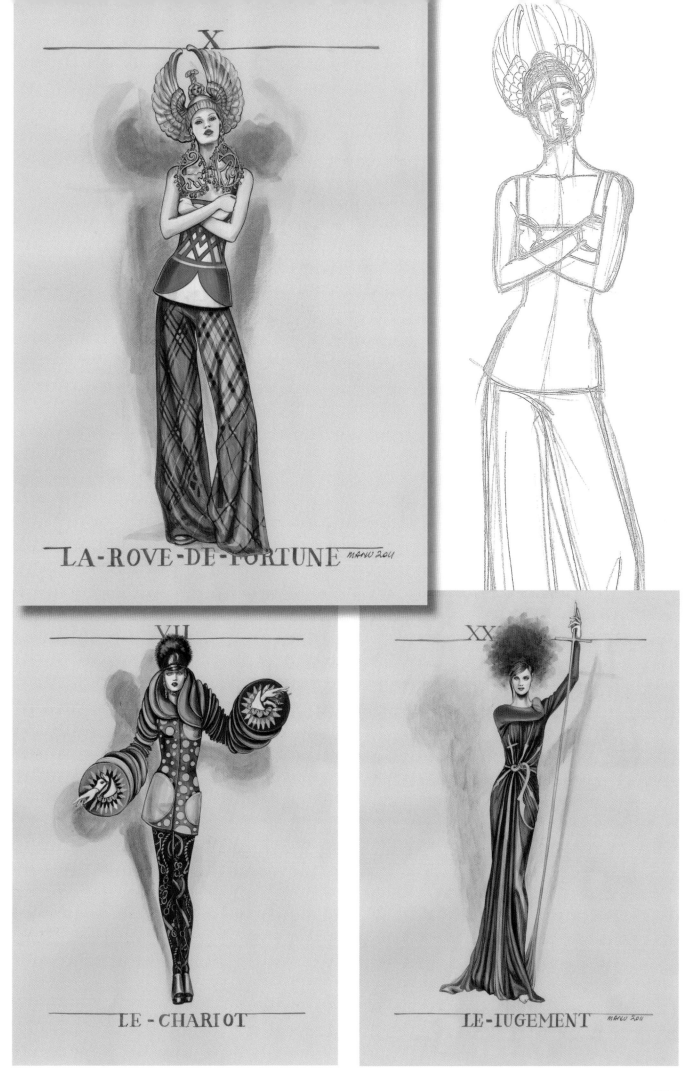

X

LA-ROVE-DE-FORTUNE MANU 2011

VII

LE - CHARIOT

XX

LE - IUGEMENT MANU 2011

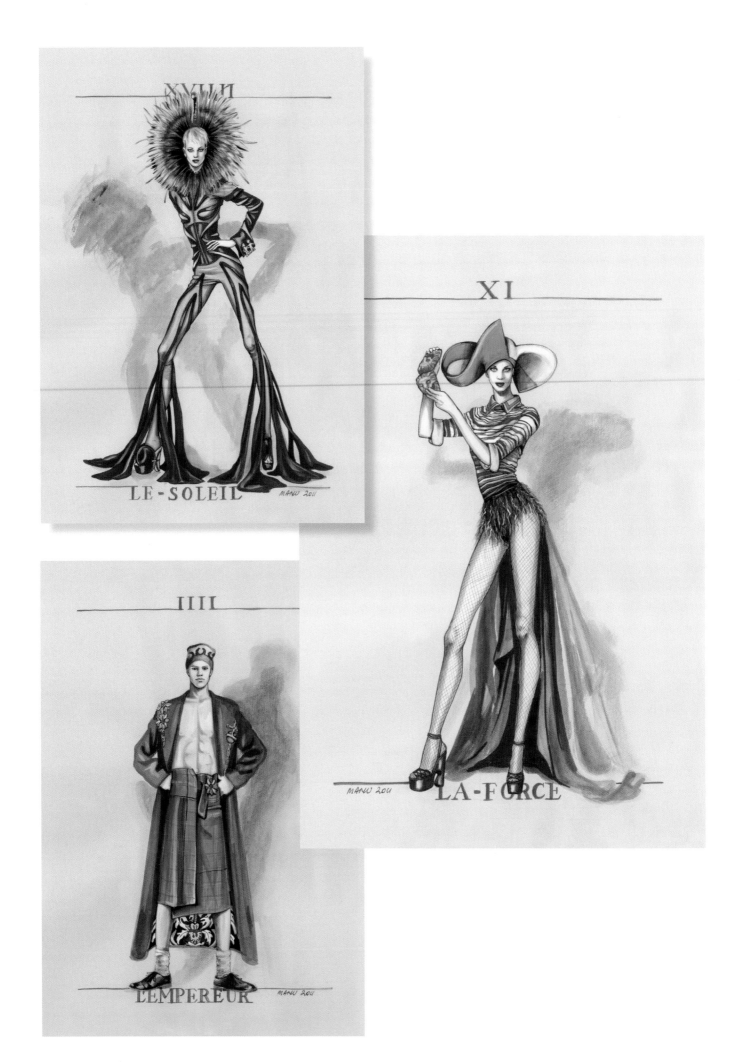

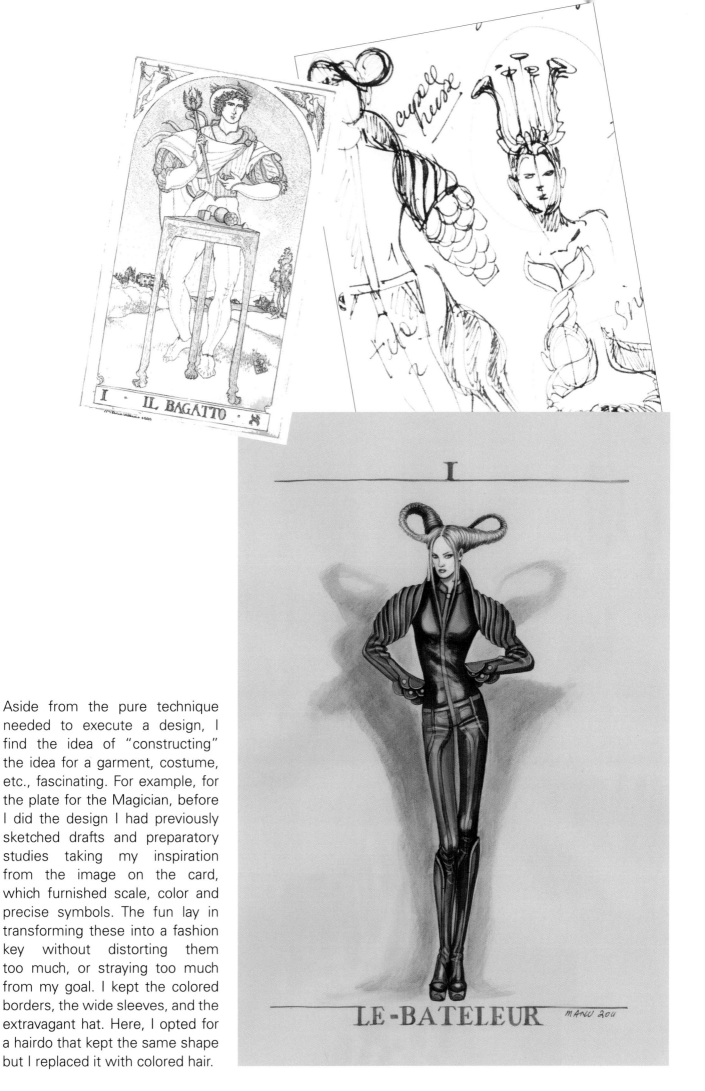

I · IL BAGATTO

I

LE-BATELEUR MANU 2011

Aside from the pure technique needed to execute a design, I find the idea of "constructing" the idea for a garment, costume, etc., fascinating. For example, for the plate for the Magician, before I did the design I had previously sketched drafts and preparatory studies taking my inspiration from the image on the card, which furnished scale, color and precise symbols. The fun lay in transforming these into a fashion key without distorting them too much, or straying too much from my goal. I kept the colored borders, the wide sleeves, and the extravagant hat. Here, I opted for a hairdo that kept the same shape but I replaced it with colored hair.

XIIII

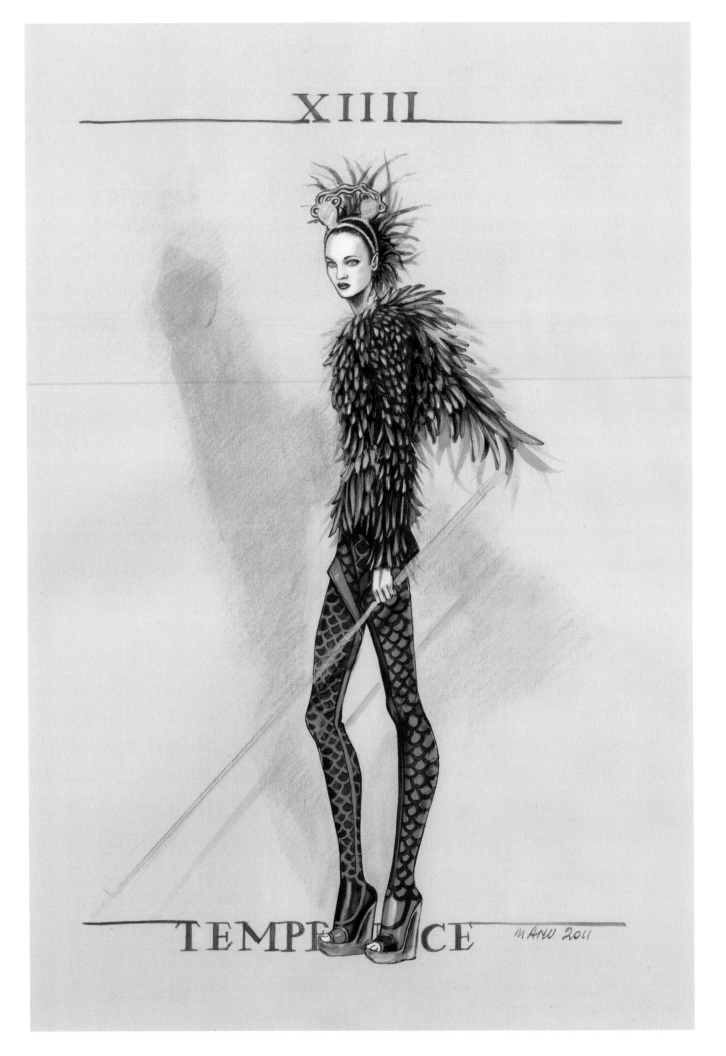

TEMPERANCE MANU 2011

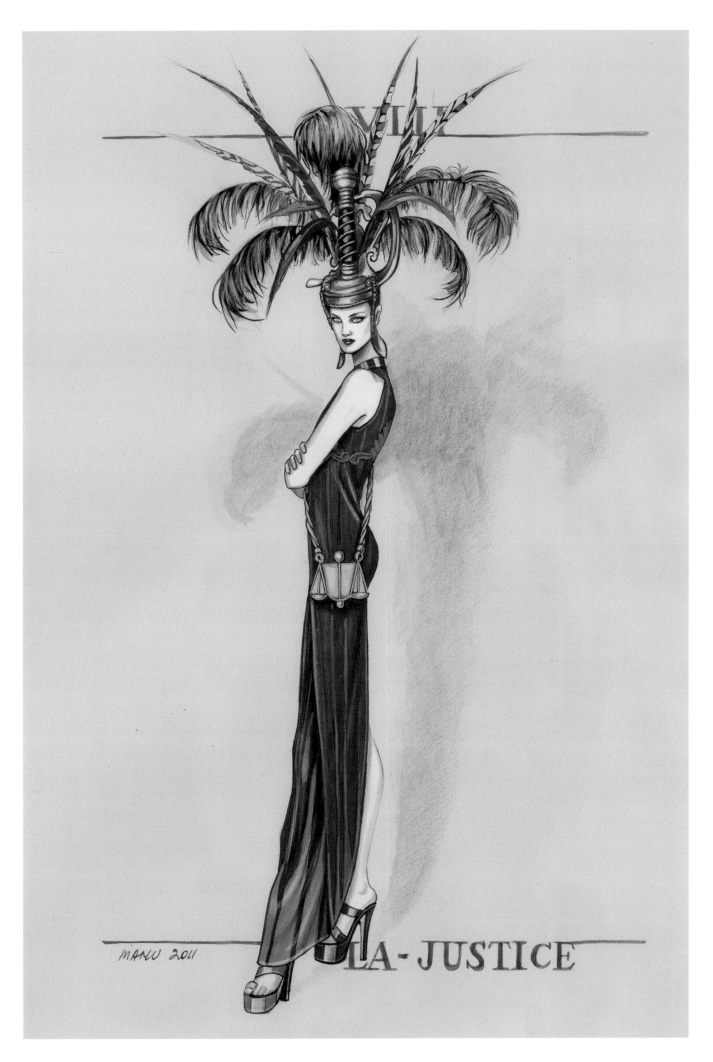

LA-JUSTICE

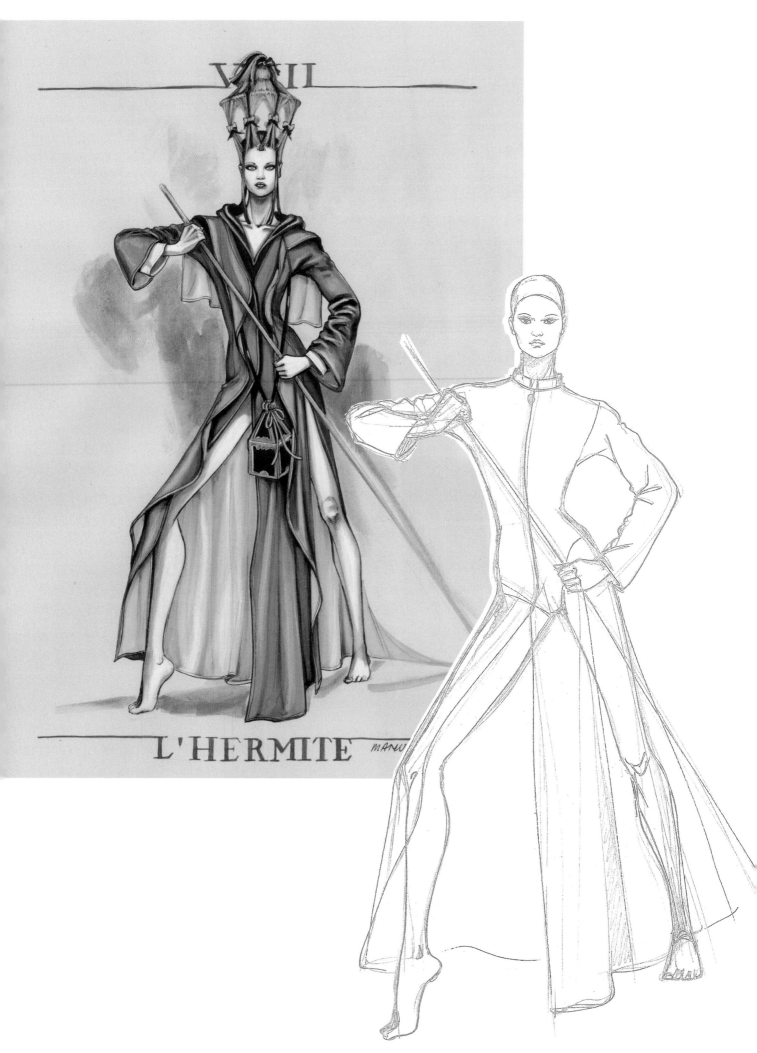

VIII

L'HERMITE MANU

178

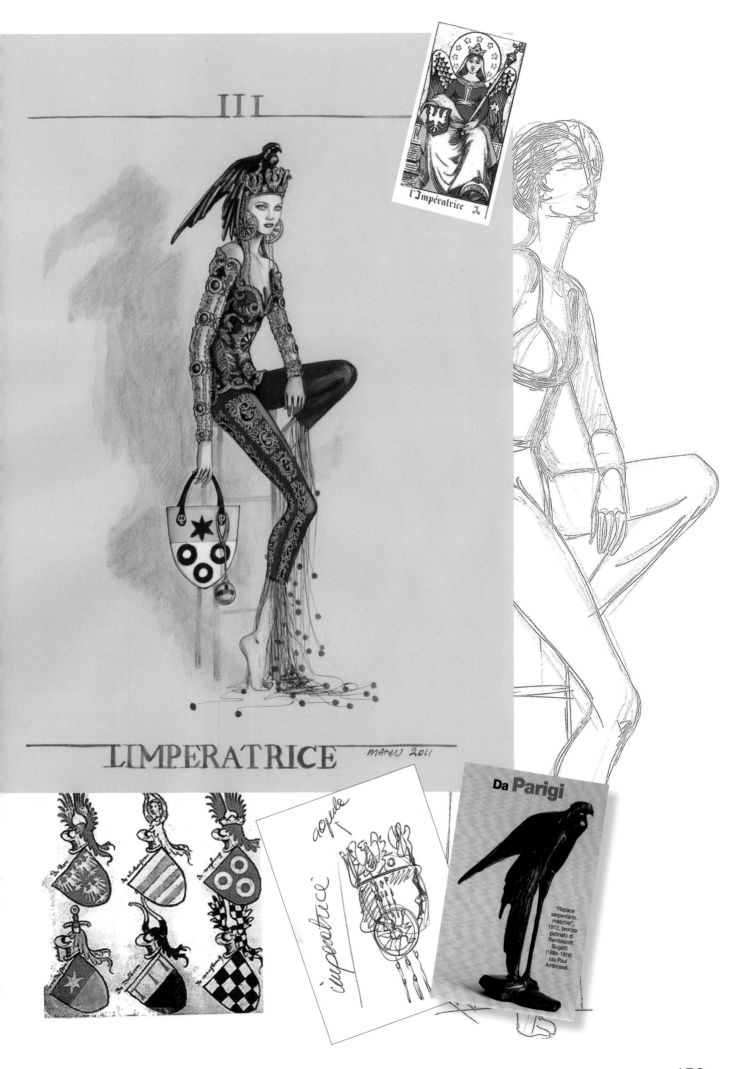

III

L'IMPERATRICE

MANU 2011

l'Impératrice

aquila

imperatrice

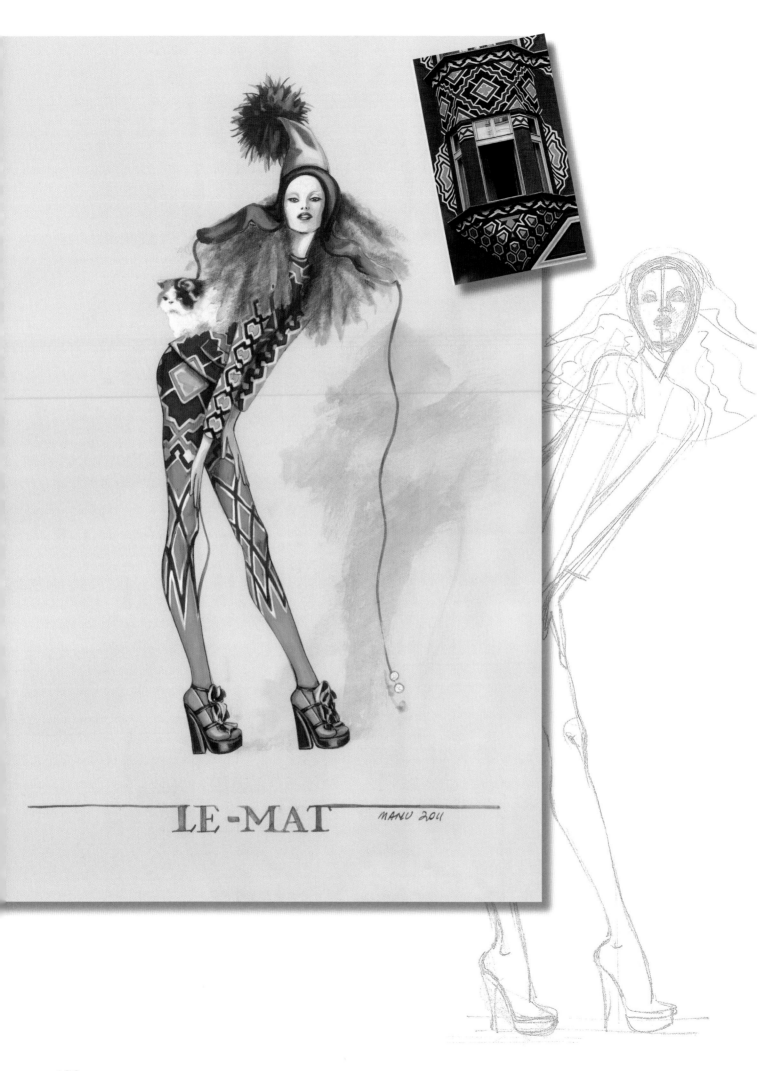

LE-MAT MANU 2011

180

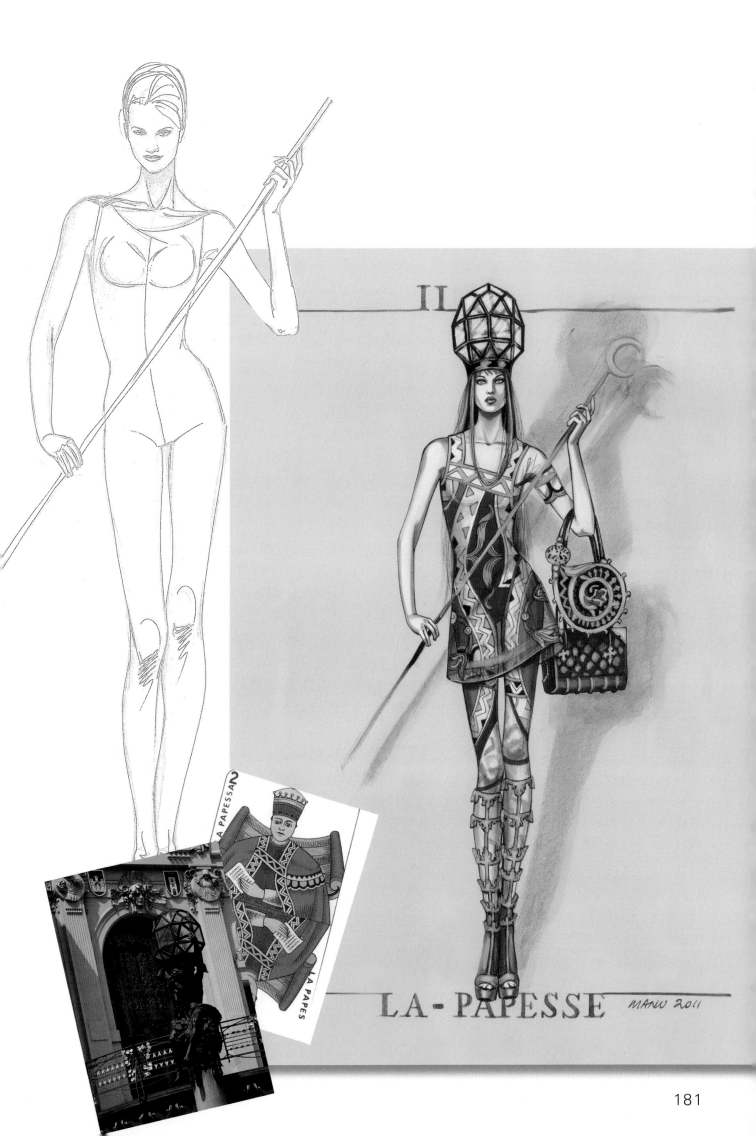

II

LA - PAPESSE

MANU 2011

LA PAPESSA 2

LA PAPES

181

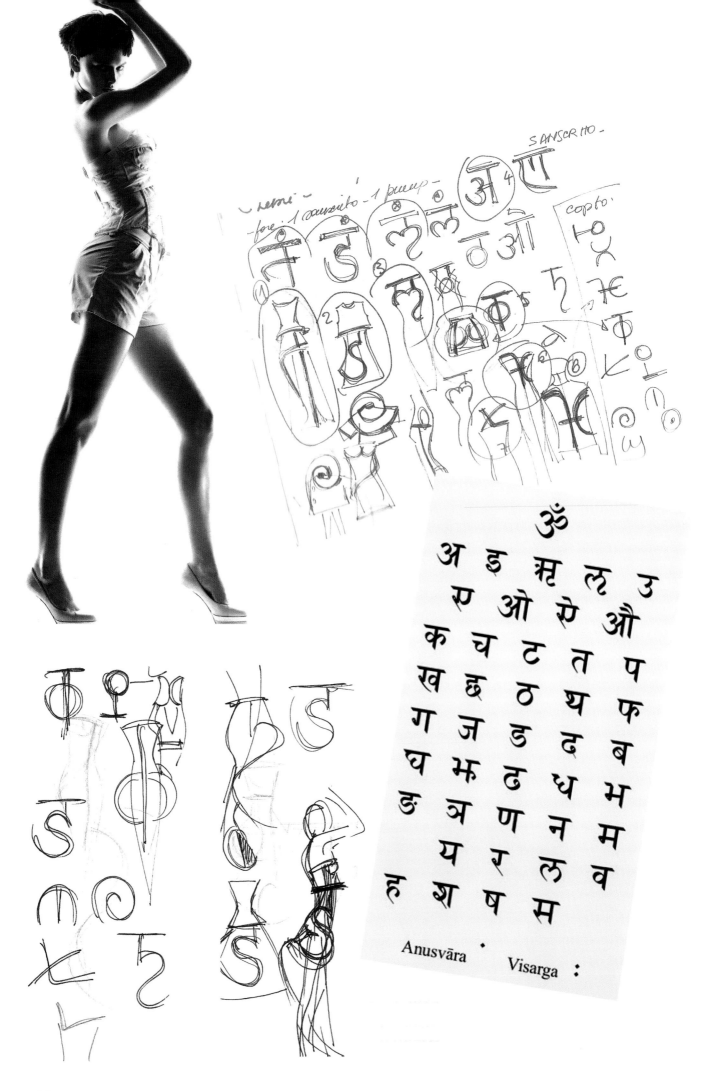

Copt and Sanscrit

For this series of plates on black cardboard, I was inspired by the Copt and Sanscrit alphabets. I am excited when I transfer special elements that have nothing to do with fashion onto fashion garments on female forms. I have always been fascinated by Copt symbols, and Sanscrit lends itself to the creation of interesting forms. I had in mind a black background with figures outlined faintly in white and gold symbols that stand out on the page creating both the details of the garment and a sophisticated and mysterious effect. So I used photographic images for inspiration and of course the alphabets, choosing signs that lent themselves best to creating the details of the clothes. The procedure is the same as I indicated on previous pages when I described drawing on a black background. For the most part I used white pastel, white tempera and gold as colors backed up by pastels, ballpoint pen, etc., to retouch detail. If you make any mistakes when drawing on a black background, for example while using a white pastel, just go over the error with black tempera as a kind of "erasure"

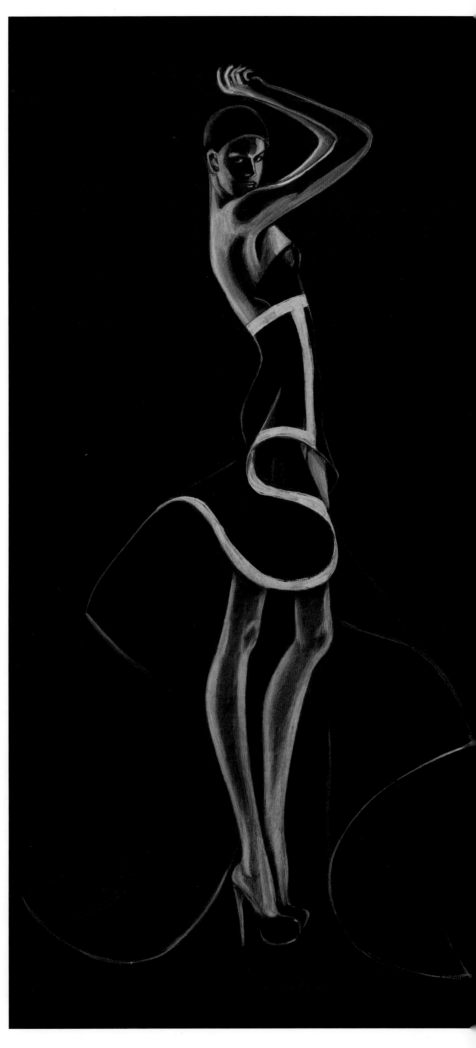

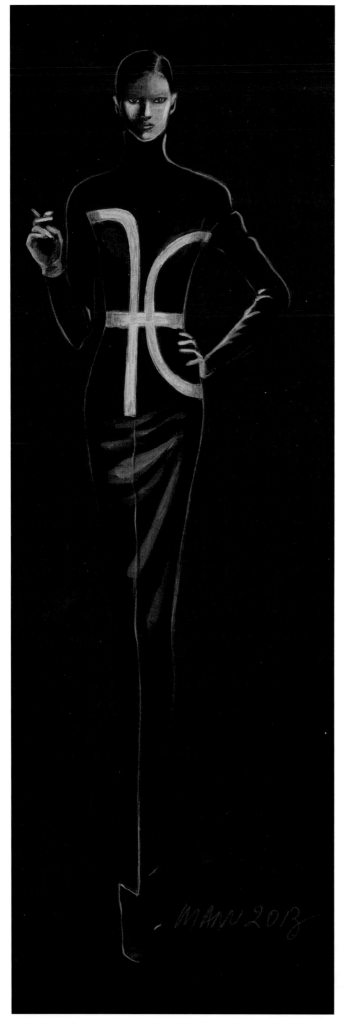 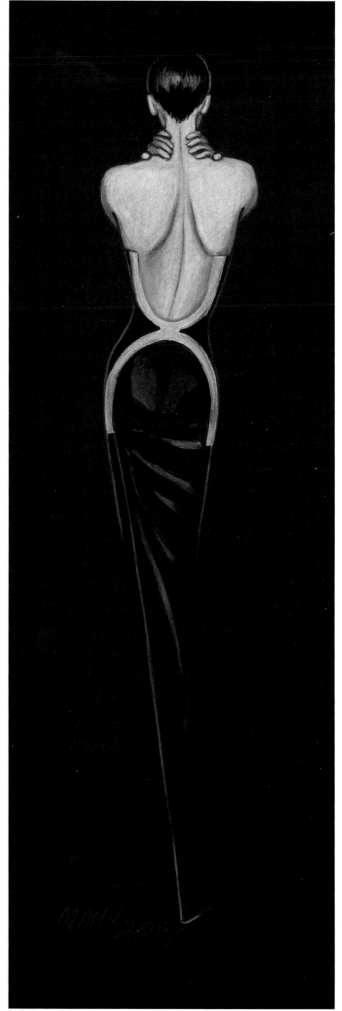

184

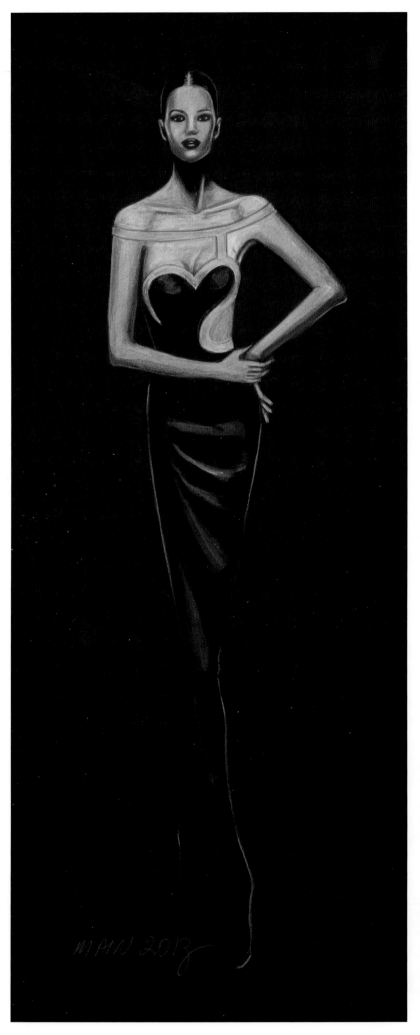
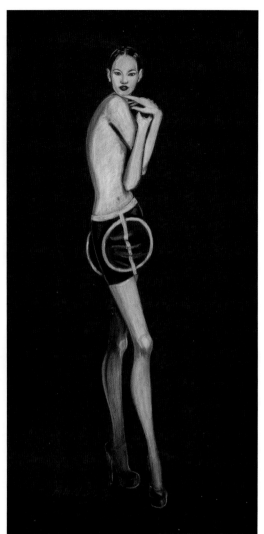
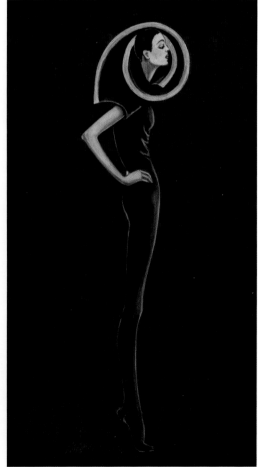

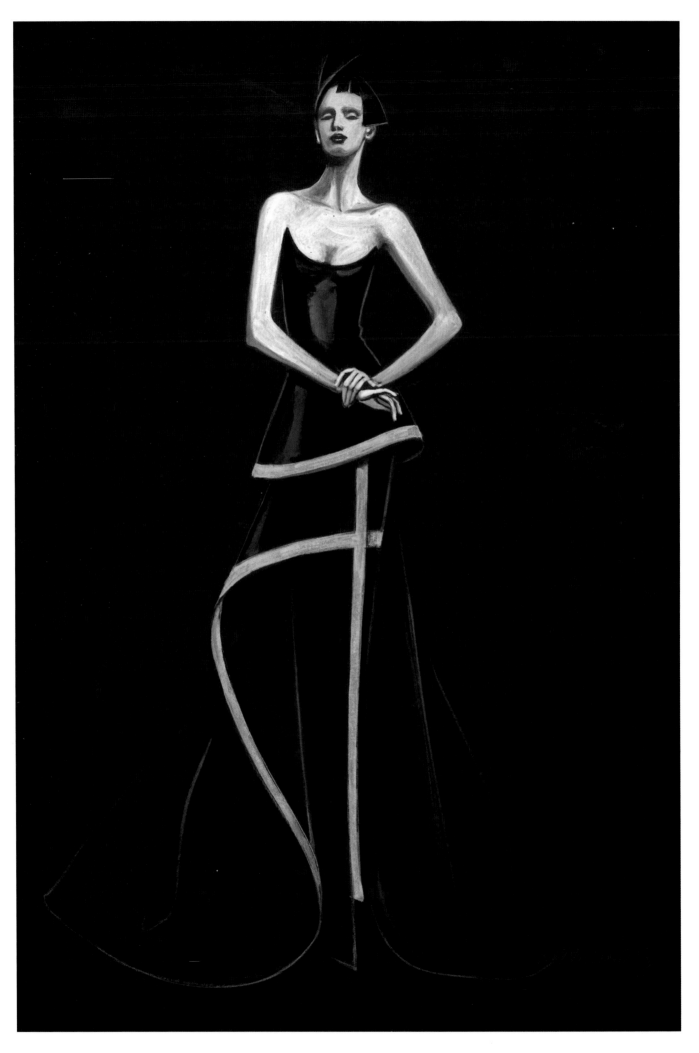

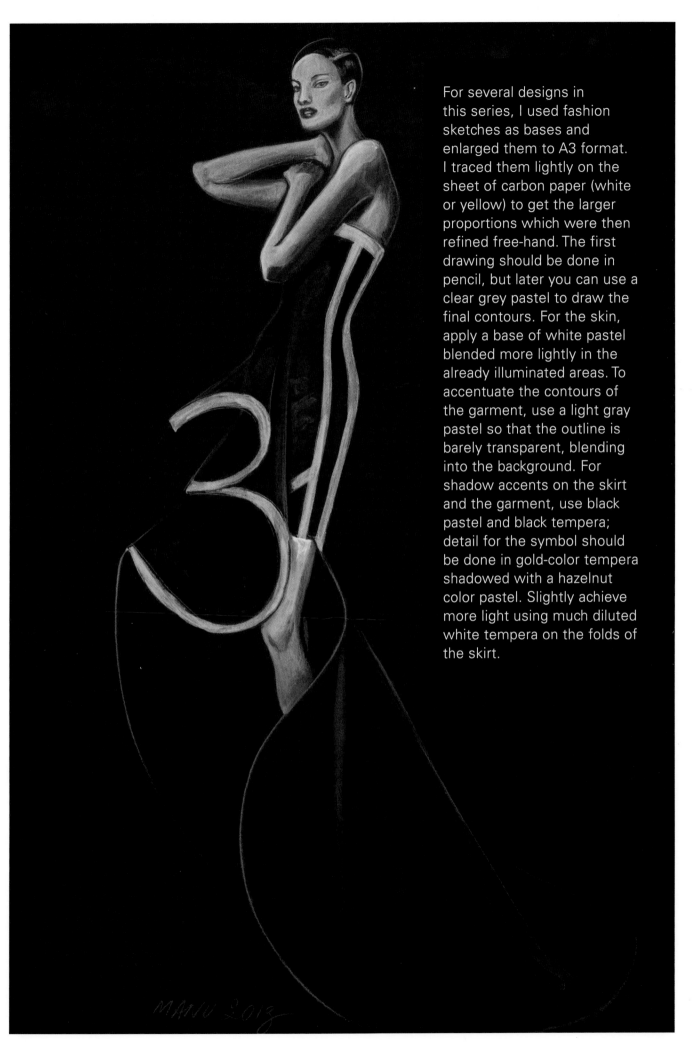

For several designs in this series, I used fashion sketches as bases and enlarged them to A3 format. I traced them lightly on the sheet of carbon paper (white or yellow) to get the larger proportions which were then refined free-hand. The first drawing should be done in pencil, but later you can use a clear grey pastel to draw the final contours. For the skin, apply a base of white pastel blended more lightly in the already illuminated areas. To accentuate the contours of the garment, use a light gray pastel so that the outline is barely transparent, blending into the background. For shadow accents on the skirt and the garment, use black pastel and black tempera; detail for the symbol should be done in gold-color tempera shadowed with a hazelnut color pastel. Slightly achieve more light using much diluted white tempera on the folds of the skirt.

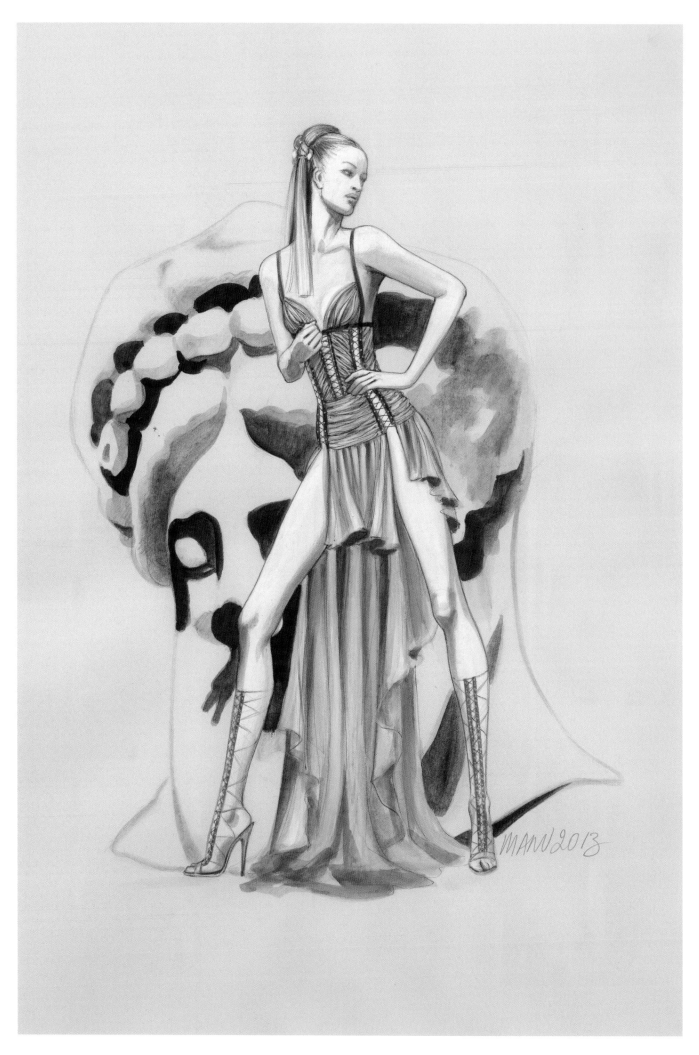

Magna Grecia

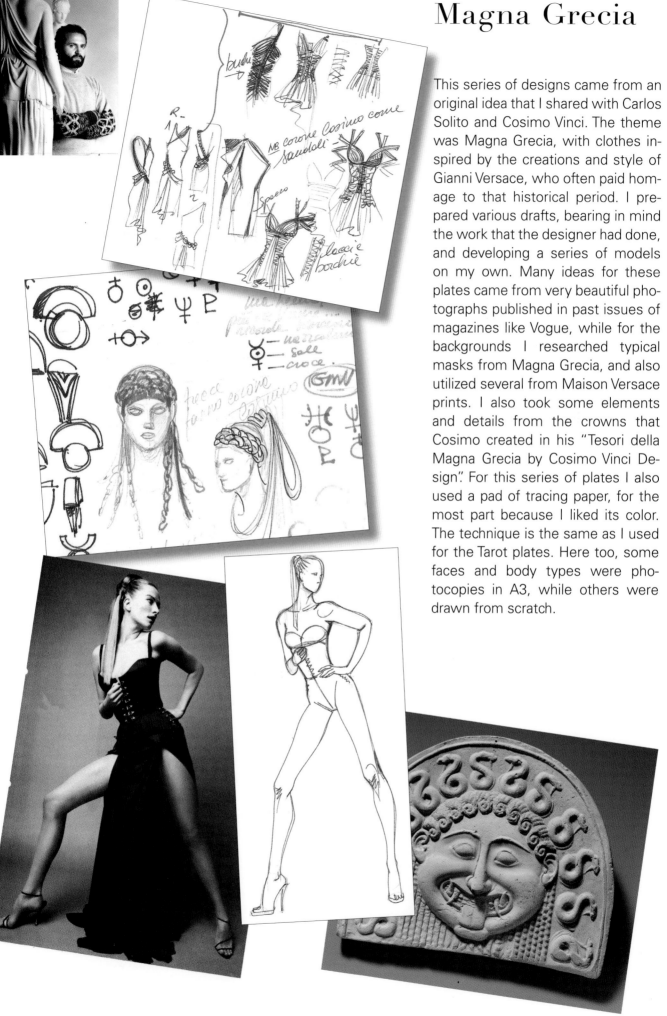

This series of designs came from an original idea that I shared with Carlos Solito and Cosimo Vinci. The theme was Magna Grecia, with clothes inspired by the creations and style of Gianni Versace, who often paid homage to that historical period. I prepared various drafts, bearing in mind the work that the designer had done, and developing a series of models on my own. Many ideas for these plates came from very beautiful photographs published in past issues of magazines like Vogue, while for the backgrounds I researched typical masks from Magna Grecia, and also utilized several from Maison Versace prints. I also took some elements and details from the crowns that Cosimo created in his "Tesori della Magna Grecia by Cosimo Vinci Design". For this series of plates I also used a pad of tracing paper, for the most part because I liked its color. The technique is the same as I used for the Tarot plates. Here too, some faces and body types were photocopies in A3, while others were drawn from scratch.

189

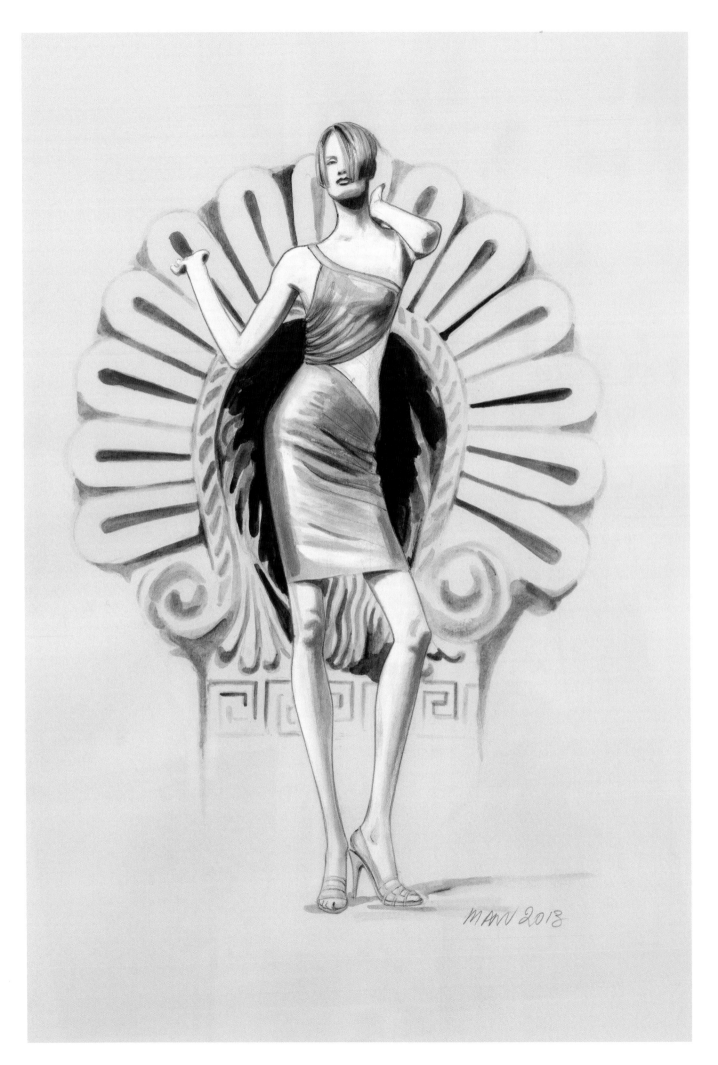

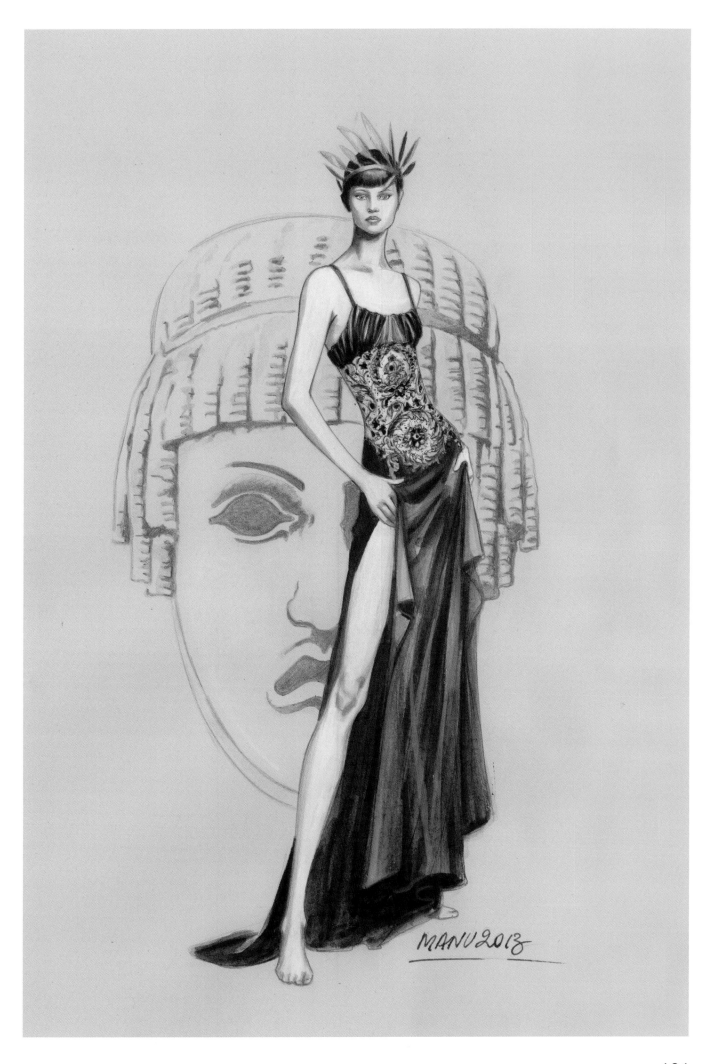

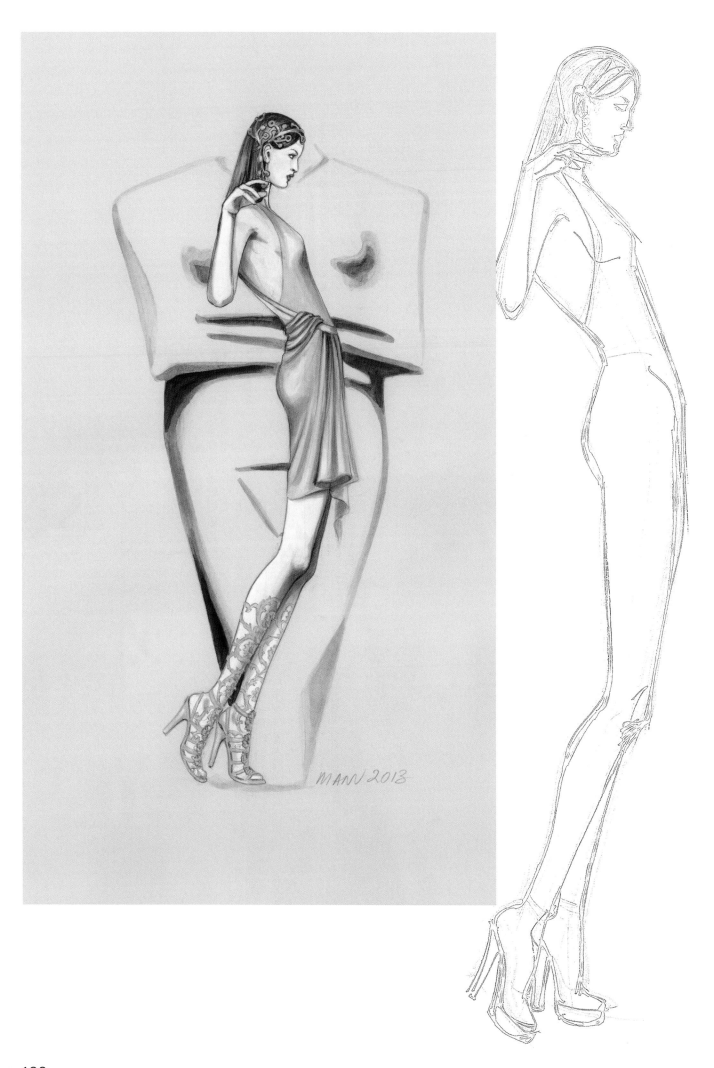

MANN 2018

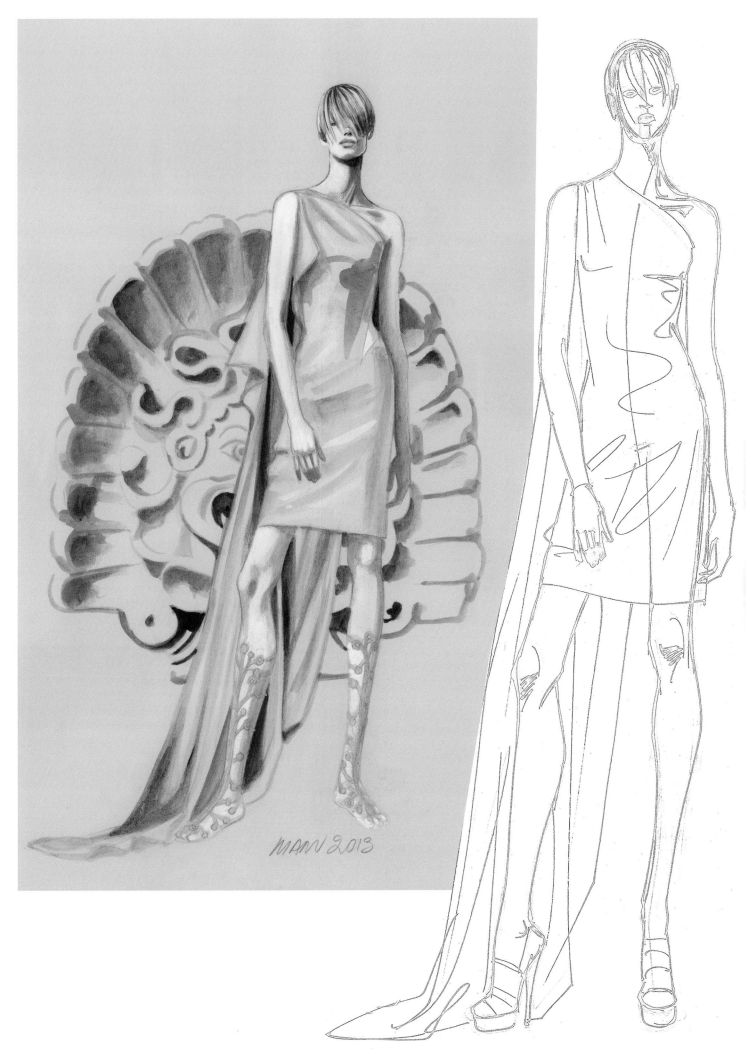

MANN 2013

193

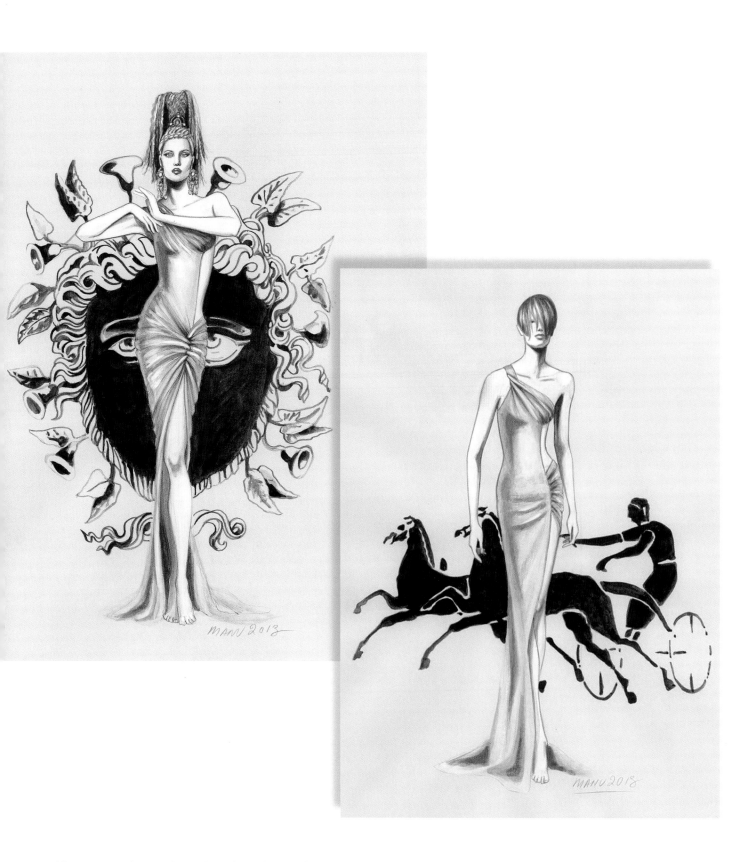

Here too, I used a sketched base for general proportions, changing the details of the pose on the basis of the photo that inspired me. For the preparatory studies for this series, I reviewed and used several of the elements that Gianni Versace had often used for his themed clothes: the asymmetry of the shoulders and in the deep openings and the drapings. I sketched these separately, but often while doing a drawing the pose itself presented its own construction solutions or details. On a technical level, having used a pad of sketch paper

the same truths held as held for the Tarot plates, aside from the colors which, using clear and sand tones and only black as contrast, there was no need to use Pantone colors here aside from some of the black details on the garment or background. I used gold tempera for the clothes and a lot of ballpoint for the lighter shadowing of the drapings. The background masks were drawn in pencil first and then gone over with black or gray tempera, somewhat diluted.

194

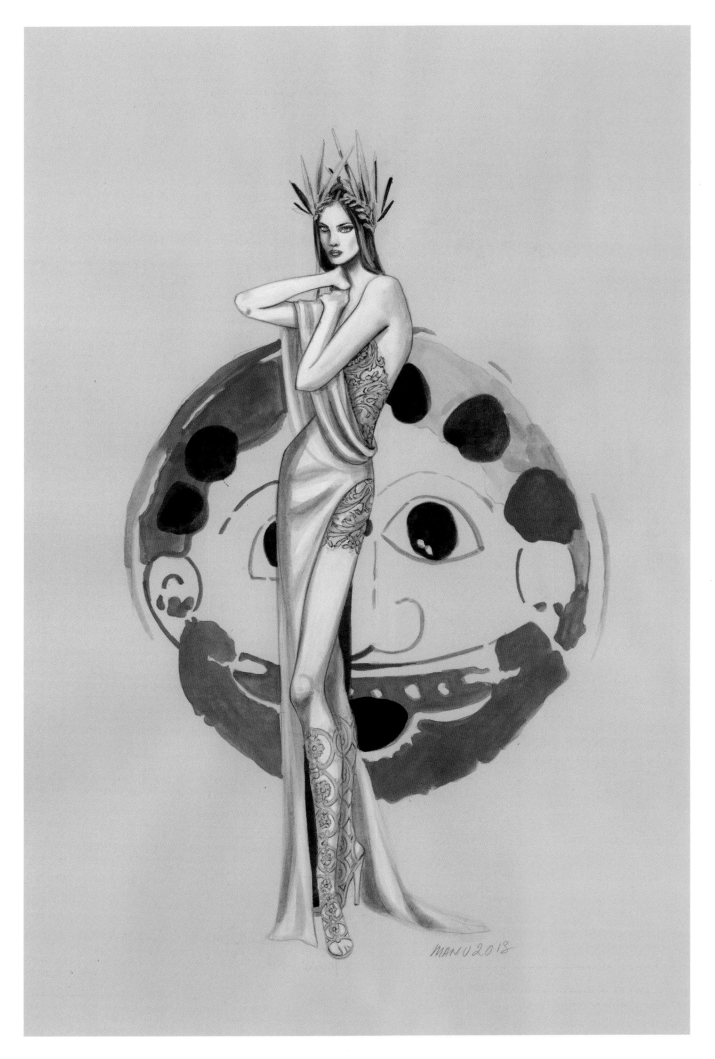

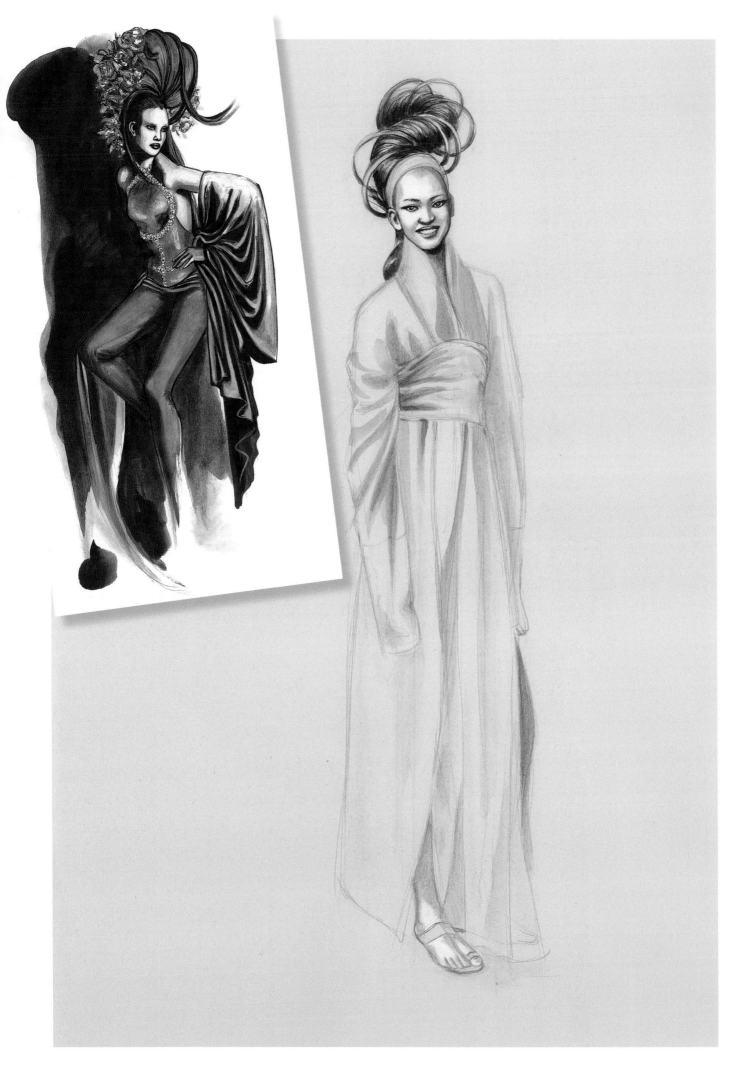

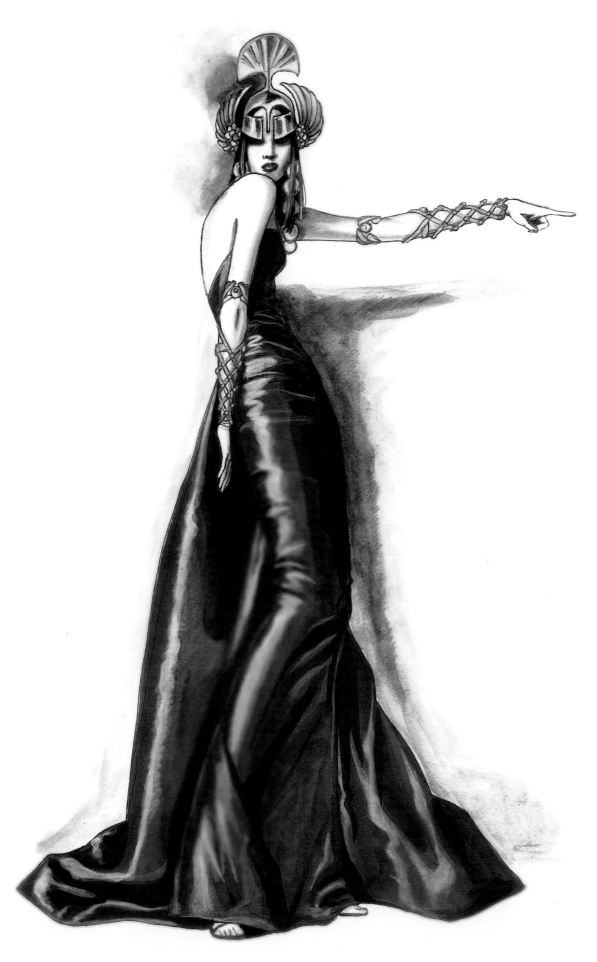

Yellow Submarine

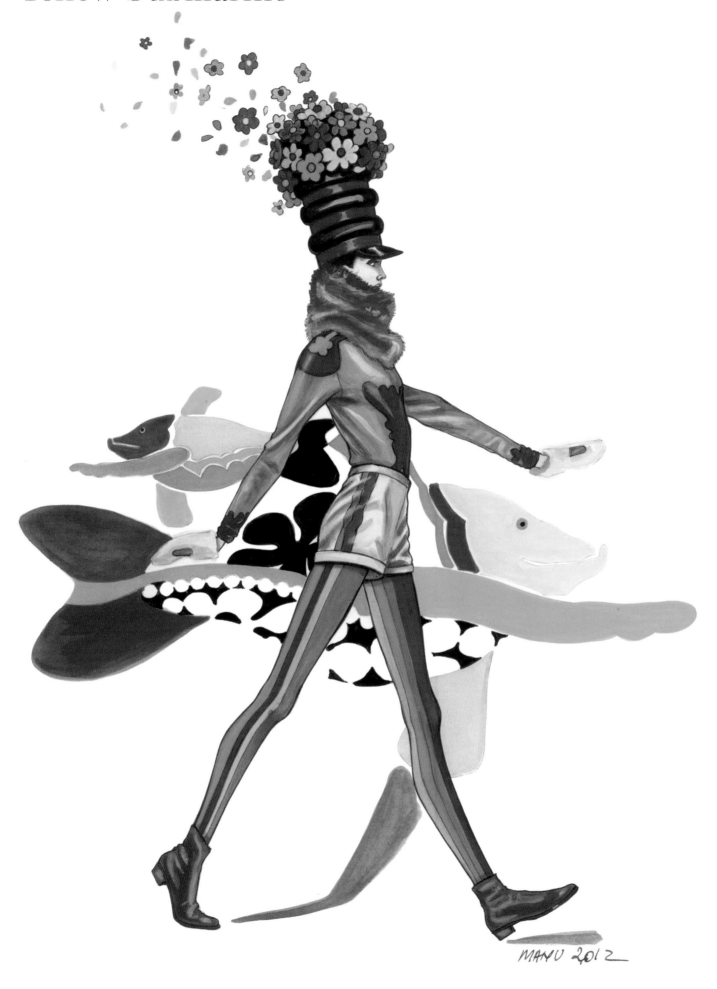

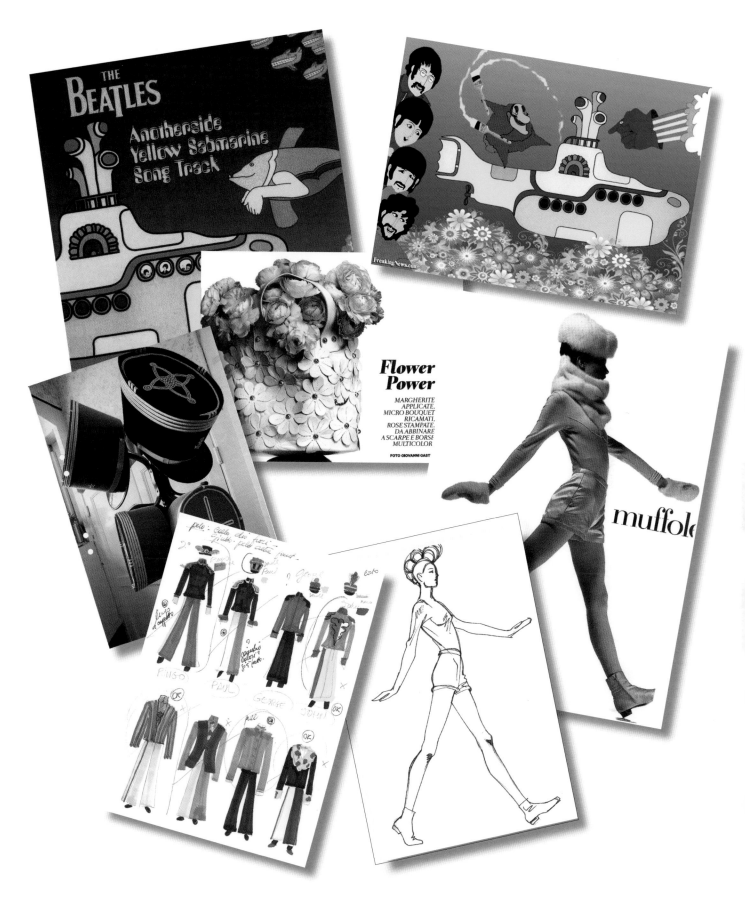

The drawings were, as intended, reproductions of the costumes created for the Beatles in their animated film, but of course they were worn by models. The colors and prints were truly exhilarating. I started out with their clothes, then I had fun developing other items but retaining many details and colors. There was a lot of material available and the opportunities for development were infinite. With all the interesting photographic material available, I adapted the volumes to the images that were suitable, or I took others from the photos, changing the patterns and adding new elements. Little was left of the original costumes from the film, most were part of an absolutely amusing progression! The material used was the same as I used for the sketch figures.

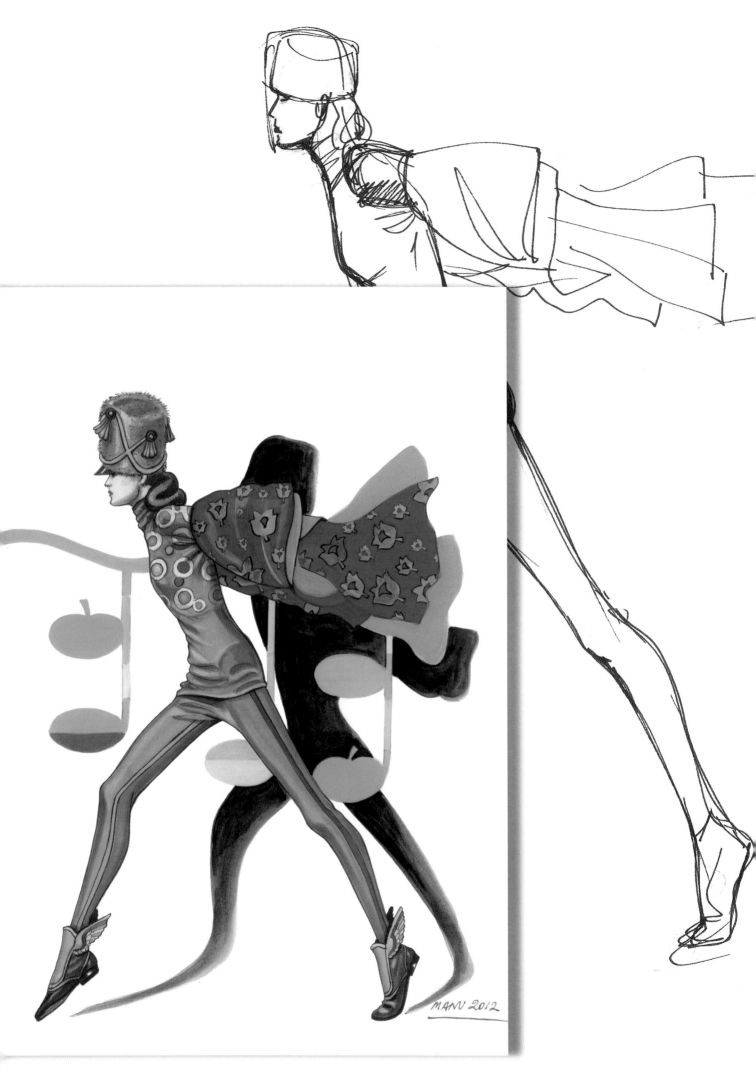

200

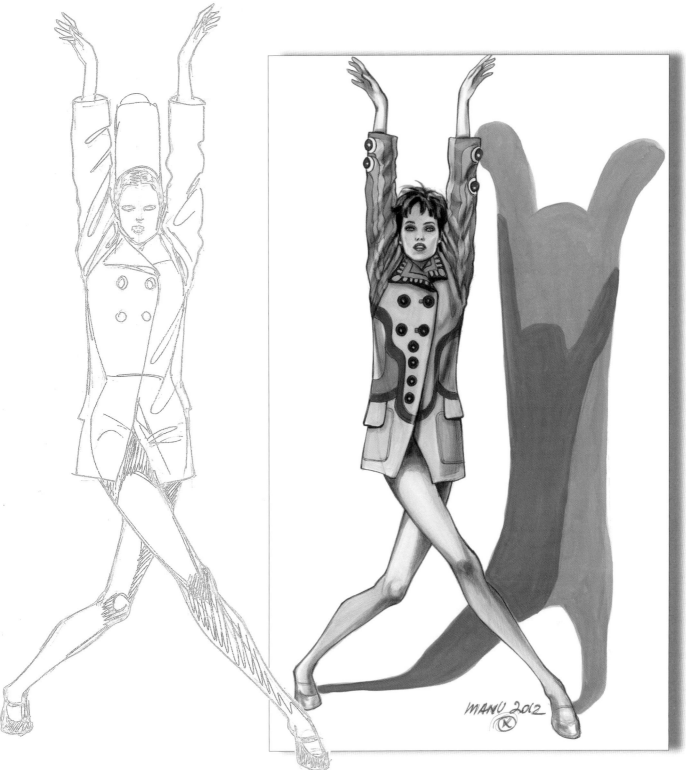

This design was born of my desire to do this unusual, bizarre pose. As you can see from the sketch at the bottom of the page, it was drawn first on a sheet and once the design was perfected, the magazine image was followed. I chose a different face for the girl because it offered a more interesting play on shadowing, which I did with a colored lead pencil on a beige Pantone Pastel base. I kept the short topper coat of the photo, but chose the details most suitable for the pose from both the garment and the theme points of view. I thought it would be amusing to use the famous colored submarine, both to create a pattern for the jacket and using periscopes to provide sense for the position of the extended arms, creating a play of lines. On a white sheet I used Pantone colors, reinforcing, later, points where

the marker seemed a bit dim--for example, the red line, which I went over with deep red Tempera Royal Talens so that it would stand out more and stay brighter and compact at times than the Pantone did (which at times tended to create lines, especially on thicker and smoother sheets). For the shadow spots, I first accentuated them by doing a double outline with light pencil, then filling them in with tempera because the Pantone would have made the contours too blunt and flat.

For the other backgrounds in this series (see designs pag. 202-209) I reproduced the elements pertinent to the theme, at times directly free-hand, mixing them, at other times by photocopying details, sometimes the words, and then retracing the contours using a light table. Coloring with Pantone or tempera.

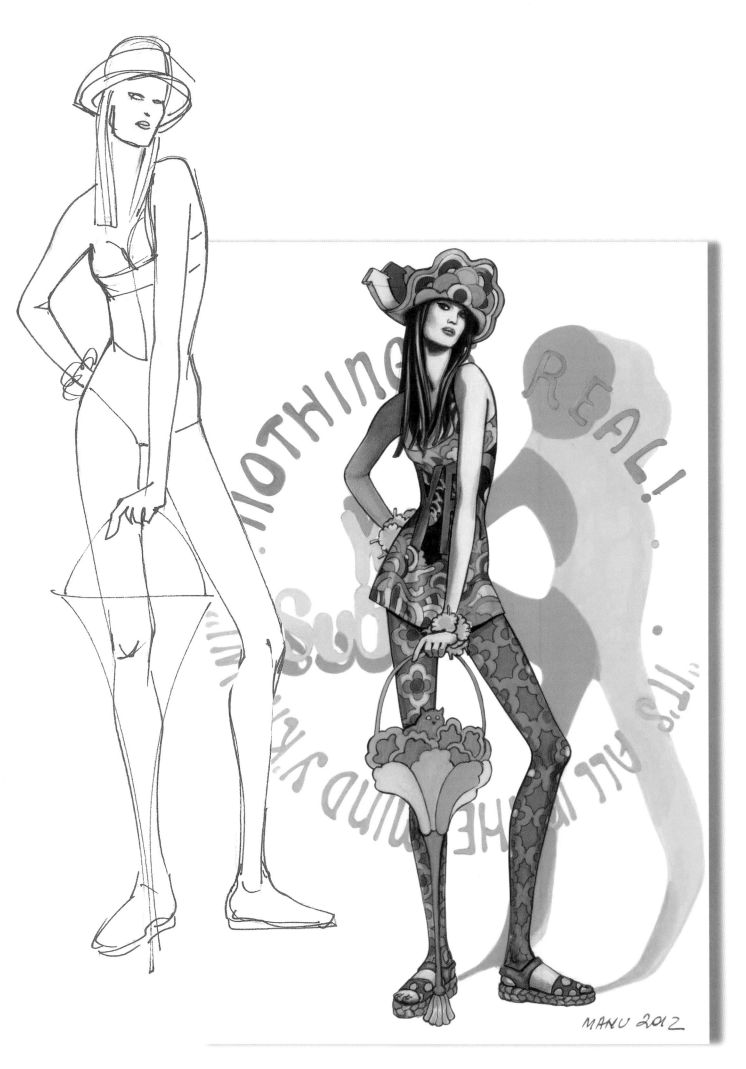

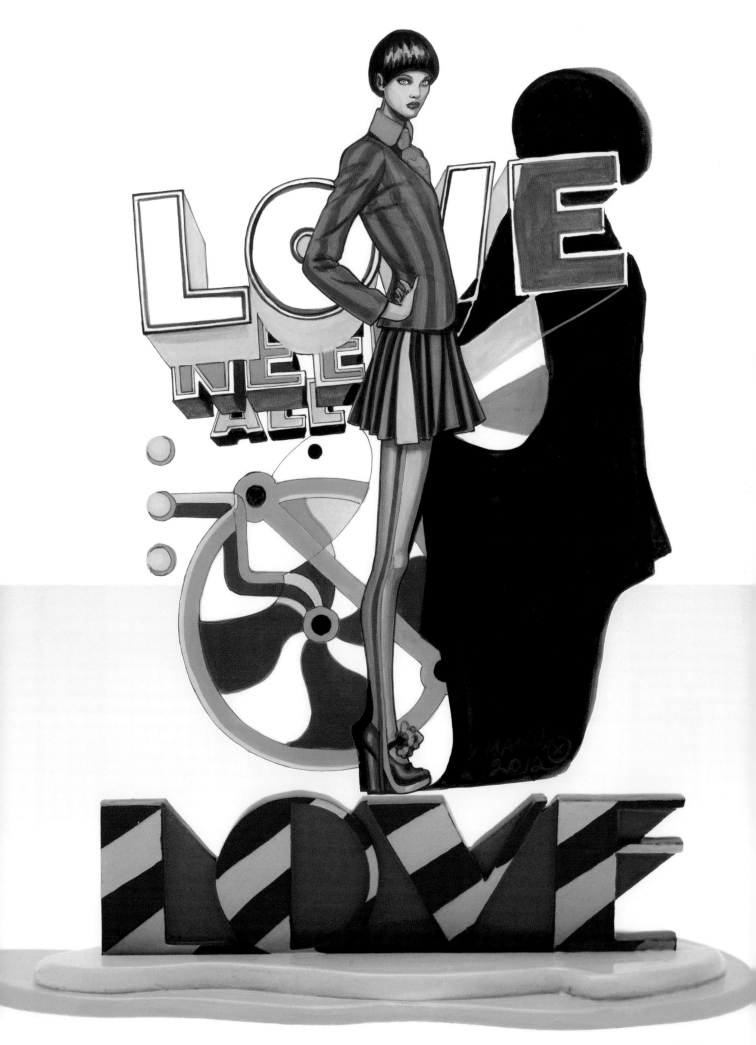

203

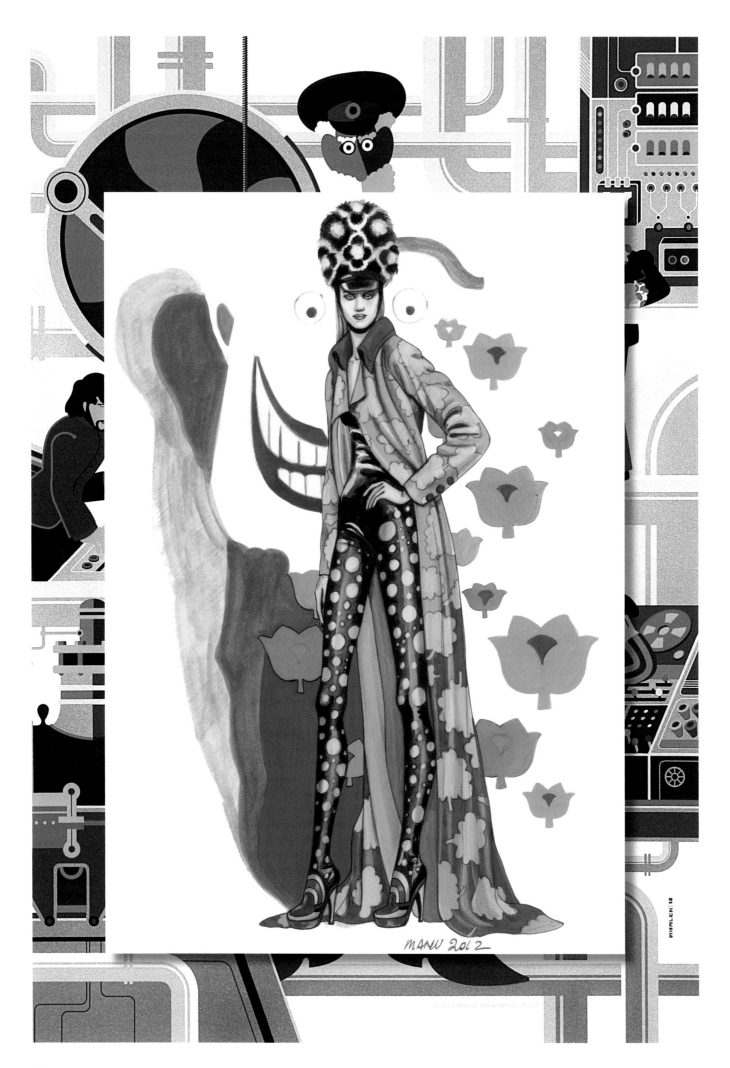

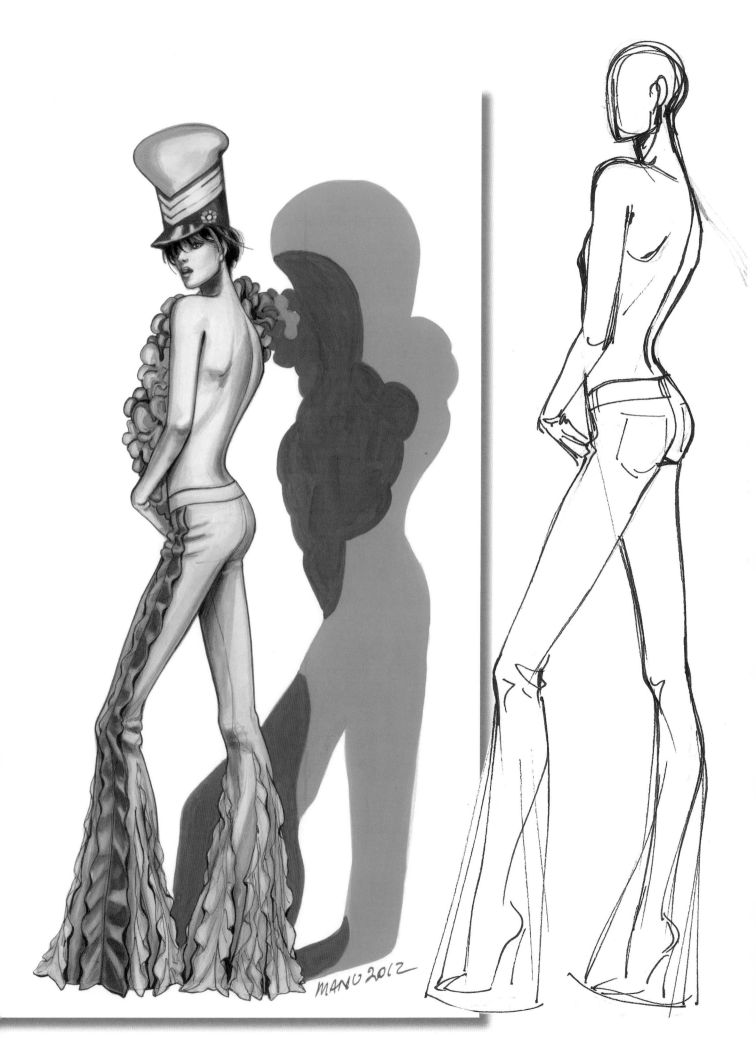

MANU 2012

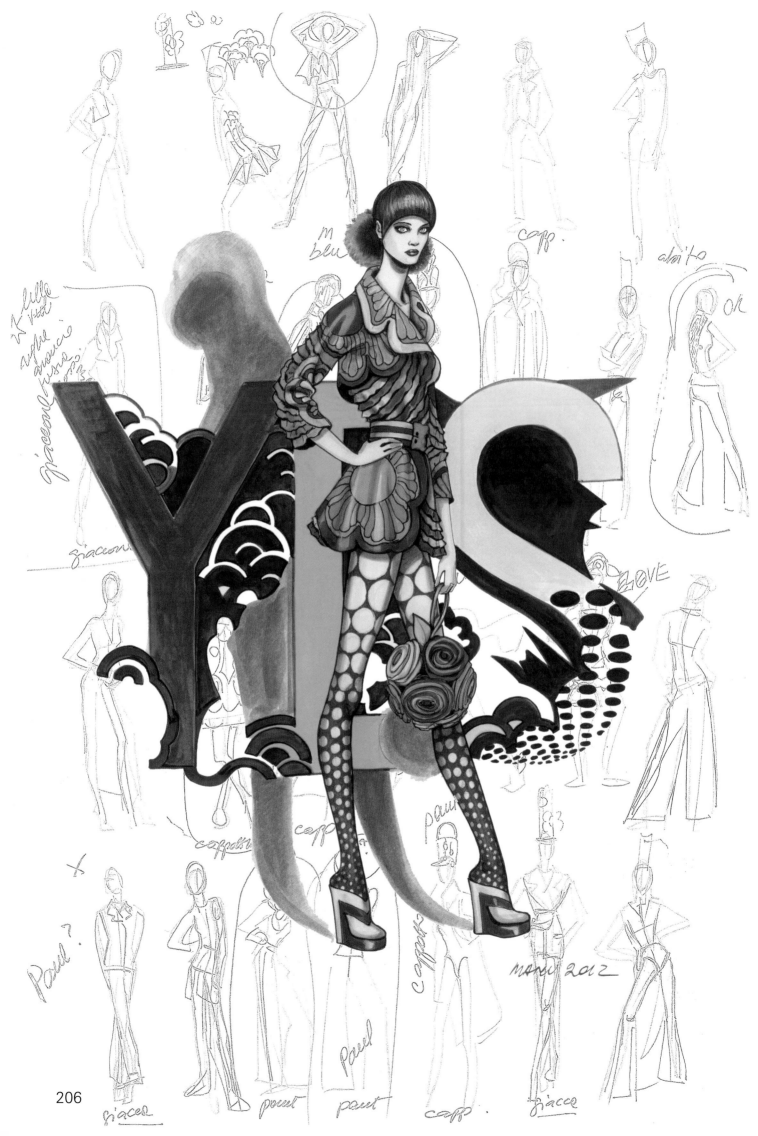

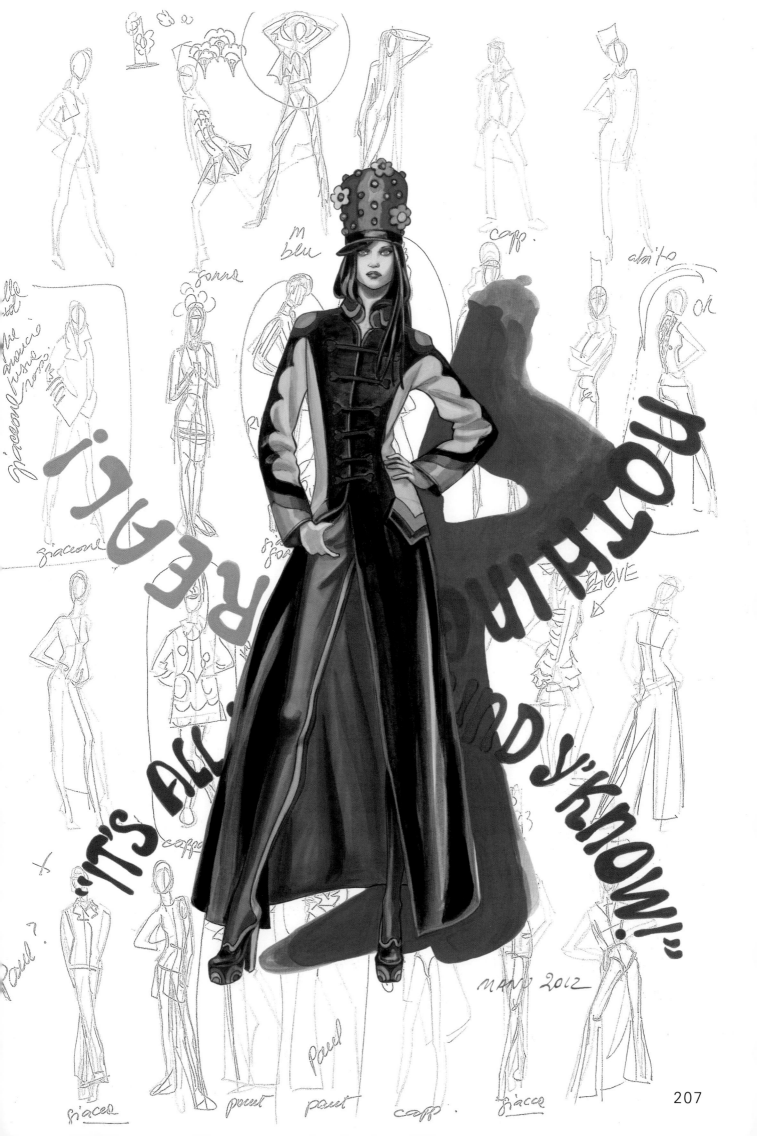

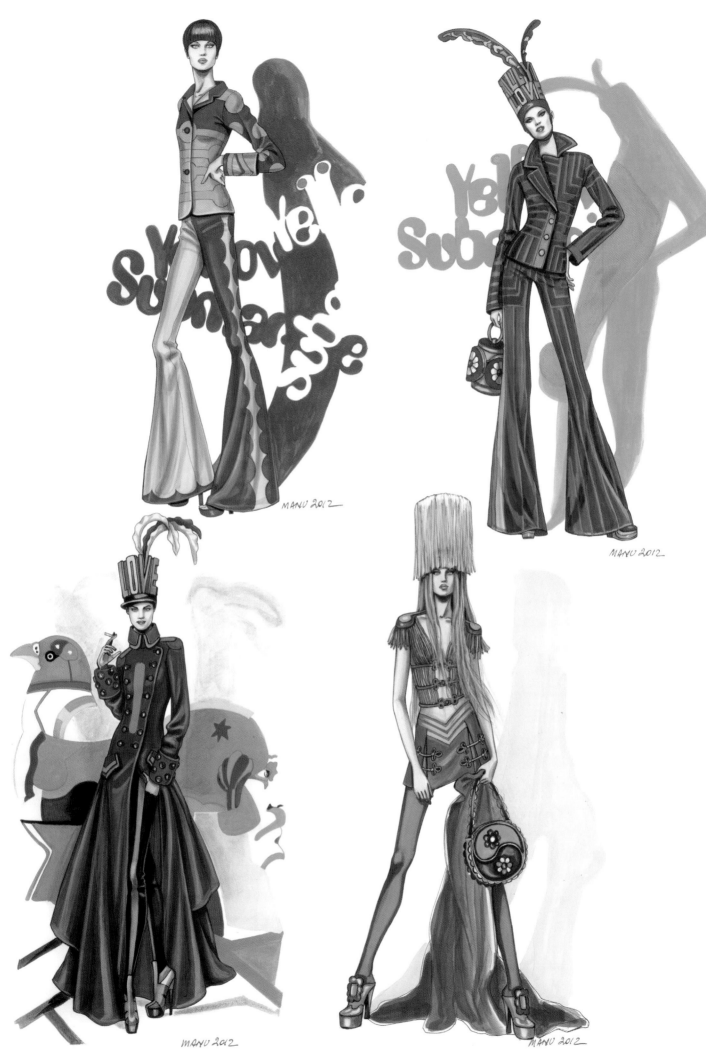

208

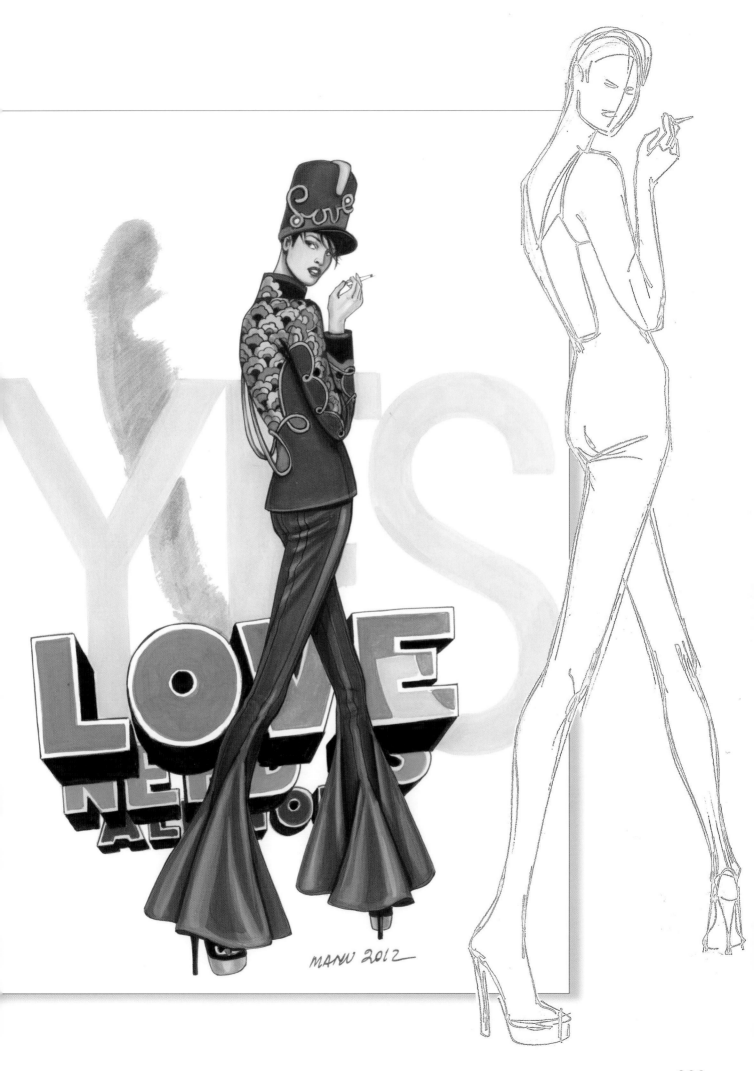

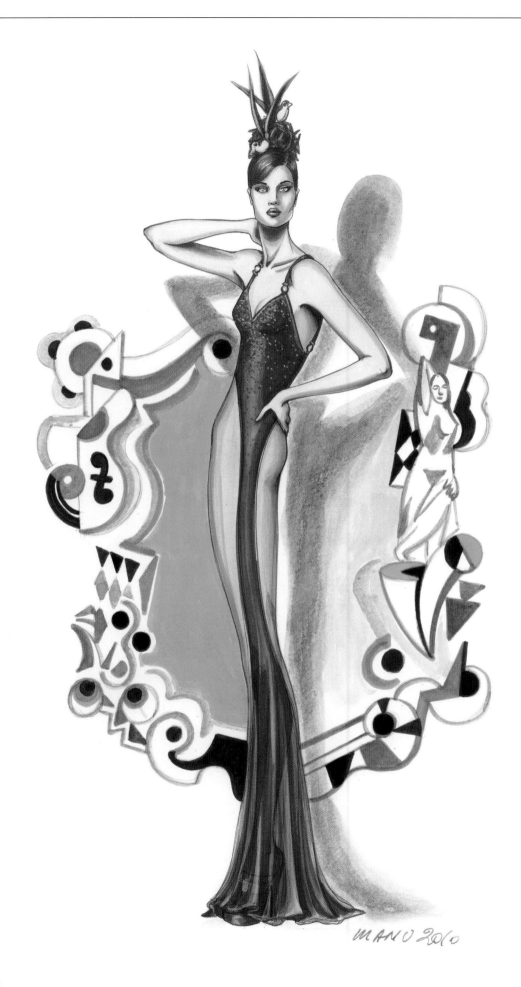

The memory of, and the affection I feel for, Gianni Versace, along with my personal enjoyment in returning after so many years to redraft classic figures, made this series of plates come to life. It was a pleasure to return to these past experiences with the spirit and the hand of today. The hand improves with time, and it had been some years since I had drawn fashion figures, so I was very curious. In that precise moment, I could feel the excitement of so many who had admired the designer's style, and together we extrapolated freely from the clothes of different collections starting from the early 1980s to 1997, reinterpreting them. It all culminated in an exhibition in Milan in March, 2011, later mounted again in Asti province.

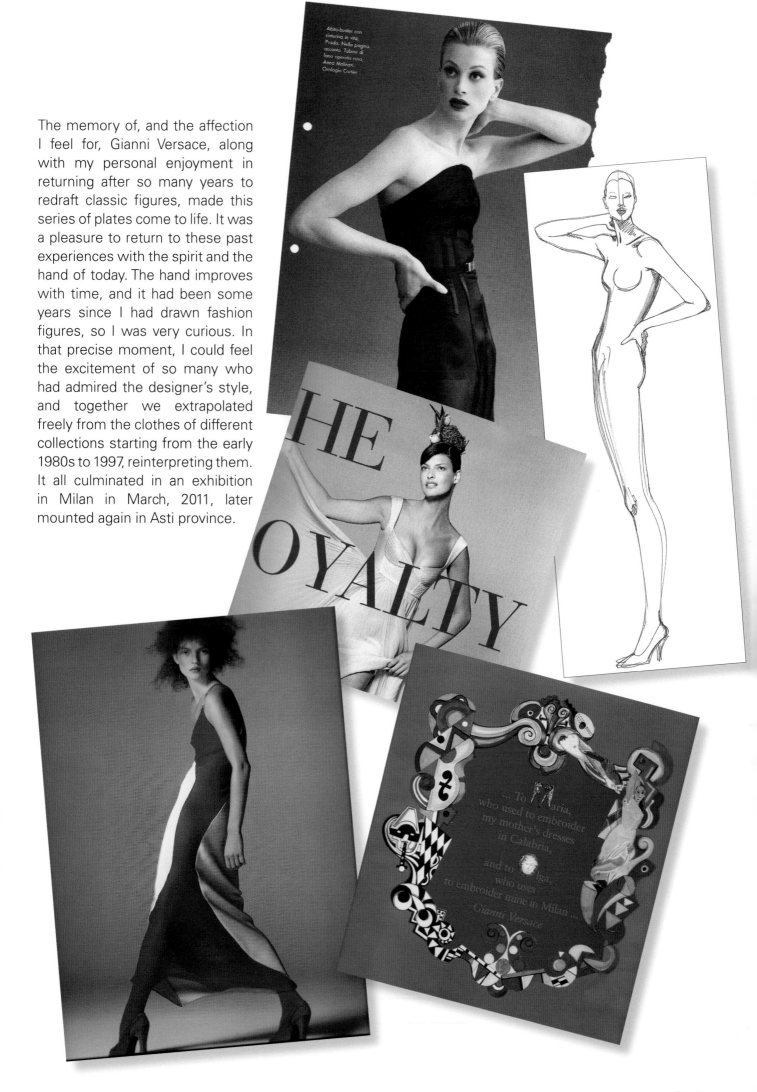

BRUNO GIANESI

A while ago when Manuela Brambatti first talked to me about this project, I was immediately excited by it and I encouraged her to keep the idea alive and continue with it, knowing full well Manuela's hesitation and the problems in tackling a complex project, problems that went beyond her artistic capabilities (those that come naturally and effortlessly, I can assure you). I am talking about all that pertains to the practical side of a project: the organization, the red tape, the contracts, etc.... and now that this is done and behind us, I am really happy. I was asked to write something about this "project" that became a "reality", and I have a problem with this. Because I would like to adopt a critical and objective point of view, but I don't know whether I can; I am linked to Manuela in a very special way which even I can't describe, there is a bond that goes beyond just knowing one another, and is made up of tacit understanding, of shared feelings and inner tumult, of states of the soul that are felt but not necessarily expressed. Then I said to myself ... but I am not a critic … Nor am I an academic or an expert in the history of style and fashion. So wouldn't it be presumptuous of me to presume write something critical, analytical or constructive??… This was not what I wanted!! I cannot, and do not want to, be "coldly objective" about Manuela's work. And along with these considerations, I realized that the text was already writing itself ... all I had to do was close my eyes and let memory take my mind back in time to the early 1980s when, just after earning my university degree in economics, I became part of the Gianni Versace team... I remember the problems, the insecurities and fears and doubts that assailed me when I found myself immersed in a world that was for me new and unknown.

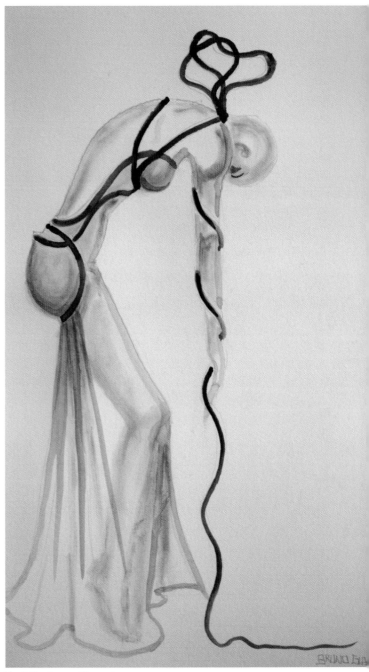

Vortici by Bruno Gianesi

I had a natural gift for design, I was passionate about the theater, and also had a rather opinionated aesthetic sense; in my drawings, Gianni saw talent and most likely a shared sense of "beauty", but I knew absolutely nothing about design—about sketching, about technical specifications, about fabric composition…in fact, I had no technical ability whatsoever. I was lost, confused and insecure. My uncertainties were disappearing ever so slowly thanks to the generous spirit, the great heart and the patience of Manuela, Manu, a little elf dressed in black, her make-up always perfectly coordinated with the colors of the different wraps which she knotted majestically around any garment whatsoever as though to underline and contrast her raven-colored hair that rose high on her head. She had an almost maternal sweetness about her, she encouraged me but, between one design and another, she corrected my work, she taught me the tricks of the trade, she spurred me on and encouraged me never to give up; and most of all she gave me faith in myself, sometimes with just a simple, reassuring smile. Years went by, my confidence grew and in time I became first assistant and in charge of all theater projects in Maison Versace. … Who, then, other than Manu, is the more suitable writer for this text? She taught me so much and I am truly happy that with equal generosity I can share her talent and knowledge to help any young person starting out on this road. I won't dwell on Manuela's artistic capabilities; her designs speak for themselves and the plates in this text are proof. Hers are not just simple sketches; Manuela's figures take shape almost magically--as you study them you expect that these extremely sensual creatures will suddenly take flight and lift off the page… The women she designs are sensual, not sexy, women proud and aware of their fascination but women as objects, elegant and never vulgar, with the elegance of yore that takes us back to the " femmes fatales fin de Siècle", to the portraits by Boldini of Marchesa Casati, fascinating, exciting, surprising—but also transgressive and revolutionary, and therefore truly modern and up-to-date. And this is actually what is so special about Manuela, her ability to match and blend together different, contrasting elements, ancient and modern, traditional and transgressional. And it isn't a matter of knowing how to draw well, of having, as they say, "a good hand", which so many have… what makes the difference is that je ne sai quoi, that other something that cannot be described, that mastery that is called class, that natural gift that one possesses independently of social class, cultural background, age, sex, or religious belief. It is the gift that produces magic from a simple sheet of paper and a pencil. I was lucky enough to live that magic, and I hope that whoever reads and uses this text has the ability and sensibility to give in to the magic and be transported by it.

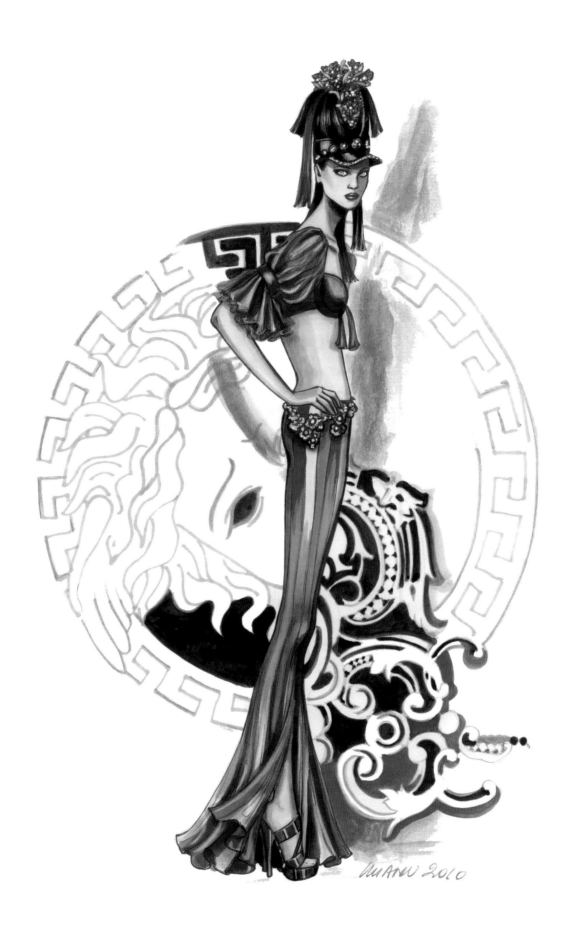

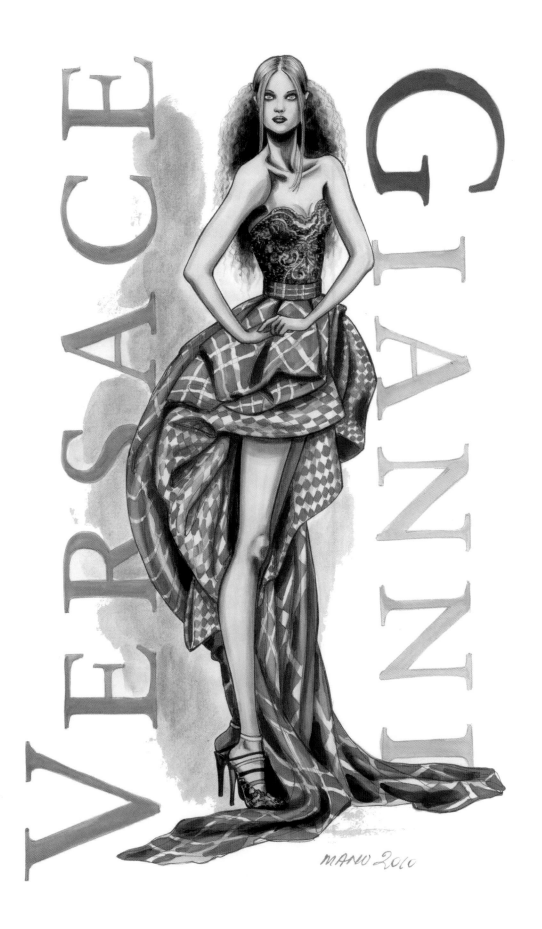

MANO 2010

215

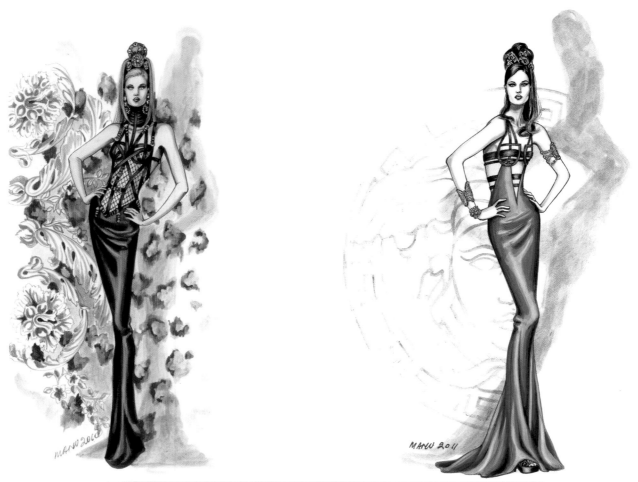

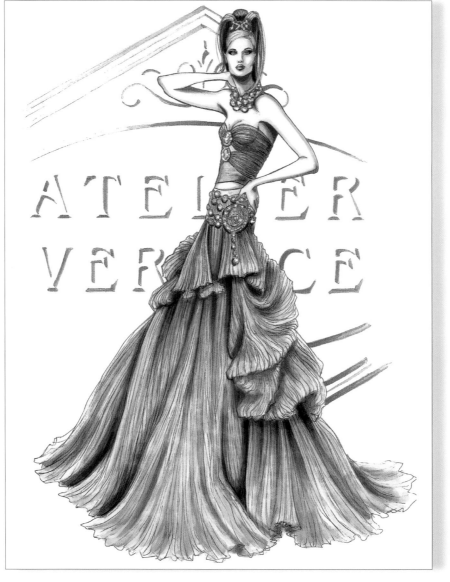

216

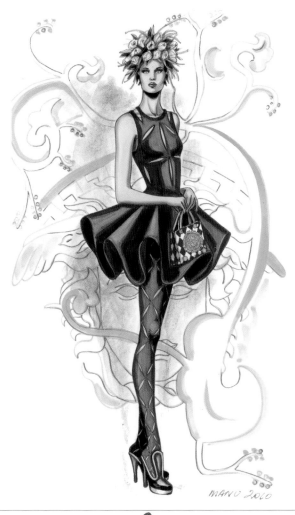

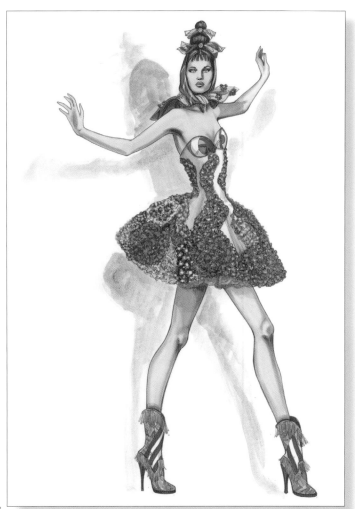

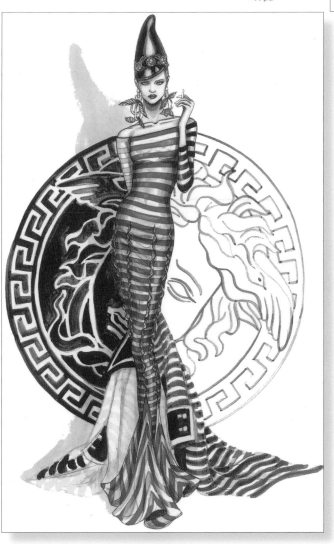

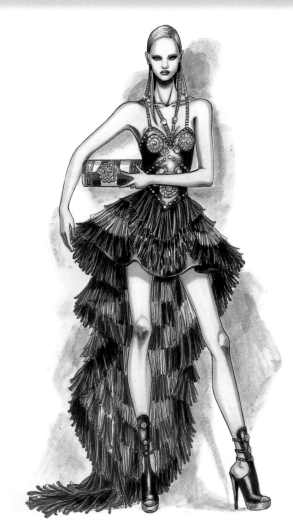

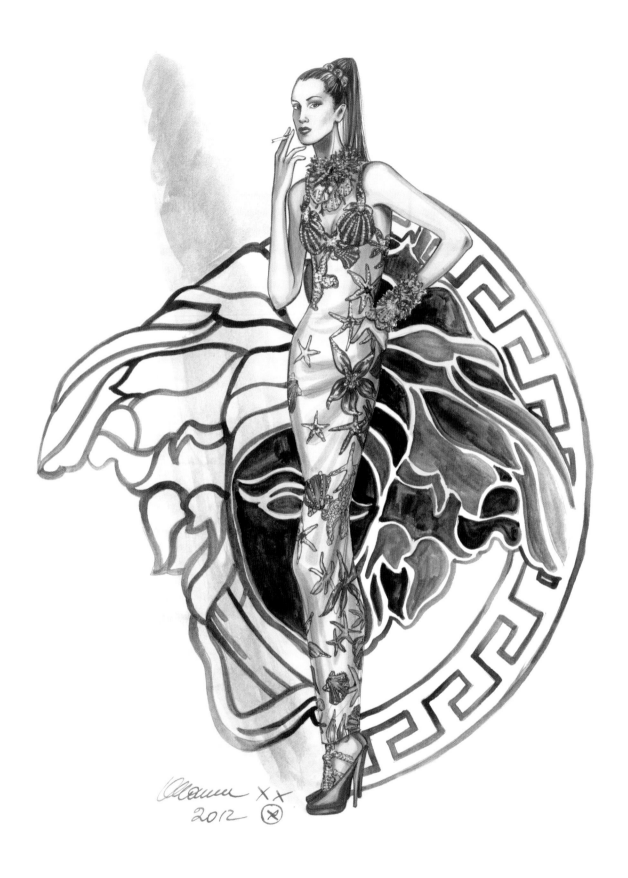

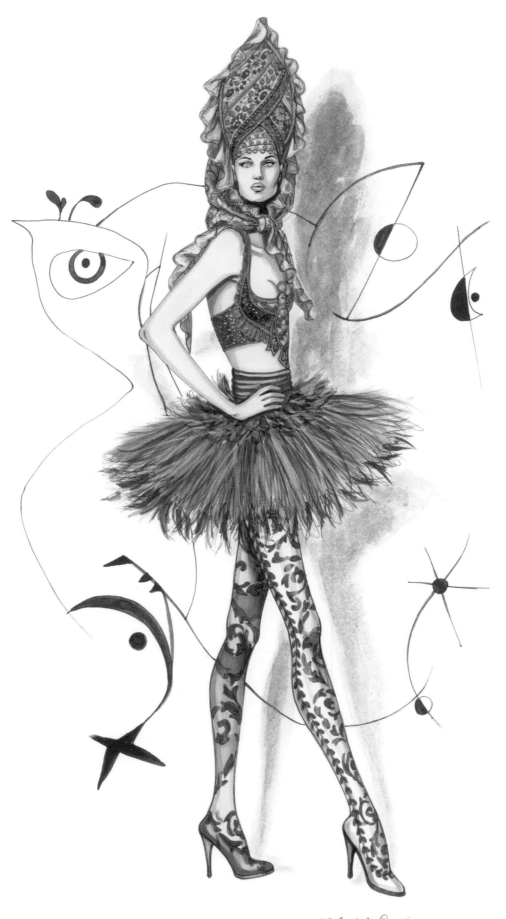

MANU 2010

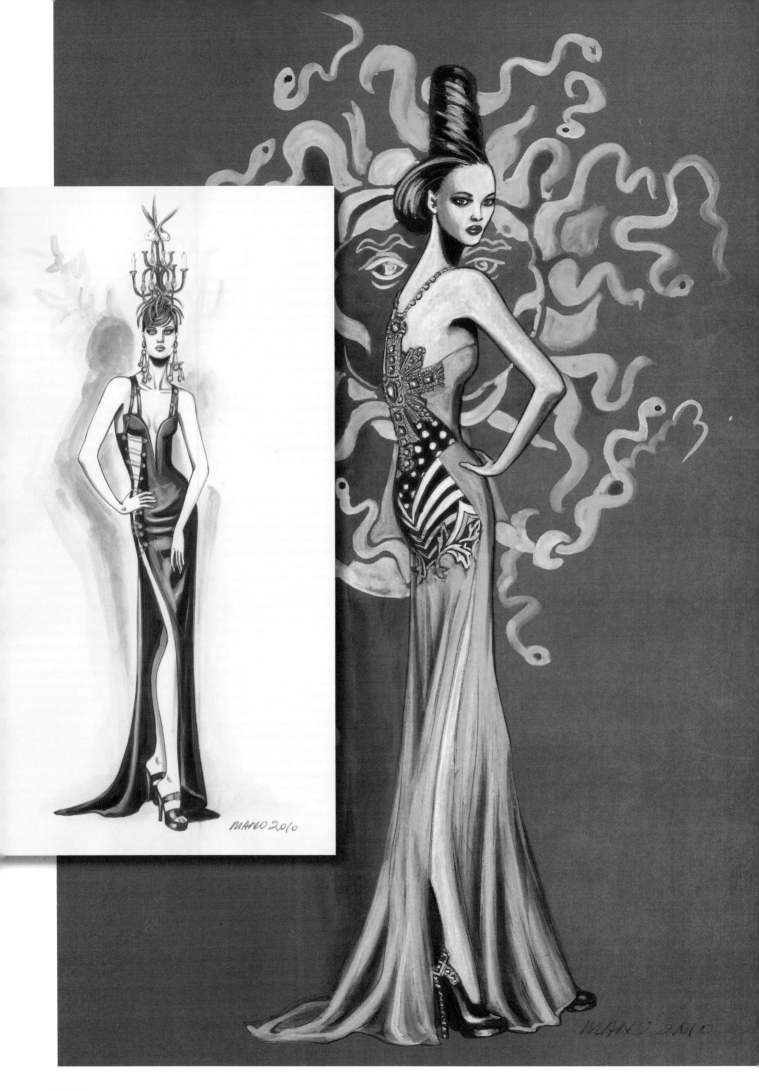

220

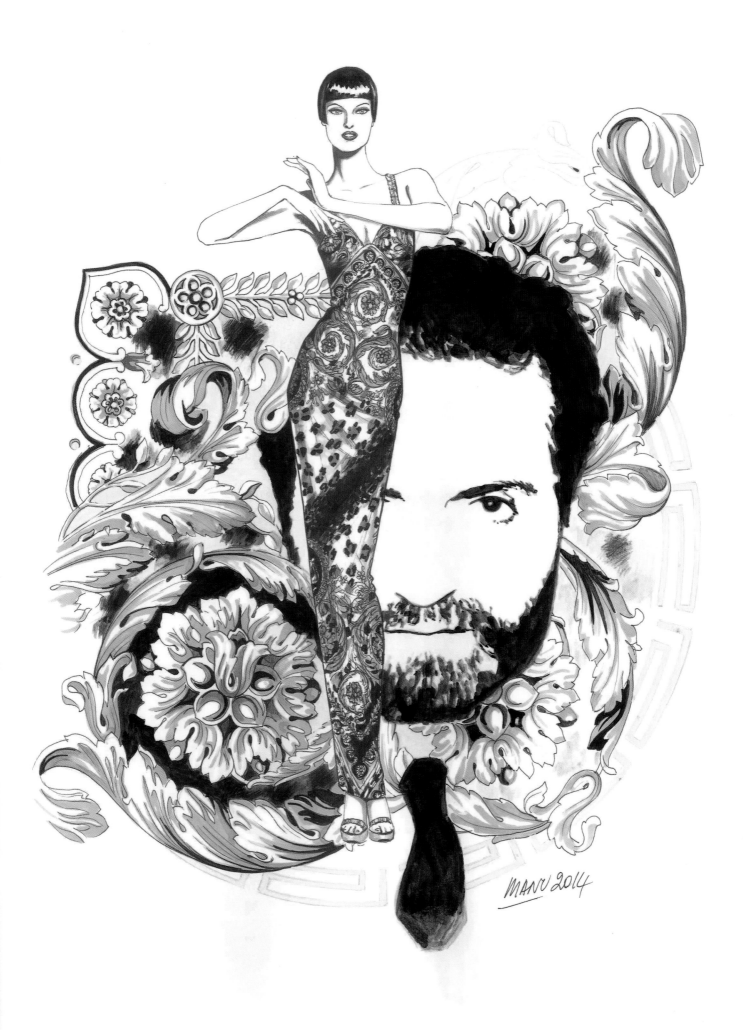

MANU 2014

HOME COLLECTION

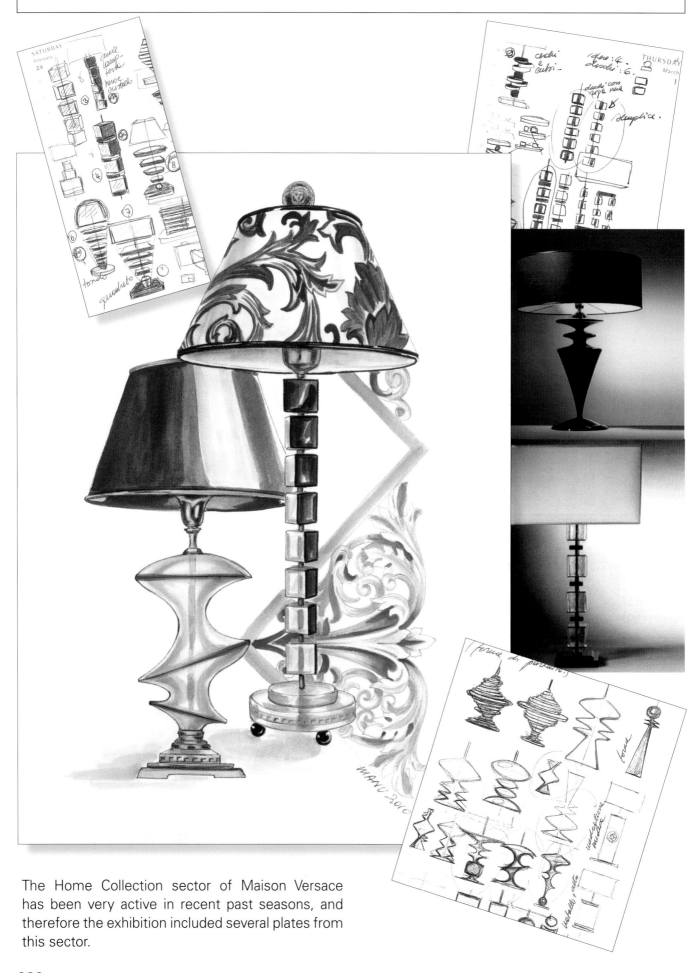

The Home Collection sector of Maison Versace has been very active in recent past seasons, and therefore the exhibition included several plates from this sector.

Versace

Giorgio

MANN 2010

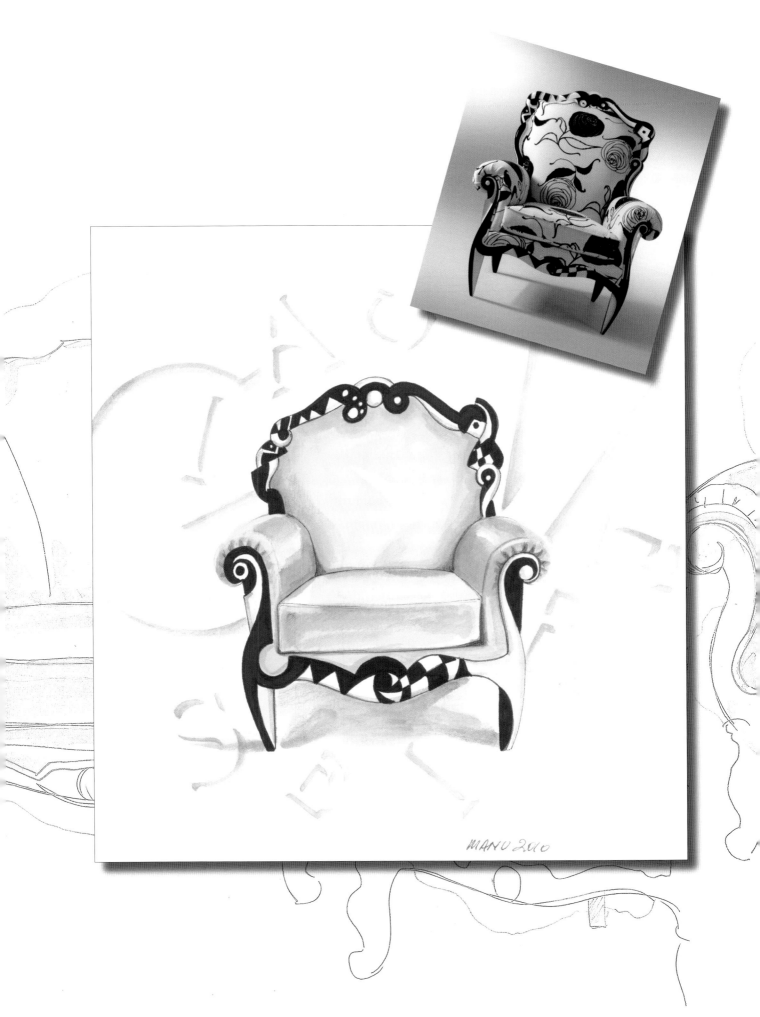

MANU 2010

For the Home

The concepts that work for jewelry work equally well for pieces for the Home Collection. A shape, a detail, can suggest something to us and can be transformative. As an example, I had found the base for an unusual table in a magazine. I liked the way it 'unfolded', like a ribbon, but was at the same time a piece of sculpture. The fun was in reproducing it (never, of course, completely identically) but as a stimulating departure point that lent itself to a new series of variations. I doodled several sketches until I got the ideas, which I found interesting, for redesigning the final versions. Here too, I used a colored sheet of paper as a background to make the contrast more pleasing, setting the elements in place as I saw fit. I used Pantone markers, Stabilo and tempera, etc.

Tea Time

These plates were designed for pure pleasure, building on professional experience that includes designs and decorations for table services produced by the Versace Home Collection in collaboration with the Rosenthal china company. I found a card that showed teapots in different styles from different periods and used it as a starting point to both redesign items and to have fun by creating new ones. Several come from books I have and have been faithfully reproduced, while others have been changed according to how the moment struck me. Some were drawn first on bits of notebook paper, or on sheets with a marble print, or a parchment print, etc. I used bases that had been designed separately, then redesigned on large-grid paper to retain the straight lines and then reproduced on paper starting with pencil then marker, etc.

TEA-TIME

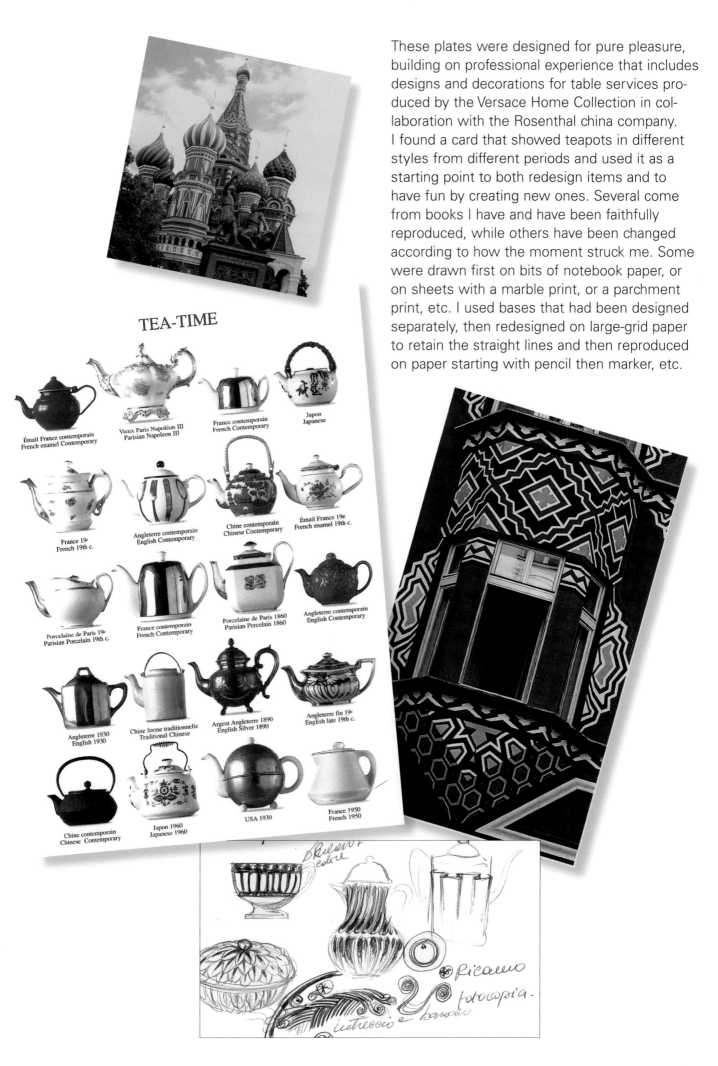

Émail France contemporain
French enamel Contemporary

Vieux Paris Napoléon III
Parisian Napoleon III

France contemporain
French Contemporary

Japon
Japanese

France 19e
French 19th c.

Angleterre contemporain
English Contemporary

Chine contemporain
Chinese Contemporary

Émail France 19e
French enamel 19th c.

Porcelaine de Paris 19e
Parisian Porcelain 19th c.

France contemporain
French Contemporary

Porcelaine de Paris 1860
Parisian Porcelain 1860

Angleterre contemporain
English Contemporary

Angleterre 1930
English 1930

Chine forme traditionnelle
Traditional Chinese

Argent Angleterre 1890
English Silver 1890

Angleterre fin 19e
English late 19th c.

Chine contemporain
Chinese Contemporary

Japon 1960
Japanese 1960

USA 1930

France 1950
French 1950

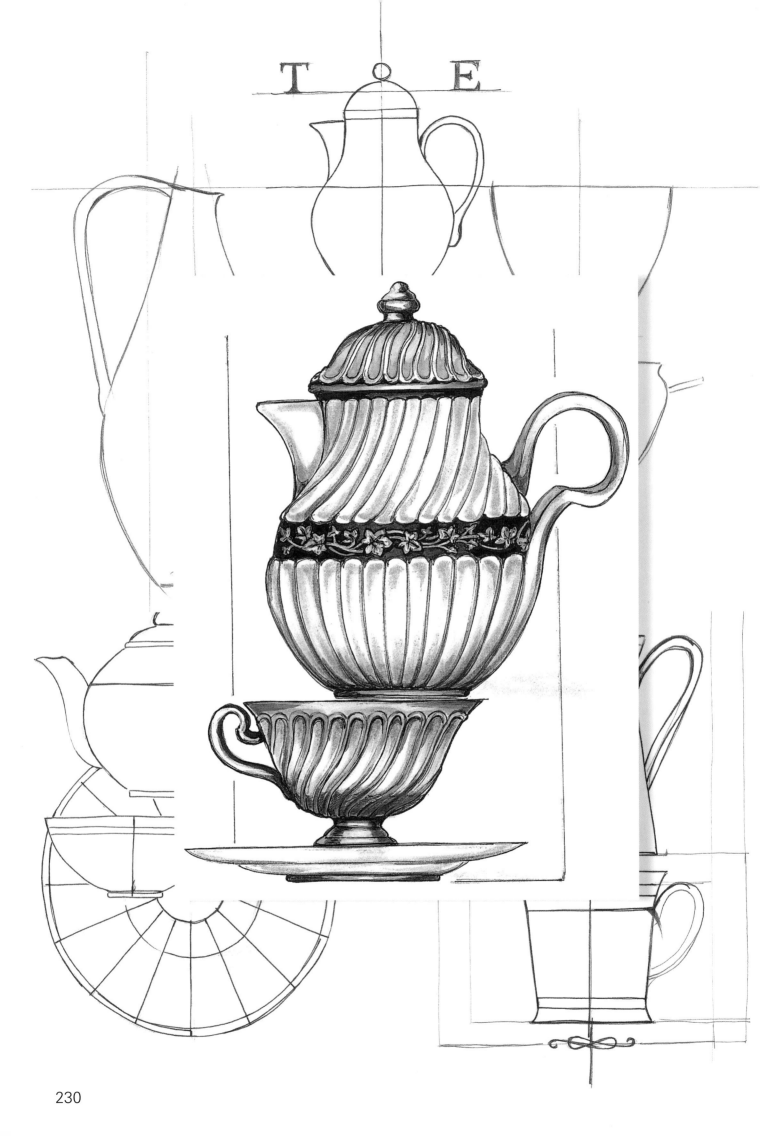

T E

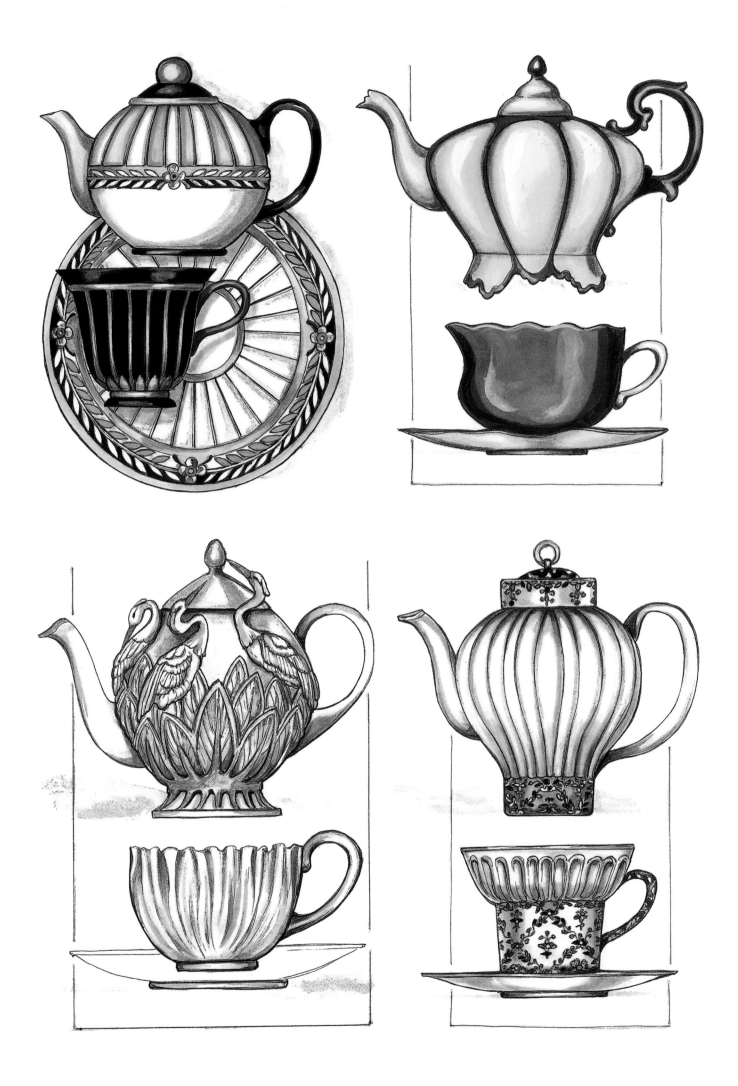

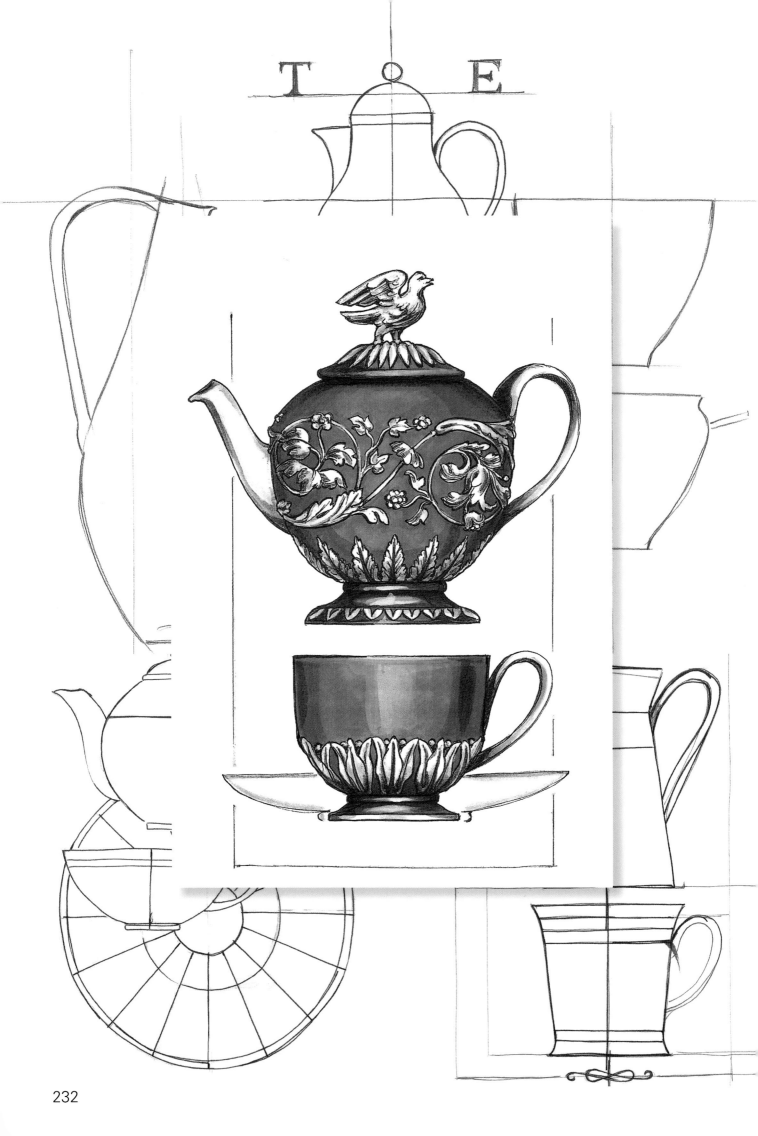

T E

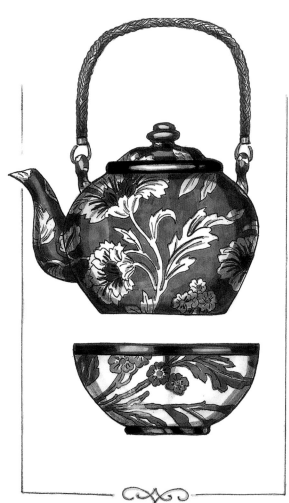

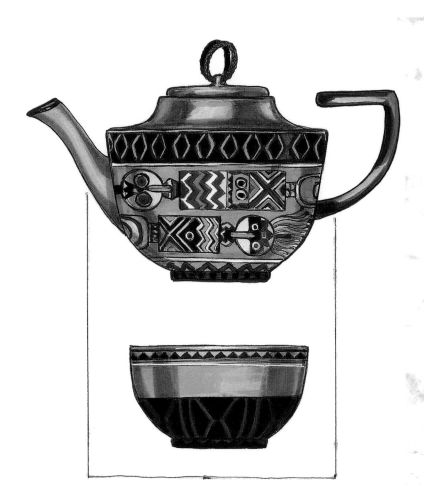

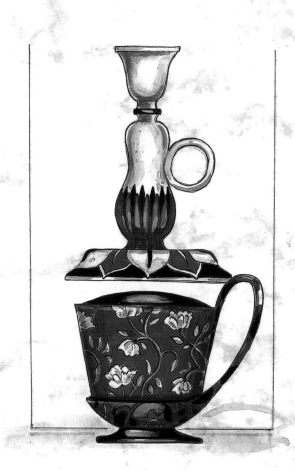

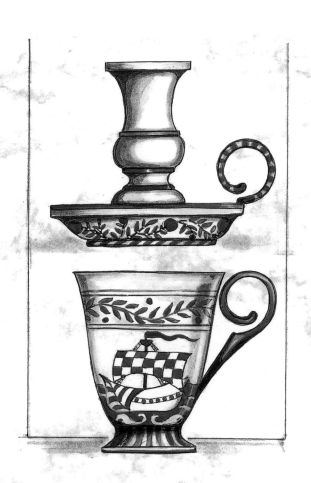

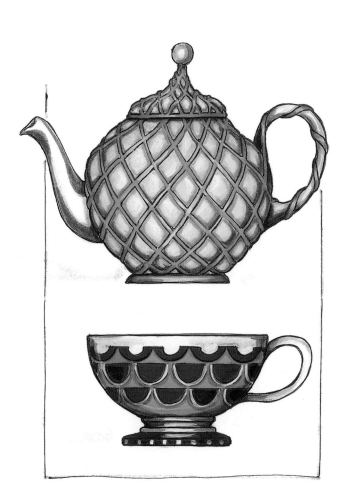

PROMOPRESS FASHION COLLECTION

FASHION ILLUSTRATION & DESIGN ACCESSORIES
Shoes, Bags, Hats, Belts, Gloves and Glasses
Manuela Brambatti and Fabio Menconi

978-84-17412-64-7
210 x 297 mm. 264 pp.

The third book from this series on illustration and design focuses on the most popular accessories: shoes, handbags, hats, belts, gloves and glasses. Brilliantly illustrated by Manuela Brambatti, a key member of the Gianni Versace fashion house for nearly thirty years, and with the participation of the designer Fabio Menconi (senior designer for Escada and Armani, among others), the book guides readers through the fashion world's most iconic accessories, and it features practical information and technical advice on how to draw them to achieve a desired result.

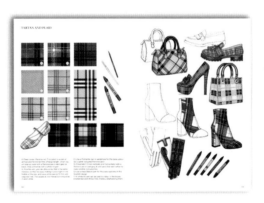

COLOUR IN FASHION ILLUSTRATION
Drawing and Painting Techniques
Tiziana Paci
978-84-16851-59-1

215 x 287 mm. 320 pp.

This book is a practical manual intended specifically for anyone interested in delving into the technique of granting colour to fashion figure illustrations to give them more life and expressiveness. In a clear an educational way, Tiziana, Paci, author of the well-know book *Figure Drawing for Fashion Design*, explains in detail the different themes examined in the work through images and examples along with concise and to-the-point texts ideal for neophytes as well as people who have been working in this field for years.

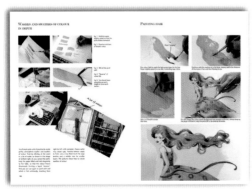

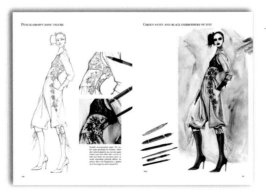

PALETTE PERFECT
Color Combinations Inspired by Fashion, Art & Style
Lauren Wager

978-84-15967-90-3
148 x 210 mm. 304 pp.

FASHION DETAILS
4,000 Drawings
Elisabetta Kuky Drudi

978-84-17412-68-5
195 x 285 mm. 384 pp.
Second Edition in 2020

FASHION SKETCHING
Templates, Poses and Ideas for Fashion Design
Claudia Ausonia Palazio

978-84-16504-10-7
195 x 285 mm. 272 pp.

FASHION HISTORY
The Ultimate History of Costume from Prehistory to the Present Day
Stefanella Sposito

978-84-15967-82-8
195 x 275 mm. 256 pp.

PRINTED TEXTILE DESIGN
Profession, Trends and Project Development
Michaël Cailloux and
Marie-Christine Noël

978-84-15967-67-5
215 x 280 mm. 192 pp.

COUTURE UNFOLDED
Pleats, Folds and Draping In Fashion Design
Brunella Giannangeli

978-84-16851-91-1
190 x 260 mm. 120 pp.

FASHION PATTERNMAKING VOL.1, VOL.2, VOL.3
Antonio Donnanno

210 x 297 mm.

ISBN vol. 1: 978-84-15967-09-5. 256 pp.
ISBN vol. 2: 978-84-15967-68-2. 256 pp.
ISBN vol. 3: 978-84-16504-18-3. 176 pp.

FASHION MOULAGE TECHNIQUE
A Step by Step Draping Course
Danilo Attardi

978-84-17412-12-8
195 x 285 mm. 192 pp.

FABRICS IN FASHION DESIGN
The Way Successful Fashion Designers Use Fabrics
Stefanella Sposito.
Photos by Gianni Pucci

978-84-16851-28-7
225 x 235 mm. 336 pp.

Manuela Brambatti

Manuela Brambatti appeared on the world's fashion scene at the end of the 1970s as a contributor to Design Offices and illustrator for fashion magazines.

She worked with different designers: Giorgio Correggiari, Krizia, Gian Marco Venturi...but her most important and defining experience was her meeting with Gianni Versace. As a member of staff and later, beginning in 1981 and up until 2009, working exclusively at Maison Versace, Manuela contributed on a creative and illustrative level in the Design Office for Women's ready-to-wear clothes and Atelier, Theater, Accessories, Children, VIP, illustrations and, in later years, in the Home Collection.

Now working as an independent, she contributes to the fashion and design sector and at the same time indulges her passion for illustrative/figurative art which allows her free expression of her creative potential. In 2011, she was the subject of a personal exhibit dedicated to Gianni Versace entitled "The dreams I shared with Gianni: an homage to his memory"; the same year she exhibited at the "Fashionable Theater" debut at the Mazzucchelli Museums in Brescia and later at the Palazzo Morando, Milan's Costume Museum.

Her designs are featured in art books like the series "Vanitas" (Abbeville Press), "Versace Teatro" vol. I and II (Franco Maria Ricci), "Versace eleganza di vota" (Rusconi), "Gianni Versace L'abito per pensare" (Arnoldo Mondadori Editore), and "South Beach Stories Gianni e Donatella Versace" (Leonardo Arte).